D1199053

Pearls
A Natural History

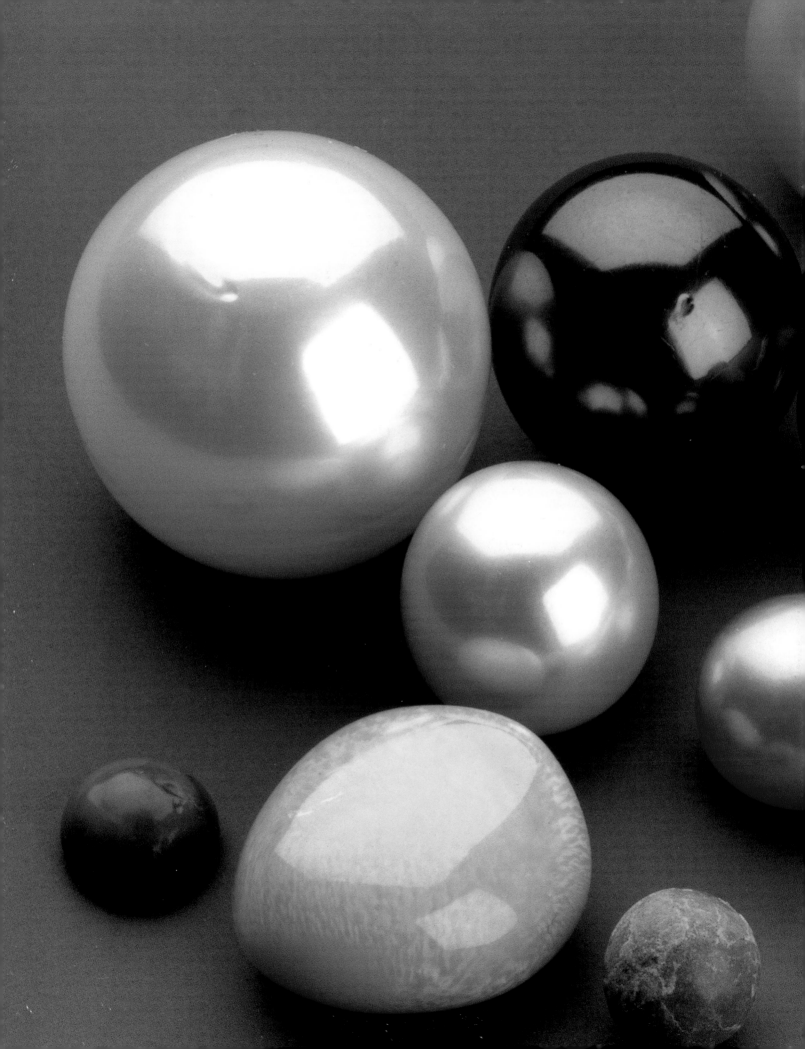

Pearls
A Natural History

NEIL H. LANDMAN
Division of Paleontology,
American Museum of Natural History

PAULA M. MIKKELSEN
Division of Invertebrate Zoology,
American Museum of Natural History

RÜDIGER BIELER
Department of Zoology,
The Field Museum

BENNET BRONSON
Department of Anthropology,
The Field Museum

Published by
HARRY N. ABRAMS, INC.,
in association with
THE AMERICAN MUSEUM
OF NATURAL HISTORY
and
THE FIELD MUSEUM

COVER AND FRONTISPIECE: A selection of spectacular pearls includes cultured commercial products and natural curiosities spanning the variety of pearl-producing mollusks. From left to right: natural blue mussel pearl (*Mytilus edulis*), cultured white South Sea pearl (*Pinctada maxima*), natural conch pearl (*Strombus gigas*), cultured Akoya pearl (*Pinctada fucata*), cultured Tahitian pearl (*Pinctada margaritifera*), natural fossil pearl (*Inoceramus*), cultured Chinese freshwater pearl (*Hyriopsis cumingii*), cultured gold South Seas pearls (*Pinctada maxima*), cultured New World pearl (*Pinctada mazatlanica*), natural irregular Venezuelan pearl (*Pinctada imbricata*), natural hard-shelled clam pearl (*Pleuroploca gigantea*), natural Scottish freshwater pearl (*Margaritifera margaritifera*), and natural pipi pearl (*Pinctada maculata*).

For Harry N. Abrams, Inc.:
PROJECT MANAGER: Harriet Whelchel
EDITOR: Deborah Aaronson
DESIGNER: Joel Avirom
DESIGN ASSISTANTS: Jason Snyder and Meghan Day Healey

For the American Museum of Natural History:
PROJECT MANAGER: Maron L. Waxman

Library of Congress Cataloging-in-Publication Data

Pearls : a natural history / by Neil H. Landman . . . [et al.]
 p. cm.
 Includes bibliographical references and index.
 ISBN 0-8109-4495-2
 1. Pearl oysters. 2. Mollusks. 3. Pearls. 4. Pearl fisheries. 5.
Pearl oyster culture. I. Landman, Neil H. II. American Museum of
Natural History. III. Field Museum of Natural History.
 QL430.7.P77 P43 2001
 639'.412--dc21

 2001000632

Published in 2001 by Harry N. Abrams, Incorporated, New York

Printed and bound in Japan

10 9 8 7 6 5 4 3 2 1

Harry N. Abrams, Inc.
100 Fifth Avenue
New York, N.Y. 10011
www.abramsbooks.com

Contents

Foreword

Pearls are among nature's most fascinating creations. They are produced by mollusks and require fashioning by no human hand. Since the first ancient peoples discovered pearls—luminous droplets mysteriously emerging from sea and river animals—they have been objects of awe and value.

Pearls long outdate human beings, however. Mollusks evolved more than 500 million years ago, and fossil pearls are known since the Triassic Period, 225 million years old. When human beings began to appreciate natural objects for their beauty and give them symbolic meaning, they soon began using pearls as ornaments, and in this book you will find illustrations of some of the earliest artifacts using pearls as well as the entire sweep of the cultural and decorative history of pearls.

Pearls, unlike other gems, are the products of living animals. Their biology, microstructure, and chemistry are as much a part of their story as their ornamental uses. As leading museums and research institutions presenting both science and culture to the public, the American Museum of Natural History in New York City and The Field Museum in Chicago are particularly suited and pleased to publish *Pearls: A Natural History* and develop the joint exhibition on which it is based. Our two institutions have collaborated to explore every aspect of pearls.

The story starts with the mollusks that produce pearls. Although many species yield pearls, some mollusks produce lackluster lumps, others the glowing beads that have attracted humans for millennia and driven them to the seas and rivers to retrieve them. The kind of mollusk and the color of its shell determine the color of the pearl—white or black or pink or several other hues; depending on the site of formation in the mollusk, the pearl may be irregular or spherical.

But whatever the color or shape, human beings have been drawn to pearls. The desire for pearls, so prominent in Renaissance Europe and the Indian subcontinent before the cutting and faceting of gemstones was developed, created a flourishing international trade. This trade inspired craftsmen to create glorious artistic and religious objects and to adorn both women and men.

The desire for pearls was so great that the market outran the supply in many pearl-harvesting areas of the world and led entrepreneurs to a new industry—the stimulation of pearl production through human intervention. Scientists and researchers had sporadically experimented for hundreds of years with the culturing of pearls, but the process was not commercially perfected until the early twentieth century. Cultured pearls have shaped the contemporary picture of a pearl—round, white, of uniform size—but it took decades of publicity to gain acceptance of cultured pearls as gems. Once accepted, cultured pearls entered the wardrobe of young women around the world, the classic jewelry of brides and princesses, movie stars and debutantes.

Cultured or naturally produced, pearls begin their formation in water animals, animals that live in the lakes, rivers, and seas of the world. As pollution and other threats to these areas proliferate and as pearl-producing species become ever more specialized, mollusks are once again threatened. Looking to the future, scientists and researchers

must find ways to keep mollusks alive not only for their unique ability to produce objects of luminous beauty but also to preserve the diversity of the planet.

This is the story we tell in *Pearls: A Natural History*. Like the exhibition, the book was a joint undertaking. Our thanks go to the four authors—Neil Landman of the American Museum of Natural History and lead curator of the exhibit and coauthors and cocurators, Paula Mikkelsen, also of the American Museum of Natural History, and Rüdiger Bieler and Bennet Bronson of The Field Museum. These scientists traveled to some of the world's leading repositories of pearls and pearl treasures, as well as to active centers of pearl culture today; here they present much original material on perliculture, as well as a rich survey of the cultural and decorative uses of pearls in societies ancient and contemporary. Their work was supported by the work of many people on the staffs of both museums and of institutions throughout the world whose holdings and research are represented in this book and the exhibition.

We also express our deep and sincere appreciation to Tasaki Shinju Co., Ltd., for its generous support of the exhibition *Pearls*.

ELLEN V. FUTTER
President, American Museum of Natural History

JOHN W. MCCARTER, JR.
President and CEO, The Field Museum

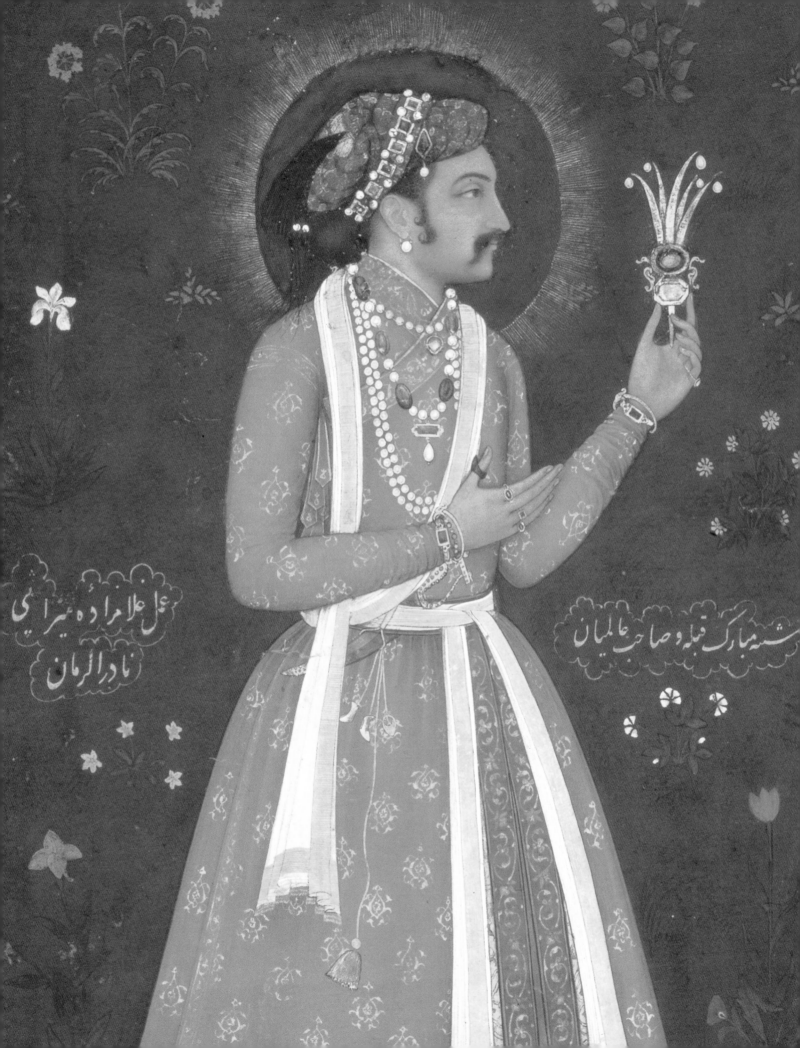

Introduction

Pearls are among the world's most-coveted gemstones. From the Roman Empire and Renaissance Europe, to imperial China, India, and Russia, to ancient North America and the present day, they have been treasured, sought, traded, bought, and stolen. Arriving in finished condition from their biological sources—saltwater pearl oysters and freshwater pearl mussels—they have long fascinated both scientists and queens. For those ancient peoples that held pearls in high esteem, they have served as portions of national treasuries and financed wars. Once too precious for all but nobility, today pearls are given to celebrate birthdays, weddings, anniversaries, and other special occasions.

Dictionaries define a pearl as a white or grayish mass, formed by an oyster, and highly prized as a gem for its luster. The classic concept, as well as the current gemological definition, presumes that pearls are nacreous, or made of mother-of-pearl (*nacre*). But not all pearls are nacreous, and not all come from oysters. For the purposes of this book, *a pearl is a calcareous body, composed of concentric layers around a central nucleus, and organically produced by a living mollusk*, a soft-bodied invertebrate animal bearing a hard external shell. In some cases, a pearl is the mollusk's response to invasion by a foreign body; the mollusk coats the invader to lessen the irritation it causes. This foreign body is usually organic and, contrary to popular lore, is hardly ever "a grain of sand."

Although the most familiar pearls are small perfect spheres, they are more commonly irregular, ranging from slightly off-round to bizarrely asymmetrical, and from minute to massive. Pearls have been produced throughout the evolutionary history of mollusks, beginning in the Cambrian Period, 530 million years ago. Fossil pearls are known from more than thirty species of mollusks, some from as many as 225 million years ago, and were common during the Age of Dinosaurs.

As one of humankind's oldest gems, pearls have inspired many theories about their formation. To ancient Romans, they were the frozen tears of oysters or the gods. Greeks attributed pearls to lightning strikes at sea. The dew theory, upheld by many peoples from antiquity through the seventeenth century, held that pearls were solidified rain or dewdrops, captured by the clams. This theory probably originated in Arabia, Iran, or India. The Roman scholar Pliny the Elder was one of its leading proponents:

> *When the genial season of the year exercises its influence on the animal, it is said that, yawning, as it were, it opens its shell, and so receives a kind of dew, by means of which it becomes impregnated; and that at length it gives birth, after many struggles, to the burden of its shell, in the shape of pearls, which vary according to the quality of the dew.* (*Historia Naturalis*, 9: 54)

Columbus noted in the Gulf of Paria, in present-day Venezuela, that "close to the sea there were countless oysters adhering to the branches of the trees which dip into the sea, with their mouths open to receive the dew which falls from the leaves, until the drop falls out of which pearls will be formed."[1] By the end of the Renaissance such views came under challenge. The English pirate Richard Hawkins succinctly dismissed the dew theory as "some old philosopher's conceit."[2] In 1609, Anselmus de Boodt speculated that

Shah Jahan by Abul Hassan (1617).

pearls were produced by the secretion of a "viscous humour" within the oyster.[3] More scientific opinions—positing that pearls were undeveloped eggs, a sign of disease, or entombed parasites—were advanced as early as the second century B.C.E. and became a subject of scientific fervor in eighteenth-century Germany.[4]

As we now understand it, pearl formation is a simple extension of shell formation in which the shell-forming tissue coats a foreign object that cannot be dislodged or, if a small fragment of this tissue is displaced into the soft body, secretes shell matter internally. Today's science of *periculture* takes advantage of this process by intentionally implanting an object to be coated within the mollusk's body and nurturing it in controlled conditions while the mollusk produces a *cultured pearl*. The formation of a *natural pearl*, also called a *fine pearl*, differs only in that the foreign object intrudes accidentally. In this sense, any pearl formed by a living mollusk, whether natural or cultured, is "real." Today, virtually all "real" pearls on the market, except pre-twentieth-century pearls from antique or estate sources and certain specialty pearls, are cultured pearls.

Although modern pearls are most often associated with Japan or the South Seas, our great-grandparents' generation thought quite differently. Until early in the twentieth century, most of the world's marine pearls came from the Indian Ocean, specifically the Persian Gulf and the Gulf of Mannar between Sri Lanka (formerly Ceylon) and India. These regions dominated the international pearl trade for more than forty centuries, yielding the famous pearls belonging to Cleopatra, Julius Caesar, and Marco Polo. At the turn of the nineteenth century, the total world production of pearls from natural or "wild" beds of saltwater pearl oysters and freshwater pearl mussels amounted in the currency of that period to about $8.1 million. Well over half of this wealth came from one region—the Persian Gulf and the Gulf of Mannar.[5]

The dominance of the Indian Ocean in pearl production has been broken only twice. Most recently and most immutably, Japan came to the forefront in the 1920s, when pearls produced by artificial culturing techniques became accepted as "real" and began to sell steadily. This not only spelled the end of commercial pearl diving everywhere, but also made pearls more readily available to the general populace. The Japanese advance was so successful that natural pearls are now a curiosity, and jewelers everywhere depend on pearls cultured by Japanese-perfected methods in the South Pacific, Australia, China, Mexico, the United States, and Japan itself.

But few are aware of the first time that the two gulfs ceased to dominate the world pearl trade. Around 1500 C.E., great quantities of pearls from the Americas began to flood the European market. Taken from the pearl beds of the Caribbean and Panama, they arrived by the bushel. Monarchs and nobles wore them by the hundreds, to such an extent that modern historians of costume and decorative arts have called this period the Great Age of Pearls. Equally unknown to most readers may be the founder of this feast—the figure Christopher Columbus—Italian explorer financed by Spain, who, in seeking a quicker route to India and the Orient, sailed westward into the Caribbean and the New World. This opulence of New World pearls was, however, short-lived, lasting only about a century and a half. By the mid-seventeenth century, the pearl-bearing oysters of the southern Caribbean and Panama were close to extinct, and the river of pearls carried from the Spanish Main dwindled to a trickle. Following this decline, the traditional pearl producers of the Persian Gulf and India-Sri Lanka quietly reclaimed their old markets, retaining their supremacy until the advent of Japanese cultured pearls.

At the beginning of the third millennium, pearls continue to be popular. Royalty, movie stars, society matrons, businesswomen, and young girls all wear pearls. What is the explanation for this enduring attachment? We live in a scientific age where most people are at least vaguely familiar with how pearls are formed by pearl oysters and pearl mussels. Yet this understanding has not lessened but rather enhanced the appeal of pearls, emphasizing the unique nature of this gem. Undoubtedly, pearls are prized as intrinsically beautiful objects because of their luster, color, shape, and silky surface. However, it is the historical associations of pearls with purity, refinement, religious virtue, glamour, and wealth that prevail in our thinking of pearls as the queen of gems.

In this volume, we have sought to present a holistic story of pearls—incorporating and interweaving, from our own varied backgrounds, elements of pearl biology, gemology, anthropology,

mineralogy, ecology, and decorative arts. This same holistic approach was pursued in the creation of the exhibit curated by the same authors, opening to the public in fall 2001 at the American Museum of Natural History, New York City, and in summer 2002 at The Field Museum, Chicago. In analyzing our research, we have recognized many periods during which pearls were especially popular: Greco-Roman (200 B.C.E.–400 C.E.), the Islamic period in West and South Asia (700–1700), the Renaissance (1400–1650), traditionally called the Great Age of Pearls, the Qing dynasty of China (1650–1910), the Gilded Age (1890–1910), and notably, the present day. The modern age can be characterized by its diversity—involving numerous countries, a wide variety of pearl-producing mollusks, and attendant variations on the method of pearl production. Today a democratization of pearls is evident; pearls are affordable not only to the rich and royal, but to almost everyone.

The first chapter of this book—Columbus's Pearls—describes the dramatic rise and fall of the American pearl fishery in the sixteenth and seventeenth centuries, marking the moment when Europe's interest in pearls was at a peak. We begin with this story because it encapsulates all the elements of the history of humans and pearls: courage, greed, splendor, vanity, astounding luxury, human suffering, enlightened science, and exploitation of both human beings and natural resources. Although Columbus and his immediate successors have recently been criticized for their blatant abuse of native West Indian peoples, this story vividly illustrates the human passion for pearls, the extremes taken to find and procure them, and the consequences—good and bad—of that quest. From there we discuss the science of pearls, the pearl in cultural history throughout the world, the history of pearling and perliculture, and finally the ecology and conservation of pearl-producing mollusks.

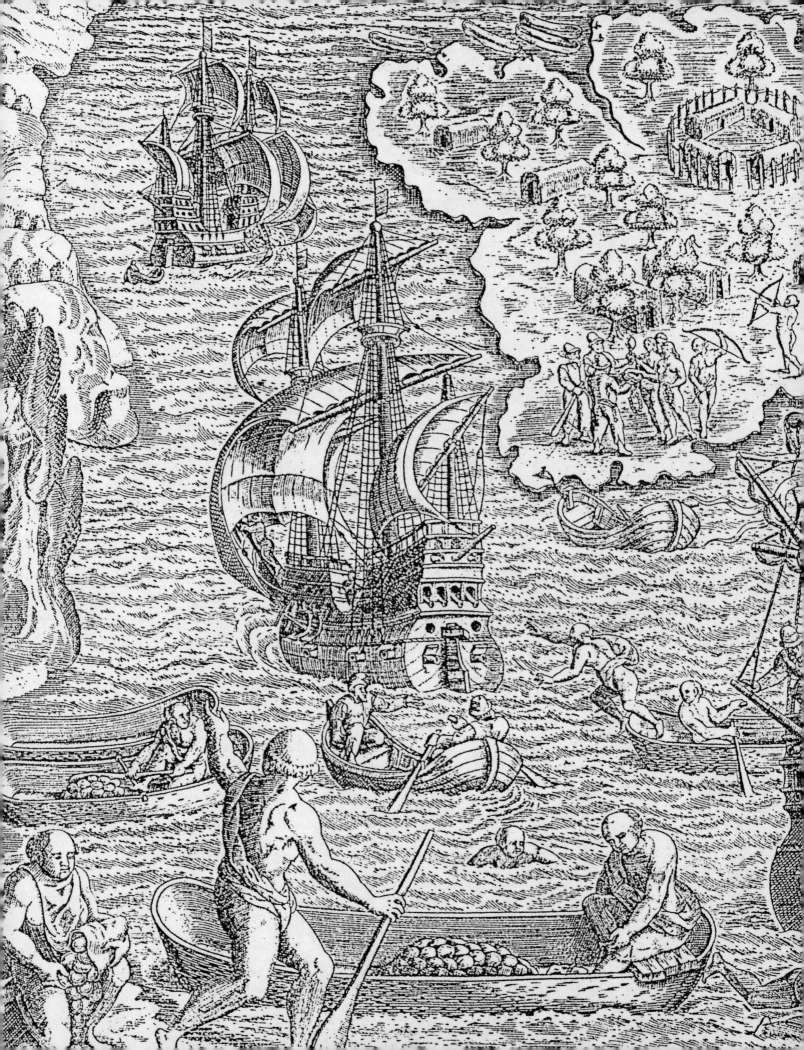

1

Columbus's Pearls

Frustrated by long and costly traditional routes through Asia Minor and the Middle East, and hampered by the Turkish occupation of Constantinople, the Spanish monarchy in the fifteenth century groped for an alternate approach to the riches of India and the Orient. Inspired by greed, a messianic desire to convert the world to Christianity, and fierce competition with the ocean-going Portuguese, King Ferdinand and Queen Isabella of Spain agreed to sponsor the Genoese explorer Christopher Columbus in an "enterprise of the Indies." His contract granted Columbus the title Admiral of the Ocean Sea and authority over all lands he discovered, as well as 10 percent of the value of all goods obtained. In turn, the monarchs presented an explicit list of the goods they expected—"pearls, precious stones, gold, silver, spice. . . ."[1] Whether by chance or design, pearls were the first item on this list.

Columbus set sail westward in 1492, carrying samples of gold and pearls to help explain his goals to those he might encounter. He made landfall somewhere in the Lesser Antilles of the Caribbean Sea, mistaking this for part of Asia, and thus introducing the name West Indies and that of its inhabitants, Indians. He explored the coasts of Cuba and Hispaniola (modern-day Haiti and the Dominican Republic), recording

only "water suitable to breed pearls" in some areas and "mussel shells which are a sign [of pearls]."[2] After establishing the settlement of Santo Domingo on Hispaniola, Columbus returned to Spain in triumph, with gold, cotton, and Indians to be baptized—but without pearls.

The Spanish monarchs were nevertheless delighted. With the pope's blessing and a reaffirmation of his rewards and privileges, Columbus was outfitted for a return voyage to the West Indies in 1493. During this trip, he discovered an abundance of oysters between Cuba and Jamaica that he ordered gathered by the boatload. While tasty, these oysters did not yield any pearls and the particular species he collected is unrecorded.[3] It was not until Columbus's third trip, when he reached the South American mainland in 1498, that he finally found the long-sought supply of pearls. Carrying provisions for the settlement in Hispaniola, he first detoured south, approaching the South American coastline. Traversing the strait off Trinidad, he entered the Gulf of Paria near the mouth of the Orinoco River in present-day Venezuela. At one Indian village, Columbus noticed that the native women wore bracelets of "pearls or baroque pearls of high quality."[4] Asked about the source of the pearls, the natives gestured to the north and west, indicating the Caribbean side of the peninsula.

Pearl fishing at Cubagua and Margarita Islands, from an engraving by Théodor de Bry (1594). Cubagua Island was the primary source of pearls from the Americas in the sixteenth century.

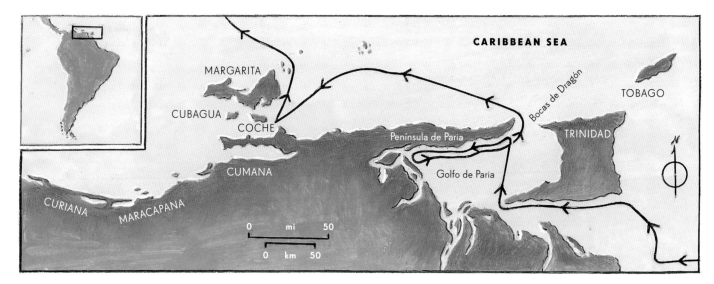

Columbus bartered for these pearls with needles, buttons, scissors, and fragments of broken majolica plates and asked the natives to set aside more pearls for his eventual return. Concerned that his provisions were spoiling in the mid-August heat, he left the Gulf of Paria through the Bocas de Dragón.

Sailing back toward Hispaniola, he passed the islands of Cubagua and Margarita, sites of what would ultimately become known as the "Pearl Coast," the richest pearl grounds in America. By coincidence he named Isla Margarita, using the Greco-Roman word for "pearl," to honor the Infanta Margarita of Austria who was engaged to marry the heir to the Spanish throne. Without exploring further, Columbus continued to his colony on Hispaniola where rival political factions were vying for dominance. Thus embroiled in mediating colonial politics, he sent two ships back to Spain with letters about the settlement and discovery of the new region which, in actuality, represented the continent of South America. To his ultimate discredit, he did not report the discovery of Venezuelan pearls, an omission that would have ruinous consequences.

In Spain, events conspired against Columbus. The returning sailors privately sold the pearls they had acquired. This news spread quickly and, along with the pearls, reached the Spanish Court. Ferdinand and Isabella were disturbed that Columbus had not sent back any pearls or reports of their discovery directly to them. They may have believed, as his detractors argued, that Columbus plotted to conceal the discovery and later claim the Venezuelan pearls for

himself. Added to these suspicions were concerns about Columbus's inept handling of the political situation on Hispaniola, his transport of slaves to Spain, which apparently offended the Christian sensibilities of the Queen, and reports of excessive cruelty to the sailors and West Indian natives.

Columbus finally returned to Spain in 1500, in chains and under arrest. Although decidedly out of favor with the monarchy, he was able to redeem himself, reportedly moving the queen to tears with accounts of his trials and tribulations. He excused himself from his failure to pursue and track down the source of the pearls, citing ill health, the lack of an adequate vessel, and concerns for the Hispaniolan settlers. He later lamented, "When I discovered the Indies, . . . I spoke of gold, pearls, precious stones, spices, and of the markets and fairs. But because not everything turned up at once, I was vilified."[5] When the royal release order came in due course, he immediately set about preparing for his fourth voyage to the New World.

Columbus embarked on his fourth and last voyage in 1502. Although no longer in disgrace, the authority and profit-sharing privileges that he had once been granted were no longer in effect. His instructions were again to "observe what gold, silver, pearls, |precious| stones, spices and other products there may be and in what quantity and where they came from."[6] During this voyage, Columbus followed the eastern coast of Central America, stopping en route in what are now Panama and Honduras. Although he encountered many natives, he

Columbus's route on his third Caribbean voyage (1498) took him off the coast of present-day Venezuela, where he first encountered indigenous peoples wearing pearls.

evidently did not acquire any pearls. Columbus returned to Spain for the last time in 1504, again without pearls, and died in 1506. Although he neither profited from his discovery nor realized its potential, his voyages initiated a "pearl rush" that was to last for the next 150 years.

COLUMBUS'S SUCCESSORS AND THE YEARS OF EXPLOITATION

The first to profit from Columbus's discovery of Venezuelan pearls were his sailors. Among them, Peralonso Niño, former pilot of the ship *Santa Maria*, was given royal permission in 1499 to explore the Pearl Coast and retrieve its pearls, in clear contravention of Columbus's active exclusivity agreement. Mainly through trade, Niño succeeded in obtaining many fine pearls, most probably from Margarita and Cubagua Islands and areas along the coast. The chronicler Peter Martyr recorded that Niño brought back "96 pounds of pearls, some as large as hazelnuts, very clear and beautiful, though poorly strung."[7]

At about the same time, with Columbus embroiled in politics in Hispaniola, his former sailor Alonso de Hojeda somehow obtained Columbus's map of the South American mainland and planned a return trip. He was accompanied by the then-unknown Italian Amerigo Vespucci, who represented Medici interests and whose account of the voyage would later earn him the name of a continent. Hojeda returned to the Pearl Coast and landed on Isla Margarita, exploring Aruba, Bonaire, and Curaçao before moving on to Hispaniola and the Bahamas. He obtained about 150 pearls and 119 marcos (approximately 27 kilograms or 60 pounds) of pearls through barter and prepared to sail for Spain.[8] Ominously, Hojeda decided to ensure the success of his voyage by raiding the islands for slaves. Vespucci claimed that Hojeda stopped in the Bahamas and loaded no fewer than 232 captive Lucayans before returning to Spain in the spring of 1500.[9] While his total profit from the pearls and Lucayan slaves was not great—only 500 ducats (approx. 2000 grams of gold)—he was the first to link these two commodities. This set a precedent that would be eagerly followed by many of his countrymen during the next decade.

The ensuing quest for pearls expanded to cover the Pacific coast of Central America. Núñez Balboa of Spain explored Panama in 1513 and, upon reaching the Pacific coast, encountered natives wearing pearls. When asked about the source of these riches, the chief responded that the best pearls came from Tararequi in the Gulf of Panama, later called Isla Perlas. As word of Balboa's discovery spread, other Spaniards headed for the Gulf of Panama and returned with sackfuls of pearls. Like the pearls from Venezuela, most Panamanian pearls were destined for Spain.

Together these explorations succeeded in exhausting the supply of American pearls that were in native hands and available through trade. As a result, the pearl trade on the Pearl Coast seems to have slowed for a few years. The next phase was the organization of pearl-harvesting ventures. The earliest mention of pearling under Spanish direction is found in a letter of 1509 from the king to Nicolás Ovando, governor of the newly established colony of Hispaniola. The letter discussed diving for pearls and the foundation of a small settlement established for that purpose on Isla Cubagua.[10] Most of the divers were probably Lucayan slaves brought from the Bahamas. Because Lucayans were accustomed to diving in search of conchs, their staple food, they fetched a high price from slave traders. Demand for Lucayan pearl divers was so high that by 1520, there were no Lucayans left in the Bahamas.[11]

Pearl harvesting developed more seriously after 1509 with Ovando's retirement to Spain and his replacement by Christopher Columbus's son Diego. As the Governor of Hispaniola, Diego Columbus established the first permanent pearl-fishing settlement on Isla Cubagua, called Nueva Cádiz. From the Spanish point of view, the settlement prospered and by 1528 there were approximately one thousand Spanish residents at Nueva Cádiz, including merchants, tax officials, craftsmen, patrons of pearl-gathering enterprises, and local Indians. There was also a large number of enslaved Caribbean and Venezuelan natives and black slaves from Africa, who manned the canoes and dived for pearls.[12]

Pearl fishing quickly expanded into other areas of the region, including Isla Margarita, Isla Coche, and along the coast at Cumana, Maraca-

pana, and eventually all the way to Cabo de la Vela in present-day Colombia. In 1526, Oviedo y Valdes gave the most complete description of pearl diving at that time:

> *Many Indians working in groups . . . leave the island of Cubagua . . . and go out in a dugout or boat early in the day to where they think they will find a large quantity of pearls. There they anchor the boat, in which one Indian remains, and he keeps the boat as still as he can. The others dive to the bottom. After some time an Indian will return to the surface and deposit in the boat the oysters in which the pearls are found.[13] He rests a while, takes a bite to eat, and once more he enters the water to stay as long as he can, finally returning with more oysters. Meanwhile the other Indians, all good swimmers, are doing likewise. When night falls and they think it is time to rest, they return home to the island and turn over the oysters to their master's majordomo. . . . When he has many, he has them opened. . . . Sometimes when the sea is rougher than the pearl fisher would like, and also because naturally when a man is working under water at a great depth, a diver's feet want to rise, it is only with difficulty that the worker can remain on the bottom any length of time. Under such conditions the Indians use two large stones tied together with a cord, which they place over their shoulders, one on each side, and enter the water . . . and since the stones are heavy, the Indian can remain on the bottom. When he wants to rise to the surface he merely drops the stones.[14]*

Working conditions were extremely harsh and mortality rates among divers very high. Diving bosses, known as *rancheros* or *patrones*, employed teams of four to seven divers per canoe under the supervision of a *majordomo*. They dived to depths of 8 fathoms (48 feet or 14.6 meters).[15] A diver did not last long on the Pearl Coast, especially in the early years. In 1515, Bartolomeo de las Casas of Spain, after witnessing the injustices perpetrated against the natives, began a campaign for more humane treatment of Indians in the gold mines and pearl fisheries. His

efforts bore fruit in 1516 when the Spanish crown, now in the hands of a new king, Carlos V, issued regulations governing pearling operations. They restricted the maximum hours of diving per day, the maximum depth, and recommended minimum requirements for food and lodging. These regulations were ignored often enough that further royal edicts were necessary. One such edict imposed the death penalty on anyone forcing a free Indian to become a pearl diver:

> *Because report has been made to us that, owing to the pearl fisheries not having been conducted in a proper manner, deaths of many Indians and Negroes have ensued, We command that no free Indian be taken to the said fishery under pain of death, and that the bishop and the judge who shall be at Venezuela direct what shall seem to them most fit for the preservation of the slaves working in the said fishery, both Indians and Negroes, and that the deaths may cease. If, however, it should appear to them that the risk of death cannot be avoided by the said Indians and Negroes, let the fishing of the said pearls cease, since we value much more highly (as is right) the preservation of their lives than the gain which may come to us from the pearls.[16]*

The Venezuelan pearls collected in the first half of the sixteenth century virtually flooded Renaissance Europe. By contemporary accounts, they were mostly small with a maximum weight of 5 carats (the equivalent of 1 gram or 20 grains, or about 9 mm in diameter), and came in a variety of colors in addition to pure white. America became known as the Land of Pearls and pearls from Cubagua were as well-known as cultured pearls are today. One recent account estimated that "in all probability more pearls were put into circulation between about 1515 and 1545, chiefly from the Cubaguan region and Cabo de la Vela, than over any comparable period of time either before or since."[17]

The actual number and monetary value of the pearls exported from the Pearl Coast are difficult to estimate. Numbers fluctuated from year to year as pearl oyster beds became exhausted and new ones were found. From 1513 to 1540, the Spanish

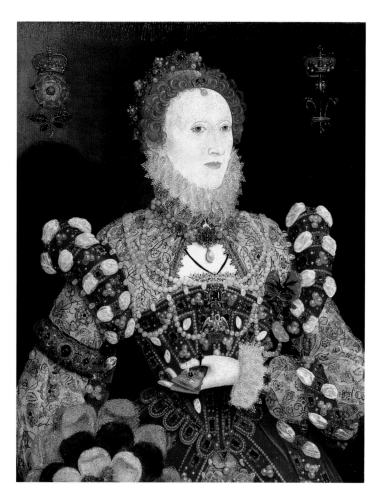

The Pelican Portrait *of Queen Elizabeth I by Nicholas Hilliard (1570s). English pirates preying on Spanish ships in the Caribbean likely seized many of the pearls adorning her garments.*

Crown's share of the pearls (20 percent, known as the *quinto* or Royal Fifth) at Cubagua alone amounted to 2,375 kilograms.[18] If this can be considered accurate, the total harvest would have been about 11,877 kilograms. However, given the vagaries of collecting and inaccuracies of reporting, this probably represents a serious underestimate. If an average Venezuelan pearl weighed 2 grains (0.1 gram, approx. 4 millimeters in diameter), this weight would have represented over 118 million pearls. In terms of today's market, this number of pearls would be worth several hundred million dollars.[19]

Pearl export at the time involved several traverses, some more risky than others. Pearls collected at various islands were first transported to local collecting centers such as Nueva Cádiz and, after various cuts were taken, including the *quinto*, most of the pearls were sent to large regional ports such as Santo Domingo. From the Caribbean ports of Santo Domingo, Cartagena, and Havana, vessels laden with their precious cargoes of pearls

and gold set sail for Spain, a trip fraught with danger from several sources. Some ships never made it back but sank at sea in then-unpredictable tropical hurricanes. Other ships were preyed upon by pirates who became increasingly more numerous throughout the sixteenth century. Most of these were English, French, or Dutch privateers who looted pearls either through attacks on ships or raids on villages. In 1592, when English pirates were spotted off the coast of Cabo de la Vela, "every ship and pearl-fishing canoe that could get away . . . sought refuge in [the] harbor."[20] One English pirate, Robert Renequer, captured a Spanish vessel from Santo Domingo in 1549 and seized nine *sacos* (bags) of pearls.[21] The celebrated English pirates John Hawkins and Francis Drake, secretly encouraged by England's Queen Elizabeth I, routinely plied the waters of the Spanish Main and seized pearls whenever they could.

Notwithstanding these losses, most New World pearls arrived safely in Spain to be placed in the Royal treasury or in the hands of private

dealers. Seville became the center of the pearl market, a position Venice had claimed in previous centuries. Garcilaso de la Vega wrote that pearls from the West Indies were so abundant in Seville "that they were sold in a heap in the India house . . . just as if they were some kind of seed."[22] Seville even surpassed Lisbon, which, through the opening of new trade routes around the Cape of Good Hope, controlled the main pearl sources in the Persian Gulf and the Gulf of Mannar. Jewelers, pearl drillers, merchants, and investors thronged the streets of Seville. Through them, New World pearls were shipped everywhere in Europe and even to Asia.[23]

This was the dawn of the European Age of Pearls. Pearls became an obsession among the elite, the height of fashion, and symbols of wealth and power. Without serious competition from other gems—sophisticated faceting techniques for precious stones were not developed until the mid-seventeenth century—pearls were unique and unrivaled. Pearl-producing areas from the New World, Persia, and India all had legends of entrepreneurs or divers who became enormously wealthy from finding a single pearl. This gold-rush mentality extended to consumers. In sixteenth-century Europe, enriched by the loot of the Age of Discovery, conspicuous consumption rose to unprecedented heights.

Portraits of European royalty at the time display a wealth of pearls in dress and jewelry. The portrait of Isabel de Valois, third wife of Philip II of Spain, by Alonso Sanchez Coello (c. 1560), shows her wearing large round pearls and rubies in her headdress, necklace, and belt, and along her bodice and shoulders. Pearls are also stitched to her collar and the top of her dress. In a portrait in the Palazzo Riccardi in Florence, Catherine de Medici, Queen of France in the mid-sixteenth century, is shown with round white pearls embroidered on her dress in addition to a pearl headdress, necklace, and earrings. In numerous portraits of Queen Elizabeth I of England, and the men and women of her court, the sight of pearls is overwhelming. Although some of these were probably European freshwater pearls or marine pearls from the Persian Gulf, others were undoubtedly American pearls, seized in the Caribbean by loyal English pirates and delivered to their revered queen.

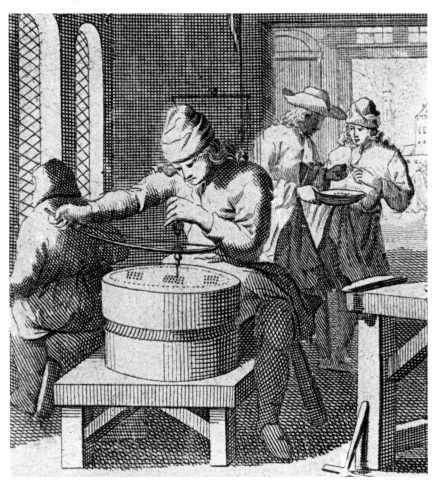

Some of the most famous American pearls acquired their own names and histories. La Peregrina, a large pear-shaped white pearl, was collected in Panama and acquired an astonishing history of ownership. The Charles II pearl was found in 1691 and was said to closely match La Peregrina in size and beauty. Another Panamanian pearl called La Huerfana or The Orphan—so named because it was found loose in the shell beds and not in a pearl oyster—also became part of the Spanish royal jewels. Noted for its large size, beautiful luster, and perfect shape, La Huerfana was briefly owned by Isabel de Bobadilla, daughter of the man who sent Columbus back to Spain in irons.

DECLINE AND DEMISE

Initially, the Spanish considered the supply of pearls in the Americas inexhaustible. An account at the time described the optimistic attitude about the future of pearl fishing in the region:

(ABOVE) Der Perlenbohrer (The Pearl Borer), *a seventeenth-century woodcut by Christoph Weigel, shows the traditional means of drilling pearls using a bowlike device.*

(OPPOSITE) *Isabel de Valois, third wife of Phillip II of Spain, epitomized the extravagant use of pearls in the European Renaissance in this portrait by Alonso Sánchez Coello.*

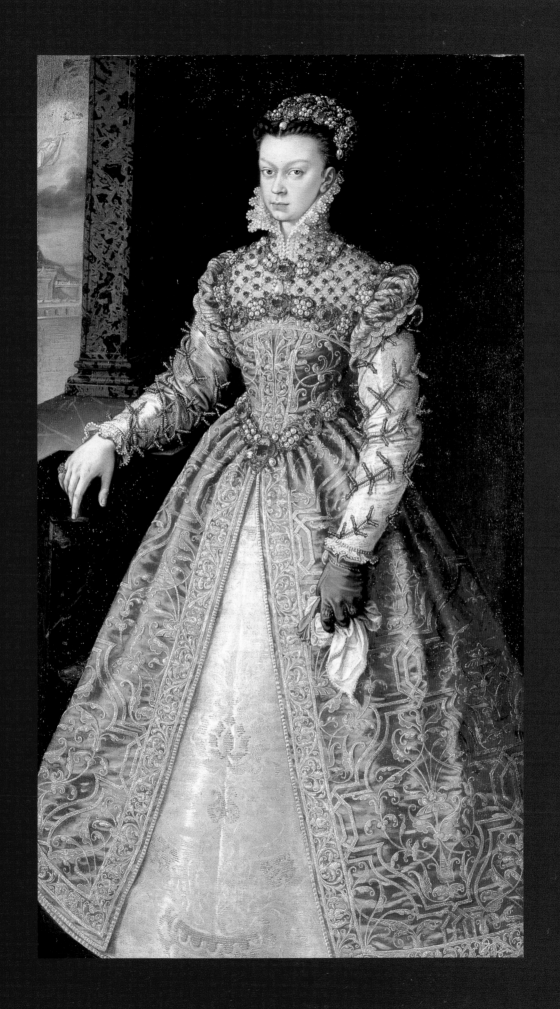

La Peregrina

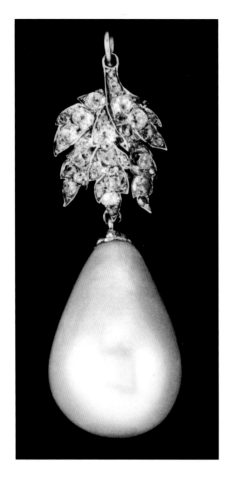

One of the most famous pearls from American waters is La Peregrina or "The Incomparable." It is a pear-shaped white pearl approximately 200 grains (10 grams) in weight, described by the Duc de Saint Simon in late eighteenth-century France as "perfectly shaped and bell-mouthed." Its provenance is contested, with some historians claiming it was found in the Gulf of Panama, and others tracing its origin to the coast of Venezuela. On the basis of its size, it most likely came from Panamanian waters because the Panamanian pearl oyster (*Pinctada mazatlanica*) is much larger and more likely to produce such a pearl than the Caribbean species (*Pinctada imbricata*). La Peregrina was found in the beginning of the sixteenth century by a slave who, as a reward, was purportedly given his freedom; his owner was granted land and title. Balboa, the Spanish conquistador in Panama, presented it to King Ferdinand V, and it became part of the Spanish Royal Treasury in 1513. In 1554, Prince Phillip II of Spain presented it to his fiancée, Mary Tudor, daughter of England's King Henry VIII, as a wedding gift. Upon her death in 1558, Phillip brought the pearl back to Spain. It was next recorded worn by Queen Margarita of Spain, wife of Phillip III, at the signing of the peace agreement between Spain and England in 1605. In 1700, it became one of a pair of earrings, when another pearl of similar size and quality was discovered (the Charles II Pearl). During the next two centuries, La Peregrina passed through a succession of royal hands including those of Joseph Bonaparte of Spain, who conveyed it to France, and Prince Louis Napoleon of France, who took it to England. It was sold in London in the late nineteenth century to the Marquis of Abercorn, who purchased it for his wife. Because the pearl was heavy and lacked a pin to hold it in its setting, the marquis misplaced it on several occasions. On the death of the marquis, his son had the pearl drilled so that it could be worn without fear of loss. From there, La Peregrina passed to Parke Bernet Galleries in London, then in 1969, it was sold at auction to the British actor Richard Burton, who purchased it as a Valentine's Day gift for his wife, the actress Elizabeth Taylor, who still owns the pearl. A few years ago, while the actress was staying at a hotel in Las Vegas, the pearl was again lost—in the plush white carpet of the hotel room. After a frantic search, it was discovered in the mouth of her pet dog.

I have oftentymes demaunded of summe of these lordes of the Indians, if the place where they accustomed to fysche for pearles beynge but lyttle and narrowe wyll not in shorte tyme bee utterly without oysters if they consume them so faste, they al answered me, that although they be consumed one parte, yet if they go a fyschynge in an other parte or on another coaste of the Ilande, or at an other contrary wynd, and continue fysshing there also untyll the oysters be lykewyse consumed, and then returne ageyne to the fyrste place, or any other place where they fysshed before and emptied the same in lyke maner, they find them ageine as ful of oysters as though they had never bein fysshed. Wherby we may judge that these oysters eyther remove from one place to an other as do other fysshes, or elles that they are engendered and encrease in certeyne ordinaire places.[24]

Nevertheless, the European demand for pearls had a heavy impact on the natural shell beds in the Americas. As the sixteenth century drew toward a close, the known pearl beds of the Americas were increasingly depleted. By the time the pioneering naturalist-pirate William Dampier visited the Pearl

Coast in 1681, pearling had become such a small-scale occupation that both supervision and taxation had relaxed. Dampier made it clear that neither Venezuela nor Panama had enough pearls left to be of interest to contemporary pirates.[25] Other indications of trouble were complaints about quality that began to appear in the seventeenth century. An anonymous British writer claimed in 1671 that "all the pearls of these five fishings [i.e., the main pearling centers along the Venezuelan coast] are of a white water [color], weak, dry, faint, milky or leady; not but that they find some fair ones, but they have not so live a water as in the East."[26]

Reality eventually set in, and Spain imposed restrictions on pearl fishing in the mid-sixteenth century, inaugurating a system of rotation so that no one island could be exploited for more than a few months. In addition, the size of the fishing boats was limited and the number of divers on each boat restricted. However, it is very unlikely that these restrictions were ever enforced. To the contrary, there are reports of still larger fishing vessels with even more divers employed in the late sixteenth century.[27]

Interestingly, one of the first explanations for the decline in the Venezuelan pearl beds in the mid-seventeenth century was polluted water from the adjacent rivers:

> The mouths of the Orinoco and other rivers along the coast as far as the Marañón [Amazon] expel and discharge a great mass of tainted water, which is carried along the coast by the current which regularly runs between those islands; its effect is like that of Greek fire or poison . . . and it killed the oysters from which they got the pearls, so that this great source of wealth is lost.[28]

This explanation is doubtful. Human activities of that time would not have introduced toxic substances with such a large-scale effect. Even natural disasters such as red tides or large discharges of muddy water following a hurricane could not have devastated the pearl fisheries along the entire coast. The report might refer to unusually large amounts of silt-carrying freshwater that reached and devastated the pearl oyster beds in the vicinity of the river deltas. However, a much more probable explanation for the decline of the fishery is simply over-fishing. Using the earlier calculation of 11,877 kilograms of pearls taken from Cubaguan waters between 1513 and 1540, with each pearl weighing 2 grains, then approximately 120 million pearls were involved in this twenty-seven-year harvest. Allowing one pearl per ten pearl oysters, then 1.2 billion pearl oysters were harvested on that part of the Pearl Coast during this time period—or approximately 40 million pearl oysters per year. This could in fact be a serious underestimate; modern Kuwaiti pearl divers have recorded only one pearl over 3 millimeters in diameter for every 4,200 pearl oysters.[29] Few species can recover from this kind of assault.

Coincident with the decline in the pearl harvest, there were difficulties in maintaining an adequate and docile work force. Rebellions among the free Indians, and enslaved Indians and Africans, were becoming increasingly common as they revolted against the cruelties of their Spanish overlords. To circumvent these problems, new pearling techniques were introduced that relied upon fewer workers and used rakes to scour the seafloor from the relative safety of the deck. Such enterprises met with little success.

With the collapse of the Venezuelan pearl industry, some Spanish merchants left the coast and headed for the interior to develop newly discovered silver mines. In the succeeding four hundred years, there have been some attempts to resuscitate the Venezuelan pearl industry but most such endeavors have proved unsuccessful.[30] Today, the occasional pearl is still found in pearl oysters off the coast of Venezuela, a reminder of a time when Spanish ships plied the shores in search of pearls, and the New World supplied the Old with such an abundance of riches that it helped usher in the flowering of Renaissance Europe.

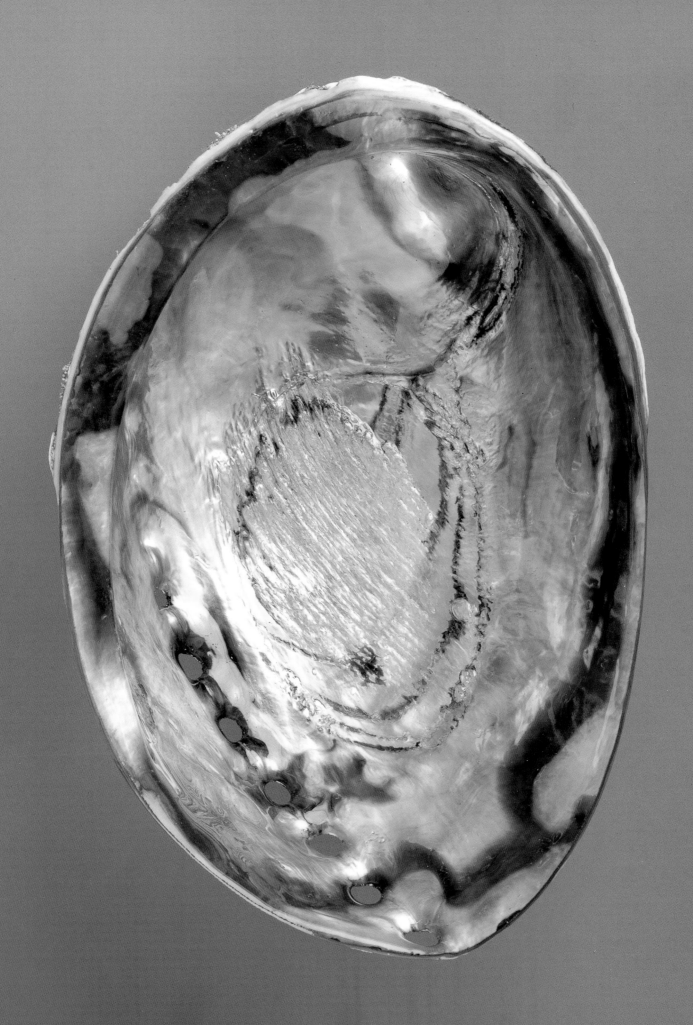

2
Natural Beginnings

PEARL MOLLUSKS

It is a singular reflection that the gem so admired and coveted by man,

should be the product of disease in a helpless mollusk.

—H. MARTYN HART [1]

After all, the most gorgeous pearl is nothing

but the splendid coffin of a miserable minute worm.

—A NOTED FRENCH AUTHORITY [2]

The Paua Abalone, Haliotis iris, *of New Zealand, glows with its spectacular blaze of azure-blue nacre.*

Pearls are produced by living animals. If broadly defined as mineralized deposits within soft tissue—*concretionary bodies* or *calcareous concretions*—they are produced by many animals including worms and arthropods, as well as mollusks.[3] In the extreme, even the kidney stones of humans could be considered pearls. But a pearl is restricted here to the concretionary product of *mollusks* (phylum Mollusca). The most familiar mollusks are seashells, but mollusks also inhabit freshwater lakes and streams, and many, the landsnails and slugs, have evolved a type of lung to survive on land. The evolutionary success of mollusks at adapting to many different environments and lifestyles has made them the second most diverse animal group, after terrestrial insects, with over 100,000 living species, and a fossil record of at least that many extinct species. Mollusks include snails and slugs (gastropods or univalves); clams, mussels, scallops, and oysters (bivalves or lamellibranchs or pelecypods); octopus, squid, chambered nautilus, and extinct ammonites (cephalopods); tusk shells (scaphopods); and chitons (coat-of-mail shells); plus a few other small groups. Pearls are known to come from marine and terrestrial gastropods, marine and freshwater bivalves, cephalopods, and a variety of fossil forms. As will be discussed further in Chapter 3, both the shells and pearls of mollusks are composed of mineralized calcareous crystals within an organic matrix.

Not all pearl-producing mollusks belong to a single family or group. The evolutionary tree of the Mollusca illustrates this point.[4] Pearl-producers are distributed across the entire tree, rather than on one branch, indicating that pearls are made by many different *and distantly related*

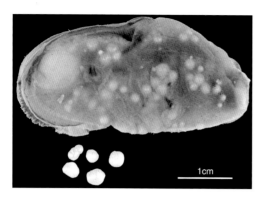

1cm

species of mollusks. Pearls might therefore be considered analogs, associated with a common response to the outside environment, or—more likely—the ability to produce pearls could be considered a primitive character shared by all mollusks. The tree also shows that the presence of nacre on the innermost shell layer is likewise widespread and, importantly, is present in the groups originating at the root of the tree. This means that some of the most primitive mollusks

are nacreous and suggests that nacre is a primitive character that was lost by mollusks over and over again in evolutionary history. Another viewpoint cautions that we might be misinterpreting nacre itself—that is, not all nacre is identical.[5] If so, a particular type of nacre could in fact be characteristic of a particular branch of mollusks and might be more readily formed into pearls. This could explain why, although any shelled mollusk can theoretically make a pearl, some types of mollusks produce more pearls than others.

Not all pearls are desirable. Those formed in edible species can be considered a nuisance— something on which to crack one's tooth. Archaeologists sometimes find pearls along with freshwater pearl mussel shells in the kitchen middens of ancient peoples. These middens are in fact trash heaps, the discards from a meal of cooked mussels. In modern fisheries, Blue Mussels (*Mytilus edulis*), the common edible variety, are prone to develop large numbers of 1–2 mil-

(LEFT) *In a response to parasites, 103 natural pearls pepper the mantle tissue of this 5-centimeter Blue Mussel (*Mytilus edulis*). Five of the largest pearls are shown extracted.*

(BELOW) *Examples of the Phylum Mollusca are, left to right: a cephalopod, the Chambered Nautilus,* Nautilus pompilius *Linné, 1758, and, below, a scaphopod or tusk shell,* Dentalium elephantinum *(Linné, 1758); a gastropod or snail, the Trumpet Triton,* Charonia tritonis *(Linné, 1758); a chiton or coat-of-mail shell,* Acanthopleura granulata *(Gmelin, 1791); and a bivalve, the Noble Scallop,* Chlamys nobilis *(Reeve, 1852).*

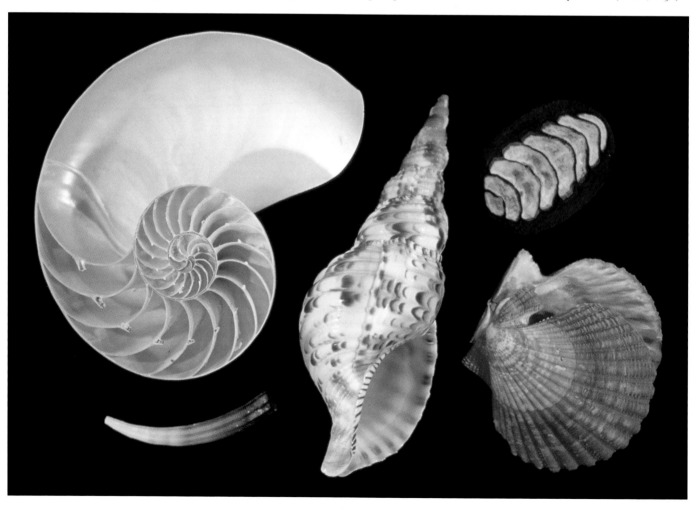

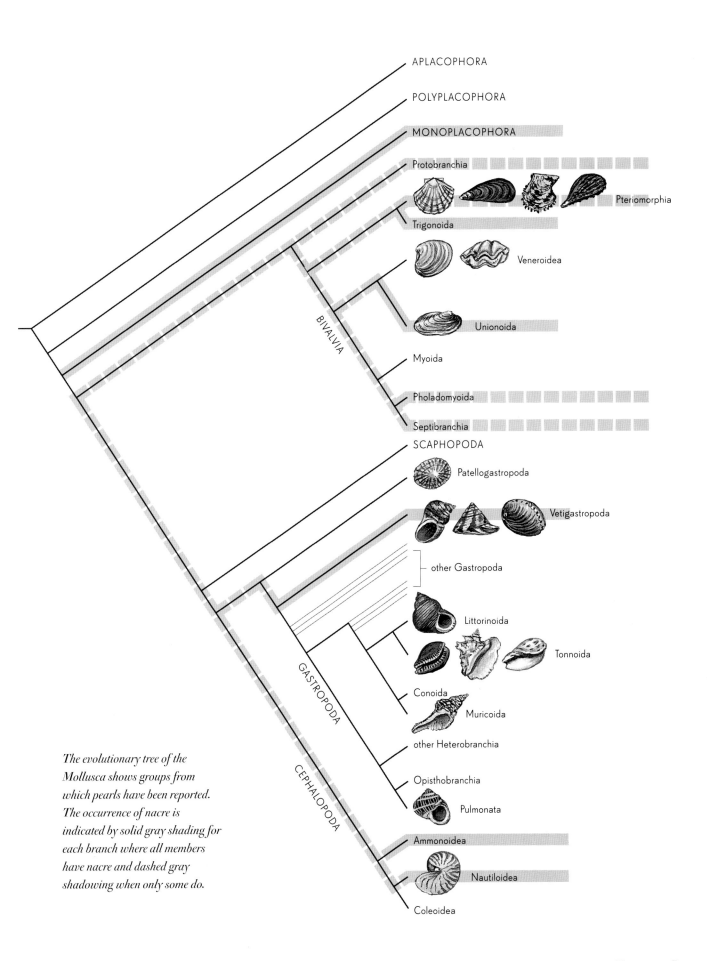

APLACOPHORA

POLYPLACOPHORA

MONOPLACOPHORA

Protobranchia

Pteriomorphia

Trigonoida

Veneroidea

Unionoida

Myoida

Pholadomyoida

Septibranchia

BIVALVIA

SCAPHOPODA

Patellogastropoda

Vetigastropoda

other Gastropoda

Littorinoida

Tonnoida

Conoida

Muricoida

other Heterobranchia

Opisthobranchia

Pulmonata

GASTROPODA

Ammonoidea

Nautiloidea

Coleoidea

CEPHALOPODA

The evolutionary tree of the Mollusca shows groups from which pearls have been reported. The occurrence of nacre is indicated by solid gray shading for each branch where all members have nacre and dashed gray shadowing when only some do.

limeter pearls within the flesh, usually related to the presence of encysted parasitic worms. One study reported a single specimen, 5.3 centimeters in length, with 103 pearls, the largest of which was 3.6 millimeters in diameter.[6] Exceptionally high incidences of *Mytilus* pearls can negatively affect consumer acceptability of the mussels and has led to the closing of commercial beds.[7]

The feature that characterizes all mollusks is a specialized tissue called the *mantle*, which lines the inside of the shell. It is this, not the shell that it secretes, which scientifically defines the group. New shell is produced mainly at the outer edge, but to some extent also occurs internally, thickening the shell walls from within and repairing minor breaks. The mantle will also coat *anything* inside its shell with smooth calcium carbonate to protect its delicate soft tissues from irritation or infection. Thus a pearl forms when an object ends up inside the body of the mollusk and becomes coated with shell material; the object that prompts pearl formation, the *nucleus*, becomes the center of the pearl.

Natural pearls are formed when a foreign particle lodges between the mollusk's shell and mantle. If the particle is small or flat enough, the natural process of shell secretion simply coats over the object, as though it were part of the internal surface of the shell, forming a blister pearl. If otherwise, the mantle tissue could curve around the particle, gradually enveloping it away from the shell surface. In this way, the pearl nucleus-to-be becomes biologically isolated, encysted within a pocket lined by mantle cells. This pocket is called the *pearl sack* and its cells layer pearl material onto the nucleus. This process can also occur any time that mantle cells end up in the inner tissues of the mollusk's body, for instance, as a result of mechanical damage or parasite intrusion. The mantle cells proliferate to form a cyst into which shell material is secreted, often covering a nucleus, such as a parasite, in the process.

Perliculture makes use of this natural reaction by artificially supplying a misplaced piece of tissue and, in most cases, a sphere of shell material as the nucleus. Marine perliculture has come to use the pearl oyster's gonad as the ideal site for implanta-

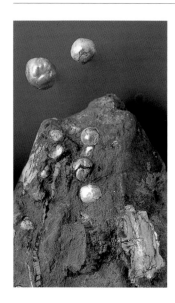

Fossil Pearls

How old is the oldest pearl? The answer is a great deal older than 3,000–4,000 years, the age usually given for the oldest surviving pearl artifacts. Pearls probably date back to the first appearance of shelled mollusks, about 530 million years ago. The geologically oldest traces of pearls are rounded depressions on an internal mold of the bivalve *Megalodon* from the Upper Triassic of Hungary (200 million years ago). Pearls first appear in abundance in the fossil record in the Cretaceous Period, 65–145 million years ago, known popularly as the Age of Dinosaurs. Most Cretaceous pearls were produced by marine bivalves of the genus *Inoceramus*, "the Pearl Oysters of the Cretaceous," and members of the family of modern pearl oysters. Fossils of *Inoceramus* have been found in rocks in Europe, Japan, and North America, implying that the ocean formerly covered these areas. Like today's pearls, the pearls of inoceramids occur free or attached to the inside surface of the valve. The pearls measure up to 11 centimeters in length and are usually dull yellow or gray. In cross-section, they show the concentric structure characteristic of all pearls.

Fossil pearls are more abundant in rocks from the past 60 million years. They are associated with a wide range of marine bivalves including oysters (Ostreidae), mussels (Mytilidae), and scallops (Pectinidae). Some of the most beautiful fossil pearls, approximately 50 million years old, are from the bivalve *Pinna affinis* Sowerby, left, found in Eocene rocks of England. These pearls have retained their exquisite luster, probably as a result of the surrounding clay matrix in which they were preserved. This matrix prevented the pearls from being dissolved after they had formed. This validates the suggestion that pearls, under the proper conditions, can last nearly forever (or at least 50 million years).

tion. This location lies in the middle of soft tissue, well isolated from hard structures such as the shell or adductor muscle, allowing the pearl to form evenly on all sides. So well ingrained in today's industry is this particular location that pearl culture descriptions often label the gonad as "pearl sack," as though it were a normal organ of clam anatomy.

Clams Do It Better

Most pearl producers are bivalves, with relatively few species commonly involved in producing pearls of commercial quality. In view of the general molluscan ability to produce a pearl, it is puzzling that so few gastropods, which comprise about 80 percent of all living molluscan species, produce pearls. Biological and ecological differences between bivalves and gastropods explain this.

The anatomy of a snail is tightly packed within a coiled shell. The organs are closely and efficiently arranged, with little room for a potential pearl nucleus to become lodged. In contrast, bivalve anatomy is loosely arranged, with more open, water-filled spaces. Most bivalves are passive filter-feeders, a mode of life that requires an open anatomical arrangement. Bivalve anatomy allows abundant circulation of water, which contains oxygen for breathing and, importantly, food particles. These food particles are strained from the water as it passes through the meshlike filaments of the gills, which also extract the oxygen for respiration. Filtering great quantities of water for food particles also naturally leads to a greater chance of stray particles becoming lodged in nearby tissues. In contrast, most gastropods are grazers or carnivores rather than filter-feeders, scraping food from rocks or from their captured prey using specialized rasp-like teeth called the *radula*. Because they do not rely on water flow for food, gastropods have less need for large water spaces surrounding their gills.

This diagram shows the anatomy of a pearl oyster, with a single cultured pearl in the pearl sack.

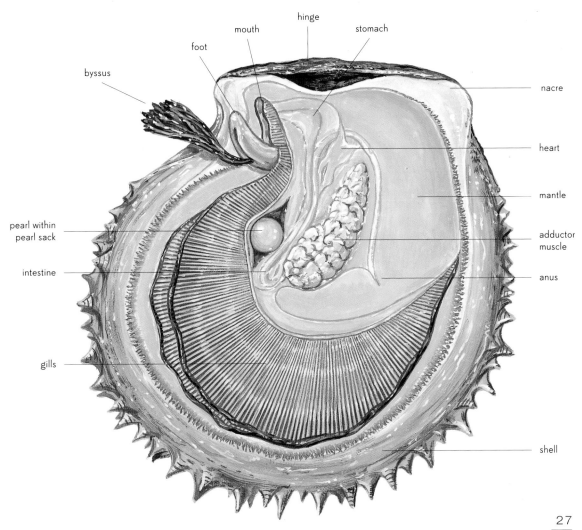

1

2

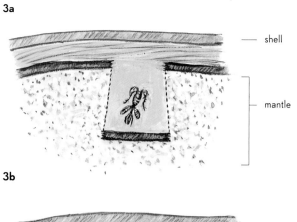

3a

shell

mantle

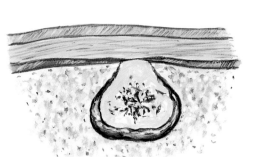

3b

4

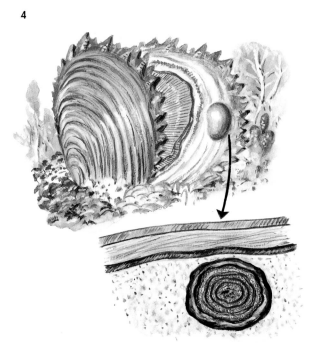

Natural pearl formation first finds a living pearl oyster (1) siphoning water full of plankton and other organic particles through its gills as food. Meanwhile, a copepod or other small organism goes astray and becomes lodged between the shell and the fleshy mantle (2). It struggles to no avail, and dies—firmly entombed within the pearl oyster. During its struggle to free itself, it breaks into the mantle epithelium (3a), taking with it a piece of pearl oyster's tissue. This tissue proliferates around the intruder's body, forming a pocket (3b). The cells of this pouch of mantle epithelium, or pearl sack, secrete layer upon layer of nacre around the disintegrating copepod (4), which now is the nucleus of a natural pearl.

Finally, and importantly, clams are sedentary and their movements are largely restricted to passive breathing and filtering water for food, making them good targets for fouling organisms and borers. In contrast, most snails are actively mobile animals, crawling and grazing on plant life or hunting other animals as prey. As a consequence, their soft bodies are moving more within their shells, and are thus better able to expel a particle that might otherwise become a pearl nucleus. Bivalves, because they move less, have less ability to reject potential pearl nuclei, and so more commonly produce pearls. Mobility has been a factor in attempts at developing cultured pearls in abalone, large ear-shaped snails that graze algae from the surfaces of rocks and that bear beautiful blue-green nacre. Artificially introduced nuclei in abalone are constantly jostled around and are more likely to be rejected from the snail's body.[8] Abalone pearl culture has only recently been successful thanks to methods to secure a nucleus and prevent expulsion.

(RIGHT) *This large natural abalone pearl (266 carats) shows a characteristic blue-green iridescence and "shark-tooth" shape indicating formation within the gonad of the abalone.*

(BELOW LEFT) *A living abalone* (Haliotis tuberculata), *photographed off Menorca, Spain, at 11 meters depth, shows its sensory tentacles and mantle fringe around the shell. Louis Boutan used this species in the late 1800s to produce the first cultured abalone pearls.*

(BELOW RIGHT) *A cross-section through a natural blister pearl in a Red Abalone* (Haliotis rufescens *Swainson, 1822*) *shows that the blister pearl was formed when a small clam, the Abalone Piddock* (Penitella conradi *Valenciennes, 1846*), *bored into the abalone shell from the outside. The abalone responded by secreting layers of mother-of-pearl on the inside surface of the shell, forming the blister pearl. The cavity of the pearl was then filled by a small nestling bivalve* [Hiatella solida (*Sowerby, 1834*)] *that moved into the hole after the death of the piddock. Fragments of the piddock's shell are present below the white shell of the nestler.*

Abalone Pearls

The abalone is a marine gastropod bearing a rounded to oval, bowl-shaped shell with a row of holes along one side. Most of the ninety species worldwide, all in the genus *Haliotis* (meaning "sea ear"), thrive on cold-water rocky shores where they cling like limpets using a strong muscular

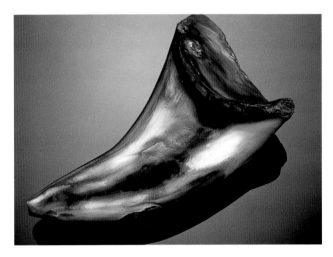

foot. This muscle is edible and is marketed commercially, especially in California, Japan, and New Zealand. Abalone nacre is blue to green with swirls of pink, silver, orange, and lavender, and is used for inlay in jewelry, buttons, furniture, and musical instruments.

Natural abalone pearls are seldom spherical. One study estimated one natural abalone pearl of gem quality for every 500,000 commercially gathered shells. Many are cusp-shaped, presumably formed within the tapered tip of the abalone's gonad. Abalone blister pearls can be formed in response to boring bivalves that invade the shell from the outside. Data from archaeological sites in California suggest that natural abalone pearls were used as trade goods by native peoples over 7,000 years ago. Baroque abalone pearls were popular in Art Nouveau jewelry of the early twentieth century. The largest known natural abalone pearl is the "Big Pink," a 470-carat baroque pearl listed in the *Guiness Book of World Records*.

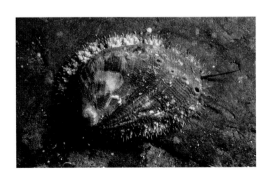

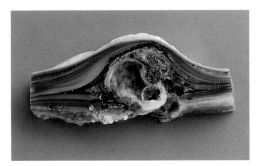

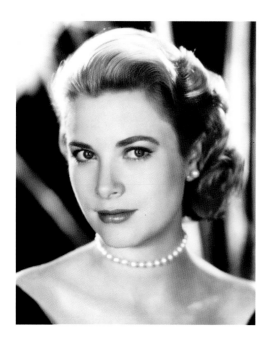

Pearls are known from only one type of cephalopod—the Chambered Nautilus—because most recent cephalopods have either thin internal shells or no shells at all. The largest *Nautilus* pearl weighs about 3.5 grams, and is described as white and pear-shaped.[9]

Marine Pearl-Producing Mollusks

The most valuable and best-known pearls come from a group of tropical marine bivalves known as pearl oysters, classified in the family Pteriidae and the genera *Pinctada* and *Pteria*. The nacre of these species varies, depending on species and individual variability, from silver to gold to gray black. Among these species is the classic cultured pearl oyster of Japan, the Akoya Pearl Oyster (*Pinctada fucata*). Also in this group are the other

Epitomizing classic elegance, the American actress Grace Kelly, who became Princess of Monaco in 1956, frequently wore a choker of white Akoya pearls.

Pearls That Aren't Pearls

A number of so-called pearls are not true pearls as here defined. *Cave pearls*, as shown above in a nest found in Lai Chau province, Vietnam (left), are not true pearls because they are not formed by mollusks. These ivory-white bodies are inorganically formed in shallow cave pools full of calcium-rich water. Like true pearls, they are composed of calcium carbonate crystals, concentrically arranged around a nucleus. However, the calcium carbonate in a cave pearl is in a different crystalline form calcite rather than the aragonite of true pearls—added and polished by the fast-moving water rotating the cave pearl.

Most cave pearls are the size of marbles, although a few are "as big as a basketball." *Coconut pearls*, on the other hand, were once also thought to be "vegetable pearls" of non-molluscan origin, although they were ultimately shown to be true pearls made by mollusks. The first European travelers to the Dutch East Indies believed that these ivory-white rounded bodies were produced by the coconut palm (*Cocos nucifera* Linné), a myth perpetuated to the present day. However, in 1939, the Dutch zoologist A. Reyne studied the structure of seventy coconut pearls in public and private collections, and showed clearly that they were the true pearls of Giant Clams or *Tridacna*. Although a product of mollusks, *coques de perle*, cut from the shell of a cephalopod mollusk—the Chambered Nautilus—are not true pearls because they are not concentrically structured around a central nucleus. Usually mounted in jewelry to resemble large oval half-pearls, as in this eighteenth-century English necklace once owned by Lady Bernard, wife of Sir Francis Bernard, governor of Massachusetts (right), *coques de perle* are simply curved pieces of polished nacreous shell.

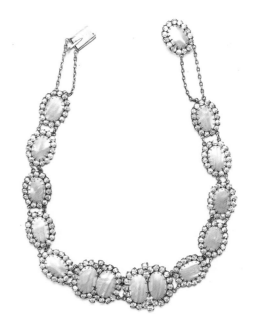

main pearl-producing mollusks involved in today's periculture industry: the Silver-Lipped Pearl Oyster of Australia (*Pinctada maxima*), the Gold-lipped Pearl Oyster of Indonesia and the Philippines (*Pinctada maxima* "golden variety"), the Black-lipped Pearl Oyster of French Polynesia (*Pinctada margaritifera*), the two pearl oysters of Pacific Mexico (*Pinctada mazatlanica* and *Pteria sterna*), and the Black-winged or Mabé Pearl Oyster of the Indo-Pacific (*Pteria penguin*). Also here are two additional species of historical importance: the Atlantic Pearl Oyster of the Caribbean (*Pinctada imbricata*) and the Ceylon Pearl Oyster of the Indian Ocean (*Pinctada radiata*). Two of these species, *Pinctada margaritifera* and *Pinctada maxima*, are the largest pearl oysters, reaching "dinner plate" diameters, and have historical importance as primary sources of mother-of-pearl for carving and inlay. Most pearl oysters live on hard substrata, either on rocks or in reef habitats, attached to rocks with a strong set of organic threads called a *byssus*.

Although almost everyone realizes that oysters make pearls, there is a common misconception that the next plate of oysters on the half-shell might contain a gem. Edible oysters, also called true oysters, are members of the family Ostreidae, only remotely related to pearl oysters, and differ from them in several important ways. Like most mollusks, edible oysters do in fact produce pearls made of calcium carbonate, similar chemically to commercially valuable pearls. However, the pearls of ostreids, like their shells, are non-nacreous, resembling small white marbles. Edible oysters attach to rock surfaces by cementing themselves by one valve, rather than by a byssus. Edible oysters, as their name implies, are in most peoples' opinions *very tasty*, while at least some reports of pearl oysters, including a 1747 report from Panama during Lord Anson's *Voyage Around the World*, consider them inedible.[10] The authors, however, can attest to the palatability of the adductor muscles of several pearl oysters, which, like those of a scallop, are commonly eaten today in Japan, Australia, and French Polynesia.[11]

The idea that pearls are a product of the tropics is also not accurate. While today's spectacular larger pearls, from the Black- and Silver-lipped

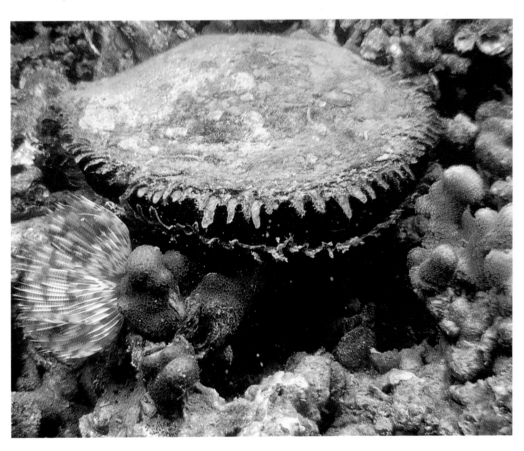

A living Black-lipped Pearl Oyster is shown in its natural reef habitat in Hawaii, amid algae, finger coral, and a large fan worm.

Marine Pearl Oysters

Silver- or Golden-lipped Pearl Oyster

Pinctada maxima (Jameson, 1901)

20–30 centimeters. This is the world's largest pearl oyster.

South Sea Pearls—white to gold, 10–18 millimeters. The largest cultured South Sea Pearl is 24 millimeters (Paspaley Collection).

Ranges naturally from the eastern Indian Ocean to the tropical western Pacific.

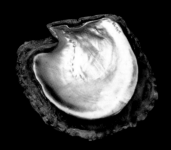

Black-lipped Pearl Oyster

Pinctada margaritifera (Linné, 1758)

15–25 centimeters. Known as variety *cumingii* in French Polynesia and variety *galtsoffii* in Hawaii.

Tahitian or "Black" Pearls—gray to black with green, blue or rose overtones, 10–18 millimeters. The largest Tahitian cultured pearl is 26.9 millimeters (R. Wan Collection).

Ranges naturally throughout the Indian Ocean and western to central Pacific.

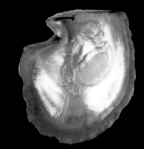

La Paz Pearl Oyster

Pinctada mazatlanica (Hanley, 1855)

7–20 centimeters.

New World Black Pearls—white to gray with blue or green overtones, half pearls 12–15 millimeters and free pearls to 10 millimeters. This species is the probable source of La Peregrina.

Ranges naturally in the eastern Pacific from Baja California to Peru.

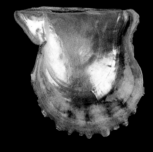

Akoya Pearl Oyster

Pinctada fucata (Gould, 1857)

8–10 centimeters. Sometimes considered a form of *Pinctada imbricata*. The varietal name *P. martensii* is used in Japan.

Akoya Pearls—white to yellowish, 2–10 millimeters.

Ranges naturally in the waters of Japan, China, and Vietnam.

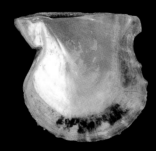

Atlantic Pearl Oyster

Pinctada imbricata Röding, 1798

5–7 centimeters.

Venezuelan Pearls—white or yellowish, not cultured, to 9 millimeters. This species was the source of Columbus's pearls.

Ranges naturally in the western Atlantic from Bermuda, and Florida to northern South America.

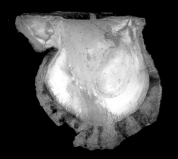

Ceylon Pearl Oyster

Pinctada radiata (Leach, 1814)

5–7 centimeters. Sometimes considered a form of *Pinctada imbricata*.

Oriental Pearls—white or yellowish, to 7 millimeters. Pearls of this oyster are historically important natural pearls.

Ranges naturally throughout the eastern Mediterranean Sea, Red Sea, Persian Gulf, and the Indian Ocean.

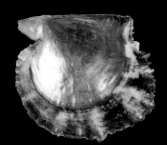

Pipi Pearl Oyster

Pinctada maculata (Gould, 1850)

3–5 centimeters.

Pipi Pearls—yellow, not cultured, 4–5 millimeters.

Ranges naturally from the Indian Ocean to the Central Pacific Ocean.

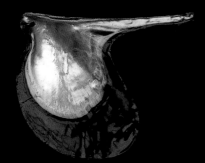

Black-winged Pearl Oyster

Pteria penguin (Röding, 1798)

8–25 centimeters.

Mabé Pearls—white, 20–25 millimeters.

Ranges naturally in the Red Sea, Indian Ocean, and the tropical western Pacific.

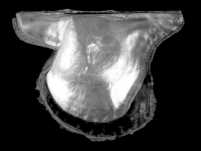
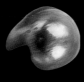

Western Winged Pearl Oyster

Pteria sterna (Gould, 1851)

6–14 centimeters.

New World Black Pearls—blue to rose-gray pearls, half pearls 12–15 millimeters and free pearls to 11 millimeters.

Ranges naturally in the eastern Pacific from Baja California to Peru.

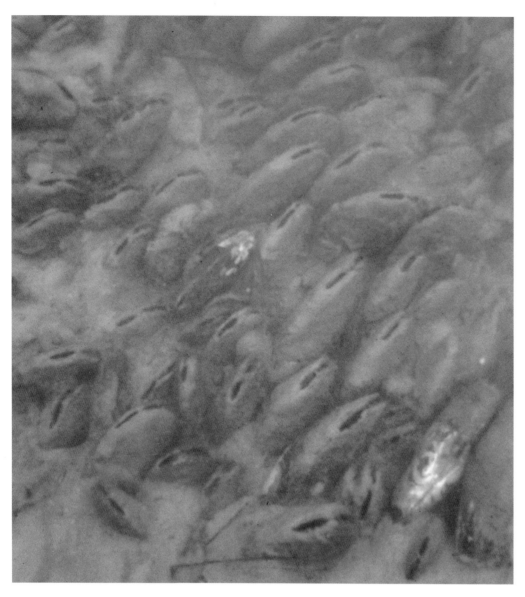

Pearl Oysters, are tropical, the "original cultured pearl"–the Japanese Akoya–is farmed in a decidedly temperate climate. The roots of this fallacy must be attributed to a very old memory, based on the historical natural pearls of tropical Venezuela and Ceylon. Today, this misconception is reinforced by the pearls of Tahiti and the Philippines, which have been available on the commercial market only since the 1960s.

Many species of marine gastropods are known to produce pearls, although only those from conch, abalone, and baler shells have commercial value. Of these, only abalone pearls are now cultured; conch pearls and the melo pearls from baler shells are available only as natural pearls.[12]

FRESHWATER PEARL-PRODUCING MOLLUSKS

Freshwater pearl mussels, also called *naiads* or *unios* (families Unionidae and Margaritiferidae, including many genera worldwide), likewise produce nacreous pearls, which can be beautiful in luster and come in diverse colors. They have figured prominently in the histories of the Americas, Europe, and Asia. Pearl mussels occur in bodies of freshwater around the world, but the greatest diversity of species is in the Mississippi watershed of the eastern United States. Some natural freshwater pearls attain spectacular sizes–a large specimen from Arkansas was recorded as 20 millimeters in diameter.[13] Mother-of-pearl from freshwater pearl mussels has

A dense community of North American freshwater pearl mussels lives in a typical sandy mud habitat.

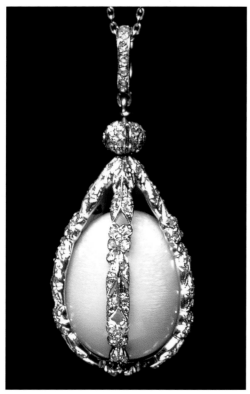

(TOP) *A living Florida Queen Conch peers from beneath its camouflaged shell with eyes on tentacled eyestalks.*

(ABOVE) *An early twentieth-century necklace designed by George F. Kunz of Tiffany & Company features a conch pearl of 4.71 grams inside a platinum and diamond cage that can be opened to remove the pearl.*

Conch Pearls

Conch pearls—in sunset pinks and golds—are the product of a unique pearl source, the Queen Conch, *Strombus gigas*. The official symbol of the Bahama Islands and the Florida Keys, the Queen Conch is one of the largest living herbivorous gastropods. It moves with a slow but powerful "leap" across the sand and seagrass, using a muscular foot to push its body up and forward. Conchs have long been commercially harvested for their succulent flesh used in conch chowder, conch salad, and conch fritters. Now protected in Florida because of past over-collecting, the larger populations in the Bahamas and Turks and Caicos Islands continue to supply meat and shells as major export items.

Conch pearls are non-nacreous but bear the silky porcellaneous luster of the shell's interior and display a peculiar flamelike effect called *chatoyancy*. Like conch shells, conch pearls span hues from white, yellow, and beige to lavender and the most-prevalent pinks, ranging from pastel to salmon to magenta. Although their pink color might be the most striking in all of pearldom, conch pearls can fade after prolonged exposure to the ultraviolet rays of sunlight because of alteration of the highly unstable carotenoid pigments that produce the tint. Even in total darkness, the proteins responsible for the rich colors of conch pearls can break down and fade over time.

Conch pearls have a relatively short history as decorative curios. Their earliest mention is in the 1839 *Catalogue of the Collection of Pearls & Precious Stones Formed by Henry Philip Hope, Esq.*, reaching their first peak of popularity in the 1850s and 1860s. Their popularity is now under revival, especially in Caribbean resort centers like Key West, Florida. Conch pearls are still among the rarest of recognized gemstones. According to various sources, a conch pearl is found in only one of 10,000–15,000 conchs, and all are natural. Most are oval or irregularly shaped, and the largest recorded is 45 carats or 180 grains. They are found as byproducts of the conch meat industry, especially in the Bahama Islands.

In 1931, the local Key West newspaper, *The Citizen*, reported the culture of conch pearls after two years of research by a man named La Place Bostwick who had also experimented, apparently unsuccessfully, with abalone pearls in California. No definitive proof exists to substantiate this claim, and no other attempts are known. Bostwick never revealed his secret, but to one inquiry, he wrote "I . . . hypnotize [the mollusks] and . . . when they understand that they must grow a pearl, they just get busy and do it."

More serious efforts to induce pearl culture in queen conchs are now being made in the Caribbean. Wild stocks are easy to maintain, the animal can be easily anesthetized, and the mantle readily manipulated for surgical implants. The herbivorous grazing of queen conchs is also conducive to developing formulated feeds to control and enhance pearl coloration.

Other Marine Pearl-Producing Mollusks

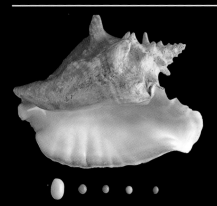

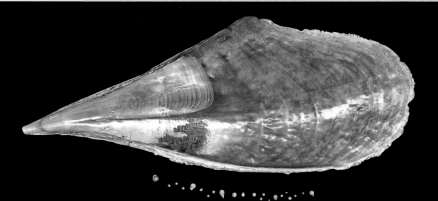

Queen Conch

Strombus gigas Linné, 1758

Ranges naturally from South Florida, Bermuda, and the Caribbean, to Central and South America.

Noble Pen Shell

Pinna nobilis Linné, 1758

Ranges naturally in the Mediterranean Sea.

Hard-Shell Clam

Mercenaria mercenaria (Linné, 1758)

Ranges naturally from eastern Canada to Florida.

Edible Oyster with blister pearl

Crassostrea virginica (Gmelin, 1791)

Ranges naturally from eastern Canada to the Gulf of Mexico.

Blue Mussel

Mytilus edulis Linné, 1758

Ranges naturally worldwide in subarctic seas.

Giant Clam with blister pearl

Tridacna maxima (Röding, 1798)

Tridacna pearls were once assumed to be "coconut pearls."
Tridacna gigas (Linné, 1758) is the source of the Pearl of Allah.

Ranges naturally throughout the Indo-Pacific.

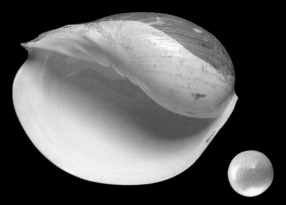

Baler Shell

Melo melo (Lightfoot, 1786)

Ranges naturally in the South China Sea, and off Singapore and Malaysia.

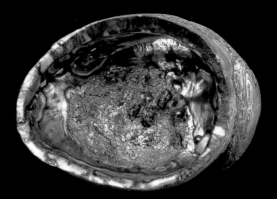

Green Abalone with blister pearls

Haliotis fulgens Philippi, 1845

Ranges naturally from southern California to Baja California.

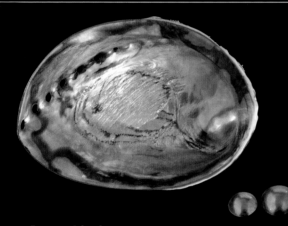

Paua Abalone

Haliotis iris Martyn, 1784

Ranges naturally in waters off New Zealand.

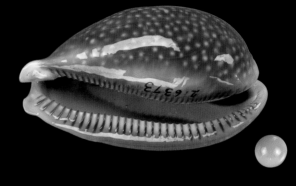

Atlantic Deer Cowrie

Cypraea cervus Linné, 1771

Ranges naturally from the southeastern United States to Cuba, and Bermuda.

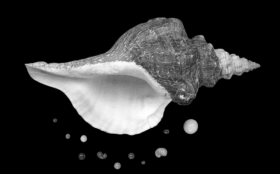

Horse Conch

Pleuroploca gigantea (Kiener, 1840)

Ranges naturally from the southeastern United States to northeastern Mexico.

Knobbed Whelk

Busycon carica (Gmelin, 1791)

Ranges naturally in the eastern United States, from Massachusetts to northern Florida.

been as important economically as their pearls, if not more so. Because many North American pearl mussels have very thick shells, they were considered ideal material for a booming pearl button industry in early twentieth-century midwestern America. Today in the southeastern United States, freshwater pearl mussels provide the raw material for bead nuclei for perliculture in most countries. Approximately 350 species of freshwater pearl mussels are alive today, inhabiting lakes, rivers, and streams, where they partially bury themselves in sandy or gravelly sediment. Regrettably, nearly three dozen species of freshwater pearl mussels are now extinct, mainly because of habitat destruction and declining water quality resulting from industrialization and land development. This subject, and the impact that the pearl nucleus industry could be inflicting, will be discussed in Chapter 8.

North American freshwater pearl mussels, because of their appearance and long use as food and tools for ancient peoples, bear fanciful common names. The Washboard (*Megalonaias nervosa*), Ebonyshell (*Fusconaia ebena*), Pigtoe (*Pleurobema cordatum*), Mucket (*Actinonaias ligamentina*), Monkeyface (*Quadrula metanevra*), Wartyback (*Quadrula nodulata*), Mapleleaf (*Quadrula quadrula*), and Three-ridge (*Amblema plicata*) are among the many species that have played important roles in the button industry, nucleus industry, or both. Some of the most historically important freshwater pearl mussels are the wide-ranging European Pearl Mussel from Canada, the eastern United States, Europe and Russia (*Margaritifera margaritifera*),[14] the Cockscomb of China (*Cristaria plicata*), and the Biwa Pearl Mussel (*Hyriopsis schlegelii*). Perhaps today's most economically important pearl mussel is the Triangleshell (*Hyriopsis cumingii*) that the Chinese perliculturists have coerced to produce a virtual flood of cultured freshwater pearls.

Freshwater Pearl Mussels

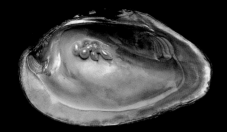

Biwa Pearl Mussel with cultured blister pearls

Hyriopsis schlegelii (von Martens, 1861)

Ranges naturally in Lake Biwa, Japan.

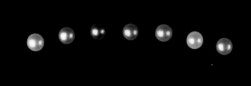

Triangleshell Pearl Mussel

Hyriopsis cumingii (Lea, 1852)

Ranges naturally in China and Japan.

Hybrid Pearl Mussel

Hyriopsis schlegelii x *Hyriopsis cumingii*

Ranges in Lakes Biwa and Kasumigaura, Japan.

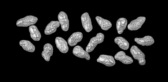

Cockscomb Pearl Mussel

Cristaria plicata (Leach, 1815)

Source of Buddha shells since the fifth century in China, as well as "rice crispie" pearls.

Ranges naturally in Japan and China.

European Pearl Mussel

Margaritifera margaritifera (Linné, 1758)

Primary source of European freshwater pearls.

Ranges naturally in Europe, northwestern Asia, and northeastern North America.

Washboard Pearl Mussel

Megalonaias nervosa Rafinesque, 1820

Historical source for buttons, and the major source of contemporary pearl nuclei in eastern United States.

Ranges naturally in the Mississippi River drainage from Canada to Mexico.

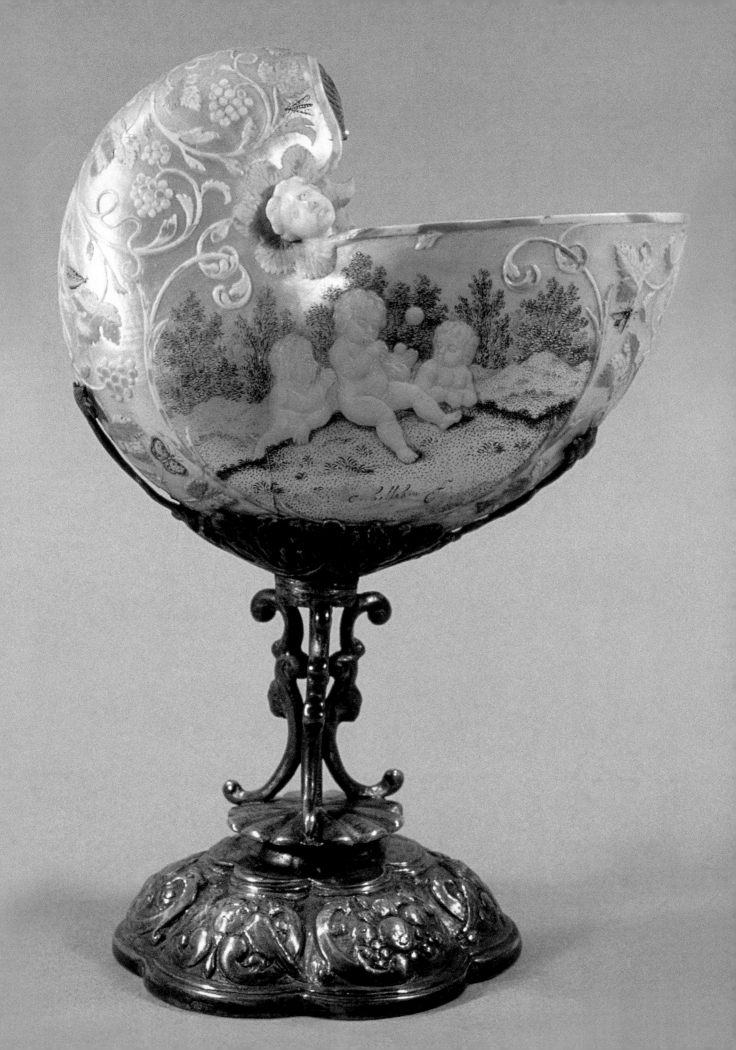

The Mechanism of Luster

PHYSICAL, CHEMICAL, AND OPTICAL PROPERTIES OF PEARLS

[The Prince of Muscat, Aceph Ben-Ali] possesses the most beautiful pearl in the world, not so much because of its size, for it weighs only 12 1/16 carats, nor because of its perfect roundness, but because it is so clear and so transparent that one can almost see the light through it.

—JEAN BAPTISTE TAVERNIER, 1678 [1]

The mother-of-pearl on this carved shell of Nautilus pompilius *from France (1830), like that of other mollusks and of pearls, is composed of calcium carbonate, a relatively soft material amenable to carving.*

The properties that make pearls beautiful and precious—their luster, color, translucency, and iridescence—are due to their physical and chemical composition. Because they are produced by the same kind of tissue that makes molluscan shells, pearls and shells share many properties. The mother-of-pearl that coats the inside of the pearl oyster's shell is the same substance that pearls are made of, and is the substance that causes both of them to be iridescent. However, the shape of a pearl—its roundness and the fact that it consists of concentric layers of nacre—brings out these qualities better than a flat surface. It is this combination of shape, microstructure, and chemical composition that gives pearls their unique character.

COMPOSITION

Pearls are primarily composed of *calcium carbonate*, expressed as the chemical formula $CaCO_3$. The shells of all mollusks are formed of this same substance. Calcium carbonate also forms the shell or "skeleton" of many other marine organisms, including corals, tube worms, sea urchins, and calcareous algae. Many of the animals that are part of a coral reef have skeletons of calcium carbonate.

There are two main mineral forms of calcium carbonate: *calcite* and *aragonite*. They are identical in chemical composition and thus experience the same chemical reactions to other substances. However, the two forms differ in the

41

spatial arrangement of their component molecules, resulting in different physical properties, such as hardness. For example, aragonite is more resistant to scratches and is heavier than calcite. Nearly all pearls are aragonitic.

Calcium carbonate makes up 82–86 percent of any pearl, and approximately 10–14 percent is organic membrane; the final component of pearls, approximately 2–4 percent, is water. The thin organic membranes, composed of *conchiolin*, are interspersed throughout the aragonitic matrix of the pearl. Conchiolin ($C_{32}H_{48}N_2O_{11}$) consists of polysaccharides and protein fibers. In addition to these basic constituents, pearls contain trace elements that are present in the water in which the mollusk lives—strontium and magnesium. Strontium occurs in higher concentrations in saltwater than in freshwater and, therefore, the pearls produced by saltwater and freshwater mollusks differ in strontium concentration.

The differences in trace element composition and the amount of organic matter in pearls cause different reactions when the pearls are exposed to X-rays and ultraviolet radiation. When natural freshwater pearls are exposed to X-rays, they usually fluoresce yellowish white whereas natural marine pearls usually do not

fluoresce at all. In contrast, when natural marine pearls are exposed to long-wave ultraviolet radiation, they usually fluoresce sky blue. Naturally dark-colored pearls, such as those from Tahitian Black-lipped Pearl Oysters or the two species from Baja California, show reddish fluorescence under long-wave ultraviolet radiation.[2]

The presence of water and organic membranes in pearls makes them susceptible to both cracking and dehydration. The organic membranes are interleaved with the aragonitic crystals. If the organic membranes dry out, the outer layers of the pearl can peel off, leaving a damaged surface. If pearls are subjected to high temperatures, as in a fire, the calcium carbonate breaks down to calcium oxide, a chalky white substance.

Calcium carbonate, the main substance of pearls, is very sensitive to acids. A strong acid such as hydrochloric acid will dissolve pearls completely. Pliny the Elder (23–79 C.E.) recounted one of the most famous legends about pearls. According to this legend, the Egyptian queen Cleopatra made a bet with the Roman general Mark Anthony that she could serve him the most expensive meal ever prepared. During dinner, she removed one of her pearl earrings, dissolved it in a cup of wine, and drank it. She reportedly offered Anthony the other earring

Concentrations of strontium, measured in parts per million, are two to four times higher in marine shells and pearls (lighter bars) than in freshwater sources (darker bars), reflecting the higher concentration of strontium in saltwater.

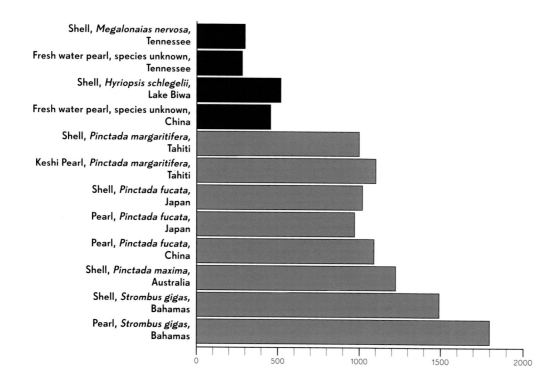

but he declined, acknowledging his defeat. This is a good story but unlikely to be true. Cleopatra almost certainly could not have dissolved her pearl in wine, or even in vinegar, without first crushing it into a powder. Pearls are, nevertheless, easily damaged by acid and Cleopatra's story serves as a cautionary tale about the care of pearls.[3]

STRUCTURE

The structure of a pearl has been compared to that of an onion (decidedly, a pearl onion) or a cabbage. Like an onion, a pearl consists of concentric layers. The layers in a pearl are composed of aragonitic material (*nacre* or *mother-of-pearl*, often abbreviated as MOP) and the organic conchiolin, surrounding a central nucleus. This nucleus can be large, or it might be so small that it is undetectable. In natural pearls, it could be a small organism such as a parasitic worm, a small crab, or a small particle of organic detritus or tissue. It is hardly ever, as is commonly romanticized, a grain of sand.[4] In some spectacular instances, the core is a small snail or fish inadvertently trapped inside the mollusk, creating a pearl that reflects the shape of the animal inside.

In contrast, in most cultured pearls, the nucleus is a spherical bead made from the shell of a North American freshwater pearl mussel that has been implanted into the soft tissues of the mol-

Caring for Pearls

Historic pearls, such as La Peregrina, are known to be several hundred years old. There are fossil pearls, some dating from 60–70 million years ago, which still retain their luster. Clearly, under the right conditions pearls can last for millennia. However, it is important to recognize the basic principles about their care.

Pearls are much softer than hard gemstones and can be easily scratched. Because they contain organic material and water, pearls can also crack if exposed to excessive dryness. In addition, acids and other chemicals can easily damage pearls.

To protect pearls:

- Store pearls in a soft cloth sack, separate from metallic necklaces.

- Never clean pearls in an ultrasonic cleaner. Vibrations can shatter pearls, especially if the nacre is thin or cracked.

- Do not use chemical cleaners, especially those containing ammonia and bleach.

- Remove pearls before washing dishes, doing housework, or applying perfume or hair spray.

- Do not wear pearls in swimming pools with chlorinated water.

- Avoid contact with foods containing acids, e.g., fruit juices and salad dressings.

- Expose pearls regularly to humid conditions. If stored in a safe, place a glass of water in the compartment with them.

To keep pearls looking beautiful:

- Wipe with a soft cloth after wearing.

- Wash occasionally in mild soapy water; contrary to popular belief, the acidic oils and perspiration from human skin can damage the surface of a pearl.

- Have pearls restrung periodically (once every two years), especially if worn frequently. Most jewelers use silk thread with knots tied between the pearls to prevent abrasion and ensure that all are not lost if the string is broken.

Pearls that have become damaged or stained can sometimes be restored to their former beauty. Pearl peeling, also known as skinning, consists of removing the outer layers of a pearl to expose fresh unblemished layers. This is very risky because it does not always remove the blemish. However, the chance remains of transforming a damaged pearl into a priceless gem.

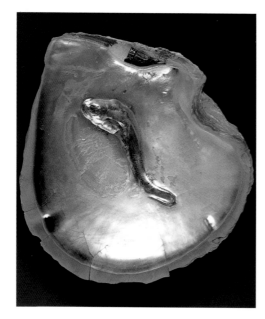

nucleus usually appears as a dark elongate cavity in the X-radiograph.[5]

The layers of nacre and conchiolin are stratified and secreted by a process known as *biomineralization*. The layers vary in thickness from 100 microns to 1 millimeter (1 micron or micrometer is equivalent to 1/1,000[TH] of a millimeter). The aragonitic material is translucent, generally colorless to white. The organic material is opaque and black, brown, or yellowish. The two types of layers do not alternate in any regular pattern but depend on the vagaries of deposition. There can be a thick layer of nacre overlain by a thin layer of conchiolin overlain in turn by a thin layer of nacre. Some areas of a pearl can show a greater concentration of organic material than others. In cultured pearls, the first layer covering the nucleus is usually conchiolin.

The aragonitic material itself consists of hundreds of thin sheets of hexagonal nacreous crystals. Each crystal or tablet is very small—250–300 nanometers in thickness (1000 nanometers is equivalent to 1 micron) in the Japanese Akoya Pearl Oyster, *Pinctada fucata*. The nacreous crystals are deposited on organic templates formed of thin layers of conchiolin; conchiolin also fills the spaces between the individual crystals in an arrangement comparable to bricks and mortar. The nacreous crystals are the bricks and the conchiolin is the mortar. In a pearl, there are thousands of sheets (pavements) of nacreous tablets. During cultivation, a pearl from the Black-lipped

lusk. The concentric nacreous layers of natural and cultured pearls are structurally the same; the difference between them is evident only by sectioning the pearl or by X ray. The implanted bead is more opaque to the rays and will show as a large solid center surrounded by a relatively thin outer coating of pearl material. It can also be visible through the opening of a drill hole under high magnification. In cultured freshwater pearls, however, only a small piece of tissue is implanted as a nucleus. As a result, it is difficult and sometimes impossible to distinguish such pearls from natural pearls even using X rays. However, the tissue

(LEFT) *A blister pearl formed around a fish that inadvertently became trapped inside a* Pinctada mazatlanica *pearl oyster.*

(BELOW) *Cross-sections of a natural pearl (left) and cultured pearl (right) show the concentric arrangement of nacreous layers. In the natural pearl, the nucleus is an organic piece of material, whereas in the cultured pearl, it is a bead of Mississippi River pearl mussel shell.*

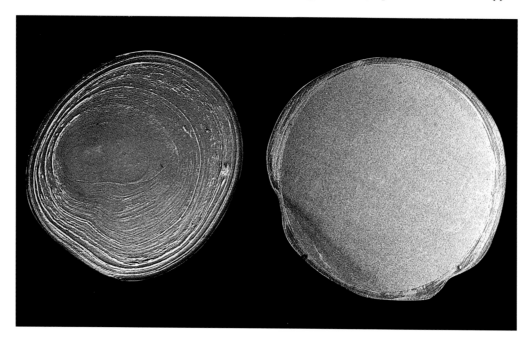

Pearl Oyster, *P. margaritifera*, is estimated to form one to seven sheets of nacre per day. This rate is faster than that in *P. fucata*.[6]

From a microscopic point of view, the structure of each pearl is unique. The history of its growth can be read in its microstructure, setting pearls apart from every other gemstone. The microstructure reflects such factors as the temperature of the water in which the mollusk lives and secretes its pearl, any storms or perturbations that occur during the growth of the mollusk, and the physiology of the mollusk. If the mollusk is transported from one environment to another during pearl cultivation, this change in environment will also be reflected in the microstructure.[7]

In temperate climates, the secretion of nacre slows in winter, during which time the nacreous tablets are more perfectly formed. The transition to summer growth is marked by more rapid secretion, resulting in less even tablet formation. As a result, the two sets of nacreous sheets are distinct from one another. The structure of these layers is reminiscent of the pattern of growth rings on a tree; however, it is much more difficult to estimate the age of a pearl than by simply counting layers.[8]

The thickness and arrangement of the nacre and conchiolin determine the luster and iridescence of a pearl. In natural pearls, keshi pearls, and tissue-nucleated pearls, the entire pearl is composed of nacre except for the very center,

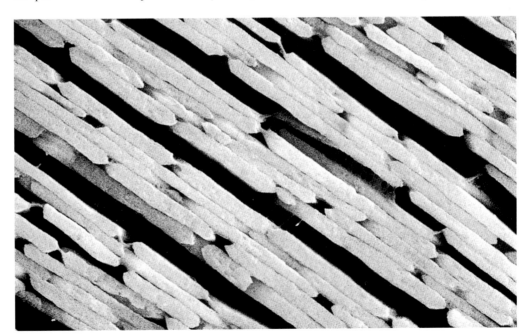

which might preserve the remains of the organism or tissue that induced pearl formation or it might be hollow. A hollow space is the void left after decomposition of the organic material that stimulated nacre secretion. In the gem trade, a hollow pearl is called a *soufflure*. In bead-nucleated cultured pearls, the thickness of the nacre surrounding the nucleus varies depending on the species of pearl oyster or mussel and the culture conditions. For instance, a Japanese Akoya pearl 7 millimeters in diameter has an average coating only 0.4 millimeters thick (11.4 percent of the diameter), while an Australian South Sea pearl of 15 millime-

(RIGHT) *Viewed in cross-section, each pearl shows a unique arrangement of layers that reflect changes in the physiology of the mollusk and the environment in which it lives.*

(BELOW) *Scanning electron micrograph of individual layers of nacreous crystals in a cultured Akoya pearl, separated by layers of conchiolin (dissolved during SEM preparation, appearing as black spaces in the photograph). Each nacreous layer is a fraction of a micron thick.*

ters, cultivated for a similar two-year period, bears nacre about 4 millimeters thick (53.3 percent).[9]

In some pearls, needlelike prismatic crystals are present in addition to nacreous crystals. For example, in some Japanese cultured pearls, a thin concentric layer of calcitic prismatic crystals surrounds the nucleus. Such a transformation from one crystal type to another can occur in a variety of mollusks and is the result of a complex interaction between the organic material and the ions of calcium and carbonate.[10] Other pearls, such as conch pearls and melo pearls, are composed entirely of prismatic crystals and conchiolin.

SURFACE

During the growth of a nacreous pearl, layers of nacre and conchiolin are secreted on the surface, one on top of another. These layers are not absolutely continuous around the entire pearl. As a result, in microscopic view, the surface of a pearl appears as a landscape of irregular plateaus forming a finger print-like pattern of meanders. The edges of these plateaus are the irregular edges of the nacreous sheets.

This variable crystalline landscape contributes to the luster and iridescence of pearls. It is as though there were a series of crystalline staircases refracting light like a prism. This rough surface also provides the telltale tooth test to distinguish real pearls, either natural or cultured, from imitation glass or plastic pearls. If a real pearl is gently run across real front teeth, it will feel gritty. An artificial pearl will feel slippery and smooth.

Because living organisms produce pearls, all natural and most cultured pearls have at least minor bumps, pits, or uneven color—such surface imperfections are generally termed *blemishes*. These are normal occurrences in pearl formation and reflect irregularities during growth; too many imperfections, however, result in a pitted or wrinkled appearance. On the commercial market, the fewer the blemishes, the rarer, and thus costlier, the pearl. In truth, a perfect pearl is an entirely human concept and rarely occurs in nature.

LUSTER

Luster is one of the most distinctive features of a pearl. Variously defined as sheen, gloss, brilliance,

radiance, or glow, luster is more than a surface reflection. It appears to originate from within the pearl, a "ball within the pearl—the more intense the image of the ball, the better the luster."[11] Kunz and Stevenson wrote "unless the shelly growth be lustrous, it does not rank as a gem pearl, no matter how perfect its form or beautiful its color."[12]

One measure of luster is the quality of reflection. If a pearl with high luster is examined under a rectangular source of light, a rectangle with sharp, clean contours will be reflected in the pearl. A dull-luster pearl will, in contrast, produce a hazy, indistinct reflection. Another assessment of luster is the contrast between light and dark areas on a pearl. The more lustrous the pearl, the greater the contrast.[13]

(TOP): *Under light microscopy, the surfaces of pearls and mother-of-pearl show a meandering fingerprint-like pattern, reflecting the edges of the discontinuous layers of nacre.*

(ABOVE): *A magnified view of these edges under scanning electron microscopy reveals the individual six-sided crystals of nacre, each of which is 3 microns in diameter.*

Imitation Pearls

Because of the rarity and high cost of real pearls, *imitation pearls* have been used throughout history. There are records of imitation pearls in the Roman Empire, the Middle Ages, and Renaissance Europe. The burial robe of Edward I of England (1272–1307) was supposedly covered with imitation pearls, one of which still exists in the collections of the Museum of London. Queen Elizabeth I is reported to have used imitation pearls to supplement real ones among the thousands of pearls that covered her dresses. In the twentieth century, the American designer Miriam Haskel produced a wide variety of costume jewelry incorporating imitation pearls, inspired by Indian and Byzantine themes (left). Today, imitation pearls are commonplace and are worn by movie stars, first ladies, and almost anyone interested in an inexpensive, yet fashionable, alternative to real pearls.

Techniques for manufacturing imitation pearls have varied over the centuries. One popular recipe in the fifteenth century suggested grinding up seed pearls, glass, and fish bones, and adding snail slime and egg whites for binding. This mixture was then set in molds, each of which was pierced with a hog's bristle, and subsequently baked in the belly of a fish. Leonardo da Vinci (1452–1519) preferred his own recipe:

> *If you wish to make a paste out of small pearls take the juice of some lemons and put them to soak in it, and in a night they will be dissolved. . . . Then wash the said paste with clear water a sufficient number of times for it to lose all trace of the lemon juice. After this let the paste dry so that it turns to powder. Then take white of egg, beat it well and leave it to settle, and then moisten the said powder with this so that it becomes a paste again. And from this you can make pearls as large as you wish, and leave them to dry. Then place them in a small turning lathe and polish them, if you wish with a dog's tooth, or if you prefer with a polishing stick of crystal or chalcedony.*

The manufacture of imitation pearls in eighteenth-century France as illustrated in Denis Diderot's Encyclopédie.

In seventeenth-century Paris, a French rosary maker named Jacquin manufactured imitation pearls of very high quality. He used iridescent fish scales from a small European species, the freshwater bleak fish [*Alburnus alburnus* (Linné, 1758)]. The ground-up fish scales were mixed with lacquer to produce *essence d'orient*. Jacquin filled small hollow glass beads with this substance and then added wax for additional weight. This formula is still widely used today but fish scales from herrings and beads of solid glass, plastic, or mother-of-pearl have replaced the original ingredients. These beads are dipped into *essence d'orient* up to thirty times, and allowed to dry after each successive dip. A synthetic pearl substance has also been invented incorporating flakes of mica, which is used instead of the *essence d'orient* or as a final undercoating for it.

The properties of imitation pearls are very different from those of real pearls. Imitation pearls weigh either much less or much more than real pearls, depending upon the nature of the bead used. Under a hand lens, the surface of an imitation pearl is flat and resembles blotting paper. It does not show any of the natural unevenness of real pearls. This difference in texture serves to distinguish imitation from real pearls. The "tooth test" is well known and described in the text of this chapter. The "rubbing test" is equally effective and involves gently rubbing two pearls together. If the pearls slide smoothly past each other, they are probably imitation pearls; if they offer some resistance, they are probably real. X-rays provide a much more reliable test. Imitation pearls are opaque to X-rays and thus appear white on the negative and black on the positive photograph. Natural or cultured pearls are translucent to X-rays and thus appear gray on both negatives and positives.

Pearls with very high luster, such as top-end Akoyas, are highly prized. Pearls with a satiny or silky luster, characteristic of Australia and Myanmar, are also very desirable in today's market. "Black" pearls from Tahiti show a mirrorlike luster. Freshwater pearls from the United States and China range in luster from milky to satiny. Poor-quality pearls have a dull or chalky luster and very thin nacre.

The luster of a pearl is a product of both the shape of the pearl and its structure and composition. Because a pearl is spherical, its surface is like a curved mirror. As a result, reflected light rays appear to emanate from within the pearl. In addition, the surface of a pearl is not opaque. The layers of nacreous crystals range from translucent to transparent, so when light rays hit the surface of a pearl, they not only reflect off the surface, they also penetrate below the surface and reflect off the deeper inner layers, giving the pearl a brilliant appearance.

Pearls also display optical diffusion, or scattering. Because nacreous crystals always show some irregularities in their alignment, light rays are scattered and diffused among the crystals. To demonstrate this phenomenon, shine a concentrated beam of light against one side of a large pearl. The light that penetrates the pearl will scatter through the nacreous layers and the entire pearl will glow, not unlike the effect of fiber optics.[14]

In contrast, a bead of mother-of-pearl cut from a shell, like the bead used to nucleate cultured pearls, does not show the same luster as a pearl because the nacreous layers are not arranged in a concentric pattern. Except for the top and bottom of the bead, which form small lustrous spots, the sides of the bead are dull because the edges of the nacreous layers intersect them at a right angle.

The intensity of a pearl's luster depends on a number of properties:

1. SURFACE. Pearls with cracked or pitted surfaces have low luster.

2. THICKNESS OF NACRE. In natural pearls, the entire pearl is composed of nacre but in most cultured pearls, only the outer layer is nacreous. Among pearls of a single type, the thicker the nacre, the higher the luster.[15]

3. STRUCTURE OF THE NACRE. Pearls in which the nacreous crystals are well formed and aligned will show the highest luster.

4. PERCENTAGE OF CONCHIOLIN. Conchiolin is opaque and does not reflect light as well as nacre. *Conchiolin pearls*, with excessive amounts of conchiolin, lack luster.

There are several commercial procedures that can enhance luster. After harvesting, pearls are usually washed in fresh water, dried, and then tumbled with a relatively soft material such as crumbled cork, bamboo chips, or walnut shell chips. This removes the organic tissue remnants still surrounding the pearl. In some instances, more abrasive chemical polishing compounds are used, followed by hand- or machine-buffing. Some pearls are also coated with transparent lacquer. These various techniques do not really improve luster but only polish the surface. In any case, the apparent improvement is temporary.

(ABOVE) *The optical properties of pearls are due to both reflection and refraction of light. Light rays are reflected off the surface of the discontinuous layers of nacre, producing luster (top). Light rays penetrate below the surface of the pearl and are refracted (bent) by the various layers (bottom). White light is dispersed into all the colors of the rainbow producing orient or iridescence.*

(LEFT) *Newly harvested Chinese freshwater pearls are tumbled to clean and polish them before sorting thus enhancing luster.*

(OPPOSITE) *High-luster pearls, one each from* Pinctada margaritifera *(right) and* Pinctada fucata *(left), in a gold ring designed by Jean Vendôme.*

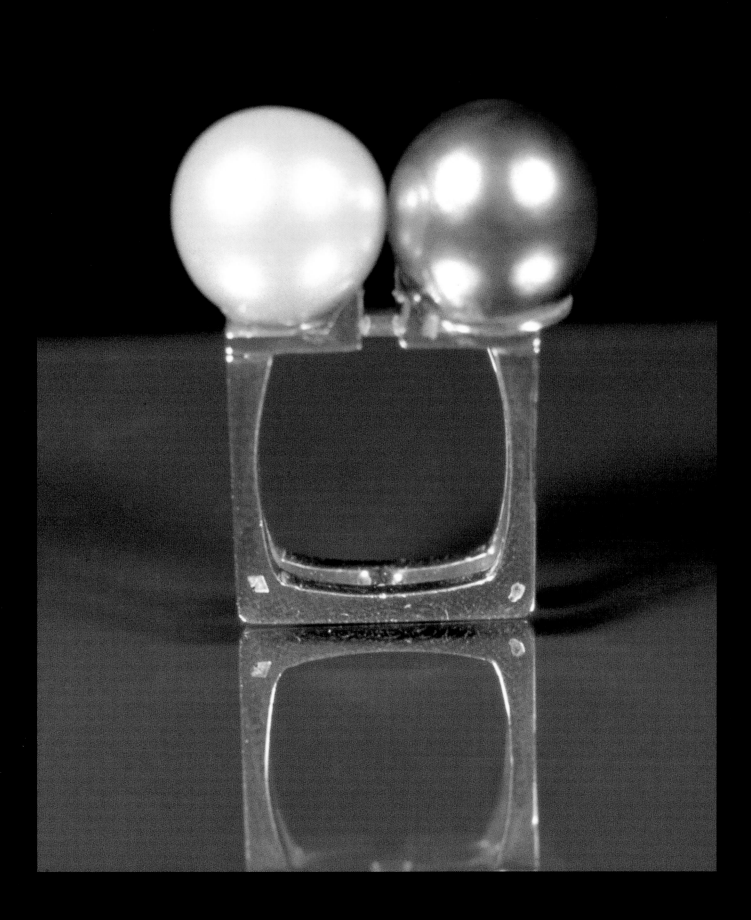

Orient is best defined as iridescence or the play of rainbow colors across the surface of a pearl. It differs from luster, although the two terms are sometimes used interchangeably. The term probably originated from the fact that orient, or iridescence, is best seen by rotating a pearl to align it in different directions. Another possibility is that the term stems from the original Latin meaning of *oriens,* "the rising of the sun."

The same criteria that determine the intensity of luster also influence the quality of orient. The predominant factors are the thickness of the nacre and the regularity of the component nacreous crystals. Multiple layers of consistently thin nacre, composed of perfectly formed nacreous crystals, produce the finest orient. The surface quality of the pearl and the amount of conchiolin also affect orient. Smooth, non-pitted pearls either composed entirely of nacre or, if cultured, with thick outer layers of nacre exhibit the best orient. Pearls made up mostly of conchiolin do not show any orient.[16]

Orient is sometimes visible on spherical pearls—for example, in Japanese cultured pearls produced in the 1950s and 1960s, with thicker nacre than that in recent years—but it is most common on irregularly shaped pearls. Such pearls have uneven surfaces with highs and lows—areas in which the nacre "collects in deep pools"—that promote iridescence.[17]

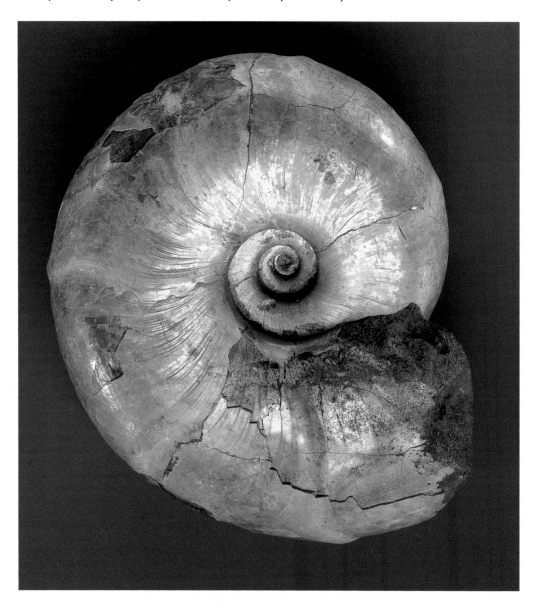

This ammonite shell is composed of nacre and shows an intense red-green orient, a characteristic also present in pearls.

This magnification of a conch pearl shows the flamelike pattern known as chatoyancy.

The scientific explanation for orient is different from that for luster. Luster is explained by the reflection of light while orient is determined by the refraction and dispersion of light. Light is composed of energy of different wavelengths corresponding to different colors in the visible spectrum. When white light passes through a prism, it is refracted and dispersed into all the colors of the rainbow. Similarly, when light rays hit the surface of a pearl, the rays are refracted by the various layers of translucent nacre to produce a rainbow effect. Thus, it is possible to see colors ranging from blue and green to orange and red.

Under certain conditions, known technically as "optical interference," the orient can be particularly intense. This depends on the thickness and arrangement of the nacreous sheets. If a ray of light is reflected off the surface of a nacreous sheet and at the same time penetrates the pearl to reflect off the next deeper nacreous sheet, the two reflected rays can reinforce each other (they are "in phase") to produce a stronger iridescent effect. This "constructive interference" is the same principle that produces iridescence on a thin slick of oil or on the surface of a soap bubble.

Orient also depends on diffraction at the surface of the pearl. The surface of a pearl is like a microscopic crystalline landscape with different sheets of nacre forming irregular edges. Light rays are diffracted along the gratelike structure of these irregular edges to produce minute color spectra. Thus, if a wax impression were made of the surface of a pearl that shows orient, the wax impression would also show it.[18]

Chatoyancy

Chatoyancy is the silklike appearance known from such minerals as tiger's-eye or crocidolite. In pearls the term has been applied to porcelainous pearls such as those from the snails *Strombus* and *Melo*, whose surfaces exhibit flame-like markings. The conch shells themselves sometimes display this same property. This effect is due to the structure of these non-nacreous pearls. Conch pearls are formed of concentric layers of fibrous or prismatic crystals rather than nacreous crystals. The flamelike or moiré pattern is an optical effect that results from the arrangement of these prismatic crystals perpendicular to the surface of the pearl.

Hardness

Hardness is defined as how easily one substance scratches another. In this respect, pearls are relatively soft compared to other gemstones. On the traditional Mohs scale of hardness, where the softest material (soapstone) has a hardness of 1, and the hardest material (diamond) has a hardness of 10, pearls have a hardness of 2.5 to 4.0. In everyday terms, that means that pearls can be scratched by a knife blade or piece of glass but not by a fingernail. Conch pearls, which have a different crystalline structure, surpass nacreous pearls in hardness and toughness, resisting scratching and drilling exceptionally well.

Strength

Pearls are relatively strong and cannot easily be crushed. A common practice among "jewelers and pearl merchants of old . . . [to] separate imitation pearls from real ones . . . [was to have] footmen stomp on them. Those that were crushed were imitation pearls. The natural pearls normally would resist such blows."[19] The authors witnessed another demonstration of pearl strength when Nick Paspaley, of Paspaley Pearling Company, picked up a South Sea pearl worth tens of thousands of dollars and sharply bounced it off the glass surface of a table. The pearl was unharmed, to everyone's relief; Paspaley's second-in-command was quick to add that only his boss could get away with that.

The strength of pearls is due to both their composition and shape. Nacre, which consists of stacked layers of interlocking crystals, is lightweight but very resistant to mechanical forces that are applied perpendicular to the surface, known as compressive forces. Because of the alternation of crystalline layers and conchiolin, nacre is also resistant to fractures and is slightly elastic as the conchiolin produces a cushioning effect. The curved surfaces of pearls also imbue them with a greater resistance to pressure; unlike flat objects, curved objects distribute pressure more evenly over the surface.[20]

For these reasons, drilling pearls for stringing is not accomplished as easily as might be assumed. If drilling is done improperly, a pearl will crack or layers of nacre will flake from the surface. Drilling

was originally done by hand, using a bow-like device, but is now usually accomplished using a specialized electric pearl drill that bores simultaneously from both sides of the pearl.

COLOR

Most people think of pearls as white. In fact, pearls come in nearly every color of the rainbow, depending, in part, on the species of mollusks that produce them. Each pearl is a complex layering of color. Experts describe the color of pearls as a combination of a predominant color, the body color, and a secondary color, the overtone or tint.

To observe the overtone in white pearls, experts recommend viewing the pearls on a white

background under direct light. The outer rim of the pearl will reflect the white background, but the overtone will appear in the dark area in the middle of the pearl. In contrast, in black pearls, the overtones will appear in the lighter areas of the pearl when viewed under diffuse light.[21]

There are many fanciful theories explaining the origin of pearl color. According to the Greco-Roman dew theory, the weather and water quality determined the color of a pearl.

> *If* [the water was] *in a perfectly pure state when it flowed into the shell, then the pearl produced is white and brilliant, but if it was turbid, then the pearl is of a clouded colour also; if the sky should happen to have been lowering when it was generated, the pearl will be of a pallid colour; from all which it is quite evident that the quality of the pearl depends much more upon a calm state of the heavens than of the sea. . . .*[22]

Another explanation maintained that the color of pearls was related to depth of the water: white pearls formed in deep water and dark pearls formed in surface water bathed in sunshine. Still other explanations attributed pearl color to the sediments that the pearl oysters lived on or to the method used to extract the pearls. In Ceylon, where the pearls were extracted after the body of the pearl oyster had rotted away, yellow pearls were thought to be the results of letting the pearls remain in the decayed body too long.

The color of a pearl generally matches the color of the inside surface of the mollusk that produces it. Golden pearls are produced by the Silver- or Gold-lipped Pearl Oyster, *Pinctada maxima*, from Australia, Indonesia, and the Philippines. Black pearls are made by the Black-lipped Pearl Oyster, *P. margaritifera*, from Tahiti and the Cook Islands. Conch pearls from the Queen Conch, *Strombus gigas*, of the Caribbean are pink and porcellaneous, like the inside surface of the shell.

In cultured pearls, the color depends on the color of the bead, if it shows through translucent nacre, and the origin of the tissue inserted with the bead. Because this tissue proliferates and secretes the nacreous layers, if the tissue comes from a region that secreted black nacre, the pearl produced from this mantle will also be black.

(TOP LEFT) *Pearls are drilled simultaneously from both sides to prevent breakage, using a specially designed pearl drill.*

(LEFT) *Pearl dying or irradiation creates unusual and often unnatural pearl colors.*

(OPPOSITE) *Cultured pearls come in a variety of natural colors.*

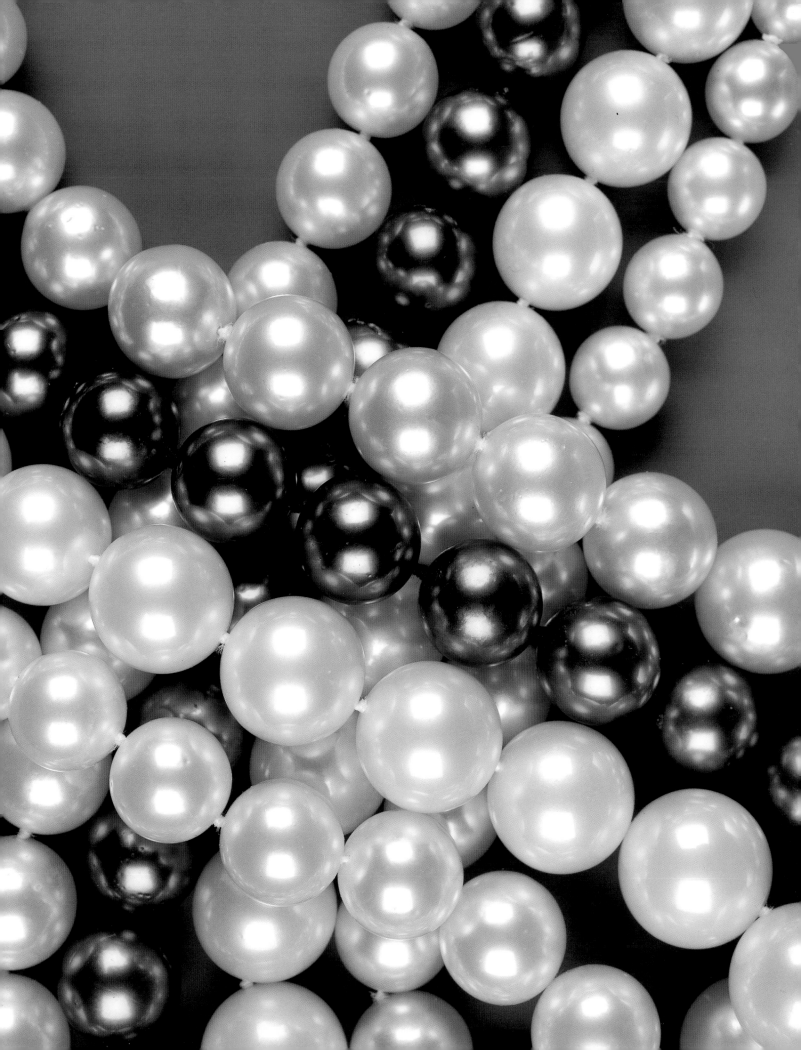

The color of a pearl depends on the wavelengths of light that a pearl absorbs and those that are reflected back. The origin of pearl color is due to two factors:

1. ORGANIC PIGMENT IN THE CONCHIOLIN LAYERS. The number and thickness of these layers vary among pearls. Pigment can also be present in conchiolin in and around the nacreous crystals. In black pearls, the source of the color is probably a melanin-like material. Some experts also cite organic compounds known as metalloporphyrins.[23]

2. COLOR OF THE NACRE. Nacre is translucent and generally colorless or white. However, if trace elements, such as iron, magnesium, or aluminum, are present in the water in which the mollusk grows, they can be incorporated into the nacre and impart a color to it.[24]

Prior to the twentieth century, pearls from the Akoya Pearl Oyster, *Pinctada fucata*, were yellowish green. As a result of selective breeding and post-harvest bleaching, more recent processes of culturing have produced Akoya pearls that are generally white in body color, with overtones of pink, silver, green, yellow, cream, or blue. Pearls from the Ceylon Pearl Oyster, *P. radiata*, from the Persian Gulf are white with a creamy overtone. Those from the Gulf of Manaar are pale creamy white with overtones of green, violet, or blue. Australian cultured pearls from the Silver-lipped Pearl Oyster, *P. maxima*, are also usually white with silvery overtones.

Non-white pearls, known commercially as "fancy colored pearls," range from black to blue to bronze to green to golden and so on. These colors are described using the same two terms above, body color and overtone. The term "tone" is sometimes used as well to refer to the intensity of the color. Occasionally, a gradation of colors occurs in the same pearl from one end to the other.

Today, the best-known colored pearls are cultured in Tahiti (French Polynesia) and the Cook Islands using the Black-lipped Pearl Oyster, *Pinctada margaritifera*. In the past, natural "black" pearls occurred in Panama and Baja California and were produced by *P. mazatlanica*. There are many shades of so-called "black" pearls ranging from an intense black to light dove gray. Usually superimposed on the color is an overtone,

described as green, rosé, peacock, aubergine, cream, blue, or bronze.

Pearls of the pearl oyster *Pinctada maxima* from the Philippines, Indonesia, and Thailand tend to be golden or yellow in color. The tone (intensity) can range from pale yellow to deep, rich gold. Common overtones are red, pink, or green. Venezuelan pearls from *P. imbricata* range in color from bronze to black to white. Historically, white pearls from this area have been described as having an unusually high translucency, almost glassy, indicating small amounts of conchiolin. Pearls from the Black-winged Pearl Oyster, *Pteria penguin*, exhibit lavender overtones.

Freshwater pearls from the United States, China, Scotland, and elsewhere occur in a wide variety of pale shades including white, pink, orange, salmon, lavender, purple, green, and bronze. The Tiffany "Queen Pearl" from Paterson, New Jersey, sold to the Empress Eugénie of France in the mid-1800s, was described as a magnificent pink pearl.

Because of the variation in color and overtone of pearls, each of which is made by an individual mollusk, it is difficult to match pearls exactly. Strands of perfectly matched pearls can take years to put together. Equally difficult is assembling a strand of pearls in which the pearls grade smoothly from one color to another.

Pearls are sometimes treated to change their color or make it more uniform. In Roman and Medieval Europe, owners supposedly fed their pearls to a chicken to remove blemishes and

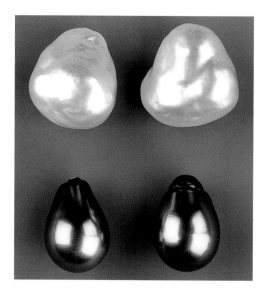

Pairs of matching pearls from Pinctada maxima (white) and Pinctada margaritifera (dark). Every pearl is unique and even those that are very similar show differences in color, luster, and shape.

This tarantula brooch of yellow gold has white and brown diamond-studded legs, a ruby eye, and a thorax of Umba sapphires; the abdomen is represented by a very unusual 27-millimeter oval horse conch pearl.

improve color.[25] The more common process is bleaching, historically in the sun, but more recently with chemicals. Although this process whitens the pearls to a uniform color, it can weaken cultured pearls if the nacre is particularly thin, leading to a higher risk of cracking.

Modifying the color of pearls involves dyeing them in a chemical solution. For example, white pearls can be dipped into a solution of organic pigments to achieve a rosé color, the intensity depending on the length of time in the dye. Chemical dyes require that the pearls be pre-drilled because it is the conchiolin layers and not the nacre that pick up the color. Off-colored pearls, or those with blemishes, are often trans-formed into black pearls by dyeing them or, more commonly, by soaking them in a silver nitrate solution and then exposing them to light or hydrogen sulfide. Another method is to expose pearls to gamma rays, a process patented in the 1960s that promotes a chemical reaction involving the trace element manganese, which is present in freshwater shells and pearls. This process is commonly used on freshwater pearls to turn them bluish gray. In bead-nucleated marine pearls, irradiation turns the inner nucleus, which consists of a piece of freshwater shell, gray or black. This imparts a metallic blue or bronze appearance to the pearl, provided that the nacre is thin enough to let the nucleus show.

There are a number of techniques to determine whether pearls are dyed. Needless to say, those that are of colors such as bright orange, lime green, or powder blue are dyed because no such colors occur in nature. Dyed pearls can usually be detected by examining their surfaces; if there are color blotches, the pearl is probably dyed. In addition, by examining the drill hole with a magnifying loupe, it is sometimes possible to detect stains on the nacreous layers or a line of darker color between the nucleus and overlying nacre. If the nucleus itself has been dyed or irradiated, it will appear black in contrast to the lighter colored nacre. Additional tests include:

1. If the color of a strand of pearls seems too uniform, the pearls might be dyed. Most strands of natural colored pearls show some color variation.

2. Black pearls less than 8 millimeters are usually dyed because non-dyed black cultured pearls (e.g., Tahitian pearls) are usually larger.

3. Under long wave ultraviolet radiation, non-dyed black pearls will fluoresce red to reddish brown while dyed pearls will either not fluoresce at all or fluoresce a dull green.[26]

WEIGHT

In absolute terms, pearls are not very heavy. Their specific gravity, the ratio between the weight of a pearl and the weight of an equal volume of water, ranges from 2.6–2.8.[27] In contrast, the specific gravity of gold is 19.3. Knowledge of the specific gravity of a substance can help identify it. Archimedes, the Greek mathematician (287–212 B.C.E.), once used the principle of specific gravity to prove that a crown was made of real gold, rather than base metal.

The slight variation in the specific gravity of pearls reflects slight differences in structure and composition. Conch pearls show the highest specific gravities (2.84–2.87). Cultured pearls with pearl mussel shell nuclei have specific gravities of 2.72–2.78 and natural pearls from pearl oysters have slightly lower specific gravities (2.60–2.70). The specific gravity of freshwater pearls from the United States and Europe ranges from 2.66 to over 2.78. Imitation pearls are either much lighter or much heavier than real pearls. Those made of hollow glass beads are much lighter than pearls, with a specific gravity below 1.55, while those made of solid glass beads usually have a specific gravity over 3.00. Although specific gravity might at first seem to be a useful diagnostic test to identify varieties of pearls, experts say it is unreliable by itself because the differences are minor and ranges tend to overlap.[28]

The weight of a single pearl can be expressed in either of two units—grains or carats. The term *grain*, equal to 50 milligrams, has usually been applied to natural pearls. A *carat*, equal to 200 milligrams or 4 grains, is the same unit of weight used for diamonds and other gemstones. It is sometimes divided up into fractions, such as one half-carat or one quarter-carat. As an example, La Peregrina weighs approximately 200 grains or 50 carats. Two other units of weight, used commercially and derived from Japanese words, are *momme* (pronounced *moh-may*), equivalent to 3.75 grams or ¾ ounce, and *kan*, equal to 1,000 mommes. Strands of cultured pearl necklaces are sold as "so much" per momme.

SIZE

Individual pearls are sized by diameter in millimeters rather than by weight. If a pearl is not spherical, two measurements—length and width—are sometimes given.

The size of the host mollusk usually determines the size of the pearl. The Pearl of Allah (also called Pearl of Lao-Tsu)[29] is the largest known pearl—23 centimeters in maximum length, weighing 6.35 kilograms. It was found in a Philippine Giant Clam, *Tridacna gigas*, in 1934 and resembles a small brain. Fossil pearls from the extinct clam *Inoceramus* attain lengths of 11 centimeters. The "Queen Pearl," from a New Jersey freshwater pearl mussel, weighed 93 grains—if spherical, as reputed, it would have been about 15 millimeters in diameter. Other large pearls include La Peregrina and the Charles II pearl, both from Panamanian *Pinctada mazatlanica*.

Natural pearls over 8 millimeters (14 grains) are rare.[30] Historically, Persian Gulf pearls (produced by *Pinctada radiata*) were variable in size, although many were less than 3 millimeters.[31] Most

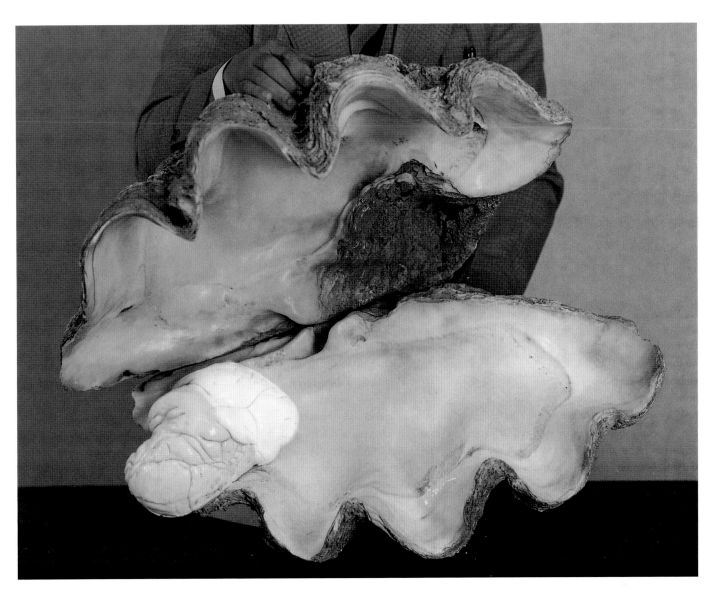

The largest recorded pearl—the Pearl of Allah—with the Giant Clam in which it was found.

from the Gulf of Mannar (also by *P. radiata*) and Venezuela (by *P. imbricata*) were also small, only uncommonly up to about 9 millimeters.[32] Modern natural pearl fisheries in Kuwait consider any pearl over 3 millimeters as commercially valuable.[33]

Seed pearl is the commercial term for a very small pearl, less than 2 millimeters in diameter (< 0.25 grain). In the nineteenth century, enormous quantities of these pearls from Ceylon were used in jewelry. Smaller still are *dust pearls,* which are nearly microscopic.

In bead-nucleated cultured pearls, the size of the pearl also depends on the size of the inserted bead and length of the culture period. Of course, larger mollusks can accommodate larger beads. Some of the largest cultured pearls on the market

today are South Sea pearls, produced by *Pinctada maxima* in Australia, Indonesia, and the Philippines. They generally range from 10-18 millimeters, but have reached 24 millimeters. The "Nugget of Australia" is a 25-millimeter irregular South Sea pearl.[34] Tahitian cultured pearls also attain large sizes, averaging 10-12 millimeters, up to 18 millimeters.

SHAPE

The shape of a pearl depends on many factors, the most important being the location in the mollusk where it was formed. If formed between the mantle and the shell, a non-spherical *blister pearl* (also called *half-* or *chicot pearl*) will form attached to

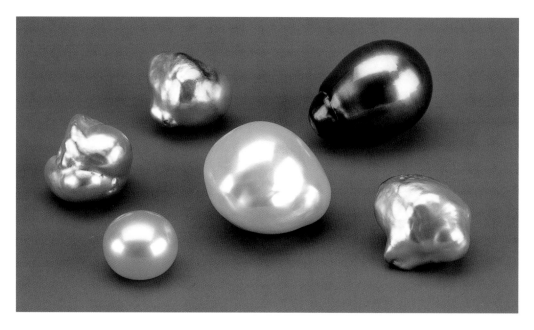

the inside surface of the shell. If formed within the mollusk's soft tissues, it will be free and unattached from the shell wall (called a *free* or *true pearl*). If formed adjacent to a muscle in the mollusk, it could become irregular in shape.[35]

A pearl's shape, whether cultured or natural, originates in the shape of its nucleus. A spherical nucleus, however, does not guarantee a spherical pearl—nacre might not layer evenly around the bead. The most-prized shape today is spherical, called "round" in the pearl industry, a shape that becomes increasingly rare as the size of the pearl increases. Thus, very large round pearls are both rare and very expensive. It is estimated that in natural marine pearls, one or two out of 1,000 pearls are round, in contrast to one in 10-50 bead-nucleated cultured pearls.[36] One of the most famous natural round pearls, La Pellegrina, collected from Indian waters in the early nineteenth century, weighs 2,200 grains (110 grams).

A pearl is checked for roundness by rolling it on an inclined surface. A perfectly round pearl should roll in a straight line, and is known variously as a six- or eight-way roller. Pearls that veer off course are not perfectly round and are called semi-round, out of round, or off-round. The most highly prized non-round pearls are symmetrical and include teardrop and pear-shaped pearls. They are evaluated by their degree of symmetry and proportion and have traditionally been used in earrings, pendants, and brooches.

Button pearls and three-quarter pearls are characterized by rounded tops and flattish bottoms. They are produced by both freshwater and saltwater bivalve mollusks, both naturally and by cultivation and should not be confused with *mabé pearls*, or assembled pearls, the modern version of the cultured half-pearl. "Potato" or "corn" cultured pearls produced by freshwater bivalve mollusks in China are off-round in shape and resemble small oval potatoes or corn kernels. Ringed cultured pearls from pearl oysters or freshwater pearl mussels are called *circlé* or circled pearls, characterized by thickened rings and furrows. Sometimes there is only a single furrow, but in other instances the

(ABOVE) *An assortment of natural pearl shapes. Round pearls are very rare in nature— only 1 or 2 per 1,000 pearls— but culturing techniques have succeeded in producing them in larger quantities.*

(BELOW) *Pearls are rolled at a Tahitian pearl farm in order to grade newly harvested pearls according to shape.*

(OPPOSITE) *A parure of seed pearl jewelry, probably from mid-nineteenth-century England, consists of a necklace, two bracelets, a pair of earrings, a small brooch, and a large brooch* en tremblant.

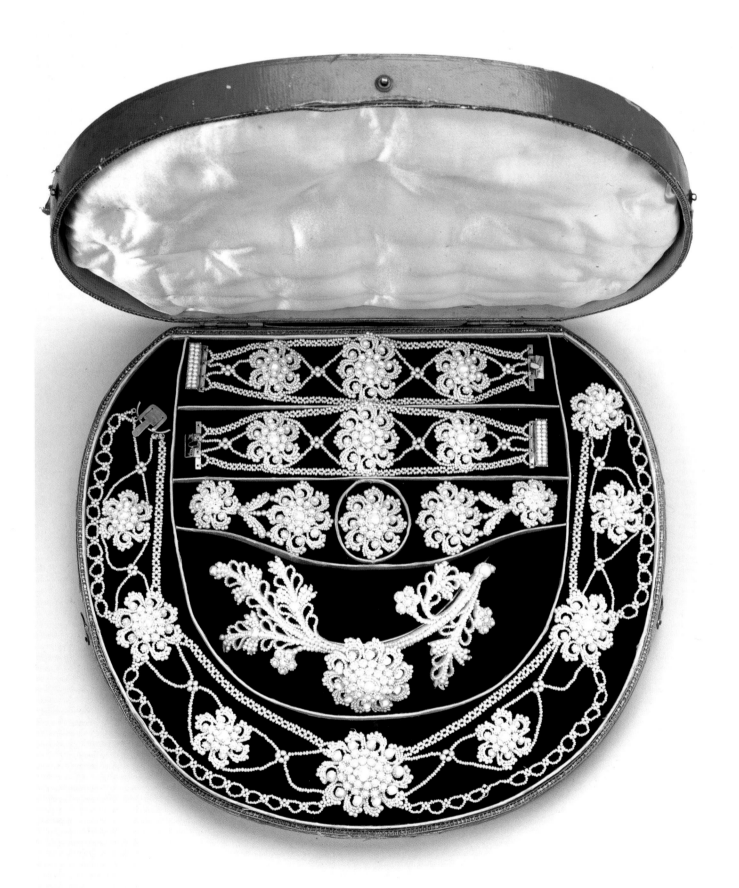

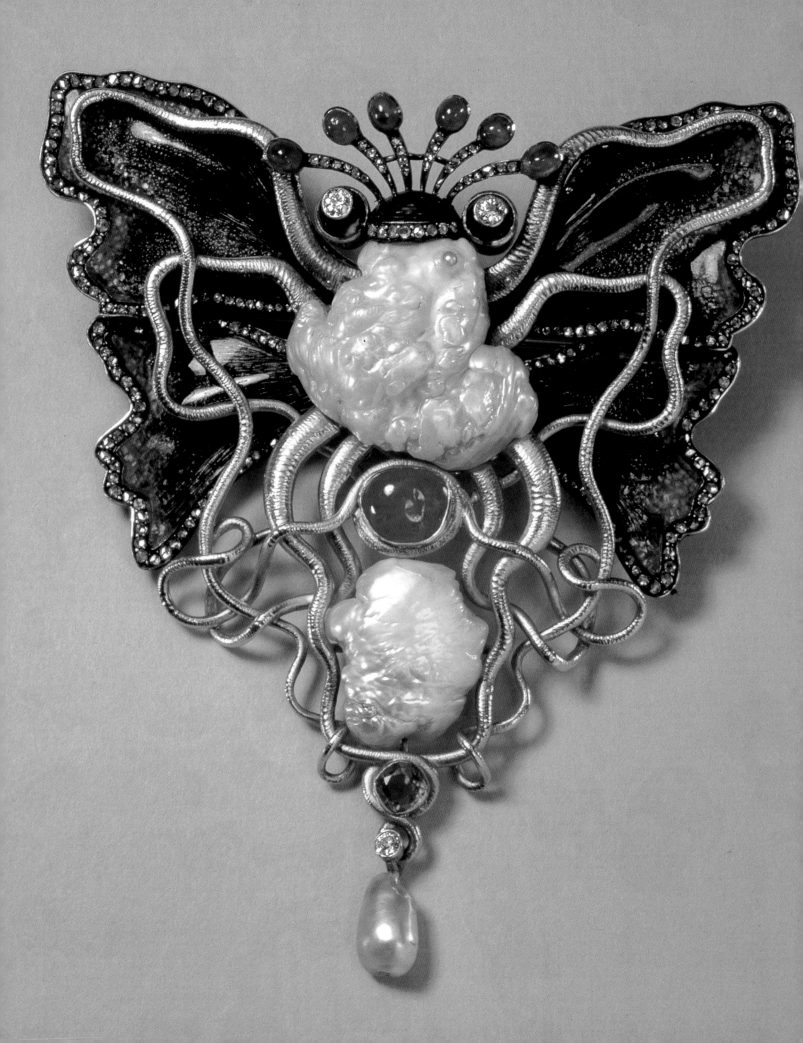

entire pearl is sculptured by a series of concentric furrows from one end to the other.

Spherical pearls are sometimes cemented together inside the mollusk during formation. The result is a string of fused pearls, two or three in a row. The most famous example of fused pearls is the Southern Cross, found in the Silver-lipped Pearl Oyster, *Pinctada maxima*, off the northwestern coast of Australia. It consists of two perpendicular rows of nine fused pearls, one row of seven intersected by a row of three pearls. One pearl of the shorter row was supposedly artificially added to complete the symmetry of the cross.[37]

Pearls with irregular shapes are called *baroque,* a French adjective originally applied to pearls and only later to architecture, art, and music. It usually describes large pearls with an irregular but interesting shape. In freshwater bivalves, dull baroque pearls are sometimes called "slugs." Baroque pearls were favored throughout European history in creating whimsical pendants and figurines.

Keshi pearls, also called *adventitious* or *chance pearls,* are one of the main types of baroque pearls on the market today. The term is derived from Japanese, meaning poppyseed. It was originally used for small seed-sized (1–3 millimeters) pearls found as by-products of Japanese cultured pearls. Initially assumed to be naturally occurring pearls, they were later considered a result of vagabonding epithelial cells accidentally introduced during nucleation.[38] Today, keshi is reserved for larger chance pearls, up to 10 millimeters in diameter, associated with cultured *Pinctada* in Tahiti, Indonesia, the Philippines, and Australia. The explanation for these larger keshi pearls is slightly different. Nucleation normally involves implanting a spherical bead and a bit of mantle tissue. If the bead is rejected or the tissue is separated from the bead, the tissue might continue to produce a pearl—this is a keshi pearl. There is no physical difference between keshi and natural pearls, except that keshi are produced via human intervention. Keshi pearls often show a high degree of orient and are very popular in modern jewelry.

Since 1995, faceted Tahitian "black" pearls have also appeared on the market. These pearls, with their flat rhombic facets, sparkle like faceted gemstones. Each faceted surface cuts across multiple layers of nacre, forming a bulls-eye pattern, much like that produced by cutting off a slice of an onion on the outside. Although the facets appear convex or concave, they are, in fact, flat.

Tintenfisch und Schmetterling (Octopus and Butterfly), *an Art Nouveau brooch by Wilhelm Lucas von Cranach (1900), is set with baroque pearls, rubies, diamonds, amethysts, and a topaz.*

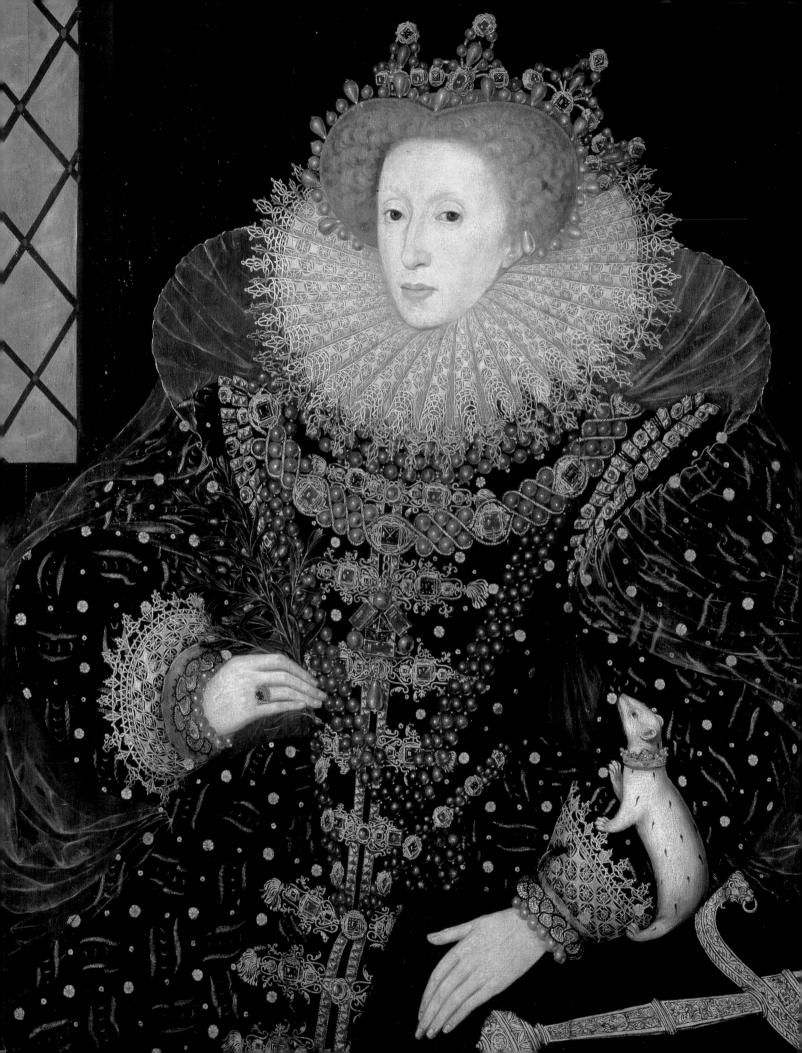

4

Pearls in Human History

THE EUROPEAN TRADITION

The round shape and silky luster of pearls have always appealed to aesthetic sensibilities. The fact that living animals produce them makes them unique among gems and has added to their fascination. Their color and origin have combined to imbue them with precious and symbolic associations, and over the centuries they have been used in religious artifacts, personal adornment, and royal trappings.

Evidence of the role of pearls in human culture appears in literature, music, and written accounts describing the sources of pearls and their use, commerce, and symbolism. Pearls have been recorded in paintings, mosaics, sculptures, coins, cameos, and textiles. Pearls alone or incorporated into jewelry, *objets d'art*, and textiles have also survived as physical artifacts. The presence of pearl artifacts depends on the vagaries of preservation, and their absence from certain time periods does not always mean that pearls were, in fact, absent at those times. On the basis of these pieces of evidence, we can construct a cultural history of pearls.

The Ermine Portrait *of Queen Elizabeth I by Nicholas Hilliard (c. 1585). Horace Walpole wrote in the nineteenth century: "A pale Roman nose, a head of hair loaded with crowns and powdered with diamonds, a vast ruff, a vaster farthingale, and a bushel of pearls, are features by which everybody knows at once the pictures of Queen Elizabeth."*

GRECO-ROMAN WORLD: AN AGE OF EXTRAVAGANCE

Pearls offer themselves to my view. Simply one for each ear? No! The lobes of our ladies have attained a special capacity for supporting a great number. Two pearls alongside of each other, with a third suspended above, now form a single earring! The crazy fools seem to think that their husbands are not sufficiently tormented unless they wear the value of an inheritance in each ear.

—Lucius Seneca, *De beneficiis*, c. 60 C.E., Book VII, chapter 9

The Oldest Artifacts

There is no evidence of extremely old pearls in Europe itself. The nearest ancient finds, discussed in Chapter 5, are a few loose pearls, some of them drilled, from sites in Mesopotamia, eastern Arabia, and the Iranian plateau.

With expansion of the Hellenic world in the fourth century B.C.E., Greeks came into contact with their neighbors to the east and observed the value of pearls in other cultures. Only a handful of objects has survived from this era. The best is a votive pin from the Temple of Aphrodite in Paphos, Cyprus, from the third century B.C.E. It is a golden column, topped by two pearls—the larger of 14 millimeters is marine in origin, while the smaller, of only 4 millimeters, is generally regarded as freshwater, but could have come from *Pinna*, a marine bivalve that occurs locally and produces small pearls.

The Roman Empire

The use of pearls became more common after Rome supplanted Greece as the dominant power in the Mediterranean. One of the best-known writers of this period, Pliny the Elder, devoted several pages to pearls in his *Historia Naturalis* (9: 54). According to him, pearls occupied "the first rank . . . and the very highest position among all valuables," and by the first century C.E., they were the most popular gem in the Empire.

Large pearls commanded enormous prices. According to the historian Suetonius, the Roman general Vitellus financed an entire military campaign through the sale of a single pearl from his mother's ear.[1] Pliny estimated that the pearl supposedly consumed by Cleopatra at her famous banquet for Mark Anthony was worth 10 million sesterces, equivalent to 80,000 Roman pounds of gold (*Historia Naturalis*, 9: 58).

Rome traded for pearls with India and the Persian Gulf along existing land and sea routes. A variety of terms were used to describe pearls, reflecting their importance in commerce. The general term was *margaritae*, but *elenchi* and *unio* referred more specifically to pear-shaped and large spherical pearls, respectively.

The Romans also acquired pearls through conquest and plunder of captured territories. Pliny remarked "in Britannia pearls are found, though small and of bad color; for the deified Julius Caesar wished it to be distinctly understood, that the breast-plate which he dedicated to Venus Genetrix, in her temple, was made of British pearls" (*Historia Naturalis*, 9: 57). According to Suetonius, pearls were one of the reasons for Caesar's invasion of Britain in 55 B.C.E.[2]

The place of pearls in Roman society is illustrated by the writings of Pliny, Seneca, and other social commentators. Most of their comments are critical and especially target women, as documented by Pliny:

> *Our ladies quite glory in having [pearls] suspended from their fingers, or two or three of them dangling from their ears. . . . Nay, even more than this, they put them on their feet, and that, not only on the laces of their sandals, but all over the shoes; it is not enough to wear pearls, but they must tread upon them and walk with them under foot as well.* (Historia Naturalis, *9: 56*)

Sumptuary laws were enacted by Julius Caesar to limit the display of pearls. These laws forbade the wearing of pearls by women below a certain rank, thus making pearls an immediate indicator of status. According to Pliny (*Historia Naturalis*, 9: 56), "a pearl worn by a woman in public is as good as a lictor [herald] walking before her."

A pearl and gold pin, dating from the third century B.C.E., excavated at the Temple of Aphrodite, in Paphos, Cyprus, features two pearls.

This bronze head of Venus with a gold and pearl earring, dates from the first to second century C.E. (height is 4.5 centimeters).

Another target of social criticism was the extravagant use of pearls in the Imperial Court. The emperor Caligula (37–41 C.E.) "in addition to other feminine luxuries, used to wear shoes adorned with pearls."[3] Caligula also elevated his favorite horse to the consulship and decorated it with a pearl necklace. Philo, the Jewish envoy to the court, observed that "the couches upon which the Romans recline at their repasts shine with gold and pearls; they are splendid with purple coverings interwoven with pearls and gold."[4] Nero (54–68 C.E.) favored pearls not only for his shoes and couches, but also provided pearl masks for the actors in his theater.[5]

There are many references to pearls in the Roman pagan religion. Pearls were commonly dedicated to Venus, the goddess of love and beauty, who according to mythology, emerged from a shell in the sea. According to the writer Aelius Lampridius, when Emperor Alexander Severus received two very large pearls for the empress from an ambassador, he hung them instead in the ears of a statue of Venus.[6] One of Cleopatra's pearls was reportedly cut in half to make earrings for the statue of Venus in the Pantheon. Several such statues have survived to this day but the pearl earrings on them have mostly disintegrated.

Pearl jewelry has been discovered from throughout the Roman Empire, especially in the provincial towns of Pompeii and Herculaneum in Italy, in Alexandria in Egypt from the Late Ptolemaic and Roman periods (100–300 C.E.),

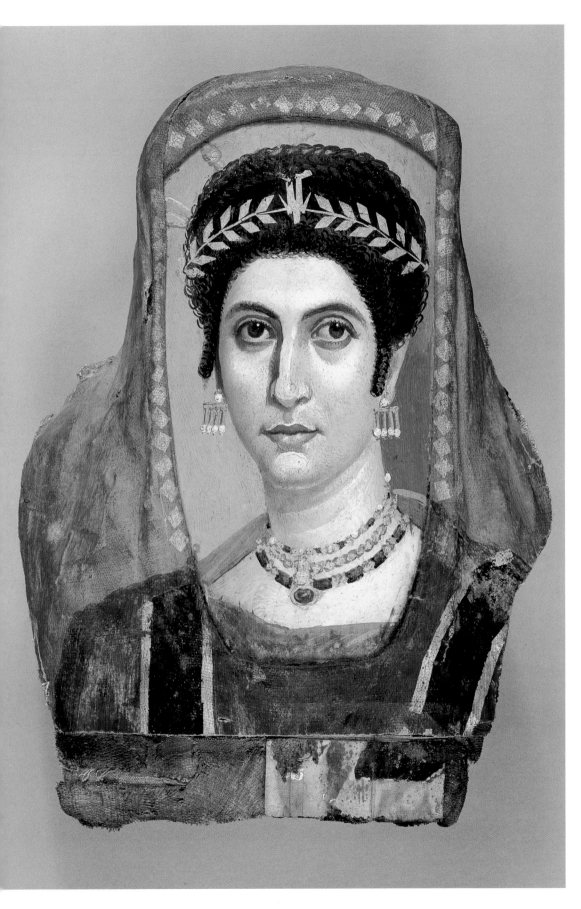

(ABOVE) *Pearl earring from the Roman Empire, first to third century C.E.*

(LEFT) *A mummy portrait shows an Egyptian (Faiyum) woman, 100–125 C.E., wearing pearl earrings in the* crotalia *style.*

and as far afield as France. The artifacts from Pompeii and Herculaneum are particularly valuable to historians because they are precisely dated by the eruption of Mt. Vesuvius that buried both cities in volcanic ash in 79 C.E.

Excavations have revealed Roman pearl jewelry in many forms. Earrings were the most common, consisting most simply of golden hoops with a single or several pearls. The classic Roman design was the *crotalia*, a crossbar on which pear-shaped pearls were suspended by wires, rattling or jingling like a castanet as the wearer moved.[7] Jewelers often mixed pearls with cabochon (polished) rubies and other precious stones to set off the pearls' brilliance. A description of Caligula's wife captured the effect:

> *I once saw Lollia Paulina at an ordinary wedding entertainment—with emeralds and pearls, which shone in alternate layers upon her head, in her hair, in her wreaths, in her ears, upon her neck, in her bracelets, and on her fingers....* (Historia Naturalis, *9: 58*)

The use of pearls in the Roman Empire is well documented in portraits, mosaics, cameos, coins, and sculptures. Wall paintings at Pompeii show women wearing pearl necklaces and earrings. A mosaic from 500 C.E. shows a bust of a female decorated with a jeweled diadem and pendant pearl earrings.[8] Egyptian mummy portraits painted on wooden coffins from the first to third centuries C.E. also depict women wearing pearl earrings, many in the *crotalia* style.

Christianity

The symbolism of pearls in the Roman Empire was assimilated into the growing Christian faith of the first few centuries C.E. Pearls symbolized wealth but also perfection and purity. Jesus Christ admonished "Give not that which is holy unto the dogs, neither cast ye your pearls before swine, lest they trample them. . . . " (Matthew 7: 6). Jesus further used pearls to describe "the kingdom of Heaven . . . like unto a merchant man, seeking goodly pearls: who, when he had found one pearl of great price, went and sold all he had, and bought it" (Matthew 13: 45–46). In the revelation of St. John, the walls of the holy city consisted of "all manner of precious stones" but "the twelve gates were twelve pearls, each of the gates made of a single pearl" (Revelations 21: 21). Many of these meanings survived and were amplified in the succeeding centuries.

BYZANTIUM AND MEDIEVAL EUROPE: THE AGE OF FAITH

> *Pearl! Fair enow for princes' pleasance, so deftly set in gold so pure—from orient lands I durst avouch, ne're saw I a gem its peer,—so round, so comely shaped withal, so small, with sides so smooth,—where'er I judged of radiant gems, I placed my pearl supreme.*
>
> —Anonymous, *The Pearl*, c. 1370

Byzantium

As the Roman Empire declined, power shifted to Byzantium in the east. The Eastern Roman or Byzantine Empire (330–1450), based in Constantinople, stretched from Asia Minor through Macedonia, and around the Mediterranean, including Egypt. It drew on the pearls it inherited from Rome as well as new treasures it acquired through trade and conquest. Its proximity to Asia influenced the use of pearls in its jewelry and textiles.

The mosaics of Ravenna, Italy, are among the best-known representations of pearls from this period. They depict the Emperor Justinian wearing a jeweled cap with a double row of pearls, and pearls hanging over his ears. His consort, Theodora, wears a headdress with two rows of pearls, ropes of pearls across her chest, and strings of pearls hanging from her headdress to her shoulders.

Throughout the history of the Byzantine Empire, pearls were used lavishly at the imperial court. Rulers wore diadems, necklaces, and collars of pearls and colored gemstones. Imperial robes were encrusted with pearls and, according to one historical account, the canopy above the throne was made of purple cloth embroidered with pearls.[9] Bracelets, earrings, pendants, and necklaces from this period have been found in Constantinople, Syria, Egypt, and parts of Europe. Jewels typically featured colored gemstones in addition to pearls, producing a kaleidoscopic effect. Earrings were long, up to 12 centimeters in length, and consisted of colorful combinations of pearls, sapphires, and emeralds.[10] Necklaces were constructed of gold

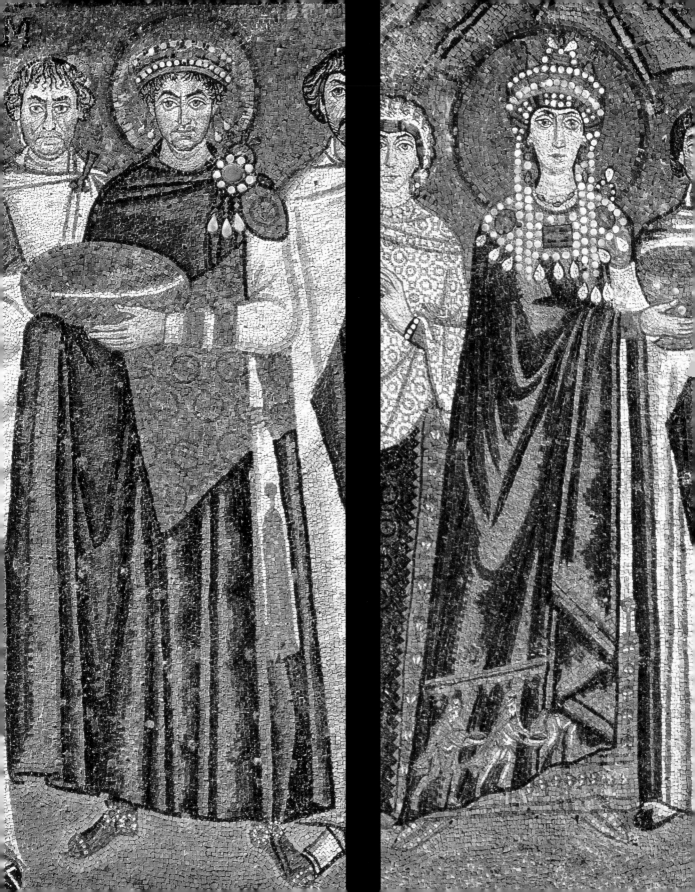

(OPPOSITE) *Sixth-century mosaics at Ravenna, Italy, depict the Emperor Justinian and his consort, Theodora, adorned in pearls.*

(RIGHT) *An early seventh-century bracelet of Byzantine workmanship, excavated in Upper Egypt, with large white pearls, sapphires, and green chalcedony.*

openwork plaques hinged together and set with pearls and other gems. Bracelets featured broad bands with a central roundel set with a gem, and bordered with pearls.

Pearls were used even more lavishly in Byzantine churches than at the imperial court. In Hagia Sophia, the center of the Eastern Orthodox Church in Constantinople, the pulpit was studded with pearls. Reliquaries, icons, chalices, and bowls were made of alabaster, onyx, and agate, encircled by borders of pearls. Vestments played an important role in church ritual and were embroidered with tiny seed pearls from India and freshwater pearls from central and northern Europe. The Roman Catholic and Russian Orthodox churches ultimately adopted this custom and similar robes appeared in Medieval England and France.

Western Europe

As Byzantium grew in power in the sixth through eleventh centuries, much of western Europe was in a state of war and turmoil. Pearl treasures were destroyed or resurfaced in new dynasties. Several such treasures have survived and reflect Byzantine workmanship or influence. The Visigothic

Guarrazar Treasure from seventh-century King Reccesvinthus, found in Toledo, Spain, includes eleven crowns of gold, pearls, and precious stones. The golden Crown of the Holy Roman Empire (also known as the Crown of Charlemagne or the German Imperial Crown, 962 C.E.) is set with pearls and precious stones.

As in Byzantium, many pearl-encrusted European treasures were created for and given to the Church, with nobles competing to donate the richest gems in hopes of eternal salvation. Reliquaries, shrines, ecclesiastical garments, crucifixes, missal covers, and altars were decorated with gems and pearls, whose status as symbols of Christian purity favored them. Raiding armies and the dissolution of monastic orders destroyed many of these religious artifacts. Only a few have survived. The Chalice of Abbé Suger (c. 1140), from the Abbey of Saint-Denis, is bordered with pearls and precious stones. The cover of the Ashburnham manuscript of the Four Gospels from the eighth-century Carolingian Dynasty is adorned with freshwater pearls.

The Crusades in the twelfth and thirteenth centuries renewed interest in pearls, as these campaigns to capture the Holy Land from the

Pearls in Medicine and Cosmetics

In addition to their ornamental uses, pearls have always been popular in Europe and Asia for their supposed medicinal properties. Pearl recipes to treat a variety of ailments were widely known in Medieval and Renaissance Europe and were published in lapidaries and pharmacological treatises. Many of these recipes were passed down from classical scholars such as Pliny, but others were derived from Arabic and Jewish teachings.

Pearls were believed to treat or cure a long list of disorders. The twelfth-century German Catholic nun and scholar Hildegard von Bingen prescribed pearls for fever and headaches. The thirteenth-century German monk Albertus Magnus recommended pearls "to relieve difficulty in breathing and heart attacks and fainting fits, and . . . against bleeding and jaundice and diarrhoea." Alfonso X of Castile, also from the thirteenth century, advised the use of pearls for "palpitations of the heart, and for those who are sad and timid, and in every sickness which is caused by melancholia because the pearl purifies the blood, clears it, and removes all its impurities." In addition, he suggested that pearls "clear the sight . . . , strengthen the nerves, and dry up moisture." The physician Malachias Geiger, in his book *Margaritologia* (1637), promoted pulverized pearls baked with other ingredients such as antlers and cinnamon as protection from the Black Death. The Persian writer Shaikh 'Ali Hazin's treatise of 1745 also discussed pearl use in medicine: "The master physicians have always used it and entered it in exhilarating drugs and electuaries. . . . It is beneficial for troubles, weakness and palpitation of the heart. It dispels worries and does all good to spitting of blood. . . . If kept in the mouth, it completely strengthens the heart. It is one of the medicines for the eye." In German rural medicine, pearls were also administered to animals—to cows to encourage the development of healthy calves, and to horses and dogs to combat blindness.

In most pearl remedies, small pearls were swallowed whole or first crushed into a powder and then dissolved in liquid with a variety of herbs. Marine pearls were usually favored over freshwater pearls but one seventeenth-century treatise specifically praised the therapeutic properties of freshwater pearls from Bavaria.

Directions to prepare these potions were often very elaborate. Anselmus de Boodt, physician of the Emperor Rudolph II of Hapsburg, published this recipe in 1609 for *aqua perlata*:

> *Dissolve the pearls in strong vinegar, or better in lemon juice, or in spirits of vitriol and sulfur, until they become liquified; fresh juice is then added and the first decanted. Then, to the milky and turbid solution, add enough sugar to sweeten it. If there be four ounces of this solution, add an ounce each of rosewater, of tincture of strawberries, of borage flowers and of balm and two ounces of cinnamon water. . . . Care must be taken to cover the glass carefully while the pearls are dissolving, lest the essence should escape.*

With the development of pearl culturing techniques in the early 1900s, the Japanese gained control of a large portion of the pearl medicine market. A modern mixture called Long-zhu Ye contains calcium from the Akoya Pearl Oyster, *Pinctada fucata*, and has been shown to reduce cholesterol levels in laboratory rats.

Chinese use of pulverized pearls as medicine and a cosmetic has a history of two thousand years, and still continues in various parts of Asia, including China (opposite), India, and Japan. According to one modern manufacturer, pearl powder was used topically under stage makeup during the Tang dynasty (618–907 C.E.) to keep the skin smooth and soft, and was later adopted by the empresses; it is also said to remove "age and liver spots on the skin." Pregnant women and those that were breast-feeding took pearl powder to "speed up bone development and promote intelligence" in their babies. Modern pearl powder manufacturers use cultured Chinese freshwater pearls, citing them as 100 percent nacre.

In the 1990s, at least one Mexican cosmetics company was advertising mother-of-pearl cream under the name "Concha Nacar." This presumably originates in the Western Winged Pearl Oyster, *Pteria sterna*, that goes by that common name.

Whatever therapeutic value derives from pearls stems from their chemical composition, that is, largely from calcium, plus approximately twenty amino acids. In its pure form, this substance is used today in measured quantities in antacids and in calcium pills against osteoporosis, although medical opinion suggests that the actual amount of assimilable calcium from pearls is small. Add to this a dose of placebo effect, and the logical conclusion is that the consumption of pearls cannot hurt and might well be beneficial.

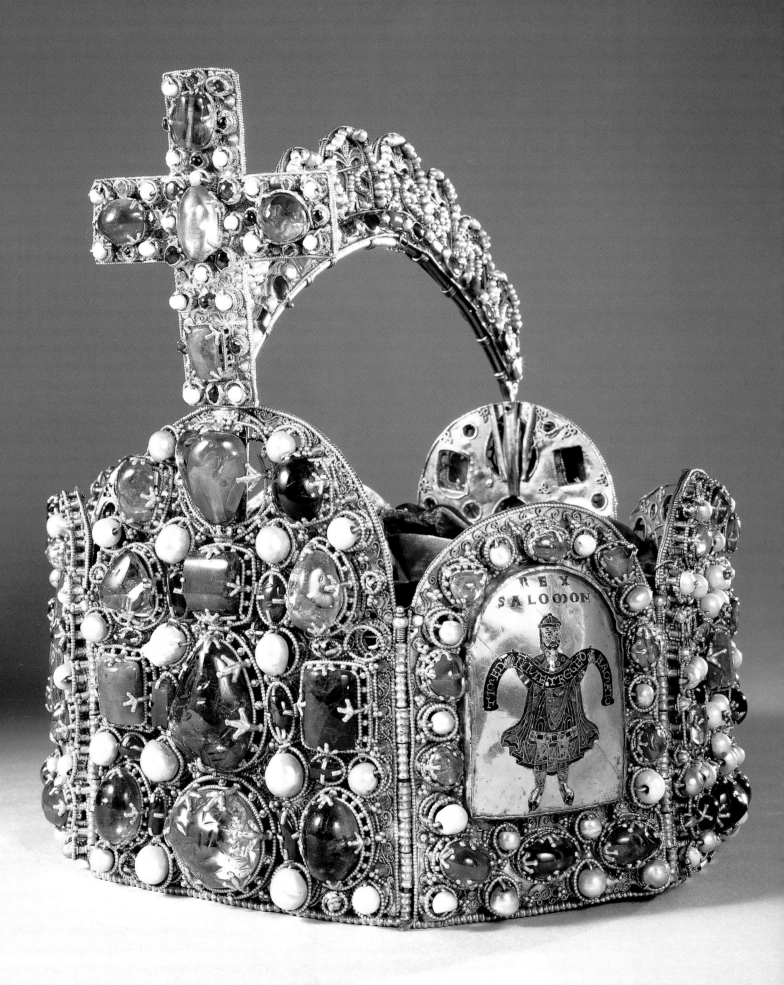

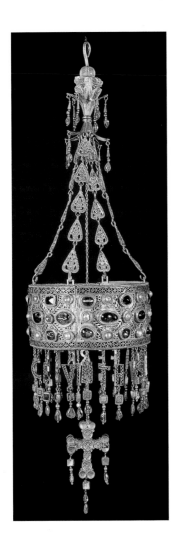

Muslims introduced Europeans to the riches of Byzantium and the Islamic world. As a result, trade routes were reopened, leading to a fresh supply of pearls on the European market. European craftsmen learned about Byzantine jewelry designs from the relics and jewels brought home by the crusaders, introducing Byzantine traditions of pearl decoration to the West and heightening the demand and desire for opulent display.

Travelers and merchants also added to the taste for pearls. Marco Polo (c. 1234–1324), a Venetian traveling overland to China and Japan, described the King of Malabar:

> [He] *wears, suspended from the neck and reaching to the breast, a fine silken string containing one hundred and four large handsome pearls and rubies. . . . On each arm he wears three gold bracelets, adorned with pearls and jewels. . . . To this king it is indeed a matter of pride to display such splendid regalia, as the precious stones and the pearls are all found in his own kingdom.*[11]

Marine pearls arrived in late Medieval Europe from India and the Persian Gulf, routed through the Levant or Constantinople mainly to Venice and other European cities. Merchants purchased pearls at these commercial centers and resold them at fairs throughout Europe. The word *pearl* itself and its variants (perle, perla, etc.) were introduced into all major European languages in the mid-thirteenth century, eventually replacing the older word *margarita*.

Freshwater pearls were also in wide use in embroidery, jewelry, and decorative articles. The main European areas with dense pearl mussel beds and associated pearls were the Scottish highlands, northern Wales, Ireland, France (Brittany and Lorraine), Germany (particularly Lower Saxony, Saxony, and Bavaria), Austria, the Czech Republic (Bohemia), northwestern Spain, Scandinavia, and Russia.[12] European freshwater pearls were rarely as lustrous as marine pearls, but as "locally obtainable jewels" they commanded great interest in Europe, and fishery rights for the pearl mussels (*Margaritifera margaritifera*) were reserved for the aristocracy, churches, and monasteries. One notable example of exclusive royal use in Eastern Europe was the presentation of a black

sable by the Russian Grand Duke Ivan III to the King of Hungary in 1488 on which were "20 Novgorodian pearls [that] were large, beautiful and pure."[13] The mixture of freshwater and marine pearls in the same piece was ultimately prohibited, probably in response to a real or perceived difference in value between the two kinds of pearls. In 1355, Parisian jewelers agreed that no worker in gold or silver should set freshwater pearls with oriental pearls except in large ornaments or jewels for churches.[14] Imitation pearls were also produced for use in minor jewelry or clothing, but laws discouraged their fraudulent use. In Venice, the penalty for misrepresentation was loss of a hand and a ten-year exile.

In late Medieval Europe, the upper classes and nobility were the consumers of pearls, and passed them down from generation to generation. Petrarch, the fourteenth-century poet, sounded a sardonic note in describing noble men and women "adorned like altars on festival days."[15] To keep pearls exclusive, sumptuary laws were enacted in many areas of Europe starting in the thirteenth century.[16] One of the most distinctive head ornaments of the twelfth to fourteenth centuries was the *coronal*, a crown with tall fleurons, popular as a wedding present. The most beautiful coronal to survive is that of Princess Blanche, the daughter of Henry IV of England (c. 1370).

The meaning, magic, and medicinal properties of pearls were much discussed in Medieval Europe, while theologians perpetuated the symbolism of the New Testament. The classical belief that pearls originated from dew persisted, with slight variations. The noted Jewish traveler of the twelfth century, Benjamin of Tudela, suggested that pearl oysters actually rose to the surface of the waters, where they captured raindrops rather than dew:

> *On the twenty-fourth of Nisan [early spring] rain falls upon the water, upon the surface of which certain small sea-animals float which drink in the rain and then shut themselves up, and sink to the bottom. And about the middle of Tishri [early fall] men descend to the bed of the sea by ropes, and collect these shell-fish, then split them open and extract the pearls.*[17]

(OPPOSITE) The German Imperial Crown, also known as the Crown of Charlemagne, originally crafted in the tenth century, with later additions.

(ABOVE) Pearls and emeralds cover a seventh-century Visigothic crown of Byzantine workmanship, part of the Guarrazar Treasure found near Toledo, Spain.

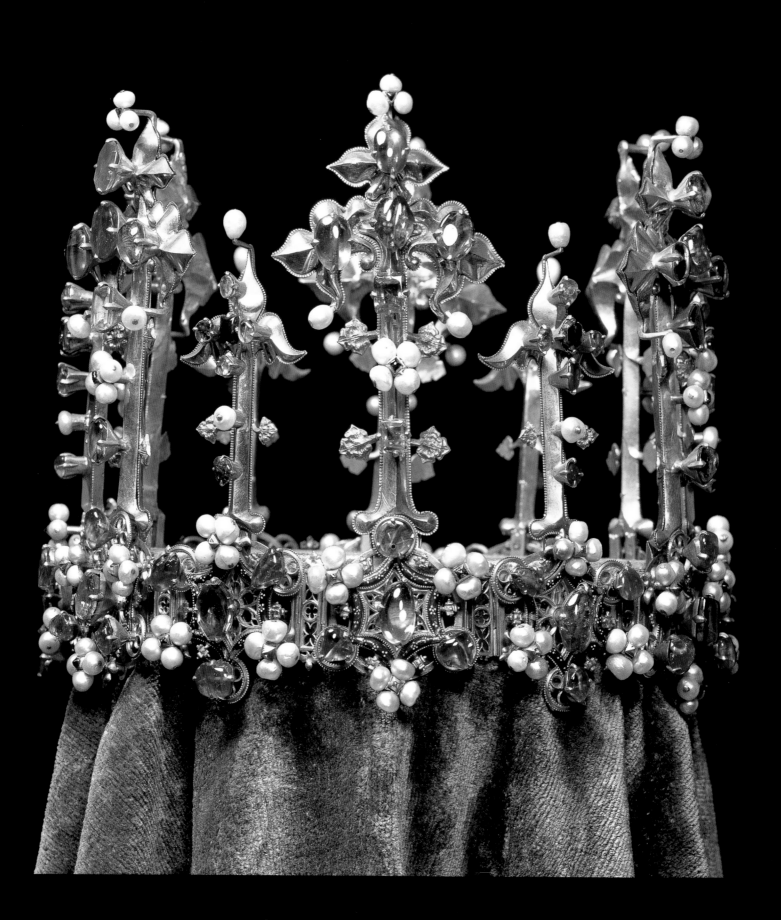

Lapidaries and pharmacological works provided pearl recipes for curing a wide range of disorders. Pearls were classified with coral and amber as "animal stones," and as such, were imbued with special properties. These beliefs about pearls further enhanced their appreciation, as they rose to become the dominant gem of the Renaissance.

The Renaissance: The Age of Splendor

Cloaks trimmed with diamond buttons . . . cockades and earrings to be yoked with manifold knots of pearl, in short to be manacled, fettered and imprisoned with pearls

—Description of the Duke of Buckingham, early seventeenth century[18]

The mid-fifteenth century heralded the arrival of the Renaissance, starting in southern Europe and spreading to the north. Along with a revived taste for art, pearls became an ever-present gem symbolizing wealth, status, and taste in an age of splendor.

The availability of pearls was unprecedented. They arrived from India, Ceylon, and the Persian Gulf via new maritime routes pioneered by the Portuguese. The voyages of Columbus and his successors opened up new pearl grounds in the Americas. Additional pearls arrived from farther afield including Southeast Asia and Oceania. The influx of pearls through Spain and Portugal changed the dynamics of pearl commerce in Europe. Lisbon and Seville displaced Venice as the centers of pearl commerce, with Lisbon specializing in pearls from the Persian Gulf and India, and Seville in those from the West Indies.

Kings, queens, and the nobility wore pearls in abundance. A freshwater Scottish pearl, found in the River Conway by a lady-in-waiting to Catherine, first wife of Henry VIII, still exists in the royal crown of Great Britain.[19] One contemporary writer observed that "the better sort of women [are seen] wearing rich chains of pearls."[20] Pearls appeared in hat ornaments, collars, chains, pendants, necklaces, head ornaments, girdles, and rings. The lavish use of pearls at the time was captured by numerous official portraits.

Portraits of King Henry VIII of England by Hans Holbein the Younger (c. 1497–1543) show the king adorned in pearls, some of which he confiscated from churches and monasteries. He is portrayed in clothes embroidered in pearls, and broad necklaces made of gold and studded with pearls and gems. Henry's third wife, Jane Seymour, is shown in another Holbein portrait (1536) wearing a gabled hood edged with pearls and precious gems. Similar bands appear at her neckline and belt. She also wears pearl necklaces and two large pendants of gems and pearls.

The many portraits of Queen Elizabeth I (1533–1603) throughout her forty-five-year reign document the vastness of her pearl collection. She wore enormous quantities of pearls to convey multiple images: the purity of the "Virgin Queen," the power implied by access to the pearling grounds of India and the Americas, the pomp of majesty, and the actual wealth of the pearls. In one of her earliest portraits (1546), usually attributed to William Scrots, the thirteen-year-old Elizabeth wears rows of pearls on her headdress, strands around her neck, clusters outlining her neckline and waist, and pendants of pear-shaped pearls. The so-called *Ermine Portrait* by Nicholas Hilliard includes large pearls in a golden framework covering her head, an intricate collar of pearls, rubies, and gold, three waist-length ropes, and a bracelet around each wrist (see page 62). The Armada portrait by an unknown artist (c. 1588), commemorating victory over the Spanish Navy, features large round pearls in seven long ropes, pear-shaped pearls in a halo around her head, and more pearls attached to her dress. The large pear-shaped pearls at her ears are nearly 20 millimeters in diameter.[21]

The men of Elizabeth's court also wore pearl jewelry. In a portrait attributed to Steven van der Muelen (c. 1560), Robert Dudley, the Earl of Leicester and Elizabeth's favorite, wore an elaborate necklace of pearls and clusters of pearls on his doublet. Sir Walter Raleigh and Sir Francis Drake were often portrayed with single pear-shaped pearl earrings. Bracelets, bandoliers, and multistrand necklaces of pearls were common, as were pearl-brocaded doublets and pearl-embroidered belts.

Pearls were prominent in the Medici court in Florence and were worn by both men and women. Agnolo Bronzino's (1503–1572) portrait of Eleonora of Toledo, wife of Cosimo de Medici, shows her wearing necklaces of large round pearls, pear-shaped pearl earrings, and a tassel of smaller pearls hanging from her belt. There are also pearls strung

The coronal of Princess Blanche, from fourteenth-century England, is decorated with clusters of pearls.

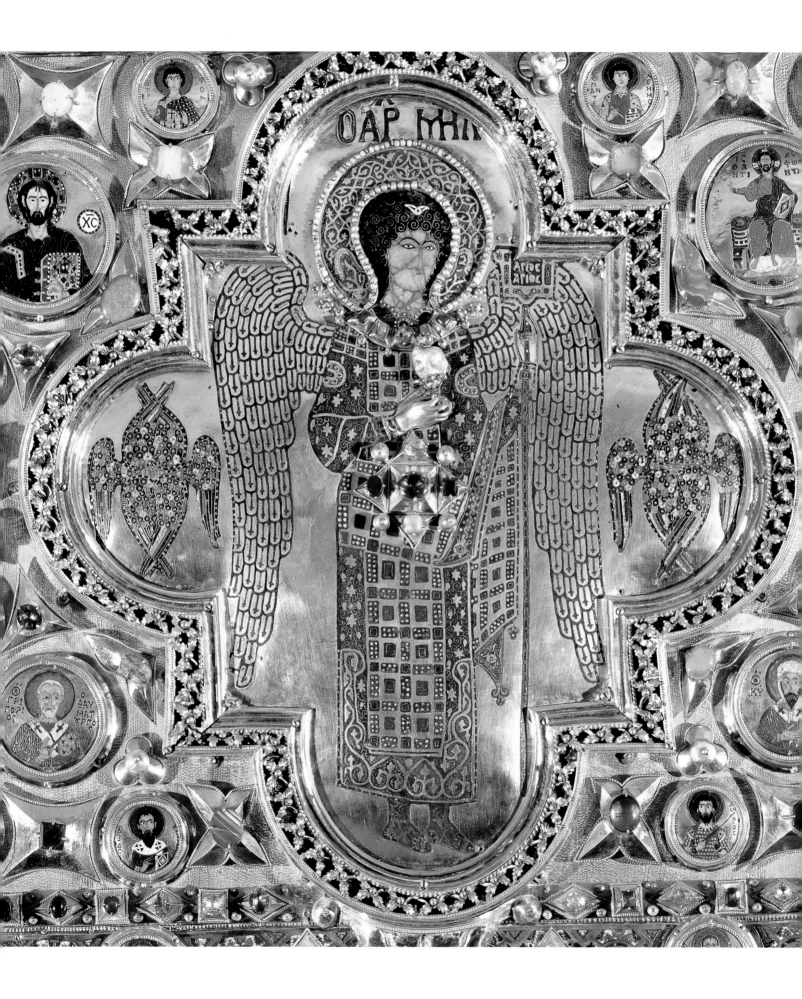

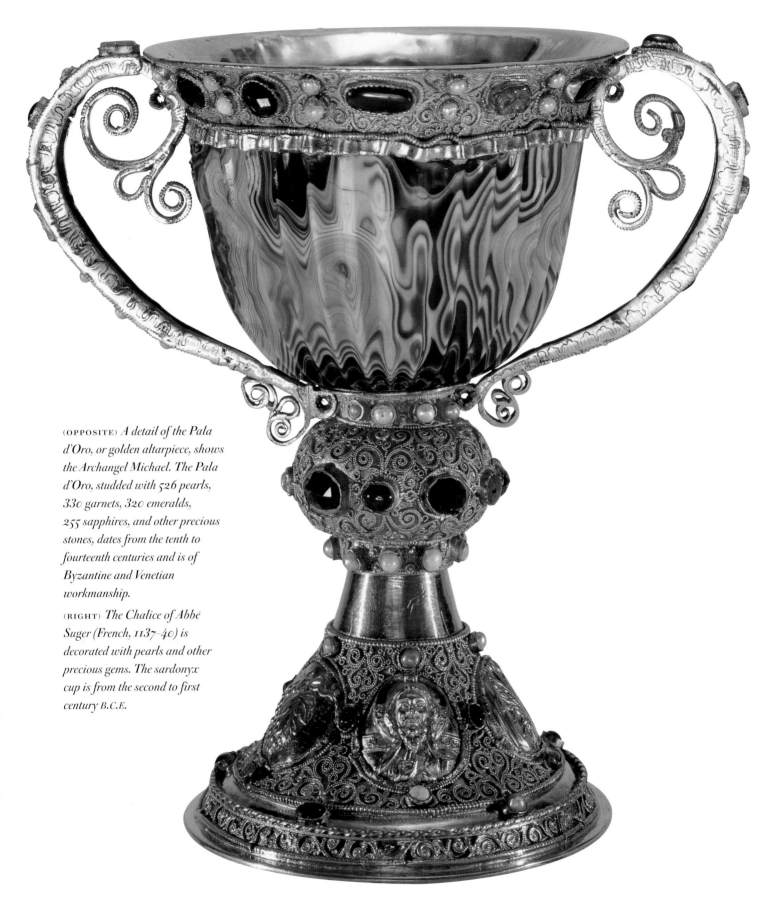

(OPPOSITE) *A detail of the Pala d'Oro, or golden altarpiece, shows the Archangel Michael. The Pala d'Oro, studded with 526 pearls, 330 garnets, 320 emeralds, 255 sapphires, and other precious stones, dates from the tenth to fourteenth centuries and is of Byzantine and Venetian workmanship.*

(RIGHT) *The Chalice of Abbé Suger (French, 1137–40) is decorated with pearls and other precious gems. The sardonyx cup is from the second to first century B.C.E.*

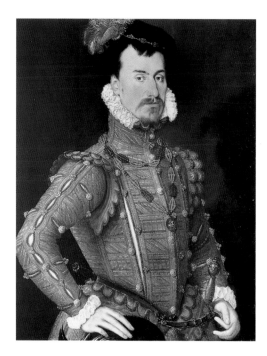

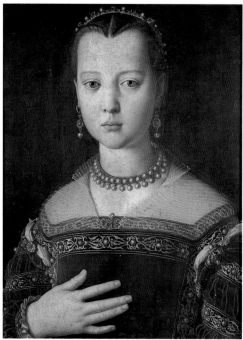

portrait wearing strings of pearls around his neck and on his hat. Marie de Medicis, the wife of Henri IV, was depicted by Frans II Pourbus the Younger (1610) bedecked with pearls in her crown, around her neck, on her ears, on her wrists, and on her bodice and sleeves.

In regions where it was not forbidden by law, pearls were worn by the middle classes. Few portraits and examples survive but the Cheapside Hoard from England is a remarkable exception. These jewels, including pendants and hairpins, were discovered during demolition work in London in 1912 and probably belonged to a jeweler or pawnbroker who concealed them during political unrest in 1630. In contrast to royal jewels, the pearls are smaller and the designs less opulent, but the inspiration is comparable.

Among the most popular jewels of the Renaissance were pearl pendants, which resembled miniature pieces of sculpture. These were built around large baroque pearls, set in gold with enamel and other gemstones. The asymmetrical forms of these pearls inspired jewelers to create fanciful beasts, such as unicorns, dragons, lions, and swans. Sea monsters, ships, mermaids, and tritons were other popular choices as befitted an age of maritime exploration. These pendants were worn suspended from chains, necklaces, or headbands, or attached by ribbons to the hair, skirt, or bodice.

Pearls were commonly used in the Christian church in ecclesiastical vestments and chalices, altars, crosses, and reliquaries. The cross of Allegiance of the Order of the Golden Fleece (fifteenth century) in the Schatzkammer Collection in Vienna is made of gold adorned with pearls, sapphires, and rubies. Other items in the same collection are composed of black ebony, diamonds, pearls, and rock crystal and contain fragments of bones or other relics. Pearls are sumptuously depicted in religious paintings and emphasize the association of pearls with Christian virtues. In the elaborate *Altarpiece of the Adoration of the Mystical Lamb* by Jan van Eyck (1432), the main figures wear rich robes trimmed with pearls in intricate designs, and crowns studded with pearls. Other figures in the alterpiece wear miters and robes embroidered with pearls and other gems. Another of van Eyck's paintings, *Madonna with Chancellor Rolin* (1436), features an enormous golden crown of pearls and rubies, and an orb set with pearls, rubies, and sapphires.

through her hair and arranged on her dress. A contemporary account described Lucrezia Donati, a mistress of Lorenzo de Medici: "She has had a new dress made with but a few pearls on it, though fine, big ones. . . . She gave a ball in the pope's room with Lorenzo . . . [who] was accompanied by a group of young men dressed in her livery, with flowing purple gowns embroidered with fine pearls."[22]

Charles IX of France, a contemporary of England's Elizabeth I, is shown in a sixteenth-century

(TOP LEFT) *Sir Robert Dudley, the Earl of Leicester, wears pearls in this portrait attributed to Steven van der Muelen (c. 1560).*

(LEFT) *Maria de Medici was painted by Agnolo Bronzino.*

(OPPOSITE) *King Charles IX of France (after a drawing by François Clouet, sixteenth century) also wears pearl jewelry.*

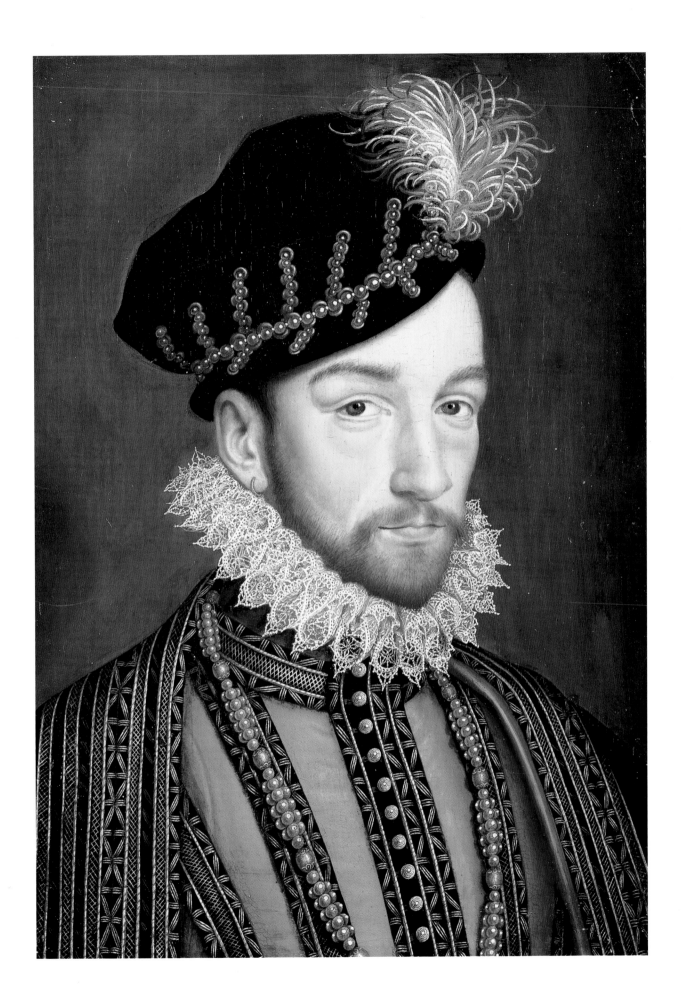

Shakespeare referred to pearls in several plays:

The liquid drops of tears that you have shed shall come again, transformed to orient pearl. (Richard III, 4: iv: 322)

. . . she is a pearl whose price hath launched a thousand ships and turned crowned princes to merchants . . . (Troilus and Cressida, 2: ii: 81)

Pearls were also a favorite choice of devotional writers as expressed in Francis de Sales's *Introduction à la Vie Devotée* (1608):

Women of both ancient and present time customarily hang pearls from their ears . . . the first part that a man must have from his wife and which the wife must faithfully preserve is the ear, so that no speech or sound may enter in other than the sweet sound of chaste words which are oriental pearls of the Gospel.[23]

Pearls apparently played a part in contemporary politics as well. An unconfirmed story from a French children's book shows that pearls could cause international conflicts. Sometime in the 1620s, George Villiers, the Duke of Buckingham of *Three Musketeers'* fame, was invited to a royal ball in Paris by King Louis XIII and Cardinal Richelieu. The arrogant Englishman arrived in a costume of unparalleled splendor, covered completely with large pearls worth the ransom of a king's brother, which he was. He danced with the ladies, including the queen, who Alexandre Dumas père said was his lover, and exchanged appropriately witty remarks with his noble French acquaintances. Then, just as the Grand Promenade was being announced, he pulled a thread in his pocket so that all the pearls on his costume fell off and rolled across the floor. Courteously, the assembled nobility of France knelt down to pick them up. The duke pretended not to notice and refused with contempt the handfuls of pearls that were offered to him. The king and cardinal, in no doubt about the real meaning of the duke's actions, promptly declared war.

(OPPOSITE) Madonna with Chancellor Rolin, *by Jan van Eyck (1436).*

(ABOVE) *A pendant in the shape of a cross, from late seventeenth-century Spain has pearls that may have been harvested by the Spanish explorers in the New World.*

Pearls figured prominently in Renaissance writing, signifying wealth, exoticism, luxury, and beauty. Christopher Marlowe's *Doctor Faustus* (I: i: 82) commanded the spirits to "fly to India for gold/Ransack the ocean for orient pearl." In Marlowe's *The Jew of Malta* (4: i: 66), a pearl is

. . . so big, So precious, and withall so orient, As, be it valued but indifferently,

The price thereof will serve to entertain Selim and his soldiers for a month.

*Errors, like straws, upon the surface flow,
He who would search for pearls must
dive below.*

–John Dryden,
Prologue to *All for Love*, 1678

Western Europe

In the late seventeenth and eighteenth centuries, pearls became less plentiful on the European market due to overfishing in South and Central America. In addition, new techniques for faceting gemstones developed, and diamonds began competing with pearls. However, freshwater pearls from northern Europe were still readily available, and they were suited to the taste for less opulent display in dress and hairstyle, changes that themselves reflected changes in the religious and political climate in Europe.

This new, less ostentatious look for pearls is captured in contemporary portraits. In Anthony Van Dyck's portrait (c. 1630) of Ann Car, Countess of Bedford, England, she wears a simple choker of large, perfectly round pearls and pendant earrings, each consisting of two enormous pear-shaped pearls. Joshua Reynold's portrait (1769) of the Viscountess Maynard features a pearl choker and a strand of pearls wrapped around a jewel on her bodice.

The changing fashion in pearls was most obvious in France. In the court of Louis XIV, pearls were still very abundant. A late seventeenth-century portrait of Queen Marie-Thérèse by Pierre Mignard shows the queen wearing pear-shaped and round pearls on her hat, pearl drop earrings, and a pearl choker. Round and pear-shaped pearls border the neckline of her gown and the midline of her bodice, and the rest of her gown is studded with clusters of pearls with other gems. However, by 1760, the French taste in pearls was similar to that of the rest of Europe. Madame de Pompadour, mistress of Louis XV, appears in a portrait by François Bucher (1759) with only several strands of pearls on each wrist. Élisabeth Vigée-Le Brun painted Marie Antoinette (1783), queen of Louis XVI, with only three strands of baroque pearls on each wrist and two short strands around her neck.

The taste for pearls in colonial America echoed that of Europe. John Singleton Copley painted fashionable women wearing single or multiple strands of pearls. For example, in his pastel portrait of Mrs. Gawen Brown (1763), she wears three strands of pearls around her neck and one through her hair. A miniature of Martha Washington by Charles Willson Peale (c. 1776) shows a choker of pearls and a strand of pearls in her hair. The pearls pictured in American portraits are much smaller than those in European portraits of the time, probably reflecting differences in buying power and availability of pearls between the two areas.

Most large pearls in the seventeenth and eighteenth centuries came from India and the Persian Gulf. However, freshwater pearls were collected in many parts of Europe at the time and some of them were exceptional. In German Saxony's Vogtland, particularly its River White Elster and its tributaries, pearl fishing became a royal privilege as early as 1563 when Duke August of Saxony reserved pearls for the crown.[24] The famous Saxon necklace of 177 pearls from the River White Elster was made from the best pearls in the collection of August the Strong (Elector of Saxony, King of Poland, 1670–1733). It became formal regalia for Duchess Maria Amalia Augusta in 1802, wife of Duke Friedrich August III (and later King) of Saxony.[25]

The most popular pearl jewels throughout Europe in the seventeenth and eighteenth centuries were large pear-shaped pearl earrings, up to 20 millimeters in diameter. These were known as *unions d'excellence*, reflecting the difficulty of perfectly matching pearls of such large size. A more complex

(LEFT) *Martha Washington wears a pearl choker and hair ornament in a miniature by Charles Willson Peale (c. 1776).*

(OPPOSITE) *Marie-Antoinette, Queen of France, as painted by Élisabeth Vigée-Le Brun (1785 version of the 1783 "with rose" painting).*

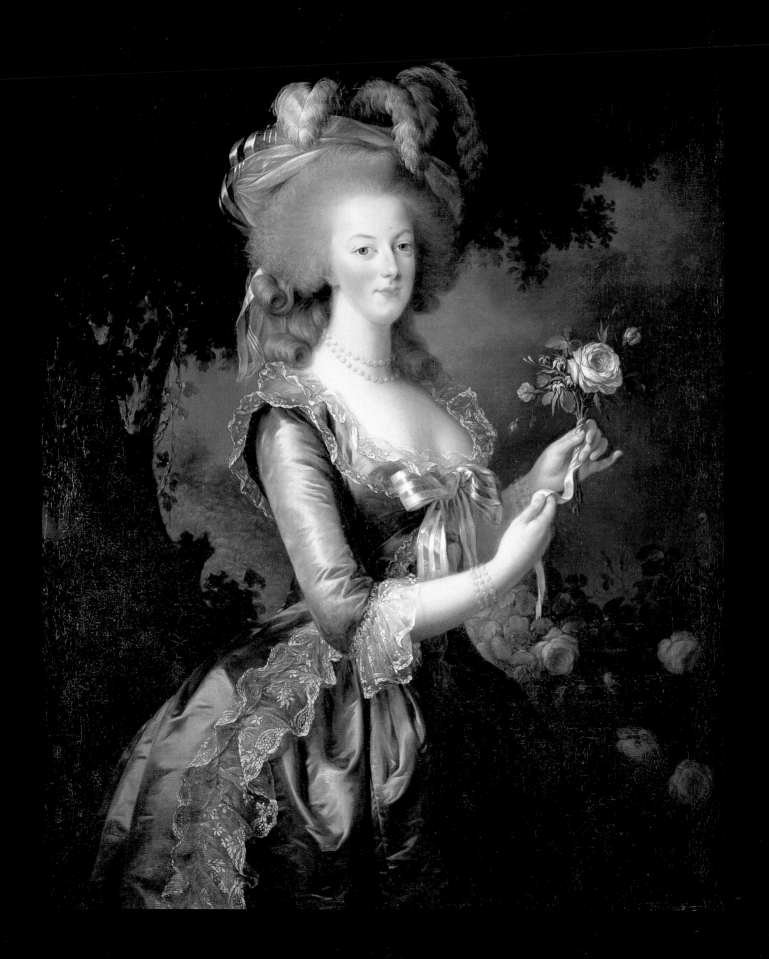

A pendant of a wounded lion from Flanders (1580) has a body of a large baroque pearl pierced by a golden arrow.

(ABOVE) Mistress and Her Maid, *by Johannes Vermeer (1667–68) shows a large pearl earring.*

earring known as a *girandole* was introduced in the second half of the seventeenth century and became increasingly popular. It consisted of a bow from which three pear-shaped pearls or other precious stones were suspended. These earrings were massive and in some instances a wire was fixed to the top of the earrings to be secured to the hair with a bow.[26]

Large baroque pearls were sometimes fashioned into small figurines or *objets d'art*. These are similar in composition to Renaissance pendants but were not worn. One unusual piece from the Museo degli Argenti in Florence represents a baby in a gold filigree cradle. Both the head of the baby and the textured blanket covering the baby are irregular pearls. Large baroque pearls were also incorporated into humorous or grotesque

figurines in Germany in the late seventeenth and eighteenth centuries. The largest collection of these from August the Strong is preserved in the Grünes Gewölbe (Green Vault) in Dresden.[27]

Starting in the eighteenth century, small pearls were used, either whole or split in half, as borders for rings, lockets, brooches, miniatures, watches, and snuffboxes. In addition, pearls framed rings and lockets given as love and friendship tokens, featuring images of doves or hearts aflame.

Russia

The use of pearls in Russia in the seventeenth and eighteenth centuries was much more opulent than in the rest of Europe. Royal workshops produced a wide range of luxurious pearl objects including

items for the czarinas, such as velvet boots embroidered with pearls. Russian noblewomen of the time wore large tiaras (*kokoshniks*) decorated with lace, pearls, and enamels from which strings of pearls hung to their shoulders.

Pearls were also prominent in Russian ecclesiastical garb. Saccos, cloaks, and cuffs were heavily embroidered with pearls in the Byzantine tradition. Both large and small pearls created a pattern of relief in the form of scrolls and flowers. The saccos or robe of Patriarch Nikon (1654) is a good example: "Nikon took off his *saccos*, which was very hard to wear because of its weight. . . . Nikon invited us to pick it up, but we could not do so. They say there are 36 lbs. of pearls on it." The actual weight is 54 pounds or 24 kilograms. Another eighteenth-century vestment, the *phelonion* of Metropolitan Platon, was covered with 150,000 pearls in the

form of interwoven branches with the monogram of Catherine the Great in the center.[28]

Miters worn by high-ranking Russian Orthodox clergy were more elaborate than some of the crowns of Western Europe. They were adorned with portraits of the saints and studded with precious stones, enamels, and pearls embroidered in geometric or floral patterns. The combination of red velvet, gold thread, white pearls, red rubies, and green emeralds produced a kaleidoscopic effect.

Icons were perhaps the most spectacular examples of pearl decoration in the Russian Orthodox Church. Icons consisted of a painting of a religious figure, often the Madonna and Child, covered by a frame or *oklad*. The *oklad* was cut to reveal the faces of the figures and was generally made of gold or gilded silver studded with precious gems and pearls. In the Kazon

(ABOVE LEFT) *A cradle with a baby and blanket is made of pearls (late seventeenth-century Holland).*

(ABOVE) *Large baroque pearls were worked into figurines like this of a physician, from the treasure collection of Saxony's August the Strong (early eighteenth century).*

(OPPOSITE) *A sixteenth-century Russian icon of the Madonna and Child has an* oklad, *or frame, decorated with freshwater pearls.*

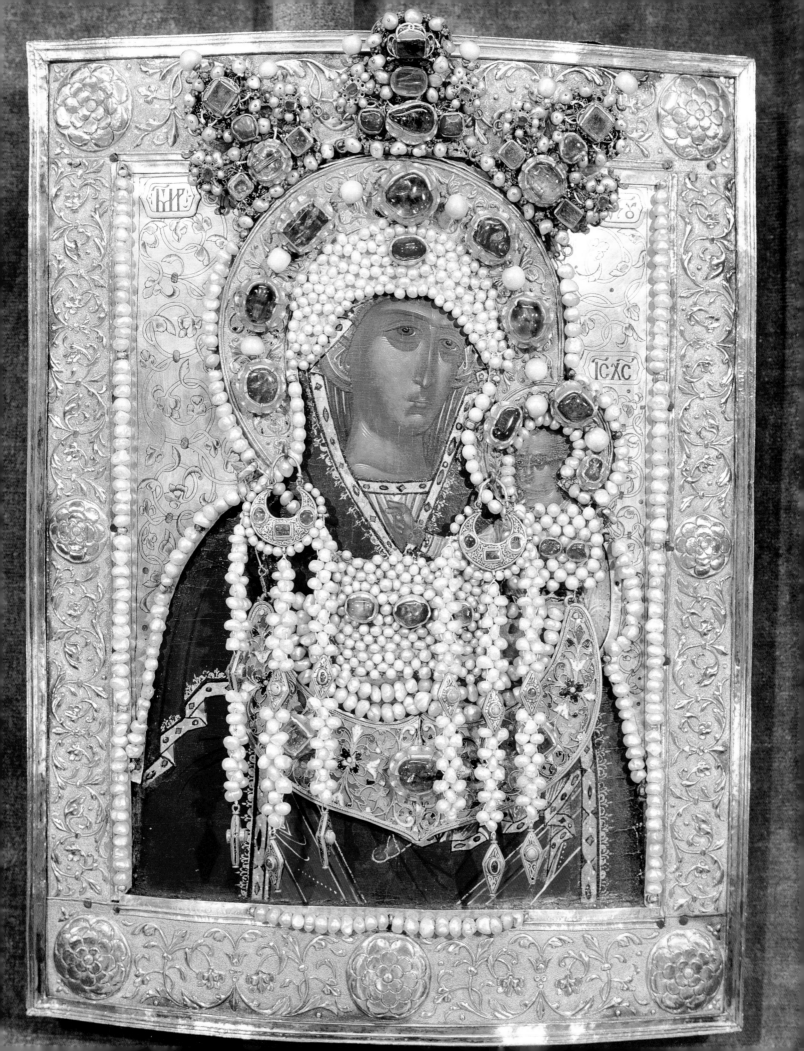

Mother of God Icon from the early seventeenth century, a net of pearls covers the head of the Virgin Mary. The *oklad* of the Our Lady of Vladimir Icon (1657) is made of gold with an intricate headdress of pearls and a broad collar of pearls and precious stones. In other icons, strings and clusters of pearls were attached to the *oklad* and hung freely from the ears and neck.

Nineteenth Century and the Gilded Age

> *My thoughts arise and fade in solitude;*
> *The verse that would invest them*
> * melts away*
> *Like moonlight in the heaven of a*
> * spreading day.*
> *How beautiful they were, how firm*
> * they stood,*
> *Flecking the starry sky like woven pearl.*
>
> —Percy Bysshe Shelley,
> *My Thoughts*, 1824

The nineteenth century witnessed a renewed interest in pearls, coinciding with the discovery of new sources in Tahiti and Australia, and the revival of the depleted fishing grounds off Panama and Mexico. Necklaces and earrings of large pearls were popular among royalty throughout Europe, and the French influence on taste was especially strong for most of the century. Pearls were acquired by the growing middle classes and seed pearl jewelry became extremely popular. The Gilded Age that capped the turning of the century was characterized by a profusion of pearls worn by aristocratic Europeans and rich Americans.

France

During the French Revolution in 1789, many of the pearls in the French Crown jewels were sold, stolen, or otherwise dispersed. Napoleon Bonaparte recovered many of these pearls and purchased new ones, in his efforts to restore the trappings of royalty. He transformed old jewels into imperial ones appropriate to the court of an emperor.[29]

The most fashionable pearl ensemble at his court was the parure, a set of jewelry often including head ornaments, bracelets, necklaces, and

Early nineteenth-century amatory lockets are bordered with pearls, French (upper) and English (lower, c. 1800).

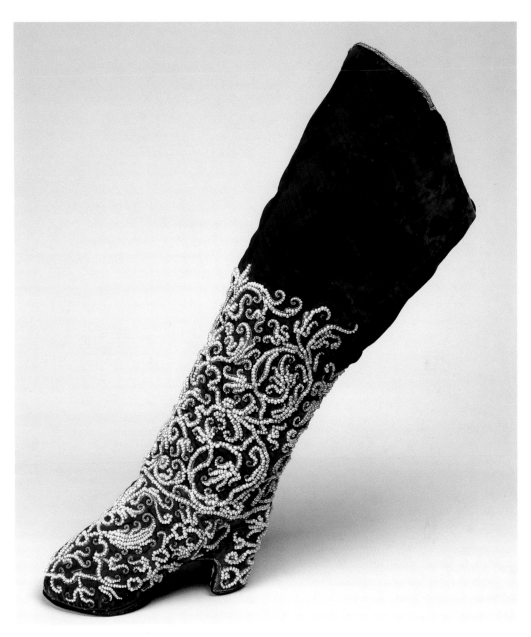

A ceremonial boot of red velvet is decorated with pearls (seventeenth-century Russia).

earrings. Diadems and tiaras featured round and pear-shaped pearls in symmetrical, friezelike arrangements. Earrings were commonly large pear-shaped pearl drops. Single-strand necklaces ranged from chokers to ropes and also featured large pear-shaped pearls. Multiple-pearl strands of different lengths were held neatly together by a clasp at the back.

The Empress Josephine possessed many such jewels, including a necklace of thirty-five black pearls, purportedly from the Tuamotus Archipelago.[30] Some of her pearls appear in her portrait by Baron François Gérard (1808). In this portrait, she wears a large crown studded with precious stones, alternating with enormous pear-shaped pearls. The same motif is echoed in her necklace. On a cushion next to her is a golden crown with twenty-four large pear-shaped pearls in addition to several hundred smaller round pearls. Her large pearl-drop earrings, a gift from her husband, are preserved in the Musée du Louvre in Paris.

The jewels of the Court of Napoleon featured a neoclassical theme, emphasizing the link between the new French Empire and the ancient world. Cameos, both contemporary and antique, were commonly used in jewelry in combination

with pearls. One of the finest such pieces, still extant in the collections of the Musée Masséna in Nice, is a cameo diadem belonging to Empress Josephine. It is of Italian workmanship carved out of a single large *Cassis* snail shell, decorated with pearls, gold, and other precious gems.

Pearls were sometimes used in unusual combinations with other gems. Turquoise, cornelian, and coral were the most popular partners. In an early nineteenth-century portrait by Baron François Gérard of Marie-Caroline Murat, a sister of the emperor, she wears a parure of gold, pearls, and turquoise. Another parure that has survived intact in the Musée des Arts Décoratifs in Paris consists of cornelians set in cabochon, each of which is bordered by small pearls.

Many of the pearls worn by Josephine reappeared, mostly reset, approximately forty years later on Empress Eugénie (1826–1920), the wife of Napoleon III. Empress Eugénie was considered one of the most beautiful and elegant women of the age and set the fashion in the Second Empire. She owned an enormous quantity of pearls. In her portrait by Franz Xavier Winterhalter (1852), she wears a magnificent parure consisting of a pearl-and-diamond coronet and diadem, a collar with strands of pearls of various lengths, and a bracelet of several strands of pearls on her right wrist. The diadem, now in the Louvre in Paris, features very large round and pear-shaped pearls in a framework of foliage studded with diamonds.

At least one of Eugénie's pearls had an American provenance. This was a large pink freshwater pearl found in 1857 in Notch Brook, near Paterson, New Jersey, by a carpenter named Jacob Quackenbush. He sold it to Tiffany & Company in New York for $1,500. It was then sent to Tiffany's Paris office, where it was ultimately sold and then given to the empress, after whom it was dubbed the "Queen Pearl." According to legend, Eugénie gave the pearl to a Philadelphia dentist and friend, Thomas W. Evans, who helped her escape from Paris when the empire collapsed in 1870. The present whereabouts of the pearl are unknown although the collection of the Cooper-Hewitt Museum in New York contains two large freshwater pearls formerly owned by Thomas Evans. They are mounted as stickpins, and one of them, pinkish in color, could be the Queen Pearl.

Great Britain

Freshwater Scottish pearls had supported a thriving commerce since the twelfth century, regulated by Parliament in the mid-1600s, but had faded in importance over the next few centuries. In 1860, Moritz Unger, a German dealer, traveled through the districts where Scottish pearl mussels had flourished. He found many pearls in the hands of common people who were unaware of their value, and purchased all he could find. As a consequence, many of the local peasants took up the search for pearls. Some met with great success and, in 1865, it was estimated that $60,000 worth of pearls had been found. One pearl was even bought by Queen Victoria.[31]

The English upper classes of the nineteenth century considered pearl jewelry less ostentatious than colored gemstones, and favored pearls in more relaxed, less formal settings such as at home or outdoors; colored gems and diamonds were reserved for receptions at court and state dinners. This aesthetic was also expressed in the elaborate mores governing mourning dress. During a year and a day of mourning, a widow wore

(LEFT) *A snake-topped stickpin from the mid-nineteenth century, with a large baroque pearl, owned by Thomas W. Evans, Philadelphia dentist and friend of the Empress Eugénie of France. It is possible that this is the famous Queen Pearl originally found in New Jersey.*

(OPPOSITE) *The fashionable Empress Eugénie, wife of Napoleon III of France, set styles (Franz Xavier Winterhalter, mid-nineteenth-century).*

only black jewels, usually made of jet, and sometimes bordered with pearls. Thereafter, she could wear pearls and diamonds and, only later, colored gemstones.

Seed Pearl Jewelry

Seed pearl jewelry became very fashionable at the beginning of the nineteenth century, especially among the growing middle classes. These tiny pearls, less than 2 millimeters in diameter, were imported from India and China and were drilled and strung on silk or, more commonly, white horsehair. They were fashioned into delicate lace-like patterns or sewn to thin templates of mother-of-pearl with larger pearls sometimes added for variety. A parure of seed pearl jewelry typically consisted of a pair of bracelets, a brooch, one or two pairs of earrings, a necklace, a ring, and a hair ornament or aigrette fitted with a springed trembler so that the pearls quivered as the wearer moved. Earrings commonly had two parts, a cluster of seed pearls on top, with a suspended rosette of seed pearls below.

Seed pearl jewelry was considered very genteel. According to one American observer in 1853, "this style of ornament for the ball room is exceedingly chaste and effective, and is probably the most becoming jewelry that a lady can wear." A newspaper account of 1870 reported "the Pearl Sets are exquisitely beautiful and constitute an appropriate and elegant present to a young bride."[32]

Bridal Jewelry

Pearls were popular wedding presents in the nineteenth century and were an essential part of wedding apparel, reflecting the prevailing notion that pearls represented purity and modesty. They also constituted a transfer of wealth, as they were handed down from one generation to the next. Kunz and Stevenson exclaimed "what a wealth of pearls was seen at the marriage of the late Emperor Frederick III of Germany with Princess Victoria," the daughter of Queen Victoria, in 1858.[33] The bride received a gift of a superb necklace of pearls from her bridegroom, three brooches of diamonds, emeralds, and pearls from her father, and a diadem and brooch of diamonds and pearls from her future in-laws.

In the United States, wealthy society families showered gifts of pearl jewels on the bride.

William H. Vanderbilt's granddaughter, Florence Adele Stone, received a single enormous pearl in addition to other gifts from her uncle Cornelius Vanderbilt for her wedding in 1894. Consuelo Vanderbilt, who became the Duchess of Marlborough by marriage in 1895, received pearl gifts from her mother: two "fine rows [of pearls] which had belonged to Catherine the Great of Russia and to Empress Eugénie, and also a sautoir [a long rope of pearls] which I could clasp round my waist."[34] In her official photograph (1902), she wears a tiara and coronet of pearls, a multiple strand pearl choker or dog collar, and a necklace of four strands of large perfect pearls.

The Gilded Age

In 1887, the French government auctioned off nearly all of its crown jewels. Many observers considered it the blackest day in French history but others seized the opportunity to buy royal jewels at bargain prices. Tiffany & Company purchased most of the finest pieces and brought them back to New York, where they served as inspiration for new designs before being broken up and sold to an eager clientele; Americans thus gained the prestige of owning European royal jewels.

The royal families in Britain, Germany, and Russia, as well as society figures in America, wore pearls in the Gilded Age. An all-white effect was sought in fine jewelry, achieved by masses of pearls or pearls with diamonds. Swags, garlands, bows, and tassels were favored motifs in jewelry design. Throughout her long reign (1837-1901), Queen

Mary Todd Lincoln was photographed by Mathew Brady (1861) in her parure of seed pearl jewelry. President Lincoln purchased the parure for her from Tiffany & Company to wear at his inauguration.

(OPPOSITE) Consuelo Vanderbilt, who became the Duchess of Marlborough upon her marriage in 1895, owned a dog collar and other elegant pearls.

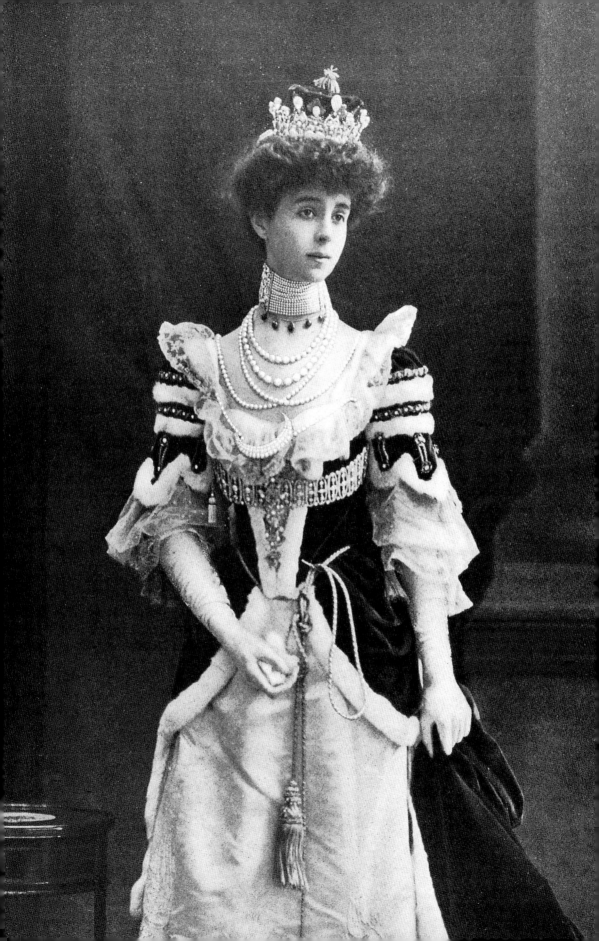

Victoria of England appeared in official portraits bedecked with pearl necklaces, sautoirs, and bracelets. The czarina Alexandria of Russia, in one official portrait, wore a long sautoir ending in pear-shaped pearls tied at her bodice, three graduated strands with pear-shaped pearls attached at her throat, pendant pearl earrings, a star-shaped badge of pearls on her bodice, and a pearl head-dress.[35] In other photos, her daughters wore simple strands of white pearls that were lengthened by two pearls a year on their birthdays, evidenced by the longer necklaces of the older daughters.[36]

A dog collar necklace was one of the most popular pieces of jewelry in the Gilded Age. Multiple rows of pearls held by vertical spacers covered a woman's entire neck. The dog collar of Consuelo Vanderbilt was especially wide—nineteen rows—and reportedly very uncomfortable.[37] Queen Alexandra, wife of Edward VII of England (1841–1910), was shown in official photos wearing a pearl dog collar, and ropes of enormous white round pearls looped below her waist and tied with a brooch.[38] She helped promote the popularity of dog collar necklaces, which she supposedly wore to hide a small scar on her throat. In the United States, Mrs. George J. Gould (née Edith Kingdon, an actress who married into New York society) was shown in a 1900 photo wearing five ropes of pearls, a pearl and diamond tiara, a pearl and diamond stomacher, and a dog collar.[39]

Other Americans wore their pearls more casually. Isabella Stewart Gardner of Boston, in a portrait by John Singer Sargent (c. 1888), wore a rope of pearls double-looped around her waist and a smaller strand around her neck. Mrs. Gardner's friend, the writer Henry James, described a similarly attired American heiress in his novel *The Wings of the Dove* (1902) wearing pearls strung twice around her neck and then "heavy and pure, down the front of the wearer's breast."

Pearls were very fashionable among nineteenth-century entertainers, who became a new sort of royalty in the Gilded Age. The opera singer Madame Nordica wore a dog collar of pearls, a stomacher, and a necklace of colored pearls. The actresses Lilly Langtrey and Lillian Russell wore several strands of pearls of varying lengths.

The jewelry houses of Tiffany and Cartier supplied pearls to American society. In 1916, Cartier offered a magnificent double strand of large white pearls. The sale price was $1.2 million, the highest asking price for a pearl necklace up to that time. Maisey Plant and her husband, members of New York society, were in the process of selling their Beaux-Arts mansion on 52ND Street and Fifth Avenue in preparation for moving uptown. The sale price on the house matched the sale price on the necklace. According to the story, Maisey offered an exchange—her house for the pearls—that Cartier accepted. The mansion was ultimately converted into the present Cartier showroom.

The Pearlies

A unique sort of royalty emerged in London in the 1880s. These were the Pearlies—men and women who covered their clothing with mother-of-pearl buttons as an inexpensive answer to pearls. The idea originated with a street sweeper named Henry Croft who completely covered his suit with buttons. The fad caught on and was imitated by a group of people in London known as "costers," peddlers who sold vegetables and produce on the streets. They elected "kings" to represent each neighborhood to protect local interests. These kings, with their wives as "queens," decorated themselves with hundreds of buttons. They wore them in vaudeville-style shows in pubs and on the street to raise money for orphanages and hospitals, and to care for needy coster families.

The Pearlies' costumes were heavy and elaborately decorated. Henry Croft's coat weighed 32 kilograms. Men's costumes typically included three-piece wool suits and caps. Women's featured long velvet skirts, tight-waisted jackets, and ostrich-feathered hats. "Pearly King" or "Pearly Queen" was usually spelled out in buttons and accompanied by symbols such as horseshoes, circles, anchors, flowers, and hearts.

The Pearlies are still active in London although there are fewer members than at the beginning of the twentieth century. The last large turnout was at Queen Elizabeth's Silver Jubilee in 1977. Pearlies continue to hold an annual memorial service for Henry Croft, the original Pearlie, and also attend the annual fall harvest service at St.-Martin-in-the-Fields Church in Trafalgar Square, London.[40]

Art Nouveau

American freshwater pearls from Ohio, Wisconsin, Arkansas, Tennessee, Iowa, New Jersey, and

In the 1880s English Pearlies started the practice of dressing in costumes covered with mother-of-pearl buttons.

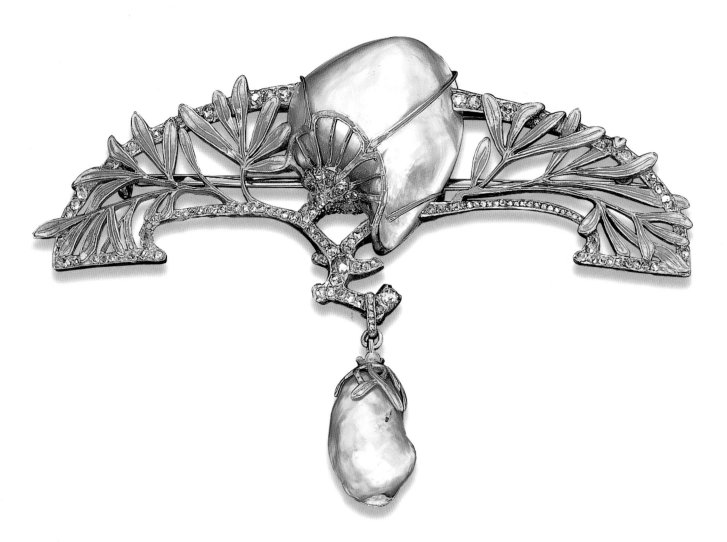

Massachusetts entered the late nineteenth-century market. These irregular pearls were perfectly suited to the Art Nouveau style, pioneered by Louis Comfort Tiffany from the United States and René Lalique from France, and appeared in the late 1890s as a reaction against traditional jewelry. This style emphasized such natural motifs as flowers or insects, asymmetrical swirling designs, and unconventional materials. Instead of diamonds and perfect, round pearls, Art Nouveau jewelry incorporated semiprecious stones, glass, enamel, and pearls in a variety of odd shapes and colors. One famous piece of this genre was Tiffany's Chrysanthemum Brooch (1904) in which the flower petals are white freshwater dog-tooth pearls of varying lengths set in platinum. In another brooch by Paul Liénard from 1902, two enameled wasps hover over a flower spray of baroque pearls. In

an imaginative design by Wilhelm Lucas von Cranach (1900), two baroque pearls are used to create a butterfly and octopus on the same brooch (see page 60).

Some Art Nouveau brooches and pendants also incorporated pink conch pearls, usually as flower buds in an enamel floral arrangement. At the same time, more traditional pieces were also designed, for example, a Tiffany pendant in which a large conch pearl is housed in a platinum cage set with diamonds (see page 35).

Equally influenced by natural forms, Peter Carl Fabergé (1846-1920), jeweler of the Russian Imperial Court, used pearls to represent flowers in many of his pieces. One of his favorite representations was lily-of-the-valley flowers, with pearls as the white blossoms, arranged in baskets of finely woven gold, planted in a bed of rock crystal, or surrounding an imperial egg.

(ABOVE) *An Art Nouveau brooch by Georges Fouquet uses the classic combination of pearls and diamonds with enamel (c. 1900).*

(OPPOSITE) *A chrysanthemum brooch made of gold, platinum, and diamonds features a creative use of Mississippi River pearls in a design by Paulding Farnham of Tiffany & Company (c. 1904).*

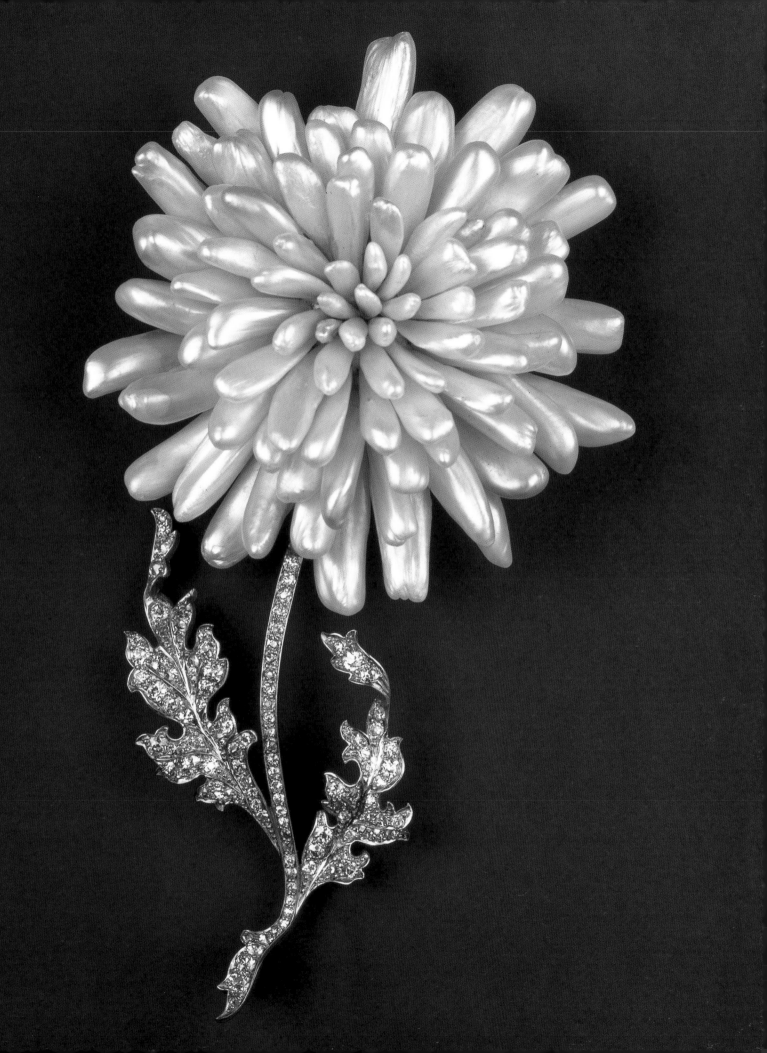

Take back your mink
Take back your pearls,
What made you think,
That I was one of those girls?

—Frank Loesser, *Guys & Dolls*, 1950

Early in the twentieth century, fine natural pearls were still reserved primarily for the rich. With the advent of cultured pearls in the 1920s, a new market was created. Pearls became more abundant and larger pearls became more affordable. Perliculturists learned to standardize pearls to the extent that major jewelry firms could guarantee the availability of cultured pearls of a particular size and color. By the end of the twentieth century, cultured pearls were produced in numerous areas, resulting in a greater variety of pearls than ever before and at prices that made them affordable to nearly everyone.

The Jazz Age

In the United States and Europe of the 1920s, long ropes of pearls were very popular. Flappers wore them as they danced the Charleston in their new short dresses. Entertainers such as Josephine Baker performed for Parisian audiences wearing two or three long ropes of pearls and little else. The dancer Irene Castle, performing with her husband, Vernon, wore ropes of pearls and popularized the "headache band," a velvet ribbon embroidered with pearls worn around the forehead.[41]

Pearls were used occasionally in Art Deco jewelry of the 1920s and 1930s but did not play a major role. At about this same time, the Parisian designer Gabrielle "Coco" Chanel promoted a new casual approach to pearls: "A women needs ropes and ropes of pearls."[42] Chanel mixed her pearls, real or imitation, and advocated wearing pearls with sweaters and skirts. She invented "the little black dress" that, when worn with pearls, was appropriate for nearly any occasion.

Cultured Pearls

The 1920s and 1930s saw the introduction of Japanese cultured Akoya pearls to the international market. These pearls were white, perfectly spherical, and 6–8 millimeters in diameter. Initially these

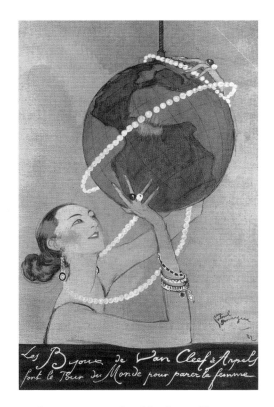

Les Bijoux de Van Cleef & Arpels font le Tour du Monde pour parer la femme

pearls were not considered "real gems," but eventually won acceptance through the publicity campaign of the Japanese perliculturist Kokichi Mikimoto.

The culturing process has effectively changed the concept of the perfect pearl. A cultured pearl is spherical, a shape that rarely exists in nature. Even the most spherical natural pearls are slightly off-round, commonly described in the past as hazelnuts or filberts. The irony of cultured pearls is that perfectly round pearls are now the standard.

Following World War II, Japanese cultured pearls became increasingly prevalent. Part of their popularity in the United States stems from American GIs stationed in Japan who brought pearls back home as gifts. Prestigious jewelry firms also began promoting cultured pearls, as pearl production in Japan peaked in 1966.

One of the most traditional associations of pearls in the twentieth century was with weddings, reaching a peak of popularity when American actress Grace Kelly married the Prince of Monaco in 1953. Her wedding dress, veil, and shoes were all trimmed with pearls. A wedding dress in the Brooklyn Museum in New York is nearly covered with seed pearl embroidery. These dresses elevated every American bride to the status of princess, as least on her wedding day.

(ABOVE) *This advertisement from Van Cleef & Arpels in Paris around 1920 suggests the worldwide appeal of pearls.*

(OPPOSITE) *Coco Chanel, the designer, was draped in pearls and photographed by Man Ray in 1935.*

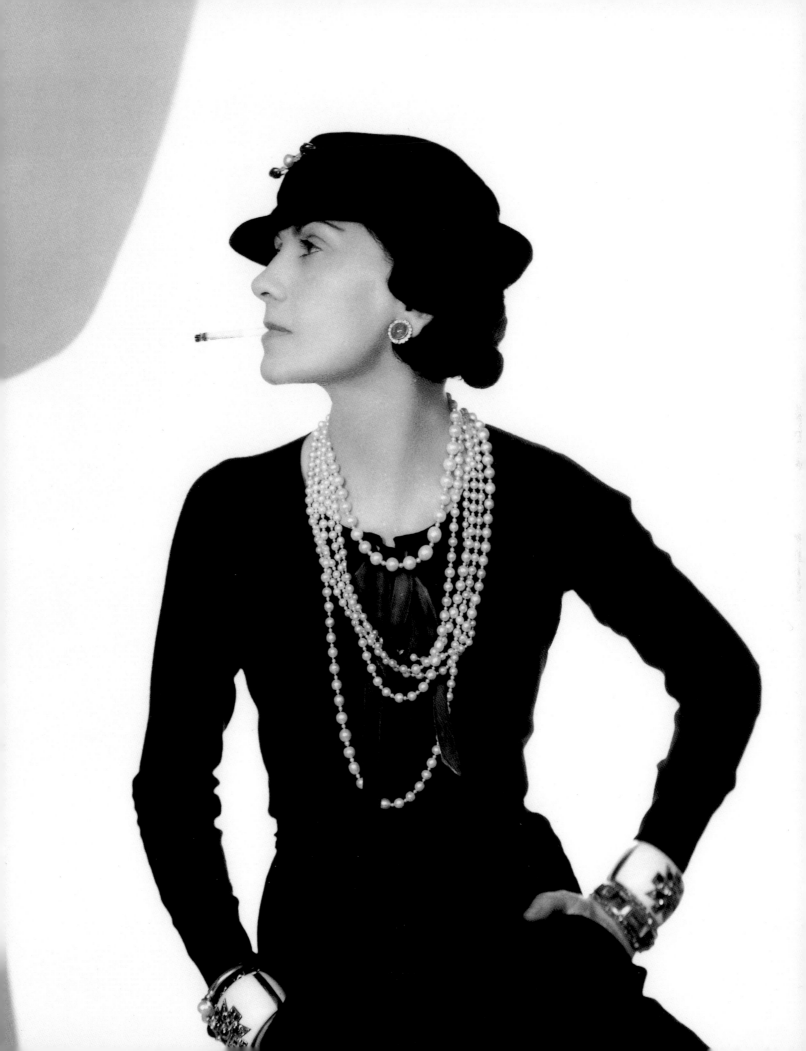

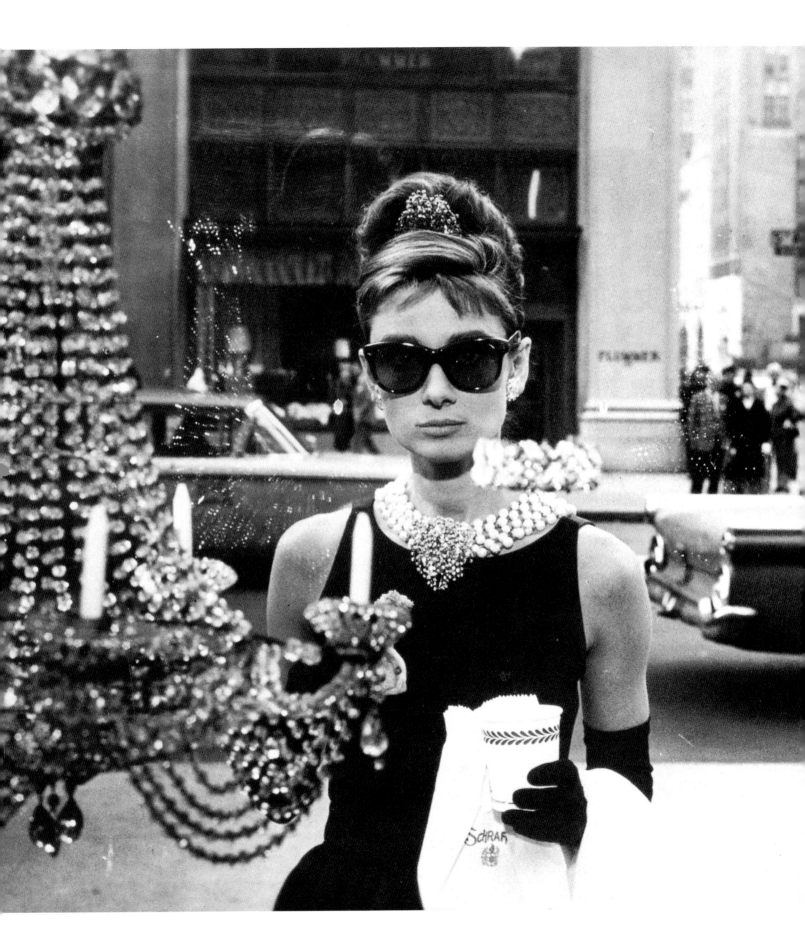

Celebrity Pearls

Pearls passed out of vogue in the 1970s but re-emerged in the 1980s with an upswing in the American economy and a renewed taste for opulence. The popularity of pearls was heightened by the re-introduction of images of celebrities, royalty, and movie stars wearing pearls—Wallis Simpson, Marilyn Monroe, Audrey Hepburn, Grace Kelly, Maria Callas, Diana Vreeland, and Elizabeth Taylor. Pearls also appeared in official portraits of almost all American first ladies, including Eleanor Roosevelt, Bess Truman, Mamie Eisenhower, Jackie Kennedy, Pat Nixon, Barbara Bush, and Hillary Clinton. These women endowed pearls with their own glamour and enhanced their appeal.

One of the most celebrated figures of the late twentieth century, Lady Diana Spencer, Princess of Wales, especially favored pearls, underscoring the association of pearls with royalty in the modern era. She often wore pearl chokers and earrings and, occasionally, the Lover's Knot Tiara with nineteen pearl drops. Most notable among her famous dresses was the "Elvis Dress," a strapless gown and jacket with a stand-up collar designed by Catherine Walker and heavily embroidered with imitation pearls.

Elaborate pearl costumes have been designed for the theater, opera, and movie studios, emphasizing the fantastic, exotic appeal of pearls in Western culture. The French couturier Paul Poiret created theatrical costumes in the early twentieth century in the style known as "orientalism," an exotic interpretation of eastern fashion that emphasized pearls. The French artist Erté created glamorous outfits covered with pearls for the French nightclub, Folies Bergères. Hollywood stars of film and television, from Rudolph Valentino (*The Young Rajah*, Paramount, 1922), Lucille Ball (*I Love Lucy*, CBS/DesiLu, 1951–57), Jack Lemmon (*Some Like It Hot*, United Artists, 1959), Audrey Hepburn (*Breakfast at Tiffany's*, Paramount, 1961), and Tim Curry (*The Rocky Horror Picture Show*, Twentieth Century Fox, 1975), to Natalie Portman (*Star Wars, Episode I, The Phantom Menace*, Twentieth Century Fox, 1999), have reflected a continuing taste for pearls in fashion in all dimensions.

(OPPOSITE) *Audrey Hepburn in* Breakfast at Tiffany's *(1961) admires the display window.*

(ABOVE RIGHT) *American entertainer Josephine Baker performed for Parisian audiences in the 1920s and 1930s clad, almost exclusively, in pearls and feathers.*

(RIGHT) *Diana, Princess of Wales, wears a pearl diadem and her now-famous "Elvis" dress studded with imitation pearls.*

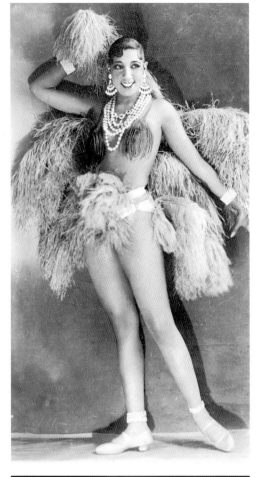

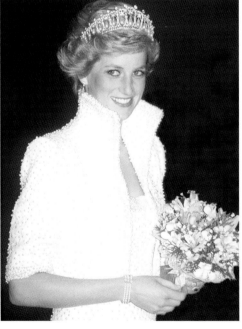

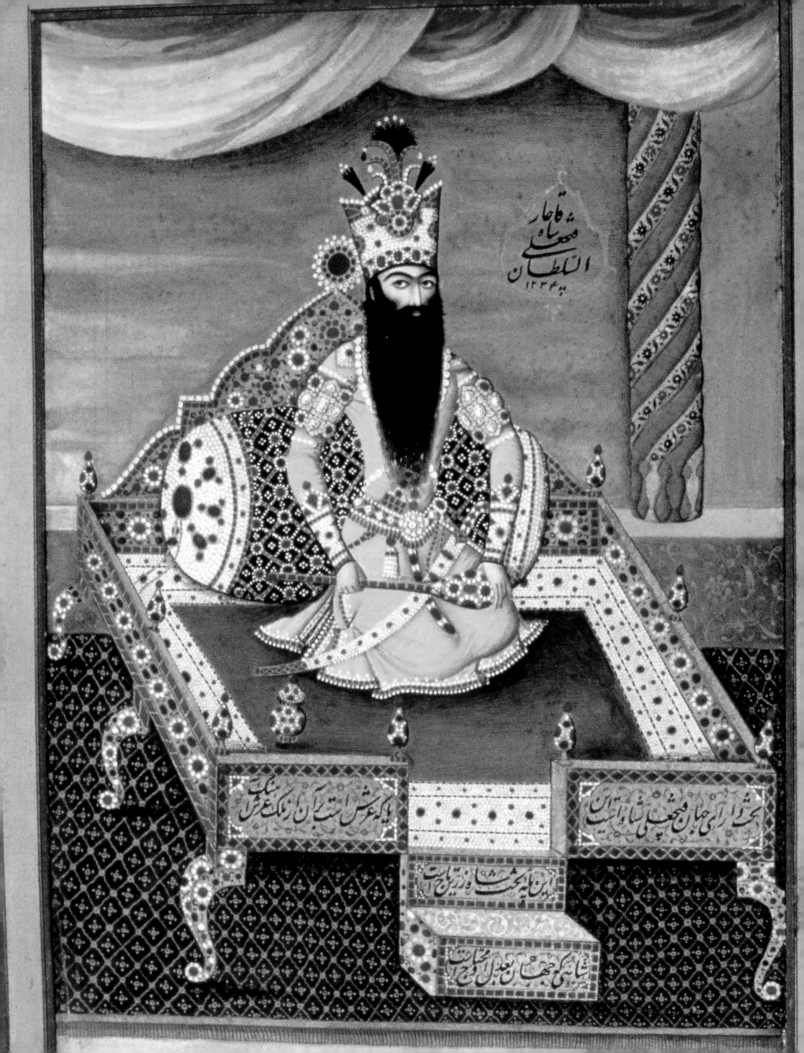

Pearls in Human History

THE NON-EUROPEAN TRADITIONS

Most of what we know about the early history of pearls relates solely to Eurasia and a small part of North Africa. Records there, although far from good, are better than for any other part of the world. We know that many societies in these parts of the world valued pearls, and we know at least a little about pearl uses, meanings, and the ways in which they fitted into economic and cultural systems.

Pearls in Europe, as we have seen, are reasonably well documented at some periods. From Roman times, Europeans admired pearls and wrote about them extensively. And yet one should not conclude that the story of pearls is mainly European. Even in the seventeenth century, when Europeans had both money and access to pearl beds, the great French gem trader Jean Baptiste Tavernier reported: "the kings and great nobles of Asia pay much more than they do in Europe, not only for pearls but for all kinds of jewels."[1] By and large, Asians paid the most for pearls, had the best pearls, and used them more lavishly than Europeans.

Written records are exceedingly scarce, but it does seem that the enthusiasm for pearls in Europe and Asia was never equaled in Africa,

Fath Ali Shah is seated on the Sun Throne.

Oceania, and the Americas. Archaeological evidence shows that pearls and mother-of-pearl were of real importance in parts of the pre-Columbian Americas; however, such evidence has not surfaced elsewhere in the Americas, either because the inhabitants did not have access to pearls or because they did not value them highly.

This chapter will outline worldwide interest—and uninterest—in pearls and how they, and mother-of-pearl, were used in regions outside Europe and the European settlements.[2]

WEST ASIA

The earliest surviving evidence of human concern with pearls comes from the same areas that saw the first cities, states, and farming communities. Mother-of-pearl, usually from freshwater pearl mussels, occurs at numerous archaeological sites of the Neolithic, Chalcolithic, and early Bronze Age periods (c. 6000–3000 B.C.E.) in Anatolia and Syria. Fifteen such sites have been recorded, including one—Korban Höyük in Turkey—with an actual freshwater pearl.[3] Saltwa-

ter pearl oyster shells are known from younger excavation sites in Jerusalem but seem uncommon at Neolithic to early Iron Age sites in Anatolia and the Levant.[4] Only a single example, from el-Qatar in Syria, is known from any site between 10,000 and 1000 B.C.E. in Jordan, Israel, Syria, Turkey, and Lebanon, even though other Indo-Pacific shells, notably cowries (*Cypraea*), are fairly common.[5]

Saltwater *Pinctada* shells and pearls at early sites occur more frequently closer to the Persian Gulf. A mother-of-pearl wedge and an inlay fragment depicting a human head in Sumerian style, both dating from c. 2300 B.C.E. in Iraq, show that ancient Sumerians used *Pinctada* shells—in this case the thick-shelled Black-lipped Pearl Oyster (*Pinctada margaritifera*). It is probable that most Middle Eastern mother-of-pearl came from this species rather than the smaller, thinner-shelled but pearl-rich *P. radiata*. The pearl scholar R. A. Donkin tabulated seven sites in Iraq and Iran that yielded shells plus six others with pearls.[6] All of these were important cities in their day, but only two—Uruk and Tepe Giyan—used pearls before the first millennium B.C.E. Along the Gulf itself, most of the early sites with *Pinctada* shells and/or pearls are on the island of Dilmun, now called Bahrain.[7]

There is no evidence of widespread interest in pearls anywhere in western Asia before the Hellenistic period, beginning c. 300 B.C.E. During the first three thousand years of cuneiform texts (Uruk to Neo-Babylonian periods), the only written indication of pearls is a famous passage from ancient Iraq in the Sumerian/Akkadian epic of Gilgamesh, dating from the third millennium B.C.E., which describes how Gilgamesh tied stones to his feet to dive and gather a plant or flower growing on the sea floor. Because Persian Gulf pearl divers later used stone weights, some commentators have concluded that Gilgamesh was using a pearl diving technique; others have further suggested that the flower is metaphorically a pearl.[8]

Other references to pearls in pre-Hellenistic documents are similarly obscure. Donkin has summarized the possible references to "fish-eyes," "gems from the sea," and so forth,[9] but none is convincing evidence of cultural involvement with pearls specifically, as opposed to precious stones, coral, or other materials. Archaeological finds from early Middle Eastern civilizations through the rise of the Persian Empire in 500 B.C.E. do show moderate use of *Pinctada* mother-of-pearl. However, despite what many pearl fanciers believe, there is no evidence that those civilizations placed great value on either pearls or mother-of-pearl.

This situation begins to change after the Achaemenian Persians—Cyrus the Great and his successors—welded most of West Asia and Egypt into a single political entity. This new empire controlled two major pearl areas, the Persian Gulf and Red Sea, and its rapidly expanding regional economy resulted in a gradually increasing interest in pearls. Finds of the remains of necklaces at the Achaemenian sites of Pasargadae and Susa yielded substantial numbers of drilled pearls; as far as we know, these are the earliest signs anywhere that pearls were considered worth collecting.[10] Further evidence of a new emphasis on pearls among the Persian elite comes from Greek references to pearl fishing in the Gulf during Alexander the Great's conquest of Persia.[11] By the fifth century B.C.E., pearls presumably from the Gulf were reaching the Greek-speaking world. Donkin surmised, plausibly enough, that Mediterranean peoples received both pearls and a taste for them from the Persian Empire.[12]

As in the Mediterranean, pearls became popular almost everywhere in western Asia during the next few hundred years. By the time the Romans and Parthians divided the empires of Alexander's successors in the first century B.C.E., most West Asian peoples used pearls as status symbols and hoarded them like gold. Greek and Roman writers made frequent comment. Androsthenes of Thasos in the fourth century B.C.E. noted that pearls were "of high value in Asia Minor [Anatolia], and in Persia and Upper Asia are sold for their weight in gold."[13] Pliny noted that Pompey the Great brought pearl-encrusted items from his conquest of eastern Anatolia in the first century B.C.E.—thirty-three crowns, a shrine, and a portrait of Pompey.[14]

Pearl jewelry from Roman sites in Asia, Europe, and Africa is relatively common in museums in Europe and North America, and examples continue to be excavated—for example, two seed-pearl earrings from early Roman-period levels were found at Sepphoris, Israel, in 1994.[15] Evi-

(RIGHT) *This first-century crystal necklace features a large Persian Gulf baroque pearl as its centerpiece.*

(BELOW) *A mother-of-pearl inlay fragment depicts the head of a Sumerian deity, excavated at Kish in Iraq, Early Dynastic period, c. 2300 B.C.E.*

Levant—appear to have shared Greco-Roman attitudes toward pearls. Surviving religious literature by West Asian writers, notably the New Testament, the Talmud, and Syriac Christian writings, treat pearls as pure and precious. A major stimulus to religious writers was the "Pearl of Price" parable in the Gospel of St. Matthew (13: 43-44). Origen, writing in Alexandria in the mid-third century, commented on this parable, invoking the dew theory of pearl formation:

> . . . *let the prophets be, so to speak, the mussels which conceive by the dew of heaven, and become pregnant with the truth of heaven, the goodly pearls which . . . the merchantman seeks. And the leader of the pearls . . . is the very costly pearl, the Christ of God, the Word.*[18]

Perhaps the greatest of all literary works devoted to pearls is a series of poetic meditations, *The Pearl*, by St. Ephraim of Syria, also writing in the third century:

> *The pearl itself is full, for its light is full;*
> *Neither is there any cunning worker who*
> * can steal from it;*
> *For its wall is its own beauty, Yea, its*
> * guard also!*
> *It lacks not, since it is entirely perfect.*[19]

dence shows that pearl shells are quite common too, although not always recorded by archaeologists focusing on structures, inscriptions, and fine art objects. Recent research revealed at least forty-one *Pinctada margaritifera* shells from eleven Hellenistic or Roman sites on the island of Cyprus, although until then only one record of such shells had ever been published.[16] Similarly, we can assume that large numbers of pearl shells exist at sites of similar age in other eastern Mediterranean regions. One interesting case is Jerusalem, where elaborately carved shells of *P. margaritifera* were sold as pilgrims' souvenirs in later times and where six examples have been identified from Roman-period excavations.[17] All of these shells must have come from the Red Sea or Persian Gulf.

The parts of West Asia that lay within the Roman sphere of influence—Anatolia and the

Despite the strong interest in pearls evidenced by surviving West Asian literature, surprisingly few examples of pearls or pearl shell have survived from that region at sites of the Hellenistic, Parthian, or Sassanian periods (300 B.C.E.-600 C.E.). Worked shell of *Pinctada margaritifera* occurs at two such sites in Central Asia and additional sites in the northern Gulf.[20] A handful of pearl jewelry items has been found at Tell Umar, the Seleucid capital in the third to second centuries B.C.E., and from pre-Islamic levels at the port of Siraf (400-600 C.E.).[21] Sites in Georgia have yielded pearl ear ornaments from the third to fourth centuries.[22] But otherwise, the non-literary evidence for pearl use in West Asia comes from graphic or plastic art representations, and here there is a serious problem: how to distinguish pearls from round beads of other kinds.

West and Central Asian art of the first millennium C.E. often includes spherical objects in bas reliefs and textiles. These appear as sewn-on costume ornaments, necklaces, or bracelets, or used

as borders of solid white circles surrounding textile motifs. Notable examples are portraits of Sassanian kings from third- to seventh-century Persia, who were depicted wearing elaborate necklaces and crowns composed of small spheres. Although many writers have interpreted these circles and spheres as pearls, there is no real proof of this. They could equally represent beads of gold or silver, precious or semi-precious stones, or glass. In the case of the famous "pearl-bordered roundels" in textile designs (originally Persian but also at Central Asian and Chinese sites, mid-first millennium C.E.), we see no evidence that these borders depicted spherical pearls as opposed to flat ornaments such as sequins, mirror appliqués, or cabochon-cut gemstones.[23]

However, there is little doubt that the depictions of round objects sometimes do represent real pearls. Donkin assembled convincing documentation from Byzantine and Arab writers that the Sassanian kings did wear large numbers of pearls. The Muslim historian Tabari wrote that Khosrau II (590–628) wore a crown of one thousand pearls, each the size of a bird's egg.[24] Khosrau II also had "a wonderful carpet 450 feet long and 90 broad [137 x 27 meters], with a border of emeralds, rubies, sapphires, and pearls."[25]

It is logical that the Sassanians and their Parthian predecessors would have been deeply interested in pearls. Their navies almost certainly controlled the Persian Gulf and its pearling grounds for more than six centuries. Internal literary sources as well as the quantity of pearls reaching the Roman-controlled Mediterranean make clear that those grounds were actively exploited. The Koran clearly states that the Prophet Muhammad, who lived at the time of the last Sassanian kings, knew that the Persian Gulf and Rea Sea both yielded pearls:

> He has let free the two Seas, meeting together
> Between them is a barrier which they do not
> transgress
> Then which of the favors of your Lord will
> ye deny?
> Out of them come pearls and coral:
> Then which of the favors of your Lord will
> ye deny? (Sura 55: 19–23)

A contemporary of Muhammad, the poet Maimun al-A'sha, produced what is probably the first detailed description of pearl diving in c. 630 C.E. It is in the form of a panegyric for the South Arabian hero Wais, the son of Ma'dikarib, who is captain of a pearling ship, presumably in the Gulf, and a diver himself:

> He cast the anchors right o'er a perilous
> deep—
> The anchors held, and the craft lay still in
> the flood.
> Then plunged he, long and lithe, his hair a
> shock,
> his teeth clenched firm, determined to brave
> the worst;
> He touched the bed, spitting oil from his
> mouth, and groped,
> athirst, his heart ablaze with the fire of
> want; . . .
> Full half a day the waters covered him up:
> His comrades knew not what he wrought
> in the deep;
> Then won he his longed-for prize, and
> upward he bore
> The Pearl in its shell, that shone like a
> burning coal.[26]

Despite its natural pearl resources and interest in pearls during the last thousand years of the pre-Islamic period, western Asia played a secondary role to Europe and the Levant in the pearl trade between the fourth century B.C.E. and sixth century C.E. As Chapter 4 shows, Romans became great pearl enthusiasts, and their wealth and political power must have helped them to acquire a significant proportion of the world's pearl output, from sources as far distant as India and Sri Lanka. However, with the decline of Rome in the fourth century and the rise of Islam in the mid-seventh century, the balance definitely shifted. By the eighth century C.E., West Asia was the center of the pearl world. Together with parts of South Asia, it would retain this central status until the twentieth century.

AFRICA

As in the Middle East and Levant before 500 B.C., Egypt has yielded very little evidence of cultural interest in pearls during the first 2,500 years of written records. Pearls rarely, if ever, appear as valuables or metaphors in the literature of the Pharaonic period.[27] There is not even a securely identified word

This royal head of silver, probably of King Shapur II, includes oval earrings and small spherical objects on the headband that could represent pearls (Sassanian period, fourth century C.E.).

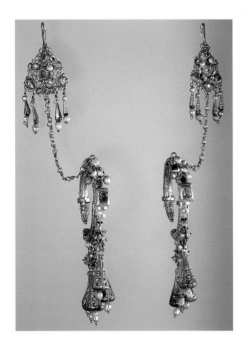

Earrings of gold, pearls, and colored gems, are from the Kabyle ethnic group, nineteenth-century Algeria.

for pearl, even though beads appear frequently in early texts—this despite the fact that ancient Egypt controlled much of the western coastline of the Red Sea, and thus had direct access to a prime source of pearls. It would seem that the ancient Pharaohs and their subjects were just not interested.

This began to change with the rise of the Persian Empire in the sixth century followed by the empires of Alexander the Great and his successors, especially the Seleucids and Ptolemies in the fourth century B.C.E. These political developments brought Egypt into close contact with fashions and status symbols of the Persian Gulf. By the time of the last Ptolemies, Egyptians were placing as much value on pearls as did other Mediterranean or Middle Eastern peoples. A well-known piece of evidence is Cleopatra's bet with Mark Anthony, which indicates the recognition of pearls as status symbols by Egyptians and Romans. According to Donkin, "more pearl jewelry of late Ptolemaic and Roman periods has been found in Egypt than in any other [Roman] province."[28]

Pearls were probably carried overland from the Red Sea port of Quseir, which was active during the early Islamic period and was still a pearl-trading center in the nineteenth century.[29] However, as a result of a fortuitous finding of remains of a ship that sank in the mid-eighteenth century, we also know that in the Islamic period, if not before, pearl shells were carried all the way to the northern end of the Red Sea. The so-called Sadana Island shipwreck was carrying Chinese porcelain, coffee beans, and at least fifty unworked mother-of-pearl shells (*Pinctada margaritifera*) presumably destined for makers of shell-inlaid furniture in Egypt.[30]

Of the two species of pearl oysters found in the Persian Gulf and Red Sea, it is significant that descriptions of pearling in the Persian Gulf rarely mention the larger *sadaf* (*Pinctada margaritifera*), whereas that species is prominent in descriptions of Red Sea pearling. We do not know whether the *sadaf* was more abundant or accessible than the smaller *bil-bil* (*P. radiata*) in the Red Sea area, but Red Sea pearlers definitely found a market for *sadaf* shells. The Sadana shipwreck shows that they were shipped to the northern end of the Red Sea where they were carved or turned into furniture inlay. Kunz and Stevenson illustrated one such carved shell, commenting that these shells were considered best-suited for button manufacture because of their dark color. Many were also being sent to Bethlehem and Jerusalem in the early 1900s to be carved with religious motifs for sale to pilgrims.[31]

Although Northeast Africans have been interested in pearls for a long time, this is not true for inhabitants of the rest of Africa. Pearl oysters of several species, including the larger *Pinctada margaritifera* and one or more smaller species of *Pinctada*, occur along the coasts of Tanzania and Mozambique. These were exploited in a desultory fashion by local people, presumably Swahilis, and perhaps by visiting Arabs as well. Arab and Persian sources, including Biruni, noted the presence of pearls at various points along the East African coast.[32] However, we know of no evidence that pearls or mother-of-pearl played a significant role in local coastal cultures, or that they were known among the cultures of interior East Africa or anywhere south of the Sahara. In recent centuries, pearls have been popular in western North Africa. Examples include jewelry worn by Jewish women in Morocco and by Kabyle women in Algeria.[33]

SOUTH ASIA

Very few archaeological finds of pearls have been made anywhere in South Asia, but there are several important early sites, as expected, along the Gulf of Mannar.[34] One key center for processing and trading pearls was the great entrepôt of Mantai on the west coast of Sri Lanka, a chief port for much of the first millennium C.E. Excavations there have yielded a small number of pearls.[35] Such finds are uncommon exceptions though, and we depend mainly on literary sources and art to see the place of pearls in ancient South Asian cultures.

Early literary sources on South Asian pearls are abundant. These include a number of classic works of the late first millennium B.C.E. and early first millennium C.E.—including the *Atharva-Veda Samhita*, Panini's Sanskrit grammar, and the Arthaśāstra—that mention the high value placed on pearls.[36] For example, this passage from the *Garuda-Purāna*:

Cloud pearls, being naturally effulgent like the sun, illuminate the sky in all directions and dispel the darkness of cloudy days. Glowing brighter than the combined light of the moon, the twinkling stars, and fire, a cloud-born pearl dissipates even the darkest night exactly like the sunrise. A cloud pearl is so priceless that the entire earth, with her oceans filled with countless jewels and covered in layers of gold, would not be equal in value.[37]

The earliest written versions of the classic Hindu texts are not earlier than 100–500 C.E., even though many of the texts themselves were composed orally long before that. The Greeks were the first to mention Indian pearls in writing. In 300 B.C.E., the historian Megasthenes noted that Indian pearls were worth "three times their weight in solid gold."[38] The philosopher Theophrastus, writing at about the same time, implied that Indian pearls were being exported to the Mediterranean.[39]

The first detailed Indian sculpture was also fairly late, appearing at the end of the first millennium B.C.E. Shortly afterward, strings of pearl-like beads were incorporated into Indian statues and bas-reliefs. One notable site for these is Amaravati in southern India.[40] Excellent depictions of pearl strings worn by both men and women also exist in early Indian frescoes—at Ajanta[41] in central India and at Sigiriya[42] in Sri Lanka, both of the mid-first millennium C.E., and in the Rangamantapa at Vijayanagara[43] in southern India, from the fifteenth century. The idealized images tend to be oversized, but are clearly pearls.

The equation of pearl size with value is probably as old in India as in the Mediterranean or China. A work on the valuation of gems, the Brhatsamhita of Varahamihira (505–587 C.E.),[44] gives values of 5,300, 3,200, 800, and 135 kāsārpanas (weights of gold) for pearls of 4, 3, 2, and 1 māsakas (or approx. 12, 9, 6, and 3 millimeters), respectively. This may have been the first time anywhere that the exponential relationship between pearl size and value was stated so explicitly.

The natural pearls shown in paintings and photographs of Indian rulers from the previous few centuries are relatively large.[45] Mughal paintings are noted for their exceptional realism, so it is probable that great care was taken to produce exact renderings of the emperor's jewelry. A famous portrait of Shah Jahan, painted by Abul Hassan in 1617, shows the emperor holding a turban ornament with egg-shaped pearls and wearing round pearl ear pendants, a turban band of round pearls, rubies, and sapphires, and four strands of round pearls around his neck, the center one having very large rubies and sapphires with a drop-shaped pearl at the center. If we assume that the iris of his eye was of normal size, approx. 12 millimeters in diameter, we can estimate the size of his pearls. Two of the elongated pearls—the one on his breast and one on his turban pendant—are very large, about 27–38 millimeters long. The round pearls at his ears and in the central neck strand are 13–14 millimeters in diameter. None of the other round pearls has a diameter greater than about 12.5 millimeters. Kunz and Stevenson include nineteenth-century photographs of other Indian rulers wearing strings of pearls of similar sizes.[46] The Gaikwar of Baroda, who also possessed a carpet made of pearls, wears seven strings of "superb" round pearls, 12–14 millimeters in diameter. The Rana of Dholpur, known as the "Prince of Pearls," wears twelve strands of 10-millimeter pearls and one of 15-millimeter pearls, which might be the largest matched natural round pearls ever found.

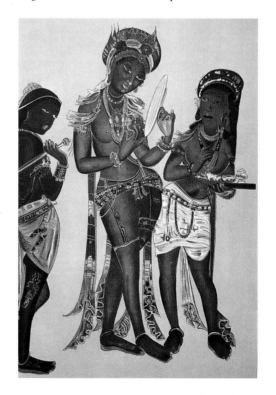

(LEFT) *A lady of rank with her maid applies makeup, from a painting in the Ajanta Caves, Central India, dating to the sixth or seventh century C.E.*

(OPPOSITE) *A pearl-decorated pendant of the goddess Hariti, excavated in Punjab, Pakistan, dates to the Kushan period, second century C.E. (diameter is 4.8 cm).*

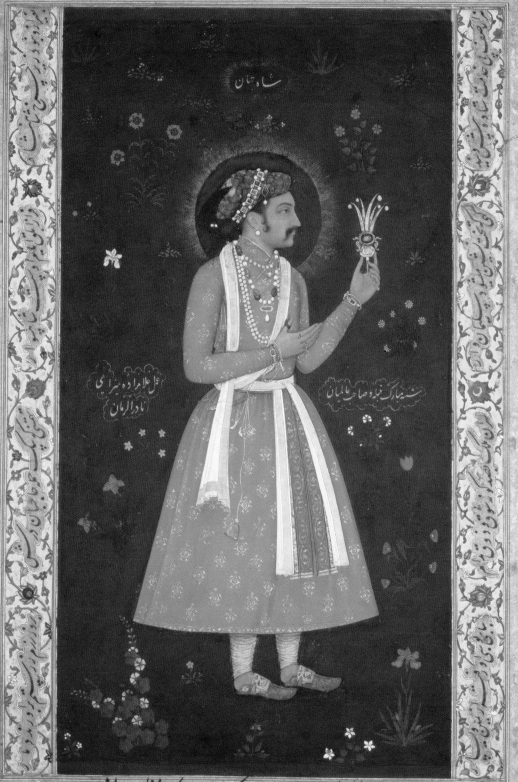

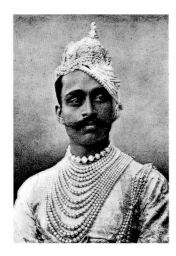

(ABOVE) *The Rana of Dholpur in his pearl regalia (1890s). The pearls in his choker necklace are exceptionally large.*

(RIGHT) *The Indian potentate Tippoo Sultan, ruler of Mysore, of the late eighteenth-century, also sports pearls.*

(OPPOSITE) *A seventeenth-century portrait of Prince Khurran, later the Emperor Shah Jahan, shows him wearing an abundance of pearls (Mughal period, India). "A good portrait of me in my 25th year," he wrote of the painting.*

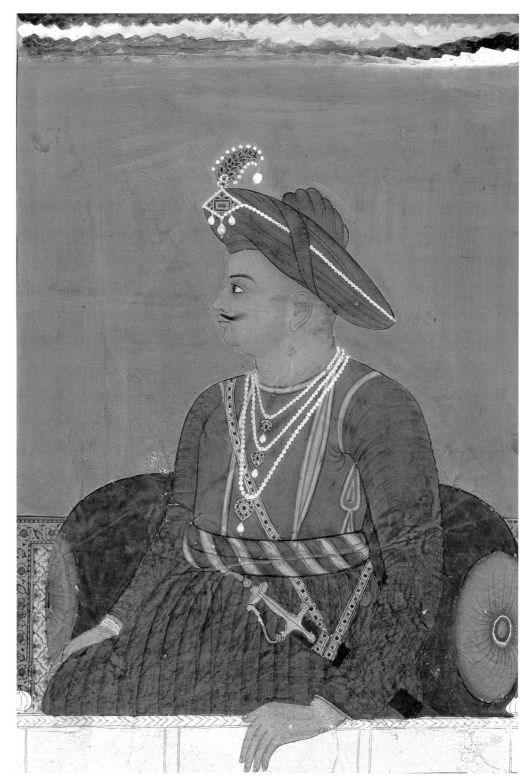

In all of their photographs of pearl-laden European princesses and American socialites, Kunz and Stevenson never show larger round pearls. Perhaps the largest natural spherical pearl reliably recorded was owned by Emperor Aurangzeb, which Tavernier measured as slightly more than 16 millimeters in diameter, weighing 122 grains (6.26 grams).[47] The largest pearl recorded by Tavernier was discovered in 1633 at Qatif in the Persian Gulf—a pear-shaped specimen weighing c. 500 grains (25.65 grams), and measuring c. 22–23 millimeters in diameter by 28–29 millimeters in length.[48] Such large pearls are outside the range of probability for *Pinctada radiata*, the main pearl-producing species of the region. The most likely source is *P. margaritifera*, which occurs throughout the Indo-Pacific, but one cannot discount in some cases the possibility of freshwater pearls from local sources. It is also possible that pearls from the large Gold-lipped Pearl Oyster (*P. maxima*) fisheries of Southeast Asia reached India long before the Mughal period. Close connections between South and Southeast Asia had existed for more than 1,500 years, and pearls had been regularly traded among the Persian Gulf, India, Southeast Asia, and China for many centuries.[49]

From the seventeenth to the early twentieth century, Indian merchants dominated the pearl trade of the Persian Gulf.[50] Their long involvement shows not only a great demand in South Asian countries, but also that Gulf pearls were considered superior in quality to those of India or Sri Lanka. François Valentyn, writing in 1712, described the city of Tuticorin on the southeastern coast of India:

> *This city is also very famous through its pearl fishery which produces reasonably good pearls, but these or the Mannar [Sri Lanka] pearls cannot match those of Ormuz and Bahrein [both Persian Gulf] in beauty of lustre and purity.*[51]

(BELOW) *This woman's hair ornament of gold with pearls, rubies, and rock crystal, said to have been made in the eighteenth or nineteenth century in Baddhi, India, was exhibited at the World's Columbian Exposition in Chicago in 1893.*

(OPPOSITE) *A necklace of gold, silk, and pearls with colored stones in the Rajput style, comes from eighteenth-century Jaipur, India.*

Wherever the pearls came from, South Asians wore them as profusely as anyone in the world. Emily Eden, sister of the English viceroy in the late 1830s, had a rare opportunity to meet secluded upper-class Indian women, and described the wives and consorts of the great Sikh ruler, Ranjit Singh:

> *Their heads look too large, from the quantity of pearls with which they load them, and their nose-rings conceal all the lower part of the face, and hang down almost to the waist. First, a crescent of diamonds comes from the nose, and to that is hung strings of pearls, and tassels of pearls, and rings of pearls with emerald drops. I can't imagine how they can bear the weight; and their earrings are just the same.*[52]

The symbolic meaning of pearls to South Asians has not been discussed thus far, yet innumerable colorful interpretations can be found. In some cases, these are quite literally invented; others draw on valid oral traditions. One aspect of the symbolism of pearls is the vexed question of flaming or light-emitting pearls in Indian, Central Asian, and Chinese mythology. Donkin reviewed the etymology of words for pearl in the various South Asian languages,[53] and found that there are words that refer exclusively to pearls, and words for all precious gems, including pearls, or any bead-shaped object of pearl, precious or semi-precious stone, or perhaps even glass. The Sanskrit term *cintāmani*, however, refers to a specific supernatural jewel that glows in the dark and belongs to or comes from serpent kings or *naga*. It "came to symbolize Buddha and the Enlightenment"[54] and is often depicted as a sphere that emits flames and appears in Tibetan Buddhist iconography. In Chinese Buddhism, it has become the plaything of dragons, the Chinese equivalent of *nagas*. So the *cintāmani*, although often translated as "flaming pearl," is not a pearl made by mollusks, and Asians do not use the term to describe decorative pearls.[55]

SOUTHEAST ASIA

The cultural history of pearls in Southeast Asia is quickly covered, for very little is known about the subject. Chinese historical sources make it clear that the region has a long history of harvesting pearls but not necessarily of using them. Hindu and Buddhist sculpture from Southeast Asian sites between the sixth and fifteenth centuries shows quantities of jewelry that, as with contemporary Indian and Sri Lankan sculpture, may or may not represent pearls. Although some ancient stone or bronze statues in early Indonesia depict strings of spherical ornaments, pearl-like jewelry is relatively uncommon.[56] Their ornamentation, as well as that of Indonesian kings and noblemen, seems to consist of precious metal chains and flexible bands rather than pearls. For instance, in published collections of Javanese court regalia, gold and precious stones are com-

(OPPOSITE) *A detail of the pearl carpet or shawl (1865) of the Gaikwar of Baroda, once called "the most valuable pearl object in the world." It is a rectangle of deerskin and silk embroidered with glass beads, diamonds, rubies, and emeralds on a field of seed pearls. The carpet measures more than five feet by eight feet.*

(BELOW) *Measuring tools used for pearls in the Persian Gulf include a balance to weigh pearls (left) and brass sieves to measure the pearls and sort by size (right).*

mon while pearls are quite rare.[57] They are also very rare in non-royal and tribal jewelry throughout insular Southeast Asia.[58]

Pearls in jewelry are also scarce in the sculpture of early mainland Southeast Asia. The most ancient sculpture in Thailand and Cambodia, from the fifth through eleventh centuries, is mainly religious and evidences a restrained approach to personal adornment. The large and flat beads worn by these statues rarely look like pearls.[59]

Later, in the heyday of Angkor in the twelfth through fourteenth centuries, when secular sculpture was abundant, pearl-like ornaments are more common.[60] Statues from Myanmar and Champa in central Vietnam also tend to have more pearl-like ornaments than do those of early Cambodia and Thailand. But sculpted human figures of the sixth through fifteenth centuries on the Southeast Asian mainland are never as commonly and heavily laden with pearls as statues of that period in

A detail from a Chinese imperial robe embroidered with freshwater pearls, Ch'ing Dynasty, nineteenth century. Dragons are often depicted with a "flaming pearl," which in all cases, however, is probably not a pearl in the molluscan sense.

"The Siamese prince in full regalia," as depicted in Kunz and Stevenson's 1908 compendium, The Book of the Pearl.

did not make efforts to exploit their extensive pearl beds. Northern Vietnam was harvesting pearls and exporting them to northern China as early as the second century C.E.[63] The Chinese geographer Zhao Rugua reported that pearls were being harvested in the Philippines, Sumatra, and Java during the thirteenth century.[64]

Sulu pearls from the southern Philippines have long had an impressive reputation for size and beauty:

> *Compared with pearls from* [the Middle East] *and* [the Gulf of Mannar], *those produced in Sulu are more bluish white* [or off-white] *in color, and rounder. They are very expensive. The Chinese use them for jewelry. Their color will not fade. They are regarded as being of unsurpassed quality. They are as large as an inch in diameter. The large ones are worth 7–800 ding* [gold] *ingots, the medium-sized 2–300 and the small ones 10–20.*[65]

Maxmillianus Transylvanus' account of a visit to Sulu by Magellan's crew in 1522 also refers to astounding pearl sizes: "Then they came to the coast of the island of Solo [Jolo, in Sulu], where they had heard that pearls were to be found as large as doves' eggs, or even hens' eggs . . . they found an [pearl] oyster there the flesh of which weighed forty-seven pounds. . . . "[66] While Magellan's crew were clearly exaggerating, the pearl oysters and pearls that they encountered were undoubtedly impressive in size, coming as they probably did from the Gold-lipped Pearl Oyster (*Pinctada maxima*) for which the Sulu archipelago is still famous. No European had ever seen a living specimen of *P. maxima* before.

Parts of northern Vietnam were producing high-grade mother-of-pearl inlay work by the eighteenth century, having been discovered by a legendary craftsman named Nyuyen Kim. The raw materials included shells from pearl oysters and freshwater pearl mussels. In the 1970s, these were becoming scarce, threatening to severely impact the inlaid furniture industry.[67] The rise of pearl farming in Vietnam in recent years may be ameliorating the problem—mother-of-pearl inlay is again common in Vietnamese shops.

South Asia. In the early twentieth century, Kunz and Stevenson believed that "the Siamese do not especially value pearls, attributing some superstitious sentiments of ill luck to them."[61]

Ancient jewelry found in quantity at archaeological sites in Java, the Philippines, and Vietnam, none of which includes pearls, suggests that during most of their history, Southeast Asians were less interested in pearls than the peoples of South and East Asia.[62] This is not to say that they

For many centuries China imported pearls from South Asia, the Persian Gulf, and Southeast Asia. Despite this, the history of pearls in China is distinct from that of regions farther to the south and west. The earliest references to Chinese pearls are to freshwater pearls from the fourth and third centuries B.C.E., and implications (but not overt statements) that pearls were obtained from the south coast of China in the sixth or fifth century B.C.E.[68] Pearls seem to have enjoyed a high value relative to other property. An early writer, probably of the fifth or fourth century B.C.E., included a discussion of "gold, jade and pearls as objects of barter. The former kings, he says, because these things came from afar and were obtained with difficulty, made use of them according to the respective value of each, pearls and jade being estimated highest, gold placed in the second rank, knife money and spade-shaped coins ranging in the lowest class."[69]

Even in remote antiquity, China had access to significant quantities of freshwater pearls from pearl mussels (*Cristaria* and *Hyriopsis*) native to the Yangtse delta and nearby rivers in central eastern China, as well as other species in Heilongjiang and Liaoning Provinces. A source of marine pearls was brought within China's borders when the Leizhou Peninsula and Hepu area (now Guangxi Province) were annexed by the Han dynasty in the second century B.C.E. China was thus well supplied with native pearls although successive dynasties showed continuing interest in high-quality foreign pearls acquired through tribute and trade. A telling anecdote comes from the anonymous chronicle *Mengxi Bitan*, published in 1166. It concerns envoys to the court of Emperor Shen Kuo (1068–77) from the southern Indian kingdom of Chulian, who "presented their tribute of pearls on a gold tray, and then used a gold lotus flower scoop to splash pearls all over the throne. Afterward, court attendants swept up tens of ounces of pearls."[70] Although the quantity of pearls does not seem that great, the chronicler clearly considers the envoys' behavior indicative of spectacular wealth. The implication is that as late as the eleventh century, pearls—or at least high-quality Gulf of Mannar pearls—were not generally available in China.

Donkin searched historical texts to assemble a comprehensive list of foreign places that Chinese geographers recognized as pearl suppliers or producers before the sixteenth century.[71] Four of these were in East Asia, ten in Southeast Asia, and no fewer than fourteen in West and South Asia. A search of records of tribute sent by foreign nations to China yielded similar results.[72] Between the seventh and fifteenth centuries, forty-five foreign delegations brought pearls as tribute. Five of these delegations came from East Asia (excluding Manchuria and Siberia), sixteen from Southeast Asia, and twenty-four from West and South Asia.

Although historical geographers still hotly debate the locations of many of the non-Chinese places named in Chinese records, the general pattern is quite clear. East and Southeast Asia did supply pearls to China in early times. However, no nearby non-Chinese pearl sources were as important in Chinese eyes as India/Sri Lanka and the Middle East. Like their European contemporaries, Chinese pearl fanciers of the fifth through fifteenth centuries used mainly domestic pearls but nevertheless esteemed the famous pearls of the Persian Gulf and the Gulf of Mannar.

Why this was so is a mystery. Japanese natural pearls were probably no better than the pearls China could acquire from its own Akoya Pearl Oysters off the Leizhou Peninsula. But the *Pinctada maxima* pearls from the Philippines, the Thai/Malay/Burmese peninsula, and eastern Indonesia were surely larger and more spectacular than most pearls of East, South, or West Asia. Why then did Chinese merchants go so far afield for their pearls? The answer eludes us. Were the economies of places like the Philippines and Indonesia too poorly developed to sustain a major increase in harvest? Were Southeast Asian pearl beds unable to sustain an increase without a catastrophic drop in the pearl oyster population? Or was it simply too much work for the local pearl divers to increase their harvests of the large-shelled *Pinctada maxima*, which tend to be widely dispersed on the sea floor and of which only a small percentage are expected to contain pearls?

In any case, foreign imports played only a minor role in overall Chinese pearl consumption. The great bulk of pearls used for ornament and

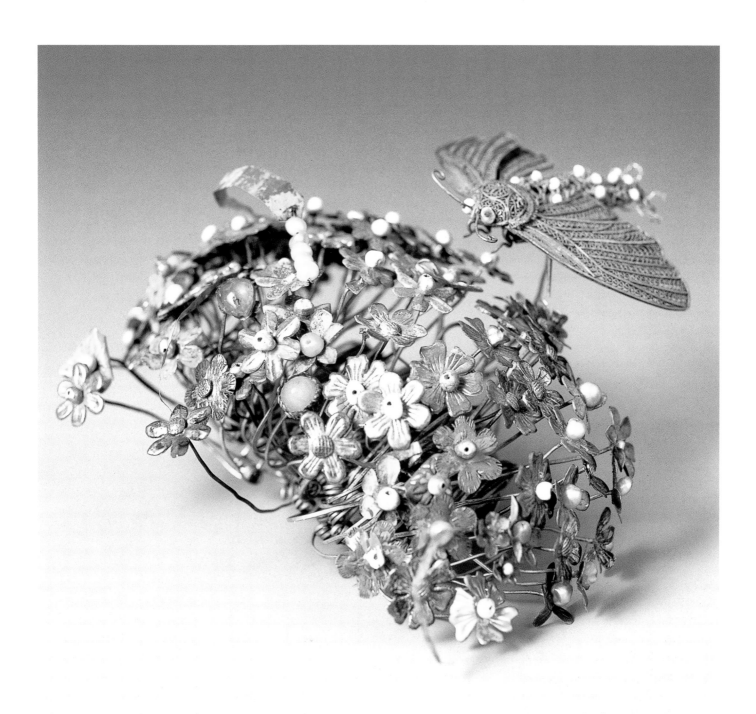

A gold headdress with pearls and precious stones, dates from the Sui dynasty (581–617 C.E.), excavated near Xian, China.

medicine came from domestic sources. We do not know whether the various domestic sources were considered equally satisfactory. Were freshwater pearls from the Yangtze and Heilongjiang fisheries as desirable as marine pearls from the Tonkin Gulf fishery off the coasts of Hepu, the Leizhou Peninsula, and Hainan Island? During the Jin and Qing periods, when Manchurian peoples controlled China, the Imperial household often expressed a preference for Heilongjiang pearls.

A fair number of pearl jewelry items and accessories have been found at Chinese archaeological sites. A good example is a gold headdress ornamented with pearls and precious stones, dating from the Sui dynasty (581–617 C.E.), excavated in 1957 near Xian. The succeeding Tang dynasty brought the heyday of textiles decorated with

"pearl" roundels and mother-of-pearl objects.[73] Of special interest is a pearl-decorated waist pendant excavated in 1973 from a Jin-dynasty (265–420 c.e.) tomb in Heilongjiang province. It was worn by a tribal aristocrat from an ethnic group closely allied to the Jin, and is the earliest evidence that local tribal peoples also wore pearls.[74]

Pearls are said to have been a matter of intense interest to statesmen in the eleventh century, when the Liao ruled all of northern China. At that time, the Liao overlords pressured the Jurchen, a semi-nomadic people in China's far northeast, to wage war against other eastern tribes to obtain falcons and pearls, two famous products of the region. To the eastern tribal peoples, however, falcons and pearls were closely linked—falcons could be used to hunt geese that had crops full of pearls from feeding in local riberbeds. Giving up falcons therefore also meant losing their monopoly on pearl harvesting, thus the eastern tribes resisted the Jurchen. By some accounts, the Liao's insistence that the Jurchen get both pearls and falcons from the eastern tribes was the main cause of a revolt that overthrew the Liao and established the Jurchen, thereafter called the Jin, as the rulers of the northern two-thirds of China.[75]

From the eleventh century on, there is abundant evidence of the use of pearls in women's jewelry from actual objects and painted representations. Portraits of imperial women of the Song (960–1279), Yuan (1260–1368), and Ming (1368–1644) dynasties show that they often wore pearls. The most popular were small- to medium-sized, often mounted on gold filigree with inlays of blue-green kingfisher feathers.[76]

The high-water mark of Chinese pearl artistry, and perhaps of Chinese interest in pearls as well, was reached during the Qing dynasty (1644–1912), particularly in the eighteenth and nineteenth centuries. The Palace and History Museums in Beijing have exceptional collections of pearl-ornamented jewelry, accessories, and furnishings from this era.[77]

One reason for persistent imperial interest in pearls was the regulation that only an emperor and males of his immediate family could wear pearls as finials on court hats. Imperial women too wore large quantities of pearls at least in the previous few centuries, although no formal rule existed for them. The official portrait of the Empress Xiaoxian, much-loved wife of Emperor Qianlong, shows many pearls.

Pearls in Chinese culture have many traditional meanings and Western authors have attributed additional meanings to them. Two such authors, both distinguished sinologists, wrote:

The pearl is one of the eight ordinary symbols—vide Eight Treasures. The term chu or pearl seems to be generically applied to a variety of round objects, as for instance the spheroid which is a concomitant of the dragon. As a symbol of good augury it is depicted entwined with a fillet. The Wonder-Working Pearl is also one of the Seven Treasures, Skt. Sapta Ratna, which represent the paraphernalia of a Chakravartti or universal sovereign, according to Buddhist legends. . . . The offspring of aged parents is compared to a pearl produced by an old oyster. The pearl is also an emblem of genius in obscurity, and is figuratively employed for the expression of feminine beauty and purity.[78]

The pearl is one of the eight jewels: it stands for purity and preciousness. . . . Tears may be called "little pearls." In ancient times, a pearl was laid in the mouth of a dead person, perhaps because the mussel becomes "pregnant by reason of thunder and the pearl grows by moonlight." The Chinese say that Tibetan monks have a "seduction pearl" which gives them magic properties for sixty years. Any woman caught in its rays becomes desperate for love.[79]

The above-quoted phrase—"the spheroid which is a concomitant of the dragon"—raises the question of the connection between dragons and pearls. Chinese dragons, as well as those of Vietnam, Japan, and Korea, are often depicted playing with flaming balls, which they spit out, chase, and eventually swallow again. Many Westerners believe that those flaming balls are pearls of the kind that comes from pearl oysters. In reality, however, they are gems of an unspecified kind. The Chinese call them *zhu*, meaning bead, gem, or pearl, but not *zhen zhu* or "true pearl." Their flame- or light-emitting quality points to some

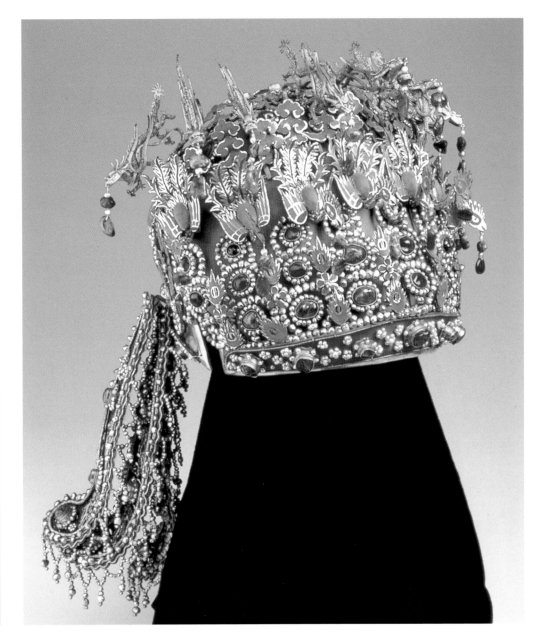

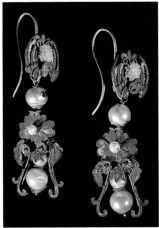

(ABOVE) *Earrings of gilded silver with pearls are inlaid with kingfisher feathers (nineteenth-century China).*

(ABOVE RIGHT) *Empress Xiaozong's headdress, of gold with pearls and kingfisher-feather inlay, was worn during Wanli's reign (1573–1620) and found in her tomb in the 1950s.*

relationship with the *cintāmani* of Indian and Tibetan Buddhists. As pointed out above, the *cintāmani* is not exactly a true pearl either.

It is difficult to say much about natural pearls in Japan and Korea. The Koreans used pearls in much the same way as the Chinese, probably obtaining most of them from the Yalu and other rivers farther north. A fourteenth-century ethnographer, Ma Duanlin, recorded that Korean women wore pearls in their hair.[80] However, very few items of pearl jewelry or adornment survive from Korea before the twentieth century.

Tavernier's observation that the Japanese of the seventeenth century did not esteem pearls,

quoted in Chapter 6, was confirmed by Kaempfer in the early eighteenth century, who was the first Western writer to describe Japanese life and history from the Japanese perspective. He noted that the Japanese at the time were just beginning to fish enthusiastically for pearls, having discovered profitable export markets in China, the Ryukyus, and Vietnam.[81] Even then, however, pearls were rarely worn or used for decoration within Japan. Neither men nor women wore jewelry before the introduction of Western fashions in the late nineteenth century, and Japanese decorative artists did not use jewels in their designs.

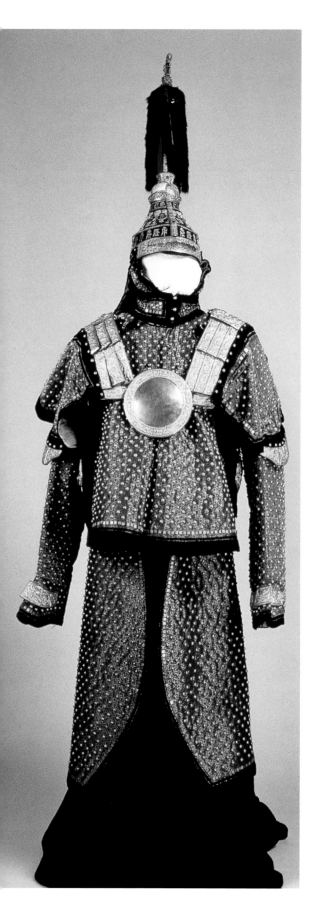

Yet the Koreans, Japanese, and Chinese all made extensive use of mother-of-pearl for inlay work, usually in combination with lacquer. Lacquer artists used both pearl oyster and abalone nacre in their work. In all three countries, nacre-inlaid lacquer was a well established craft by the twelfth century.[82]

Oceania and Australia

There is little direct evidence for a traditional interest in pearls among the native peoples of Australia and the Pacific. Although the Melanesians north and east of New Guinea used marine shells extensively in jewelry manufacture, costume accessories, and money-beads, they seem not to have been attracted to *Pinctada* shells. In Australia, the aboriginals of northern coastal areas did not use pearls either, but did often wear breastplates of pearl shell (*P. maxima*). Captain James Cook observed several of these near the Endeavour Strait in 1770.[83] Many Polynesian peoples also used pearl shell (mostly *P. margaritifera*) to make fishhooks, which are often found in archaeological contexts.[84]

Otherwise, most of the evidence for the role of pearls and pearl shell in Pacific and Australian cultures dates to a period well after the introduction of European attitudes and customs. It would not be hard to conclude that pearl shell in pre-European times was a minor, not especially useful, commodity and that pearls were nothing more than children's playthings. Only one historical detail might contradict that conclusion. From the diary of Joseph Banks, later one of Europe's leading scientists, written while a young man on Captain Cook's ship in 1768–71, *Endeavour*, comes an anecdote that unfolds on Ulhieta, in the Society Islands not far from Tahiti:

> One of these girls had in her ear 3 pearls, one of them very large but so foul that it was worth scarcely any thing, the other two were as large as a middling pea and of a good and clear water as well as shape. For these I offerd [sic] at different times any price the owner would have but she would not dream of parting with them. . . . Indeed, they [the local Polynesians] *have always set a value upon their pearls, if tolerably good, almost equal to our valuation. . . .*[85]

(LEFT) Emperor Qianlong's armor, Qing Dynasty (c. 1750). The finial of his helmet (opposite) is topped with a large pearl.

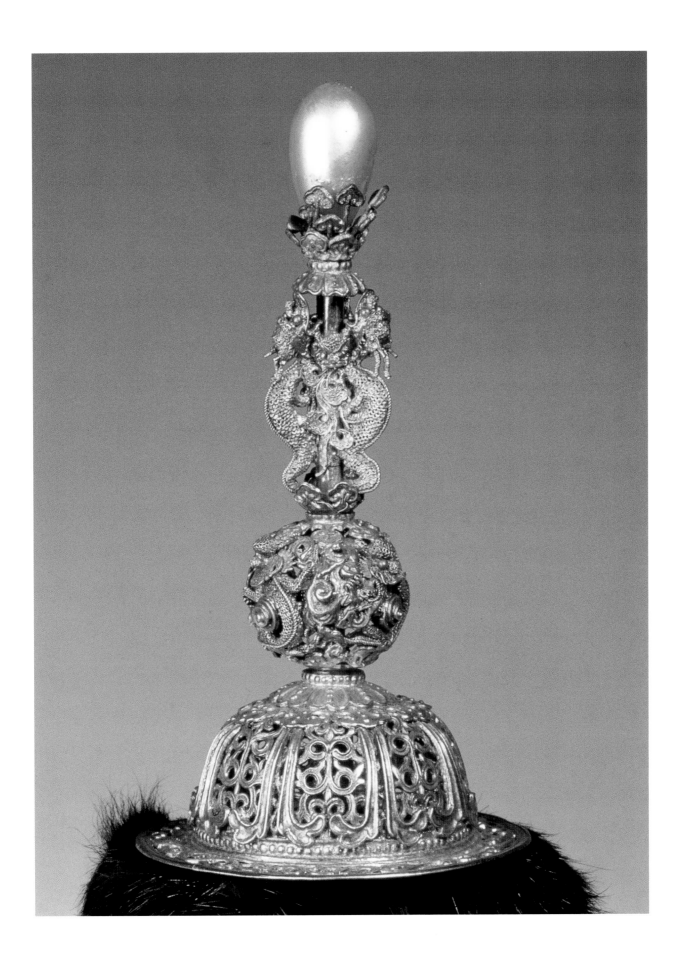

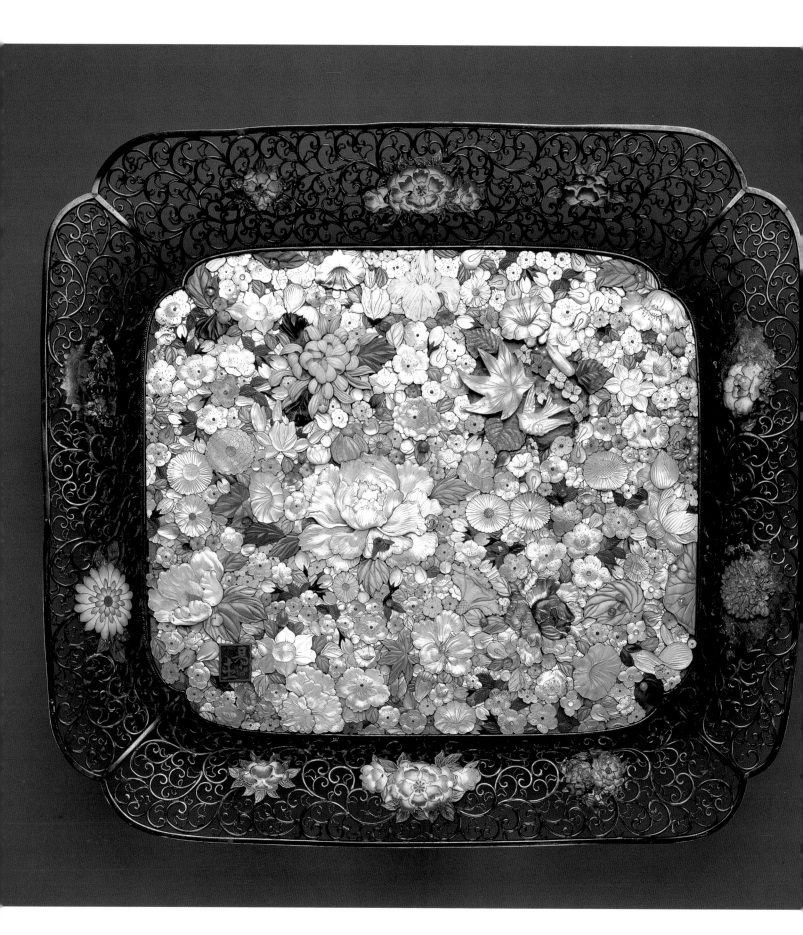

Because Cook and his crew were the first white men to visit that part of the Pacific, it seems certain that the local Polynesians' high valuation of pearls did not originate with Europeans.

We do not know of historical evidence that other Polynesians or Pacific islanders were interested in pearls before the arrival of the Europeans. On the other hand, it is clear that they became very interested during the 230 years since Cook's voyages. This could explain the existence of numerous rather recent legends concerning pearls.

South and Middle America

This description of Hernando De Soto's travels in the southern United States between 1539 and 1542, as given by the great Peruvian historian Garcilaso de la Vega in 1605, is at least part fantasy but, coming as it does from a highly perceptive half-Inca whose thinking was steeped in Inca lore, it may epitomize the combined dreams of the conquistadors and the conquered:

Near Cofaciqui [Cofitachequi] was the temple of Talomeco, over a hundred steps long by forty broad, with the walls high in proportion. Upon the roof of the temple were shells of different sizes, placed with the inside out, to give more brilliancy, and with the intervals "filled with many strings of pearls of diverse sizes, in the form of festoons, from one shell to the other and extending from the top of the roof to the bottom." Within the temple, festoons of pearls hung from the ceiling and from all other parts of the building. In the middle were three rows of chests of graded sizes, arranged in pyramids of five or six chests each. "All these chests were filled with pearls, in such a manner that the largest contained the largest pearls, and thus in succession to the smallest, which were full of seed-pearls only. The quantity of pearls was such, the Spanish avowed, that even if there had been more than nine hundred men and three hundred horses, they all together could not have carried off at one time all the pearls in the temple." [86]

(OPPOSITE) *A silver Japanese decorative tray is inlaid with flowers of mother-of-pearl (Meiji Period, late nineteenth century).*

(BELOW) *Korean tray of lacquer with inlaid mother-of-pearl floral motif, dates from the late Koryŏ to early Chŏson periods, fourteenth to fifteenth century.*

Garcilaso's notion of shells used as shingles may be significant. The real De Soto would have encountered only the deeply convex shells of North American freshwater pearl mussels. However, northern Ecuador, which formerly supplied the Incas and other Andean peoples with sea products unobtainable in areas farther south, had relatively flat pearl oysters (*Pinctada mazatlanica*) that might have been usable as roof covers.

Inca queens commonly used pearls and pearl shells as ornaments: "Coya Chimbo, wife of Sincho Roca, and her attendants were decked with ornaments of gold and necklaces of pearls. The seventh Coya, Ipavaco, wife of Yaguar Huachac 'had a chapel inside the palace for her prayers, plated with gold and silver and a great quantity of pearls and precious stones.'"[87] In Ecuador, the first evidence for the working of *Pinctada* shells dates to the Valdivia Phase, as early as 3000 B.C.E. The Valdivia people used pearl shell to produce numerous fishhooks and decorative plaques.[88]

The peoples of the northern Ecuadorean coast, in what is now Manabi Province, seem to have been interested in pearls before the Spanish Conquest. In 1571, Juan de Salinas de Loyola commented:

> There have been many signs along this coast that there had been pearl fishing, which practice has been hidden by the Indians after the coming of the Spanish . . . the tombs that have been discovered have contained a great quantity of large and valuable pearls, save that these have suffered damage for so long a time; there has also been found a great quantity of the shells of these oysters from the time during which the natives dove for them.[89]

The shells may have also played an important role. At Los Frailes in northern Ecuador, the excavation of an ancient shell-workshop site showed that its inhabitants had a strong interest in the

A carved shell of Pinctada mazatlanica *depicts two deities holding a fish (second-century Ecuador).*

shells of pearl-producing species. Among the most common shells were *Pteria sterna* (31 percent) and *Pinctada mazatlanica* (12 percent).[90]

A similar pattern existed in ancient Mexico, where pearl-shell disks and plaques were major items of trade. The only thorough survey of marine shell use in Mexico is that of Feinman and Nicholas in the Oaxaca Valley, approximately 150 km from the Pacific coast. Their work shows that from 500 B.C.E. to 800 C.E., shell objects and debris from *Pinctada mazatlanica* dominate the molluscan remains at archaeological sites. The excavation of a shell workshop at Ejutla, which supplied shell ornaments to the rest of Oaxaca and perhaps other parts of Mexico, yielded more precise statistics: *P. mazatlanica* accounted for 68 percent of the shell total.[91]

The ancient Maya of southern Mesoamerica sometimes did use actual pearls as ornaments. An example is a necklace found in a tomb of the Early Classic period (fourth through sixth centuries C.E.) at the site of Dzibanche in Quintana Roo, Mexico.[92]

NORTH AMERICA

There is no doubt that the inhabitants of the southeastern United States treated freshwater

pearls seriously, as appropriate objects among members of the elite and in ceremonies. High-ranking women wore them, as shown in Théodor de Bry's famous drawing of 1594 depicting a Virginian "chief lady" with her arm in a sling of pearls. Pearls were extensively used in Florida, North Carolina, Virginia, Tennessee, and near the lower Mississippi River. Interestingly, judging solely from historical documents, "one gets the impression that there were more pearls among the eastern tribes, between the Chesapeake and Florida, than among those on the 'Father of Waters' [Mississippi River]."[93]

Kunz and Stevenson expressed doubts about these documents, stating that many accounts were exaggerated or outright lies. But they quoted Daniel Coxe as saying in 1722 that he saw many of "a sort of shell fish between a mussel and a pearl oyster, wherein are found abundance of pearls and many of an unusual magnitude" in places visited by De Soto and other Spanish explorers. These pearls seem to have been a by-product of catching clams for food. Most such pearls were ruined by the fact that the local Indians broiled the clams over a fire until fit to eat, "keeping the large pearls they find in them, which by the heat are tarnished and lose their native luster." Despite this, "the Indians put some value on

"Chief lady of Pomeicoc," a high-ranking Native American woman in North Carolina, as drawn by de Bry in 1594, wears four strands of freshwater pearls as a slinglike necklace.

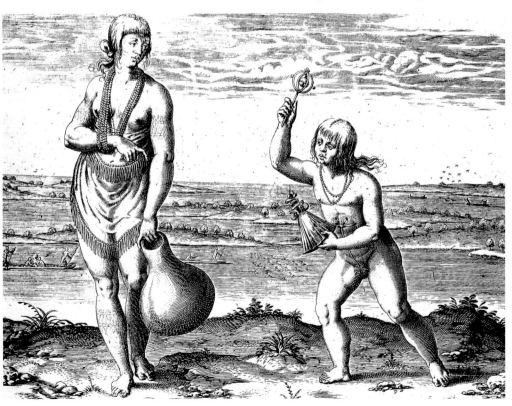

them, but not so much as the colored beads we bring them."[94] Archaeologists in the southeast have not generally found pearls in large quantities, leading to the suggestion that "the fabulous quantities of pearls described in the Spanish narratives may actually have been highly polished shell beads."[95]

The Ohio Valley is another matter. There, archaeologists have found pearls in substantial quantities—so many, in fact, that it is safe to say that 90 percent of the pearls from ancient sites anywhere in the world are from tributaries of the Ohio River. One of the first coherent accounts of these pearls is from Squier and Davis' classic description of excavations at "Mound Builder" sites during the 1840s:

Several hundreds in number, and not far from a quart [0.9 liters] in quantity, are in our possession, which retain their structure sufficiently to be strung and handled. The largest of these measures two and a half inches [6 cm] in circumference. . . . Great numbers were so calcined [by burning] that it was found impossible to recover them, and a large number crumbled to pieces after removal from the mounds. It is no exaggeration to say that a number of quarts of pearls were originally deposited in the mounds referred to; probably nearly two quarts were contained in a single mound.[96]

Most of these mounds were later assigned to the Hopewell culture, c. 200 B.C.E.–500 C.E. The name is from a group of mounds near Chillicothe, Ohio, excavated by Moorehead in 1891. His finds, afterward deposited at The Field Museum in Chicago, included large quantities of drilled pearls and objects with pearl inlays made of native copper, bears' teeth, jet, and bone.[97] All had been burned more or less severely, presumably during sacrificial rituals. Many came not from burials but from rich ceremonial deposits. Twenty-two such deposits are known from six sites, yielding many other kinds of rarities besides pearls—native copper objects, large mica cut-outs, obsidian weapon points, carved stone pipes, meteoritic iron, native silver, sharks teeth, and conch shells.[98] There is no doubt that among Hopewell peoples, pearls were considered both precious and collectable. As Kunz and Stevenson wrote, "In the age of the mound-builders there were as many pearls in the possession of a single tribe of Indians as existed in any European court."[99]

No one knows what meaning pearls had in Hopewell culture or in the cultures of other New World peoples. One archaeologist nevertheless has recently speculated: "In Pre-Columbian America, especially valued brilliance was embodied in matter emanating from rivers, lakes and the sea. The whiteness of shells, gloss of fish (scales) and translucence of pearls were natural qualities imbued with a sacredness magnified by their origins beneath the water's mirror-like surface—the boundary between the physical and spiritual worlds."[100]

(OPPOSITE) *A Heiltsuk mask of the moon portrayed as a person decorated with abalone inlay around and across the face (British Columbia c. 1850).*

(TOP RIGHT) *A mannequin of a Hopewell man wearing native copper earspools and three strands of freshwater pearls, excavated in 1891 at the Hopewell site (200 B.C.E.–500 C.E.) near Chillicothe, Ohio. The antler headpiece and ornaments in the center of the strands are of native copper and silver.*

(BOTTOM RIGHT) *This raven image, of native copper with a pearl as the eye, was excavated at the Hopewell site in Ohio.*

Getting Pearls

THE HISTORY OF HARVESTING NATURAL PEARLS

Are there not, dear Michal,

Two points in the adventure of the diver:

One—when, a beggar, he prepares to plunge?

One—when, a prince, he rises with his pearl?

—ROBERT BROWNING, *PARACELSUS*, 1835

An advertisement for the Boepple Button Company, from the early 1900s, features a pearl choker but not a single pearl button.

HARVESTING MARINE PEARLS

The days when pearls could be found by wading out into the sea are long gone. The last time and place for this kind of pearling was northern Australia in the early 1860s, where a pair of former sailors named Tays and Siebert founded what would become a major pearling industry.[1] In that case, it took less than ten years for white adventurers and forcibly recruited aboriginals to collect all of the pearl oysters—of the smaller Australian species, *Pinctada albina* Lamarck, 1819—accessible by wading or swimming from shore.[2] From then on, Australians turned to the deeper water and larger species, *P. maxima*, which required divers operating from boats to gather pearls. In other parts of the world, this switch occurred much earlier. Deep pearl diving in the Persian

Gulf probably began in the third millennium B.C.E. and was being practiced in most pearl-producing areas by the time the first historical descriptions were written.[3] Early diving methods were similar in all areas before the invention of underwater breathing devices. A diver held his breath, went down 10–15 meters (to more than 30 meters in some areas), collected a few clams, and then surfaced to prepare for another dive. Diving was dangerous, and divers were usually poor and often unfree.

The movement of pearls from diver to market was also similar across cultures. The divers turned their pearls over to their employers—small-scale businessmen or local leaders—who in turn funneled the pearls into a surprisingly unified international trading system dominated by gem traders and their aristocratic clients. During

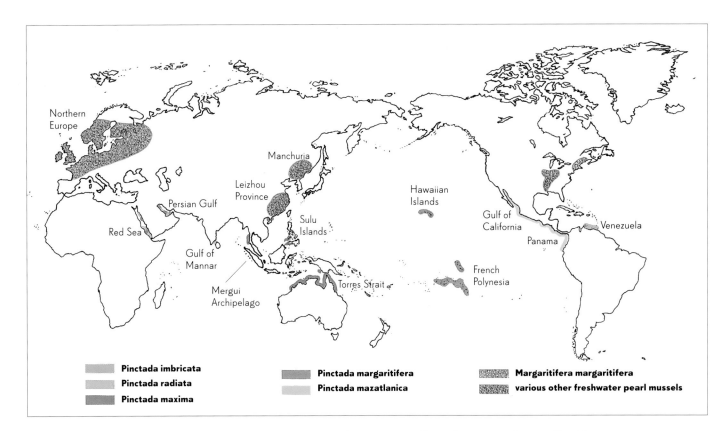

Pearl harvesting areas of the world.

most periods, the leading buyers of pearls were wealthy Southwest or South Asians. East Asians and Europeans generally lacked money for, or interest in, pearls until the first few centuries C.E. of the Roman Empire and again during the European Great Age of Pearls.

The Western Indian Ocean

Three small areas in the western Indian Ocean—the Persian Gulf, Red Sea, and the Gulf of Mannar—dominated the world's pearl markets from antiquity through the 1920s. They not only yielded the lion's share of the world's pearls, but their inhabitants were more interested in pearls and paid higher prices for them.[4]

In the Persian Gulf in the nineteenth century, pearling boats were fairly large and standardized. Most came from Bahrain Island and adjacent parts of the Arabian mainland, including Kuwait and Qatar. The typical Persian Gulf pearler was a large *dhow* of 18–30 meters in length, displacing 10 to 50 tons of water, with a crew of about 65: 25–30 divers, 20–25 rope-tenders, plus sailors, cooks, a navigator, and a skipper. Each diver was equipped with a basket attached to his waist as well as a horn nose-clip, leather finger guards, and possibly a knife. He descended feet-first, weighted by a 30-pound stone with a rope attached to it so that it could be retrieved. Upon reaching the bottom, he would drop the stone weight and swim around, gathering as many pearl oysters as possible (10–15 at most, but often only 2 or 3, of either *Pinctada radiata* or *P. margaritifera*) into the basket. A tug on the rope then signaled the rope-tender to pull up both the stone and diver. Boats stayed on the pearl banks for several weeks; the men ate, slept, prayed, and opened pearl oysters—all on board. The shells seem not to have been kept, and the pearl oyster meat was never eaten.[5] It is evident these methods date from very early in the Persian Gulf. The ninth-century writer Mas'udi mentioned the horn nose-clips, and also added that the divers' ears were plugged with oil-steeped cotton.[6] Varthema described a very similar system at the end of the fifteenth century.[7]

The most significant characteristics of the Persian Gulf industry are its scope and permanence. In 1905, it was estimated that a third of the world's pearl divers were employed here, generating half of

(RIGHT) *These earrings with button-shaped Persian Gulf pearls surrounded by diamonds were signed by Raymond Yard (c. 1920).*

(BELOW) *Malachias Geiger's 1637 engraving shows his interpretation of four methods of pearl harvesting used in various parts of the world—seining for "swimming pearl oysters" in Perimudam, using dip nets to catch fish that have eaten pearl oysters in the Caribbean, diving for pearl oysters in the Persian Gulf, and wading for pearl mussels in Scottish rivers.*

the world's pearls.[8] Moreover, this phenomenal productivity was seemingly inexhaustible. The Persian Gulf produced very large quantities of pearls for several thousand years, and had done so without interruption. Unlike pearl beds almost everywhere else, the pearl oysters here seem never to have experienced long periods of scarcity during which their populations, brought to near-extermination by over-fishing, slowly recovered to exploitable levels. Why this is so is not entirely clear but could involve deep-water reserve populations, beyond the reach of divers, whose reproductive activities can replenish the shallow-water beds.

Further evidence of this remarkable resource is the fact that the Persian Gulf supports a contemporary natural pearl fishery. With the introduction of scuba gear, a pearl-gathering operation was re-established in Kuwait in 1982, based on pearls from the Ceylon Pearl Oyster, *Pinctada radiata*. As of 1993, the diving fleet consisted of 25 speedboats, 3–8 meters in length, each usually with a single diver. For the monitored year 1989, approximately 6,300,000 pearl oysters were harvested.[9]

The Red Sea, between Arabia and Africa, and the Gulf of Mannar, between India and Sri Lanka, had close Persian Gulf connections. In the southern Red Sea, pearl fishing in recent centuries was done from *dhows* from the Persian Gulf with 20–80 men or from smaller local Bedouin boats called *sambuks* with 6–25 men. The actual diving was done from two-man dugout canoes

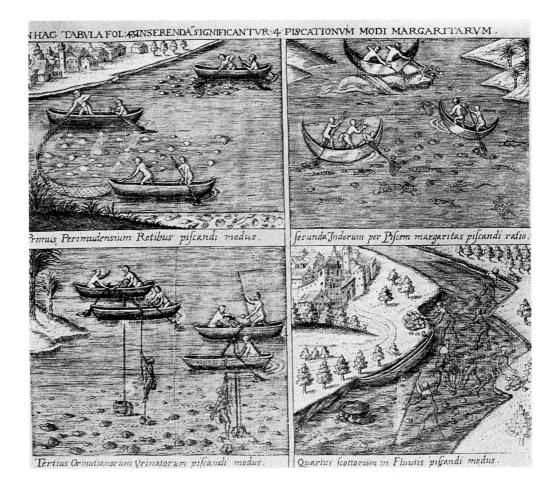

N HAC TABVLA FOL. 43 INSERENDA SIGNIFICANTVR 4 PISCATIONVM MODI MARGARITARVM.

Primus Perimudensium Retibus piscandi modus.

secunda Indorum per Piscem margaritas piscandi ratio

Tertius Ormutianorum Vrinatorum piscandi modus.

Quartus scottorum in Fluuiis piscandi modus.

called *uri*.[10] The divers were either slaves from the interior parts of Africa or free Danakils from the Somali coast. In deep water, they used diving methods much like those practiced in the Persian Gulf. But in shallower water of 5–7 meters, they used a waterglass—a box with a glass bottom to locate the clams—and a short stick of iron or hardwood to pry them loose from the ocean floor.[11] The differences in methods could be partly due to the presence of two separate species of pearl oysters, the smaller *bil-bil* (*Pinctada radiata*) and the larger *sadaf* (*Pinctada margaritifera*).[12] The *bil-bil* is thinner-shelled and produces numerous, smaller pearls, while the thick-shelled *sadaf*, sought primarily as a source of mother-of-pearl, produces fewer larger ones. Some sources said that the quality of natural Red Sea pearls was very high. They were "whiter than either Gulf or Ceylon pearls and with a stronger luster."[13]

The Gulf of Mannar must have already been fished for pearls in the early first millennium C.E., when major civilizations emerged in Sri Lanka and southern India. However, these pearl banks did not become historically prominent until about 1000 C.E., when Arab and Chinese travelers noticed them. In the 1060s, the Chinese geographer Zhou Chufei described the pearl fishery of Si-nan (later Ceylon or Sri Lanka):

> *Whenever pearls are fished for they make use of thirty or forty boats, with crews of several dozens of men to each. Pearl-fishers, with ropes fastened around their bodies, their ears and noses stopped with yellow wax, are let down into the water about 200 to 300 feet [61–91 meters] or more, the ropes being fastened on board. When a man makes a sign by shaking the rope, he is pulled up. . . . What the pearl-fishers call "pearl's-mother" is under the control of officials, who keep a register in which the finds of shells are entered under the names of the fishermen, in the order in which they occur.*[14]

In later centuries, the Mannar pearl banks were exploited by boats ranging from dugout canoes to big cargo lighters.[15] Some seem to have been specialized diving barges—open one-ton vessels with very shallow draft, 14 meters long by 2 meters wide.[16] Crews averaged 20–30 men, including a master, pilot, water bailer, government inspector or "boat guard," and about ten divers

*A pearl diving scene in Ceylon from an 1813 treatise shows divers, dredges, and merchants, with (at top) the two kinds of pearl oysters (*Pinctada radiata and P. margaritifera*), separated by a large, pear-shaped pearl.*

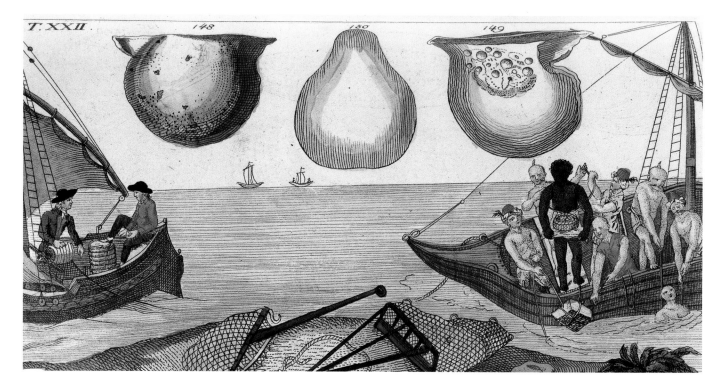

This detail comes from the earliest known depiction of pearl diving in the Persian Gulf, from the Catalan Atlas, *drawn in Majorca, Spain, in 1375.*

with one rope tender each. According to some sources, pearling vessels also had shark charmers on board.[17] Diving equipment included a mesh collecting bag and a rounded pyramidal stone weight. Tavernier wrote that Mannar divers used a series of three ropes—one for the diver, one for the sinkerstone, and one for the shell bag.[18]

It is not surprising that the diving methods practiced by Mannar pearlers resembled those used by their Persian Gulf colleagues, for there were close connections between the two fisheries. First, pearling vessels from the Persian Gulf often came to Mannar to fish. Second, the primary pearl oyster in both areas was *Pinctada radiata*, which would have had similar life habits in the two locations. Finally, both fisheries belonged to the same commercial system, dominated by big pearl merchants in Bombay and controlled by the same governments, i.e., the Portuguese in the seventeenth century and later the Dutch and British.

The differences in pearling between the Persian Gulf and the Gulf of Mannar lay in conservation, governmental regulation, and commercial centralization. The Persian Gulf had an effective conservation system that allowed for sustained harvesting over decades and centuries, dominated by small- and medium-sized enterprises, with virtually no governmental interference. In contrast in the Gulf of Mannar, periods of uncontrolled overcollecting were punctuated by decade-long breaks of depleted pearl oyster populations. Mannar pearling was tightly regulated by the government and, for much of its history, entirely in the hands of one or two wealthy businessmen.

A last difference was in the method of pearl extraction. While Persian Gulf pearlers opened their pearl oysters on board ship, those on nearshore Gulf of Mannar banks returned to port each night with the pearl oysters unopened. Government regulators could thus ensure that the divers and crews did not remove pearls while still at sea. In port, the unopened shells were divided between the government and the boat owners, each of whom would add the day's take to his own carefully guarded pile on shore, and left to rot. All observers, from the early Chinese geographers on down, remarked on the impressive odor:

The odour from these heaps attracts myriads of flies, which lay untold eggs on the oysters. The maggots that emerge eat out the flesh of the oysters within 7 to 10 days . . . ; the more flies, the quicker is the process. At the end . . . nothing remains except the shells, some sand and dirt, and whatever pearls there may be. . . . During the "rotting" process the stench given out by the heaps is overpowering and most nauseating to those unaccustomed to it. . . .[19]

The rotting technique was used occasionally in other areas. However, only the Sri Lankans and southern Indians seem to have used it extensively, despite criticism from the seventeenth-century gem trader Jean Baptiste Tavernier, who claimed that it turned the pearls yellow.[20] The technique was so unpleasant that pearl processors were actively persecuted by their neighbors.[21] We can presume that rotting would have been less widely used in Mannar if the risk of thievery were lower, as it was in the profit-sharing fisheries of the Persian Gulf.

The Indian Ocean coastline of East Africa also includes pearl banks that apparently were never exploited on a significant scale. From the ninth century on, this region was visited by Arab traders who must have searched for pearls.[22] Kunz and Stevenson quoted nineteenth-century European entrepreneurs as claiming that rich new pearl industries could easily be established there.[23] This never materialized, suggesting that accessible pearls were limited. Nevertheless, the medieval Persian scientist al-Biruni (c. 1030 C.E.) mentioned a link between the Gulf of Mannar and Sofala on the southern coast of East Africa:

In former times there were pearl banks in the bay of Sarandib [Sri Lanka] but at present they have been abandoned . . . other pearls have been found at Sofala in the country of the Zanj, so that people say that the pearls of Sarandib have migrated to Sofala.[24]

In the eyes of traditional pearl traders, the Persian Gulf, Red Sea, and the Gulf of Mannar (plus East Africa) represented a single commercial

(ABOVE) *An Australian pearling lugger heads for the pearl oyster grounds at Eighty Mile Beach off Western Australia (1970s).*

(LEFT) *The gear of each of these pearl shell divers off Broome, Australia (early to mid-1900s), included a copper diving helmet and breast-weight weighing a total of about 200 kilograms.*

system.[25] Divers in these regions, if not members of local ethnic groups, were often Arabs from the Persian Gulf. The dominant merchants were Hindus and Muslims based on the western coast of India—in Bombay, Goa, and perhaps Surat. Quality pearls from anywhere in the western Indian Ocean seem to have passed through the hands of these merchants, who financed much of the diving and whose customers included the world's wealthiest and most pearl-interested clients. As noted by Tavernier in the 1600s:

> Many are astonished to learn that pearls are transported from Europe, where they are very abundant, to the East, but it should be noted that in the fisheries of the Orient, pearls do not attain the same great weight as do those in the West. . . . [26]

Southeast Asia

A number of other marine pearl fisheries were exploited in the centuries before European contact. The most important was a Southeast Asian group, which represented a pearling tradition quite distinct from that of the Indian Ocean. Three centers were involved: the Mergui Archipelago of Burma (now Myanmar), the Leizhou Peninsula of southern China, and the Sulu Islands of the southern Philippines. With long histories of reasonably continuous use, these areas supplied pearls to markets that lay outside the sphere of the Bombay-centered commercial system that controlled the bulk of the world's pearl trade.

The least important of the three Southeast Asian centers was the Mergui Archipelago. Originally, Mergui divers were nomadic sea gypsies, members of the Malay-speaking group known as the Mawken. The divers—both men and women—lived in their boats with their families year-round. Their targets were Gold-lipped Pearl Oysters (*Pinctada maxima*), trepang (sea cucumbers, relatives of starfish), and a variety of other commercial sea products.[27] Pearls probably represented only a minor percentage of their annual harvest. While it is unclear whether the Mawken were free, dependents, or slaves of other ethnic groups, there is no doubt that they occupied a legally inferior position with minimal rights and social prestige.

Starting in the late 1880s, pearling vessels from the northwestern Australian fishery, using advanced techniques with air pumps and diving helmets, began to visit the Mergui Archipelago. The British colonial government leased pearling rights to specific parts of the Archipelago starting in 1898, and by the mid-1900s, over-harvesting in shallow water had forced the divers, mostly Japanese and Filipinos, to depths greater than 27 meters.[28] This ended free pearl diving by the Mawken. As far as we know, neither the Mawken nor any other Burmese group with a traditional pearling background is associated with contemporary perliculture ventures.

The Sulu pearl fisheries of the southern Philippines, also harvesting *Pinctada maxima,* are better documented than those at Mergui. The earliest mention is by Wang Dayuan (1349) who wrote that "Su-lu" pearls were white, round, valuable, and in demand among Chinese.[29] In 1770, the British traveler Alexander Dalrymple seems to have been the first outside writer to witness actual diving by Sulu peoples. They dived from small boats of two or three persons, swam to the bottom head-first rather than feet-first using stone weights and wooden goggles, could collect in depths as great as 27 meters, and were often attacked by sharks and "sea-devils" (rays). Dalrymple also mentioned use of the *palit,* a dredge with long forward-projecting wooden teeth for collecting pearl oysters.[30] Streeter, writing in the 1880s, was also an eyewitness, and confirmed the regular use of such dredges and the fact that the divers were either slaves or members of the Bajau ethnic group.[31] Originally controlled by individual families, the Sulu pearl banks were ultimately "free to all persons, even strangers . . . because the universal admission of Mahometan Law, the sea being deemed incapable of such a propriety."[32]

The Bajaus (or Badjaos), sea nomads treated as pariahs of very low social status but not actual slaves, were the main pearl divers of the Philippines.[33] Most were non-enslaved retainers of high-status individuals, especially the Tausug overlord, the sultan of Sulu. Diving was conducted individually or carried out by large groups assembled for the purpose—a nineteenth-century Spanish source described a pearling expedition of two thousand fishermen (more than two hundred boats) led by three Tausug noblemen.[34] The sultan and his lords claimed any large pearls that were found. Although slaves could earn their freedom by finding an especially large pearl, Bajau divers were not always con-

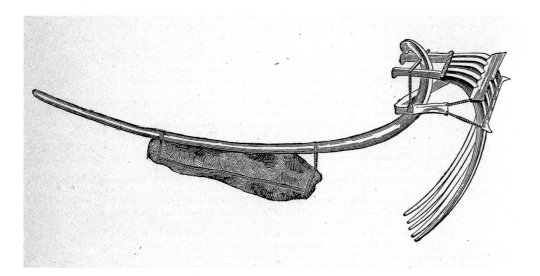

tent to turn over their pearls to the authorities. In 1770, Dalrymple noted "to evade the right of the lord . . . [they] frequently rub off the outer coats of the pearl, till they reduce them to the size to which they are entitled."[35]

Unlike the Mawken of Mergui, the Bajau of Sulu are still deeply involved with pearl fishing, having the diving skills and traditional rights to the pearl beds that yield the big shells needed by modern Filipino perliculturists. They still free-dive to depths well beyond the safe limits of normal scuba diving. The French writer Christophe Loviny's description of a Bajau pearl diver named Masa, armed with only homemade goggles, a rope, and a hand-held weight, is one of the few published observations of an expert traditional breath-holding diver:

He plunges and disappears like a torpedo into the deep blue, pulled down swiftly by a heavy lead weight. Equipped with air tanks, we follow him with difficulty, despite our fins. Soon we can no longer distinguish him in the plankton-rich water, but thanks to the rope that ties him to the boat it will be impossible to lose him. Our depth gauge indicates 60 meters. To continue our descent would be to court danger. He must be deeper! We wait anxiously as seconds pass. Finally, the rope shakes, a signal from Masa for his buddies to pull him back up. Hoisted up by his companions, who have remained on the boat, Masa surges past us as fast as he dove.

He gestures to me with the huge oyster that he has picked up on the bottom. . . . [36]

The third center of Southeast Asian pearling is the Leizhou Peninsula and Hepu county in southern China. Here diving involved yet another pariah ethnic group, the Danjia, known to Westerners as the Tanka "boat people."[37] Both men and women participated, with the women handling the boats while the men dived.[38] By the third century C.E., pearling in the Leizhou-Hepu area had become a state monopoly, and this continued through successive dynasties except briefly in the twelfth century when private diving replaced government-controlled operations.[39] An early Chinese encyclopedia complained about divers opening shells underwater and concealing pearls in their mouths.[40] In 1637, the technical writer Song Yingxing described special barges, wider and rounder than ordinary vessels, with windlasses to haul up the Danjia divers. They dived with ropes around their waists and wore a sort of helmet with "open end of a curved tin pipe attached to their noses and mouths, enabling them to draw breath."[41] Song's illustration shows these pipes as short and shaped like cow's horns, suggesting that they functioned like modern snorkels.[42]

The Leizhou-Hepu pearl fishery was apparently active from the first century B.C.E. to the seventeenth century C.E. As a result of the practice of various Chinese governments of exiling dissident intellectuals to Hainan Island, just south of Leizhou, a number of written descriptions exist of pearl diving over the years, among them the *Ballad of the Pearl Divers* by Yuan Zhen, an eighth-century poet:

(ABOVE) *A Sulu pearl dredge of heavy wood, weighted with a large stone. In use in the southern Philippines until after 1900, such dredges were dragged along the sea floor in such a way that pearl oysters would clamp themselves on the prongs, allowing their capture.*

(OPPOSITE) *Danjia pearl divers in the Leizhou-Hepu area of southern China. Each diver wears a tin snorkel and is raised to the surface by ropes attached to a winch. Often redrawn and reprinted, the first version of this woodcut appeared in the 1637 edition of Song Yingxing's famous technological treatise* Tiangong Kaiwu.

*Sea waves—no bottom—and the pearls
 sunk in the sea;*
*And men who gather pearls—doomed to
 death by gathering.*
*Of a myriad men doomed to death—one
 finds a pearl;*
*A bushel measure will buy a slave girl—
 but where is the man?*
*Year after year they gather pearls, but the
 pearls have fled from men;*
*This year the gathering of pearls is left to
 the god of the sea.*
*The sea god gathered pearls until every
 pearl is dead;*
*Dead and gone the shining pearls, empty
 the waters of the sea.*

*Pearls are creatures of the sea, and the sea
 is subject to the god;*
*The god now freely gathers them—but how
 many more men!* [43]

Yuan poignantly alludes to human suffering due to over-harvesting, which seems to have happened periodically during the history of southern China. While officials in charge of regulating pearl diving were blamed, sharply increased quotas imposed by the central government often must have been the real cause.[44] It is unclear whether a final, climactic over-harvesting incident occurred during the seventeenth century or whether the new rulers of China simply preferred freshwater pearls from Manchuria, their ances-

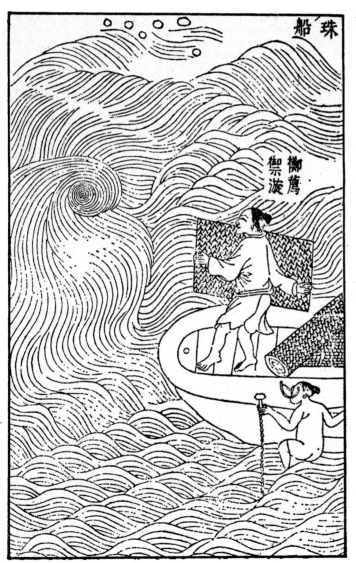

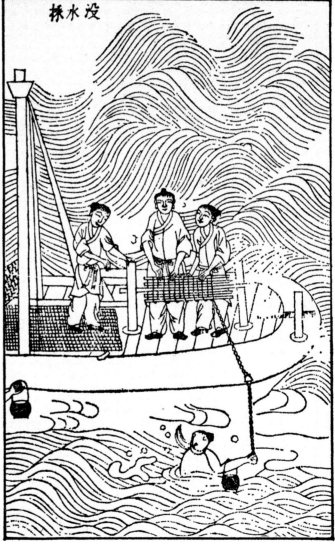

tral homeland.[45] In any case, there was little pearling in Leizhou-Hepu after 1700.[46]

Other Marine Pearl Fisheries

Outside these two major pearling regions, the rest of the world saw relatively little marine pearl production before the period of European expansion. As the preceding chapter shows, pearls were not greatly prized by all of the world's peoples. The Japanese, Polynesians, Australian aboriginals, and pre-Columbian peoples of Middle and South America all used pearl shell more or less extensively. However, they showed very little interest in actual pearls.

It is especially hard to imagine that Japan, at the center of international pearl trade for the previous century, was a very minor pearl source for most of its history. While the Japanese had long acquired small numbers of pearls from the local Akoya Pearl Oyster (*Pinctada fucata*), they did not show real interest in gathering pearls before development of the Chinese export market in the eighteenth century. The famous *ama* female divers, for instance, were diving mainly for abalone. As late as the 1880s, Tavernier wrote "There are, finally, on the coast of Japan pearls of very beautiful water and quite large size, but they are very irregular (baroque); in any event, they are not fished for, because . . . the Japanese do not esteem them as jewels."[47]

Two parts of the Americas did have pre-European marine fisheries that placed at least some emphasis on pearls as well as shells–the Caribbean coast of Venezuela and the Pacific coast of Central America. Before the arrival of Christopher Columbus and the Spanish in the late fifteenth century, the Indians of coastal Venezuela and Panama showed a liking for pearls, which they dived for and wore but did not value excessively.[48] Later, around 1523, the Spanish conquistador Hernando Cortés received gifts of pearls from the Aztec chieftain Montezuma, which Cortés learned came from the western coast of Mexico along the Gulf of California. In the eyes of most early inhabitants of the tropical Americas, pearls were much less important than shells, especially those of pearl oysters and the brilliant orange shells of thorny oysters (*Spondylus*). As pointed out in the preceding chapter, whole and fragmentary shells of these species are found at most archaeological sites in highland Mexico and northern South America.

Polynesia furnishes another example of traditional indifference toward pearls. Colorful, romanticized, and famous for the diving skills of their men and women, the Gambier and Tuamotu Islands of eastern Polynesia are for many Europeans the very heartland of pearls and pearl diving. And yet, despite isolated cases like that of the Tahitian girl and Joseph Banks cited in Chapter 5, Polynesians of pre-European contact do not seem to have been particularly interested in pearls. For them, the attraction was the mother-of-pearl shells, from which they carved ornaments, fishhooks, and inlay. Interestingly, the first European traders to reach the Central Pacific in the 1820s were also more interested in pearl shells than in pearls. By the time the French took control of the islands in 1880, Polynesians were diving for pearl shell so intensively that pearl oysters were in danger of being wiped out. The new colonial government cited conservation as the reason for introducing a restriction or *rahui*, forbidding pearl diving on all but a handful of pearl beds each year.[49]

The Polynesians were excellent divers, descending headfirst to considerable depths with only a pearl shell for use as a knife, a coconut fiber sack, and a wrapping to protect the left hand.[50] Because diving suits were forbidden in the Tuamotus after 1892, free-diving for pearl shell survived as an economic activity until the 1950s. As the Swedish ethnographer Bengt Danielsson described it, entire families would migrate to atolls that had opened for pearling that year. Diving by both men and women was done from small outrigger canoes that, because of the layout of coral atoll lagoons, never had to go more than a few kilometers from the fishing camp.[51]

It is only in the previous forty years that Polynesians have begun to focus on pearls rather than pearl shells, with the lucrative rise of periculture using the Black-lipped Pearl Oyster (*Pinctada margaritifera*). The lagoons where pearl shells were formerly gathered have been taken over by pearl farms, and cultivated pearls are a major factor in the economic life of many islanders.

In Australia, pearls were also not esteemed, and pearling, even for pearl shell, was not prac-

A Mexican pearling fleet in a 1914 photograph taken off La Paz during the height of Baja California pearl fishing. The fleet usually consisted of a "mother boat" brigantine and several canoes.

ticed until the arrival of European traders and colonists. After a brutal initial period of free diving by forcibly recruited aboriginals, Indonesians, and Filipinos, pearl gathering after about 1890 was done by divers in copper helmets and rubber suits.[52] Operations in both main pearling areas, the northwestern coast and Torres Strait, used mother ships of about one-hundred tons plus a number of smaller ships or *luggers*, each with one diver, a tender, and several men at the air pump.[53] The crews of the luggers seem to have been an international lot, including "Japanese, Malays, Chinese, Arabs, native aboriginals and South Sea Islanders."[54] Some of the divers were Filipino *Manila men* but most were Japanese, often from Taiji Province.[55]

Diving helmets continued in use by Australian pearlers from the 1880s to the early 1970s. The perception that Japanese and Filipino divers were better able to use them led to a relatively independent class of professional non-Australian divers, who earned good money and had some influence on the development of the industry. In Torres Strait, for instance, the divers were in such a strong position by 1900 that they could treat the pearls that they found as perquisites of their job, and as a result, their employers were receiving much shell but no pearls.[56] As in Polynesia, perli-

culture now operates in many of the same places using much of the same equipment formerly used for gathering pearl shell.

HARVESTING FRESHWATER PEARLS

Pearls and pearl mussel shells from rivers and lakes in the temperate parts of North America and Eurasia have also played an important part in the history of pearls. Julius Caesar is said to have invaded Britain in 55 B.C.E. to gain control of its pearl-producing rivers. The Manchu rulers of China during the Qing dynasty (1644–1911) actually preferred freshwater pearls from their native Manchuria to the marine pearls of Leizhou. And in the early 1900s, the pearl rivers of the Mississippi drainage ranked among the world's leading producers of commercial pearls. Three regions had important freshwater pearl industries before the twentieth century: northern Europe, eastern Asia, and eastern North America.

European Freshwater Pearls

The widespread pearl mussel *Margaritifera margaritifera* occurred in most larger streams in temperate parts of the Eurasian landmass, and much has been written on its natural pearls.[57] Pearls were harvested in many European countries and

numerous fine examples survive as part of royal European regalia.

Scottish pearls are perhaps the best-known European freshwater pearls, and several periods of intense harvesting are on record. One was prompted by the discovery in 1620 of a "great" pearl in Aberdeenshire, which was sent to King James I. In 1621, the Privy Council of Scotland responded by proclaiming that all pearls found in Scotland belonged to the Crown. Harvesting was limited to July and August and the Crown claimed the "best for bignesse and colour." The first year's harvest resulted in both large quantities of pearls and the discovery of new beds.[58] Between 1761 and 1764, pearls worth £10,000 were fished from the River Tay and shipped to London. By 1769, the pearl mussel populations had been depleted, and no new Scottish pearls appeared on the market for a hundred years.[59] In the 1860s, a German dealer buying pearls from local country folk prompted another pearl rush. In the summer of 1864, the pearls from Scottish rivers reportedly netted fishermen £12,000. Queen Victoria's taste for these pearls sustained this industry, and while over-fishing depleted many beds rapidly, others survived. In the early years of the twentieth century, pearls were still being harvested in commercial quantities from the Rivers Tay, Earn, Teith, Dee, Don, Ythan, Spey, Findhorn, Doon, and Nith.[60] One of the most spectacular Scottish pearls—a 43-grain specimen

known as "Little Willie" or the Abernethy Pearl after its discoverer, local pearler Bill Abernethy—was discovered in the River Tay in 1967.[61]

Pearling in Germany is particularly well documented, but far less known. Large numbers of European pearl mussels were harvested for pearls during the height of the German pearl fishery in the sixteenth century. In the nineteenth century, documents for the period 1814–57 show a harvest of 159,000 pearls from Bavarian rivers alone.[62] This is an amazing number, considering that only one pearl was found for every one hundred pearl mussels, with only one in 2,700 a good one.[63] Most importantly, European Pearl Mussels were not killed during the search for pearls, but instead were carefully opened and examined before harvesting. In Saxony, this process was done with a bent, pointed, 25-centimeter implement, the *Muschelschlüssel*, or mussel key, while Bavarian pearl fishers used a more elaborate tool, the *Muschelzange* or mussel tongue. Pearl fishers often worked alone because examination of the pearl mussels was considered confidential. "Promising" pearl mussels were often identified by shell deformities caused by the growing pearls:

> . . . it is seldom that a mussel of perfectly normal and regular shape contains a pearl. The fishers claim that three characteristics of the outside of the shell indicate the presence of pearls, namely: 1. Grooves or ridges

Early German instruments used to examine freshwater Margaritifera margaritifera *for pearls. From Malachias Geiger's* Margaritologia *of 1637, a book that deals exclusively with the medical applications of the pearl mussels in Bavaria.*

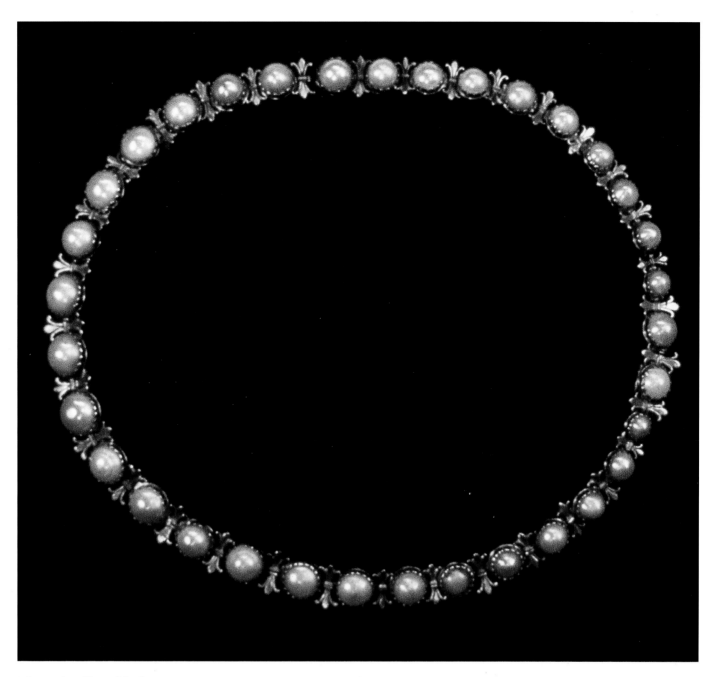

The royal necklace of freshwater Scottish half-pearls was once owned by Mary, Queen of Scots.

from the beaks to the margins [the "Perl-zeichen"]; 2. A kidney-shaped outline; 3. The asymmetry of the valves with regard to the median vertical plane of the animal.[64]

Pearl mussels with small or insufficiently developed pearls were often marked with the date of inspection scratched on the shell, then left for future harvesting. Only when a pearl was considered "ready" for harvest would the adductor muscles of the clam be cut and the pearl extracted.[65] Managers displayed a patience that spanned generations:

Bruno Rudau reported the harvest of a particularly beautiful pearl in 1868 whose shell carried the date 1801. This careful monitoring and selective harvesting explain the surprisingly high ratio of high quality pearls—Saxony's Vogtland region harvested a total of 21,396 pearls between 1719 and 1913, of which 12,932, or 60 percent, were of high quality.[66]

The European pearl fishery was important enough to warrant experiments in transplanting populations across political borders. In 1769, Duke Karl Theodor of Palatine asked his Bavarian counterpart Maximilian III for four hundred

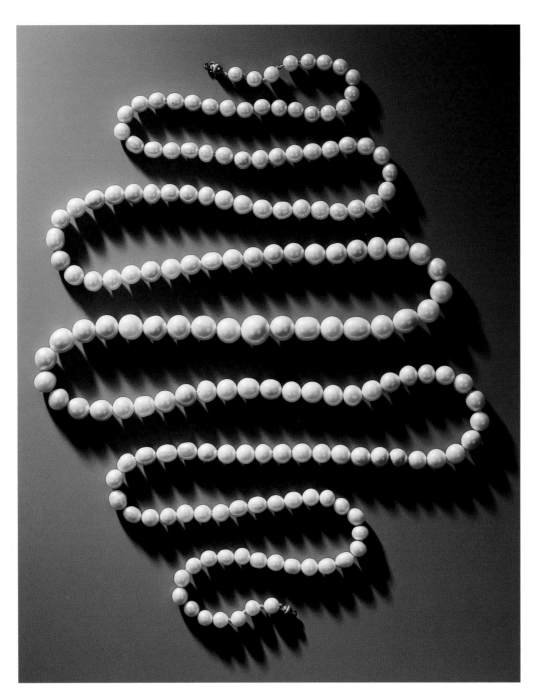

(LEFT) *A necklace of 177 of the highest-quality European freshwater pearls, selected from the crown jewels as formal regalia for Maria Amalia Augusta, wife of Duke (and later King) Friedrich August III of Saxony.*

(ABOVE) Perlen-Sucher in seinem Wasser-Habit (Pearl Searcher in His Water Outfit), *a historic representation from Germany's Vogtland. Wooden tongs were used to retrieve mussels from shallow streams.*

(OPPOSITE) *Queen Marie of Bavaria, wife of King Maximilian II, who reigned from 1848-1864. The Queen is wearing a necklace of large natural freshwater pearls harvested from Bavarian streams. Painted between 1823 and 1850 by Joseph Stieler.*

living pearl mussels, resulting in a rare successful transplantation from the Danube to the Steinach River.[67] Saxony's pearl fishing specialists were also "borrowed" by other royals—and thus spread their expertise to other German states (e.g., Hessen), and as far away as Norway and Russia.[68]

Asian Freshwater Pearls

Freshwater pearls in eastern Asia came from two distinct areas, central China and a region that included northeastern China and southeastern Siberia. Each had a different climate and a different kind of pearl mussel. The traditional fishery of northeastern China, eastern Siberia, and northern Korea was based on several species of pearl mussels similar to *Margaritifera margaritifera* of northern Europe and the eastern United States.[69] The fishermen were tribal peoples, who dived for them, sometimes through the ice, on the beds of fast-flowing streams. Often the pearls were sent as tribute to regional governments, especially that of China.[70]

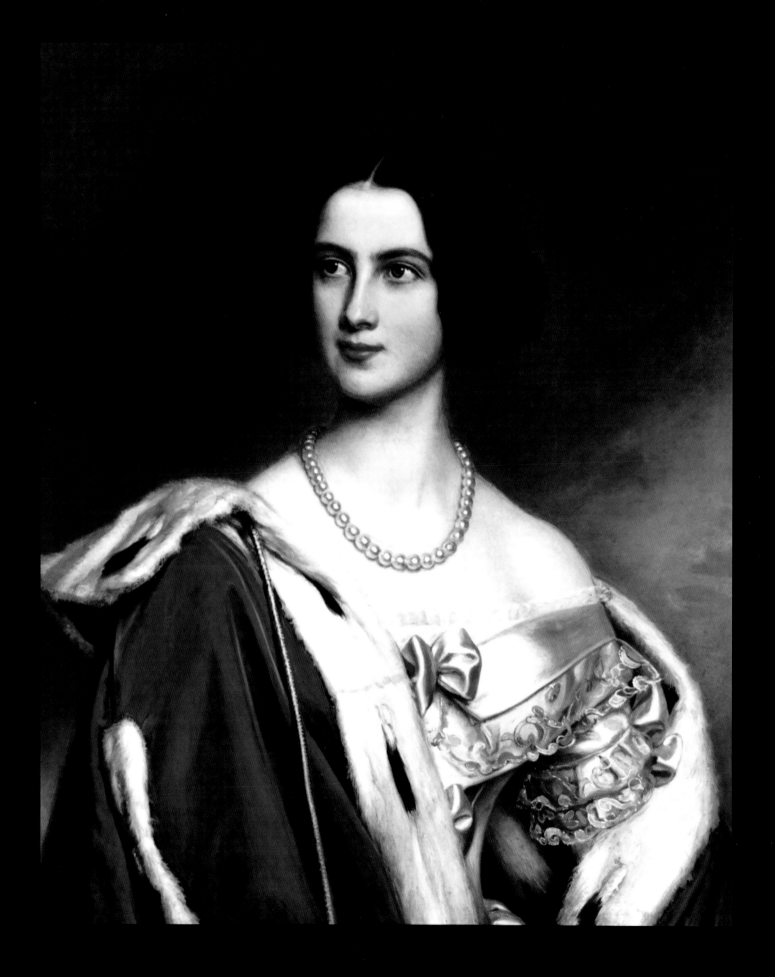

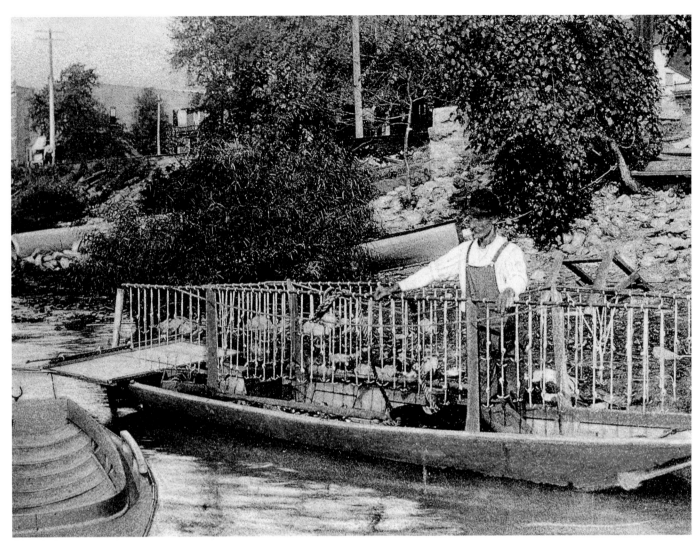

Fishing with "crow-feet," around 1915. American musselers used triple hooks to harvest pearl mussels in the Mississippi region, a method still used in a few locations today.

The pearl mussels of central China belong to two other genera, *Hyriopsis* and *Cristaria*. Both have long been protected and encouraged in the wild state, although full domestication through hatchery rearing is a modern development. In central eastern China, farmers fished for them in fall and winter, for which fees were paid to the owners of the lakes and streams. By the fifth century, wild-caught pearl mussels began to be used for producing nacreous Buddha figures and semi-detached round pearls. By the nineteenth century, this industry had matured to the point where it was essentially farming. The pearl mussels were kept in shallow canals and ponds, protected and fed, in part with liquefied "night-soil."[71]

North American Freshwater Pearls

Nothing is known about pearl-gathering techniques among the prehistoric Indians of the Mis-sissippi River and its tributaries. Great quantities of pearls found at sites of the Hopewell culture in present-day Ohio confirm that pearling was carried on intensively. High demand by the Hopewell elite must have placed severe stress not only on local pearl mussel populations but also on the human inhabitants of the Ohio River drainage coerced to keep the pearls coming. The Hopewell pearl boom ended before 200 C.E.

The existence of commercially valuable pearls in the United States was not recognized by European-Americans until the mid-nineteenth century. The initial discovery is supposed to have been a 400-grain pearl found in the 1850s by David Howell of Paterson, New Jersey. Various stories relate that he was either making a stew for himself or cooking swill for his pigs. In either case, the enormous pearl was valueless, having been ruined by the heat. Then, a few months later, a

Boepple: Muscatine's Pearl Button Maker

John Frederick Boepple (1854–1912) began as a lathe worker and button maker, producing horn buttons and other objects in his workshop near Hamburg, Germany. As was customary in the European button industry, he experimented with seashells of various Pacific origin as raw material and around 1872 was given a box of North American freshwater pearl mussels. He found them particularly suitable for button production because of their thick layer of mother-of-pearl. After the death of his wife, facing inflation and prohibitively high taxes on raw materials, he moved to the United States in search of a source of good button shells, equipped only with the information that his specimens came from a river two hundred miles southwest of Chicago. He arrived in March 1887 and, after investigating several rivers in Illinois, ultimately settled in Muscatine, Iowa, where he "found the right kind of shells." He started producing mother-of-pearl novelty items, using the proceeds from the sales of occasionally encountered pearls to buy tools and materials. In 1890, when the protective McKinley tariff made imported pearl buttons expensive in the United States, Boepple began producing mother-of-pearl buttons too, cutting them with a water-lubricated sawdrill (below). He thus transformed a small Iowa town into the "Pearl Button Capital of the World."

Boepple launched his first button factory in Muscatine in January 1891 in the basement of a shop, but quickly fell out with his partners. A year later, he founded the J. F. Boepple Company, and in a short time employed more than one hundred people. Former employees quickly copied his button-making methods and other companies owned by eastern importers sprang up, with no fewer than thirty-six enterprises established in the first six months of 1898. Boepple was a master craftsman but a poor businessman, and his own success was short-lived. Resisting automatization of his plant and embroiled in legal battles with former partners, he ultimately lost the use of the Boepple company name and most of his financial interest in the factories. By 1909, he held a government position as a shell expert at the Fairport, Iowa, fisheries station. Here he was involved with assaying the quality of pearl mussels in various river systems, with trying to reseed depleted riverbeds with hatchery stock, and with developing less destructive collecting techniques. The man who started the boom but faltered in his own business had become a spokesperson for conservation. In an ironic twist of fate, Boepple died in January of 1912 from a foot infection caused by a cut (on a pearl mussel shell?) acquired while wading in an Indiana river—on the first day of a pearl button workers' strike in the city.

(ABOVE) *Freshwater pearl mussel shells from which button blanks (second row) have been cut, including a Pistolgrip* [Tritogonia verrucosa (*Rafinesque, 1820*); *upper left*], *a Pimpleback* [Quadrula pustulosa (*Lea, 1831*); *upper right*], *a Round Hickorynut* [Obovaria subrotunda (*Rafinesque, 1820*), *middle left*], *a Yellow Sandshell* [Lampsilis teres (*Rafinesque, 1820*), *middle right*], *and a large Washboard (*Megalonaias nervosa; *lowermost*).

(BELOW) *John Frederick Boepple works at his button-making lathe in the late 1800s.*

The United States Freshwater Pearl Button Industry

Parallel to the history of pearl harvesting, the freshwater pearl button industry in the United States developed with little regard for molluscan populations, and benefited from the initial abundance of natural resources and cheap local labor. The shells used for high-quality buttons needed to be flat and large to yield as many "blanks" (the first coin-shaped stage of button production) as possible, completely white, preferably iridescent, with a firm but not too hard consistent texture, a smooth surface, and uniform thickness. In addition, and most importantly, the pearl mussel species had to be abundant and accessible with the collecting methods commonly employed. In 1916, the peak year in button production, U. S. factories, primarily based in Iowa, New York, and New Jersey, turned out forty million gross (about six billion) buttons with a product value of $12.5 million, and employed 9,500 factory workers, 9,700 musselers, and nearly 600 shoremen and boatmen. The industry also spawned several supporting industries such as toolmakers and a cottage industry of women sewing buttons on display cards.

The immense demand for large quantities of pearl mussels rapidly depleted local fishing grounds, and the attempts of the United States Bureau of Fisheries to reseed the rivers by releasing fish with the glochidial larval stages of pearl mussels were met with little success. In Iowa alone, an estimated two million kilograms of pearl mussels were harvested in the year 1928. Calculating the relatively large number of twelve usable buttons from a single shell valve, or twenty-four per pearl mussel, the forty million gross buttons of the 1916 production year must have consumed 280 million pearl mussels. Only the shells were used on a regular basis—the cooked-out "meat" was occasionally used as hog feed, fertilizer, or just dumped into the river. The waste shells, after the button blanks had been cut out, were used for fertilizer or ended up as road fill.

The United States pearl button industry enjoyed several decades of success, although it faced major competition with the Japanese, who entered the U. S. market in 1908 with buttons from Chinese pearl mussels and marine snails (*Trochus*), at a fraction of the U. S. shell or labor costs. This, combined with dwindling pearl mussel supplies, poor industrial relations after a 1911–12 strike, and inevitable changes of fashion after 1913, brought on a slow decline in the industry. In 1923, protective tariffs against Japanese button imports brought a short reprieve but could not overcome the latest enemy: the invention of the zipper. As everywhere else, the ultimate demise of the United States pearl button industry came with the advent of plastic buttons in the 1940s.

This however, did not end the North American pearl mussel shell use for industrial purposes. With the decline of the button industry, the shells remained a sought-after source for the nuclei for cultured pearls—and so United States freshwater pearl mussels have experienced it all, having been collected for food, for pearls, for button shells, and for nuclei.

neighbor, Jacob Quackenbush, found a smaller but perfect pink freshwater pearl that he sold to Charles L. Tiffany. Later known as the "Queen Pearl," this find made the reputation of American pearls and stimulated enormous interest in freshwater pearls in this region. Although the ensuing pearl rush on the Atlantic seaboard ended quickly, it spurred widespread exploration of American stream beds, which in turn led to rapid development, first of casual pearl hunting, then of systematic shell harvesting.

By the 1880s, the extent of pearl fishery opportunities in the American Midwest became apparent, and large-scale harvesting began, first for pearls and then for pearl shell, a directly opposite pattern to those in Polynesia and Australia. The key to this expansion was the phenomenally species-rich American pearl mussel fauna, with many large and thick-shelled forms including the so-called Heelsplitter, Pimpleback, Elephant Ear, Mapleleaf, Pigtoe, Pistolgrip, Butterfly, Yellow Sand or Banana, Mucket, Pocketbook, Black Sand, Washboard, and

This brooch (c. 1900), with freshwater pearls from Wisconsin and Tennessee and sapphires from Montana, was exhibited at the Paris Exposition of 1900.

Ebonyshells.[72] The man who put this industry on the map was John Frederick Boepple, a German immigrant who came to the United States in 1887 and settled in the Mississippi River town of Muscatine, Iowa. Here he opened his first freshwater pearl button "factory" in 1891 based on the abundant and beautiful American pearl mussels. Shortly thereafter, this small Iowa town earned the right to call itself the "Pearl Button Capital of the World, outproducing more established centers in Europe, such as Birmingham, England, which had dominated button production since the seventeenth century."[73]

America's pearl button industry enjoyed several decades of success, but weakened in the 1910s and 1920s for a variety of competing factors. Although Muscatine celebrated a half-century of pearl buttons in 1946 with movie star Ronald Reagan crowning a Pearl Button Queen, the advent of plastic buttons

had already doomed the industry. Demand for pearl mussel shell fell sharply, so that most "mussel fishermen went back to farming and the pearl hunters, unable to survive on pearls alone, went back to prospecting for gold."[74]

An alternative market for pearl mussel shell, however, already existed. By the 1920s, Japanese pearl farms were importing several hundred tons of Pigtoe shells per year to be cut into nuclei to be implanted into Akoya Pearl Oysters. Japanese imports ceased during World War II but recovered rapidly afterward. Freshwater pearl mussel shell had become a major export item for states along the Mississippi by 1960. Despite growing conservation concerns, freshwater pearl mussels from the American Mississippi River drainage continued to supply the majority of nuclei for the world perliculture industry in the year 2000.

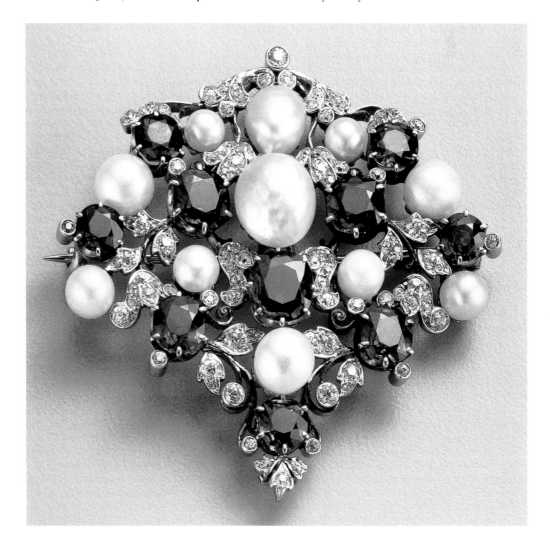

The Organization of Pearl Fisheries

Several important themes emerge from an examination of traditional pearling around the world. One is the importance of labor organization. A second is the central role played by governments in determining the success and indeed the existence of their respective pearl fisheries. And a third is the rarity of effective conservation methods.

In organizing diving for pearl-producing mollusks, entrepreneurs everywhere needed to employ highly skilled laborers for risky work, to keep wages low, and to prevent workers from stealing the pearls. These problems were not unlike those faced by managers of mines for gems and precious metals and were often similarly solved—by limiting the workers' mobility though indebtedness, government-required labor service, indenture, peonage, or actual slavery. In only a few cases—for example, hard-hat divers in Australia—were administrators forced to pay competitive wages. Almost all others, despite the seeming glamour of pearl diving, involved a great deal of oppression and misery.

In the Persian Gulf, the system was relatively democratic, with profits divided by the captain and crew of each boat. According to one formula, the divers received 30 percent, and the captain and rope-tenders 20 percent each; 30 percent went for provisioning.[75] This system could be profitable—many wealthy merchants in Bahrain were said to have started as poor divers.[76] The procedure in the Gulf of Mannar was somewhat less equitable, with the unopened pearls oysters parceled out at sea before returning to port, at a ratio of one-third to the crew, and two-thirds to the government. Many pearls oysters in the government's share were reportedly opened surreptitiously by the crew before the boats reached land, and the pearls stolen.[77] Although each boat had a guard to stop this, they often did not—"the guards simply add to the number of thieves on board."[78] In such circumstances, a skilled diver could earn 5–6 times as much as a common laborer of the time.[79] It was thus possible for pearl divers to accumulate fortunes, but most remained deeply in debt, and these debts were often passed from father to son.[80]

In the Red Sea, enslaved boys were often used as pearl divers:

The lofty Bedouins refuse to dive themselves but train their young slave-boys to the art. The slave while training, will be shown a shell at the bottom, and told to fetch it. If he fails to bring it up, he is bound to be flogged, and his very life is jeopardized; and even when he brings up the most valuable shells, scanty food is his only reward.[81]

Slaves often did the diving in Sulu in the southern Philippines as well, working alongside the free but outcast Bajau. One surmises that the Bajau were bound by annual quotas, as were imposed on the Danjia of southern China. The Danjia were treated with great cruelty by Chinese officials who in turn would be punished by their superiors if quotas were not met.[82] The Spanish in the Caribbean and Panama treated their enslaved Indians and Africans with even greater cruelty—as noted in Chapter 1, the mortality rate of pearl divers was appallingly high. And the situation was equally bad in Australia, where impressed or kidnapped aboriginals, often from inland areas without knowledge of the sea, were forced to dive for pearls to depths of 15 meters or more, or to die trying.[83]

The dangers of pearl diving were great, with a high death rate. In all pearling areas before the late nineteenth century, divers worked nearly naked, without air supply, goggles, or any equipment except a knife, a rope, a rock to serve as a sinker and—in the Persian Gulf—a nose clip made of horn. In many regions, pearl oysters were collected from depths of 8 to 16 meters, and divers faced the special risks associated with diving to these depths—the bends, or nitrogen narcosis, eye and ear problems, and so on. Some areas had particular dangers—saltwater crocodiles and stinging jellyfish off the Australian coast, sawfish in the Persian Gulf, and sharks everywhere.

The history of pearling in all but a few regions has been one of boom and bust, for both the pearl mollusks and the social systems that depended upon them. The often rapid depletion of pearls and pearl shell encouraged the development of a gold-rush mentality, where it is in every participant's interest to get as much as possible, as quickly as possible. When the pearl banks were barren, the institutions connected with pearling often disappeared completely, and the population

that dived for pearls and served the divers either moved away or turned to other work. In boom times, pearling centers resembled gold camps, with large transient populations hoping to get rich quick. Kunz and Stevenson's description of a pearling settlement in Ceylon at the turn of the twentieth century gives the flavor of such centers:

> *The population includes 8–10,000 fisher-men (Moormen, Tamils and Arabs), pearl merchants (Moormen and chetties), boat repairers & other mechanics, provision dealers, priests, pawnbrokers, government officials, koddu-counters, clerks, boat guards, a police force of 200 officials, coolies, domestic servants, women, children, entertainers—jugglers, fakirs, gamblers, beggars, female dancers, loose characters . . . Cingalese, Arabs, Moormen, Kandyans, Veddahs, Chinese, Jews, Portuguese, Dutch, half-castes, the scum of the East and the riffraff of the Asian littoral, the whole making up a temporary city of forty thousand or more inhabitants.*[84]

Similar conditions, perhaps less multiethnic but equally colorful, must have existed in other pearling centers—Hepu in China, Isla Cubagua in Venezuela, Jolo in Sulu, Broome in Australia, Papeete in Tahiti, and so on—during times when pearl mollusks were plentiful. The only partial exception was the Persian Gulf, where the long-term stability of the *Pinctada* supply might have been conducive to the formation of somewhat more stable pearl-connected institutions, and the long-lived pearling ports like Kuwait City, Manama in Bahrain, and Doha in Qatar.

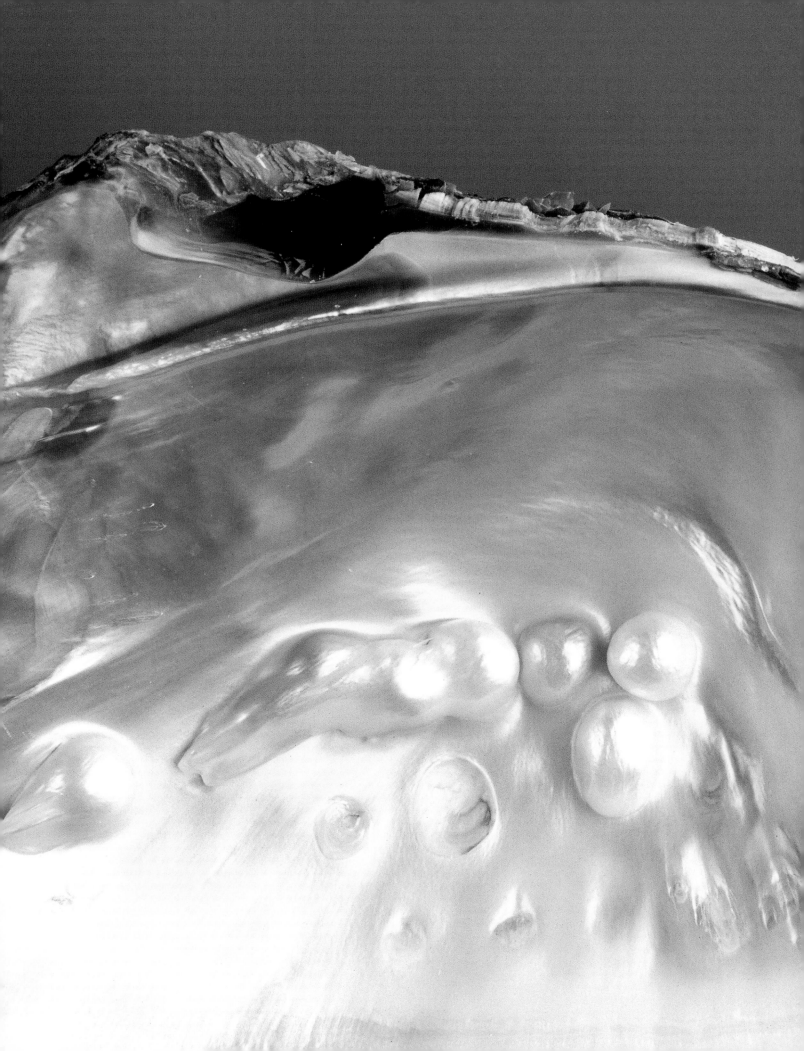

Making Pearls

THE METHODS OF PERLICULTURE

It may be that there is a future before such semi-artificial methods.

—W. A. HERDMAN, PRESIDENT OF THE
MALACOLOGICAL SOCIETY OF LONDON, 1906

The work belongs to the animal.

—ROBERT WAN, CHAIRMAN OF TAHITI PERLES, 1999

Accidental blister pearls have attached to the shell, instead of remaining free, in the "new" Chinese freshwater pearl mussel, Hyriopsis cumingii.

It is impossible in this book to cover comprehensively all of the world's pearl-culturing techniques. According to one review, thirty-two nations were involved in some stage of pearl production in 1995.[1] International perliculture is also a rapidly changing scene, and any description of current practices will be rapidly outdated. Even this brief survey will illustrate, however, how a single basic technique has been adapted to meet the varying needs of mollusks, environments, and societies.

The modern techniques of perliculture are largely Japanese innovations, developed at the turn of the nineteenth century. Kokichi Mikimoto (1858–1954) is most remembered for this achievement, not because he alone developed the technique, but because of his promotional efforts and the prestigious company that bears his name today. Mikimoto was a shrewd businessman who worked aggressively to convince the gemological community and the buying public that his cultured pearls were "real." He was not, however, the first person to

culture a pearl. The process of pearl formation had long been studied, accompanied by experiments to induce living mollusks to produce pearls. Most of these studies and experiments occurred outside Japan. Moreover, most of this research focused on freshwater pearl mussels, the "poor cousins" of the marine pearl oysters used by Mikimoto.

EARLY STUDIES AND PERLICULTURE METHODS

Despite the legendary roles played by dewdrops and moonbeams in pearl formation, serious naturalists realized very early on that only the mantle epithelial cells of a mollusk are capable of producing calcium carbonate and conchiolin to form a shell or pearl. Mantle tissue thus plays a central role in every attempt, no matter how early, at understanding pearl formation.

Apollonius of Tyana related the first tale of artificially producing pearls in the first century

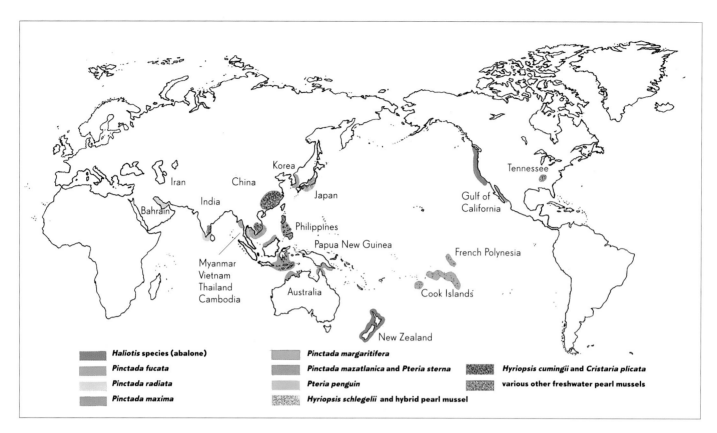

Pearl culturing areas around the world.

C.E. He described inhabitants of the Red Sea coastline pricking the bodies of pearl oysters (presumably *Pinctada radiata*) with a pointed instrument. The juice that dripped from the wound was collected in an iron mold, and allegedly turned into pearls as it hardened.[2]

The first real evidence of successful pearl production is by the Chinese, perhaps as early as the fifth century C.E.[3] They inserted various objects between the shell and mantle of freshwater pearl mussels (probably *Cristaria plicata*), returned them to the water, and recovered them a year or more later to find their insertions coated with mother-of-pearl. Thus the first cultured pearls were blister pearls. The inserted objects were whole or half-spheres of ivory, ceramic, or shell, or lead or clay, in the shape of spheres, fish, or most famously, small Buddhas.[4] As described by F. Hague in 1856 in Zhejiang Province, still the leading pearl-producing area in China, the pearl mussel was opened with a spatula of mother-of-pearl, and the shaped objects were introduced against the inner shell using a split bamboo rod. The pearl mussels were then returned to the canal or pond for a number of months. Kunz and Stevenson stated that "the mussels are nourished with equal parts of powdered ginsing, china root, peki, which is a root more glutinous than isinglass, and of pecho, another medicinal root, all combined with honey and molded in the form of rice grains."[5] Other observers claimed, less romantically, that the main pearl mussel food was human manure.[6]

At harvest, the pearlized Buddhas were cut from the shell and processed in much the same way as modern mabé pearls.[7] The practice continues today for the religious and tourist trade, with half-pearls in the form of various deities or even Chairman Mao.

Beginning in the 1700s, a number of slightly different Chinese pearl shells appeared in Europe. All seemed to show the same culturing method, introduction of a foreign object through a hole drilled through the pearl mussel's shell. The object—a wire loop, a pointed piece of iron, or a brass wire flattened like a nail-head—produced an irregular blister pearl by "inducing pearl juice from the mantle."[8] In the 1750s, the Swedish naturalist Carl Linné used this same basic method to successfully induce the first free pearls in European freshwater pearl mussels.[9] These were inserted through

the hole in the shell and held away from the inner surface by a fine silver wire. His "secret" was lost and not fully disclosed until 144 years later.

At about this same time, European scientists began seriously speculating about the origin of natural pearls. Different schools of thought maintained that pearls were simply a sign of disease in the clam,[10] that they were formed of surplus "shell fluid" which the pearl oysters produced but did not excrete,[11] that they were the clam's own undeveloped or aborted eggs.[12] Observing Chinese pearl shells led the Danish clergyman and conchologist Johann Hieronymus Chemnitz to postulate in 1791 that pearls are formed as a defense mechanism against intruders.

With increasing biological understanding of the process, and aided by experimental approaches and invention of the microscope in the 1600s, investigators found entombed parasites in some freshwater and marine pearls. Building upon Chemnitz's defense explanation, in 1856 F. de Filipi and Friedrich Küchenmeister proposed the *parasite theory*—that pearls can be induced by the presence of parasites, and often form around them—initiating a line of thought that is still, in part, endorsed today. Subsequent authors have accepted, rejected, or at least hotly debated the parasite theory.[13] Some have suggested that pearls can form around mucus or small yellow globules that occur naturally in mantle tissue,[14] and others that they might also form by naturally occurring calcareous deposition, to serve as reserve material for shell growth.[15]

Another topic of great debate in the nineteenth and early twentieth centuries was the development of the pearl sack, the anatomical structure within which pearls are formed. Most researchers assumed that it was derived from the outermost mantle cells. Others argued that the deeper mantle tissues were responsible.[16] In the early 1900s, it became clear that epithelial cells could be carried into deeper tissue, sometimes by intruding parasites, or that certain stimuli caused them to wander deeper on their own.[17] Discussing the parasite

Chinese freshwater pearl mussels with Buddha-shaped blister pearls have been produced since the fifth century C.E. A modern equivalent depicts a profile of Chairman Mao.

Linné's Pearls

Anyone who could induce this illness in mussels could make them produce pearls; and if one could, what could be more profitable?

—Carl von Linné

The Swedish naturalist Carl von Linné (1717-1778), also known as Linnaeus, is best known for developing the system of binominal nomenclature, whereby each animal or plant bears a two-part name, the genus and species (e. g., *Homo sapiens*). But Linné also produced the first spherical pearls ever cultured in any mollusk, saltwater or freshwater. This, rather than his botanical acumen or his nomenclatural system, was the reason why he received his noble title "von."

Using the River Mussel *Unio pictorum* (Linné, 1758) from a slow-flowing creek in his home town of Uppsala, Linné drilled a small hole through the shell and inserted a granule of limestone or plaster between the mantle and the shell. In an attempt to produce free pearls instead of blister pearls, he held the bead away from the shell's inner surface by a T-shaped silver wire. The pearl mussels were returned to the riverbed for six years, and resulted in free pearls of modest quality.

In contrast to his many other academic contributions, Linné sought to market this discovery. In July 1761, the State Council of Sweden recommended the price of 12,000 dalars (about US $4,800). He sold his "secret" the following year to Peter Bagge, a Gothenburg merchant, for 6,000 dalars. Bagge received a monopoly permit from King Adolph Frederick but never used it. Neither did his grandson, J. P. Bagge, who received another permit for the process in 1821. Eighty years later, W. A. Herdman found Linné's manuscripts and other materials then housed, as they are now, in the Linnean Society of London, and published a full account of Linné's pearl-culturing method. After a mere 144 years, the secret was finally revealed.

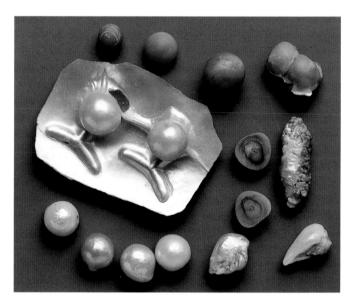

Free pearls cultured by Linné in 1761, now in the collection of the Linnean Society of London. The pearls still attached to a piece of shell reveal much of his once secret technique. They are mounted on T-shaped metal posts that originally held them protruding into the mussel, away from the shell surface.

theory, A. Zawarzin showed that epithelial cells could grow along the path made by an intruding parasite, envelop it, and thus form a pearl sack.[18] Louis Boutan and later August Rubbel postulated that the pearl sack was formed by invagination, an in-pocketing of the mantle surface.[19] It has recently been hypothesized that *Pinctada* species have a genetic disposition for hyperactive mantle growth, leading to the formation of folds and pockets into which epithelial secretions produce free pearls.[20] Friedrich Alverdes in 1913 had already shown that detached mantle cells could form a pearl without the presence of a bead nucleus.[21] Importantly, he concluded that the actual nucleus of a pearl did not matter—it was, rather, the bit of mantle tissue that

was necessary for pearl formation. Later, Fritz Haas, a malacologist at The Field Museum, explained the formation of the pearl sack with or without the presence of a bead: "Detached epithelial cells . . . rearrange themselves into a pavement-like flat epithelium if placed upon an even background [i.e., the surface of a bead]. . . . These same cells, if . . . denied a suitable, solid stratum to settle upon, will arrange themselves, step by step, into a hollow ball. . . ."[22] Thus the graft, with or without a bead nucleus, is all-important to pearl formation, a premise that lies at the heart of all successful contemporary perliculture industries.

Experimental pearl culture began in earnest in the eighteenth century, long before the process of

pearl formation was fully understood. Concurrent with Linné in the 1750s, Frederick Hedenberg of Sweden nucleated pearl mussels with "pearl-seeds" of his own manufacture, and produced the first marketable cultured pearls.[23] Evidence of New Jersey freshwater perliculture was found in the collection of Isaac Lea bequeathed to the Smithsonian Institution in the 1850s—a hemispherical piece of candle grease partially coated with pink nacre. During this same period, Kelaart successfully used the Chinese Buddha-shell technique on Ceylon Pearl Oysters (*Pinctada radiata*), and Finnish experimenters produced nacre-covered fish from pewter molds in freshwater pearl mussels.[24] In 1880, freshwater pearls from Saxony, nucleated with small shell beads or poor-quality pearls from other freshwater pearl mussels, were exhibited at the Berlin Fisheries Exhibition.

Beginning in the late 1800s, these experimental techniques were transported to the European colonies in the South Pacific. Drilling through the shell to insert a nucleus, the Frenchman G. Bouchon-Brandely produced the first pearls from Tahitian Black-lipped Pearl Oysters (*Pinctada margaritifera*) in 1884.[25] His initial effort would not bear commercial fruit until the mid-1960s. In Western Australia, G. S. Streeter of Broome produced half-pearls in the Silver-lipped Pearl Oyster, *Pinctada maxima*. Streeter's success was furthered by Australian Fisheries Commissioner William Saville Kent, who secured the nucleus to the inside of the shell with resin. Saville Kent started Australia's first commercial perliculture venture in Queensland, and successfully marketed his cultured half-pearls. In 1890, he produced a spherical cultured pearl, the first since Linné's 140 years earlier. He died in 1906 without recording his method.[26]

In Japan, Kokichi Mikimoto began his pearl culturing experiments with the Akoya Pearl Oyster (*Pinctada fucata*) at about this same time. He produced his first cultured half-pearl in 1893, using a cumbersome "all-lapped system" of wrapping a bead nucleus completely in mantle tissue, thus manually creating a pearl sack before implantation. This technique is attributed to Otokichi Kuwabara, who worked for Mikimoto.[27] Mikimoto patented the all-lapped technique in 1896, and although it was technically difficult to perform, its use continued for some time for both

half- and free pearls. The first cultured pearls to appear on the European market were produced in this way. The method was described in the 1938 *Bulletin of the New England Museum of Natural History*:

> . . . *a skilled operator makes an incision in the oyster and an "irritant," usually a mother of pearl bead . . . , is placed on the outside of the secreting epithelium (skin) of the mantle. The epithelium . . . is then dissected from the oyster and drawn over the nucleus making a small sac. This is tied and the sac taken from the oyster and grafted into the tissues of another oyster.*[28]

Today's method differs by maximizing the size and shape of the nucleus, thus shortening the procedure and assuring a spherical pearl, and minimizing the tissue, thus better controlling the type of nacre-producing cells.

Tatsuhei Mise, a carpenter, produced the first spherical Japanese cultured pearls in 1904. Mise's technique was much simpler than Mikimoto's, using only a small piece of mantle tissue inserted with the nucleus. Mise applied for a patent in 1907, but was rejected on the basis that Tokichi Nishikawa, a biologist and Mikimoto's son-in-law, simultaneously tried to patent the identical procedure, claiming that he had developed the technique earlier in 1899. Mise and Nishikawa ultimately signed a joint-ownership agreement in 1908. Mikimoto received his own patent for the production of spherical pearls in 1916, and eventually also bought the Mise-Nishikawa method, establishing himself as the "father of pearl culturing." Nevertheless, invention of the bead-plus-tissue method currently used to produce free cultured pearls must be properly credited to Mise.[29]

Whether or not the Japanese discovery of pearl-culturing methods occurred independently of other efforts, it is interesting that several key figures in the development of cultured pearls might have met in an unexpected place—in Queensland, Australia. William Saville Kent produced his first spherical cultured pearls there in 1890, and in his capacity as Fisheries Commissioner, monitored the partly Japanese crews of the more than four hundred vessels of the Arafura Pearling Fleet gathering mother-of-pearl shell in the Torres

The Struggle for Acceptance

In 1930, the natural pearl industry was reeling from both the effects of the Great Depression and Kokichi Mikimoto's sensational cultured pearls. Cultured pearls not only looked just like natural pearls, they were considerably less expensive. The initial effect on the market was negative, however, because methods had not yet been devised to separate inexpensive cultured pearls from expensive natural ones. In the Pearl Crash of 1930, pearl prices plummeted by 85 percent in a single day when bankers refused to extend credit to dealers on their pearl stocks. To protect the high price of natural pearls, the European pearl syndicate sued Kokichi Mikimoto, charging that his pearls were "fakes." Several eminent scientists were brought into the investigation, including Professor Lyster Jameson of Oxford University, and Professors Louis Bouton, Louis Joubin, and R. Dollfus of France. All testified that Mikimoto's pearls were genuine. Professor David Starr Jordan, former president of Stanford University, concluded, "As a cultured pearl is of exactly the same substance and color as the natural or 'uncultured' pearl, there is no real reason why cultured pearls should not have the same value as natural pearls." The only difference between cultured and natural pearls was that the nucleus was artificially, rather than accidentally, introduced. With the lawsuit won, Mikimoto intensified his promotional efforts to gain

public acceptance for cultured pearls. He produced his own Art Deco jewelry, exhibited at world's fairs, and distributed samples of his pearls around the globe. Many natural history collections contain samples of Mikimoto pearls and pearl oysters, as a result of his contact with the academic community. From the start, Mikimoto had labeled his product "cultured pearls" although by law he was not required to do so. Today, cultured pearls are fully accepted and few consumers even know that natural pearls exist. However, gem regulations in most countries now require that cultured pearls be labeled as "cultured" or "cultivated" to distinguish them from natural pearls.

(TOP) *Kokichi Mikimoto, the father of modern periculture.*

(LEFT) *The Yaguruma "Wheel of Arrows" Sash Clip, shown assembled and disassembled, features diamonds, sapphires, emeralds, and 41 cultured pearls. This unusual piece can be used in twelve different ways (as a brooch, ring, or hair accessory) by disassembling and reassembling its various parts. It was displayed by Kokichi Mikimoto at the Paris World Exposition in 1937.*

Strait. Significantly, two of those crewmembers later played a role in the development of periculture in Japan: the stepfather of Tatsuhei Mise and Tokichi Nishikawa himself.[30]

The Modern Periculture Method— Akoya Pearls of Japan

Mikimoto, Mise, and Nishikawa perfected the methods of saltwater periculture in the Akoya Pearl Oyster (*Pinctada fucata*) during the early 1900s, leading to a thriving Japanese industry. At their pre–World War II

height in 1938, approximately 350 pearl farms were active in Japan, covering 5,200 underwater hectares and producing over 10 million cultured pearls.[31] The original technique is still in use in Japan, with modifications and enhancements intended to increase the yield. Nearly all active periculture ventures worldwide use a version of the basic Japanese procedure. We will use that procedure as the starting point in our discussion of modern periculture.

To begin, one first needs a reliable source of adult clams. Japanese periculturists originally

(OPPOSITE) *An ama diver is shown with abalone shells, from a Japanese woodcut by Suzuki Harunobu (c. 1769).*

employed female divers, called *ama*, to collect wild adults for nucleation. The site of much of this activity was Honshu Island's Ago Bay, where wild populations of Akoya Pearl Oysters once flourished naturally on the rocky bottom.

Because dependence on gathering mature wild clams risks depleting the resource very quickly, aquaculture methods have been developed to provide a reliable supply of new clams. The first step was deploying *spat collectors*, submerged tangled materials (e.g., branches, old fishing nets, ropes, or earlier, stones)[32] on which free-swimming pearl oyster larvae can settle. These were already in general use by the time Mikimoto began his experiments.[33] The spat could be raised in controlled environments until of sufficient size for nucleation. The next step was the full domestication of the pearl oyster, managing all aspects of pearl oyster reproduction, spawning, and settling under laboratory control.

Aquaculture has the advantage of allowing the farmer to select parent clams for their desirable characteristics, and thus produce a greater number of the next generation with those features. The Japanese have done just that with the Akoya Pearl Oyster. Although its nacre and pearls were originally yellowish green, like those of the closely related Ceylon Pearl Oyster, aquaculture has created "improved" Akoyas with whiter nacre. The disadvantages of aquaculture include the cost of additional facilities, increased labor, and algal food for the young pearl oysters.[34] The more serious loss is that of genetic diversity in the pearl oyster population.

In Japanese pearl farm hatcheries, adults are induced to spawn, and fertilization occurs, in large aquaculture tanks. The planktonic larvae are maintained and fed for fifteen to twenty-five days, until they are ready to settle and metamorphose into juvenile clams. At this point, spat collectors are introduced to the tank, providing convenient hard surfaces for settlement. The juveniles are plucked off the spat collectors and packed into baskets for transport out into the bay to be suspended from floating lines. There they remain for a "grow out" period originally lasting about three years, and more recently reduced to two years.[35]

During the long "grow out" period, water quality in the bay must be monitored closely for any change in temperature, relative amounts of

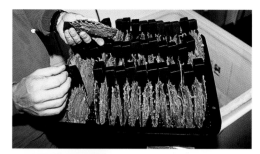

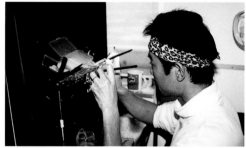

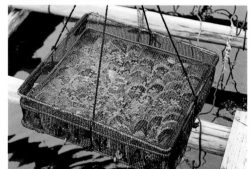

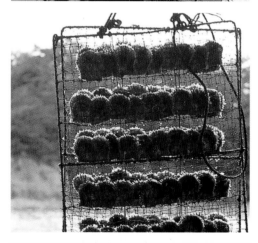

(TOP TO BOTTOM)

The first step of periculture is to obtain a pearl oyster or mussel of good health and sufficient size for nucleation, either by wild collecting or aquaculture. The mollusk is then relaxed so that it can be opened to insert a wedge (black) between the shell valves.

Next, the relaxed mollusk is fitted into a grafting clamp, and the wedge is removed. An incision is made in the gonad or mantle, depending on the species and product desired. A graft (mantle tissue) is inserted from another mollusk. In most cases, a bead nucleus is also inserted. The clamp is then released, and the mollusk closes naturally.

Third, the nucleated clams are held in "post-operative" care, and animals with unsuccessful grafts are culled.

In the fourth step, successfully nucleated clams are moved to a culture area, at lesser density, and are protected from predators in racks. The grafted mollusks are cleaned periodically, if necessary, to remove debris and fouling organisms, and are maintained for at least the minimum time for nacre accumulation.

Harvesting is the final step. For Akoyas and freshwater pearl mussels, harvesting results in sacrifice of the clams. In contrast, the larger pearl oysters are reoperated upon; if the first pearl is of suitable quality, a second bead or a mabé nucleus will be implanted, and the culturing process will be repeated.

planktonic food, or dangerously toxic red-tide organisms that might adversely affect the health of the crop. The hanging baskets provide protection against predators such as starfish, crabs, and fish, but also provide additional surface on which algae, barnacles, anemones, and cementing worms can settle. These so-called fouling organisms on the outer surfaces of the shells can cause deformities and prevent the shells from closing; on the baskets they can interfere with water circulation.[36] Periodic cleaning of the baskets and shells is therefore necessary.[37] Assuming that all goes well, in two years' time, the juveniles—now known as "mother oysters"—have grown large enough to be returned to the pearl farm.

Up to this point, perliculture is similar to most other aquaculture ventures. Now, however, the pearl oysters undergo a process that is unique to perliculture: *grafting* (also called *nucleation* or *seeding*), meaning the implantation of a pearl nucleus, with or without a shell bead, into a pearl oyster. Skilled grafters (still mainly Japanese in most countries) are experienced, highly paid technical staff whose work results tend to be carefully tracked in terms of the percentage of quality pearls produced.[38]

The pearl oysters must first be prepared for grafting. It is the natural response of a bivalve to close tightly when removed from water or handled. Pearl oysters are therefore placed in a water bath, sometimes of slightly higher temperature or with a mild anesthetic, until they relax and gape. This step must be carefully controlled—over-relaxation can kill the animal. Once it is gaping, a wooden or plastic wedge is inserted into the shell, holding the valves apart, a technique adapted from early freshwater perliculture experiments.[39] The pearl oyster can then be removed from the water and placed into the grafting clamp without closing when the wedge is removed. But time is now critical—too long in this position can also be fatal.

The next step is literally a surgical operation. Great care is taken not to stress the pearl oyster more than necessary. A small incision is made into the gonad (reproductive organ) of the clam, forming a pocket. The grafter then uses tools resembling dental picks to introduce two ingredients: a bead nucleus and the piece of tissue called the *graft*. The bead will ultimately form the nucleus of the pearl. The graft will proliferate to form the pearl sack that will secrete layers of nacre onto the bead.[40] It is the nature of these cells that will determine the color and quality of the cultured pearl.

The bead nucleus, usually a perfect white sphere, is produced from the thick shells of freshwater pearl mussels harvested from the Mississippi River watershed of North America. Grafters use the largest practicable beads to produce the largest possible pearls. They must judge carefully, however. A bead that is too large for a given pearl oyster might be rejected or kill the clam. The maximum bead size used for Akoya Pearl Oysters is 9 millimeters.[41]

The graft inserted with the bead is a 2-millimeter square of nacre-producing epithelium freshly cut from the frilly mantle edge of another Akoya Pearl Oyster.[42] The grafts are coated with dyed antibiotic to help prevent infection, and for

(RIGHT) *The specialized tools of grafting resemble dental or surgical tools.*

(BELOW) *Masanori Kubo, a grafter at Mikimoto Pearl Farm in Ago Bay, Japan, practices his delicate craft.*

SPECIAL TOOLS FOR NUCLEUS INSERTION OPERATION

A Graft lifter
B Nucleus lifter
C Retractor probe
D Spatula
E Shell speculum
F Graft trimming block
G Brass clamp

Bead Nuclei

To culture a round pearl in most parts of the world, one must implant a bead nucleus in the body of a mollusk. Marine pearl oysters are sensitive to the composition of this bead. The seminal experiments in bead materials were those of Mikimoto in the late nineteenth and early twentieth centuries. Initially a bead had only two requirements—the mollusk must not reject it, and nacre must adhere to it. After initial experiments using such materials as lead, gold, and silver, which were successful, two additional requirements were realized—the beads must be reasonably affordable and capable of being drilled without cracking. Japanese periculturists ultimately settled on beads made from the shells of freshwater pearl mussels. Most Asian freshwater pearl mussels are too thin-shelled, so Mikimoto and his colleagues looked to North America, where the pearl mussels used in the booming pearl button industry had ideal characteristics, being white, thick, and similar to nacre in physical properties. The preferred species was originally the white-nacred Pigtoe (*Pleurobema cordatum*) from the Tennessee River. During the 1920s, 200 to 300 tons of Pigtoes were exported to Japan, with each ton yielding about 30 kilograms of nuclei.

The world's marine periculturists still exclusively use nuclei made from freshwater pearl mussels gathered from the Tennessee and neighboring rivers. However, the once-favored Pigtoe is now federally protected in the United States as a result of over-collection and habitat decline, so by the year 2000 approximately ten other species of pearl mussels were being collected for nuclei in Tennessee and Alabama. About 50 percent of all nuclei are made from Washboard (*Megalonaias nervosa*) shells because of their size and thickness.

Pearl mussels are harvested either by divers or by the use of crowfoot brails, bars with a series of chains with wire triple-hooks dragged by small boats along the river. As the chains drag over living pearl mussels in the sand, each clam closes suddenly as a protective response to touch, trapping one of the hooks. Although diving does less damage to pearl mussel populations, the brailing method is used in large rivers and where diving is prohibited.

Japanese periculturists once insisted, and often still do, upon producing bead nuclei themselves. Therefore, American musselers sold whole shells to Japan for processing, after the meat had been boiled out and used for animal feed. Beads produced from American shells are re-exported by Japan to many other areas, but are now also being made in the United States.

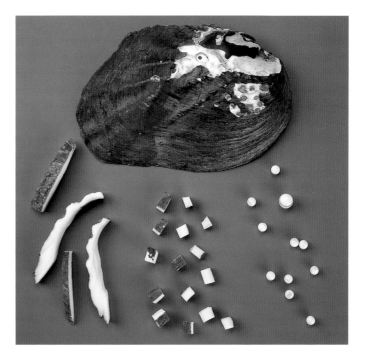

Nuclei for marine pearls in China and Vietnam are made from the shells of local pearl mussels, although both countries also use nuclei cut from American shells in Hong Kong.

To make bead nuclei, Washboard Pearl Mussel shells are successively cut into strips and cubes, and are then polished into smooth spheres.

Bead manufacturing has not changed greatly since before World War II. The shells are first cut into long slices then into small cubes that are rounded and polished with fine abrasives.

During the peak year of 1993, the United States exported nearly 7,000 tons of pearl mussel shells to Asia. The following year, exports dropped to 6,500 tons, considerably short of the requested 10,250 tons. But the sustainability of wild pearl mussel resources and the probable consequences of their decline are concerns that have long been apprehended. As early as 1949, a report on Japanese periculture by the occupying Allied Forces noted that attempts to find substitutes were unsuccessful and that "the best-known nuclear material remains the thick-shelled bivalves of the Mississippi Valley." In 1963, another author wrote, "Japanese buyers are concerned about dwindling supplies." As a result, the Japanese pearl industry invited many of the leading pearl mussel exporters to Japan in 1992 to discuss the issue. In 1994, and again in 1997, musselers predicted that by the year 2000, alternative sources of bead nuclei would be necessary.

Despite these deliberations, American pearl mussel shells were still being harvested for nuclei production well into the year 2000. Remarkably, the supply never completely dried up, and,

because of this, the development of a commercially viable substitute in the United States may have been decelerated. Nevertheless in the year 2000, an active search was underway in some countries, examining materials such as other molluscan shells, composites, man-made materials, recycled rejected nuclei, and ceramics. Most interesting so far is a manufactured material called *bironite* that matches most of the physical characteristics of pearl mussel shell and might be declared acceptable in due time, although pearlers are concerned whether customers will "accept a pearl that is not totally natural." Another potential avenue is the development of reconstituted nuclei from crushed shell material, an idea that has possibly been under study in Japan and China since 1996. Breeding and raising North American freshwater pearl mussels specifically for bead material seems one of the few ways to significantly reduce the collection of live pearl mussels, but such techniques have not yet proven feasible. Whatever the alternative method or material eventually chosen, the cost of finished pearls will almost certainly increase.

easier visualization, and are kept moist on a wet graft-trimming block—traditionally a block of soft wood such as crepe myrtle or magnolia.[43] The graft must be inserted "right side down" so that the nacre-secreting surface faces the bead nucleus. Incorrect insertion can produce a deformed pearl, or coat the bead with non-nacreous shell material. Circlé pearls could be the result of the graft folding during insertion.[44]

One or two sets of bead-plus-graft are inserted in each Akoya Pearl Oyster. Once these nucleus materials are in place, the grafter's task is complete. The incision wound does not require suturing—in a healthy clam under good conditions, it will heal itself. The grafting clamp is released, and the clam closes naturally. Nucleated pearl oysters are then moved into "post-operative" care, consisting of relatively crowded racks or baskets suspended from log rafts close to the laboratory.[45] After this one- to two-week period, any dead clams or other "unsuccessful grafts" are discarded. Those remaining are cleaned and spread into culture racks with ample room between them to grow and feed, after which they are moved into more open waters of the lagoon. In Japan's Ago Bay, the racks hang from culture rafts at 2–3 meters depth.[46]

The culturing period is long and full of apprehensive hope—hope that the clam will survive, that the environment will cooperate, and that the nacre will be deposited evenly to produce a perfect pearl. But this period is not without activity. Although the pearl oysters now reside in open waters with adequate natural plankton as food, care and maintenance are similar to those used during the "grow out" period. Water quality is monitored, and fouling organisms are cleaned from the pearl oysters and their culture racks with scrapers and high-pressure water jets.

The length of the culture period is critical. If too brief, a thin, inadequate layer of nacre will result, while too long a period risks losing pearl oysters to natural causes and pollution.[47] Akoyas were once held three years until harvest, but like the "grow-out" period, this has been shortened to six months to two years.[48]

At the end of the culture period, the pearls are harvested. Harvesting occurs in winter, when the pearl oysters are less active, and nacre produc-

Preparing the graft, or tissue squares, from a strip of mantle epithelium from a pearl oyster; this will be inserted with a bead nucleus to form a cultured pearl.

tion, slowed down by the cold, has reached peak luster.[49] In Japan, harvesting results in killing the nucleated pearl oysters. Even under the best of circumstances, a remarkably small percentage of the harvested pearls will actually be marketable. Out of every one thousand nucleated Akoyas in an average Japanese pearl farm, five hundred will die during the culturing period, about two hundred and fifty will produce poor-quality pearls, two hundred will produce saleable pearls of low to medium quality, and only fifty will produce top-grade gem-quality pearls. In comparison, as of the year 2000, pearl yields from the Black-lipped Pearl Oysters in French Polynesia are even lower: of one thousand nucleated pearl oysters, four hundred and forty will die during the culturing period, and two hundred and forty will reject the nucleus. Of the pearls produced from the remaining three hundred and twenty pearl oysters, only eight will be high quality.[50]

Other Modern Perliculture in Saltwater

Most other pearl-farming countries use variants of the Japanese method. However, each perliculture venture has had to modify the technique according to local conditions and the needs of its particular pearl oyster species.

In 1935–36, Mikimoto transported Akoya Pearl Oysters to Palau in the western Pacific where a promising operation continued until the outbreak of World War II.[51] In addition to Japan, Akoya Pearl Oysters have also been cultivated in southern China as well as in northeastern Vietnam and Thailand.[52] Chinese Akoya pearls are generally smaller than those produced in Japan and are usually considered slightly lower in quality. China began full-scale production in 1983, and the 1999 yield was considered competitive with Japan.[53]

The countries bordering the northern Indian Ocean are home to the Akoya-like Ceylon Pearl Oyster, *Pinctada radiata*. Tradition in this region strongly favors natural pearls. Petroleum rather than pearling now dominates the economics of countries on the Persian Gulf and Red Sea. Nevertheless, hatchery production of pearl oysters and perliculture are clearly active, evidenced by recent research publications plus a published training manual.[54] Bahrain, Iran, Sri Lanka, and India have each attempted to develop cultured pearl industries.[55] One study investigated the possibility of on-shore perliculture, a novel approach using an entirely closed system.[56]

South Sea Pearls of Australia

William Saville Kent (1805–1908) produced the spherical and blister South Sea pearls in Australian *Pinctada maxima* in Queensland in the early 1900s. Although his short-lived success did not signal the birth of the modern Australian pearl industry, it could have stimulated the rise of perliculture in Japan, as described above. The next notable attempt was in the 1920s by A. C. Gregory of Broome. Remarkably, Gregory's activities prompted the Australian government to amend its Pearling Act to prohibit the production, sale, or possession of cultured pearls, further assuring the continuing Japanese lead in the industry. The Act was finally repealed in 1949, and Japanese-born Tokuichi Kuribayashi, with Australian and American partners, revived pearl culturing in Australia. The first pearls from Kuri Bay, named for Kuribayashi, were harvested in 1958. By 1973, Kuri Bay was producing about 60 percent of the pearls produced from *Pinctada maxima*. Since then, the gem industry has accepted only these as "South Sea pearls," despite the fact that pearls from *Pinctada margaritifera*, which occurs in many southern seas, would seem to have an equal claim. There are still fewer than twenty licensed perliculture firms in Australia, half of them Japanese-owned. They produce nearly half of the world's annual yield of South Sea pearls.[57]

The Silver-lipped Pearl Mussel (*Pinctada maxima*) of northwestern Australia is the largest of all pearl oysters, attaining a diameter up to 30 centimeters across. Like the Black-lipped Pearl Oyster of Polynesia, and in contrast to the Japanese Akoya, it is thick-shelled and, since 1814, has supported an extensive industry for its beautiful mother-of-pearl. Unlike the Akoya, its natural habitat is offshore in deeper water (10–50 meters), on sand instead of rocky reefs. For that reason, Japanese techniques of culturing in nearshore lagoons did not work. The modifications of the basic perliculture method that were necessary to accommodate this pearl oyster have made this industry unique.

Australian perliculturists still rely largely on wild-collected adult clams as their source of

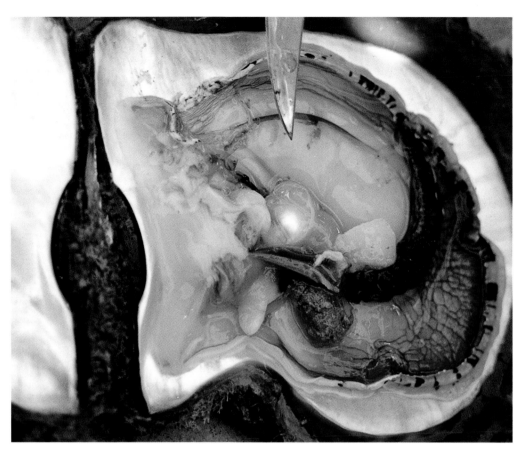

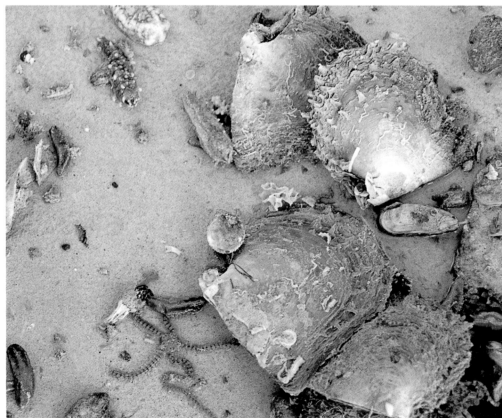

(ABOVE) *The Silver-lipped Pearl Oyster,* Pinctada maxima, *is opened to reveal its anatomy and a newly formed cultured South Sea pearl.*

(RIGHT) *In preparation for nucleation, wild-caught* Pinctada maxima *have been scraped to rid the surface of naturally occurring fouling organisms.*

"mother oysters," whereas pearl farms in other countries have long since decimated their local wild stocks and have turned to hatcheries. To minimize the risk of over-collecting, the Australian government imposes strict collecting quotas.[58] It also requires that collected pearl oysters be 120 millimeters in shell diameter, or about two years old.[59] These wild-caught mother oysters have not been "improved" by controlled breeding, but they are healthier than hatchery-raised pearl oysters. Larger individuals are left behind to maintain a genetically diverse breeding stock. A 1994 study showed that collection was not overtaking natural production, and promising numbers of spat in the Timor Sea in 1995 verified this conclusion.[60] Meanwhile, hatchery operations are showing increasing success, and farm-raised pearl oysters are supplementing the wild-caught quotas.[61]

The modern diesel-powered vessels that collect the wild shells are directly modified from the sailing *luggers* used formerly for harvesting mother-of-pearl. The vessels move slowly over the pearl beds, dragging behind them divers wearing modern surface-supplied scuba equipment rather than cumbersome hard-hat gear. Most of the wild pearl oysters are gathered within a 200-kilometer radius of the old pearling port of Broome.[62]

In the largest of the periculture ventures, virtually all operations are conducted at sea.[63] Following collection, the pearl oysters are measured and counted, cleaned, packed into holding racks, and

(TOP) *Floats at the surface of the water mark the location of a culture bed of* Pinctada maxima *in Kuri Bay, Australia.*

(ABOVE) *Racks of nucleated pearl oysters are periodically cleaned with water pressure to remove fouling seaweed and barnacles using a specially designed boat-based cleaning machine.*

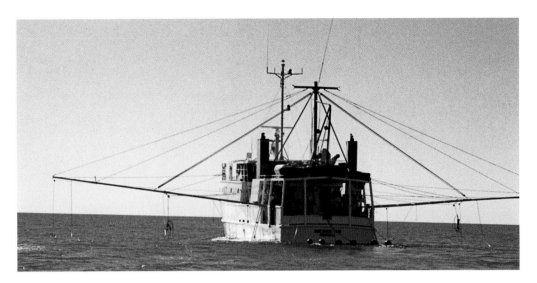

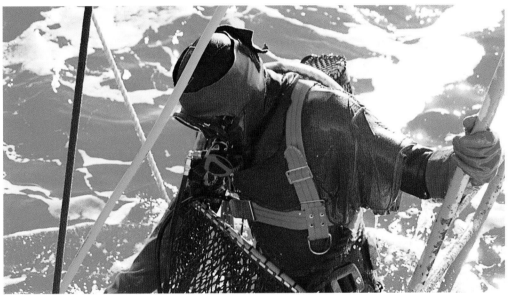

(TOP) *A modern pearl diving vessel is at sea off Broome, Australia.*

(ABOVE) *An Australian pearl diver emerges from a strenuous forty-five-minute dive with his net-full of wild* Pinctada maxima.

stored in offshore holding locations. When needed, they are retrieved by divers on another ship. Relaxation prior to grafting apparently requires no anesthetic; these pearl oysters gape naturally after spending overnight in a calm tank on board the ship. Nucleation is performed on the laboratory ship mainly by Japanese grafters. Each grafter's work, like that of each diver, is carefully tracked; in the end each pearl literally bears a pedigree of who handled it and when. Once nucleated, the pearl oysters in flat racks are transported immediately to underwater grounds where they lie flat on the bottom for three to five months, turned each day by divers to ensure correct positioning of the nucleus and even formation of the pearl sack.[64] To check the presence and position of the nucleus, the pearl oys-ters are X-rayed on the laboratory ship.[65] Those that have rejected the bead are allowed to complete a keshi pearl, if one is detected, or they could be re-nucleated. Later, the pearl oysters are suspended from floating lines in near-shore culture beds, where they are cleaned frequently. The culture period usually lasts two years.[66]

The methods used to produce high-quality South Sea pearls require a considerable per-pearl-oyster investment. Great care is taken to handle the pearl oysters gently and leave them out of water for as short a time as possible. The extra attention can pay off—in some modern pearling firms, post-operative mortality has been reduced to only 3–5 percent, and about 60 percent of grafted pearl oysters produce saleable pearls.[67]

Japanese Akoyas are often double nucleated, but they are always killed at harvest. In contrast, the larger Silver-lipped Pearl Oysters of Australia almost never receive two nuclei at once, but are robust enough to withstand a second nucleation. At harvest time, each pearl oyster is remounted on the grafting apparatus, the first pearl is removed from the pearl sack, and a second larger bead is inserted. Because the pearl sack is already present, a second tissue graft is unnecessary. Second pearls are usually larger, but are often not as perfect as first pearls, because of the age of the pearl oyster and the presence of a physical wound in the pearl sack itself. Third and fourth pearls are said to be too dull in appearance for fine jewelry. Even a fifth round of mabé nucleation is possible in a healthy *Pinctada maxima*, but such intensive use is not deemed practical.[68]

Other South Sea Pearl Ventures

The geographical range of *Pinctada maxima*, in both its white- and gold-lipped forms, is more restricted than those of other *Pinctada* species,

being confined to northwestern Australia, Papua New Guinea, Indonesia, the Philippines, Thailand, and Myanmar. Nevertheless, *Pinctada maxima* supports successful perliculture throughout its range.

South Sea pearl farmers in the Philippines use Gold-lipped Pearl Oysters to produce pearls that range from gold to silvery gray. Filipino perliculture still relies in part on wild-collected pearl oysters as parent oysters for hatchery-raised clams used for nucleation.[69] "Grow-out" usually lasts three years; however, at least one pearl farm is nucleating pearl oysters at only eighteen months, using small bead nuclei to prepare a pearl sack for a larger bead insertion at two years of age.[70] The first harvest occurs after two or three years and second grafts are normal, although only 10 percent are successful.[71] As of the year 2000, no major environmental problems affect the Philippine pearl industry.[72]

A Japanese team led by Sukeyo Fujita, and financed by the Mitsubishi Corporation, first produced South Sea pearls in Indonesia in 1928 and continued successful production near the island of Sulawesi until the beginning of World War II.[73] All

"Grade A" South Sea cultured pearls.

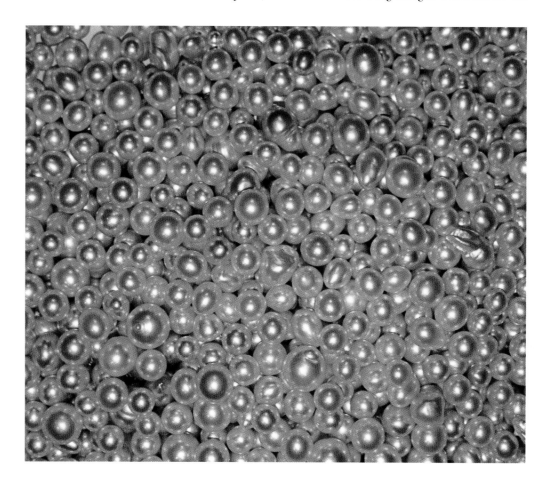

Indonesian pearls were once known as *dobo pearls*, after a prominent trade center. As of the year 2000, Indonesia's pearl industry is centered in the eastern part of the country, especially the Aru Islands, where environmental conditions are stable. The methods are close to those used in Australia, but the pearls have warmer colors—champagne, cream, yellow, gold, and pink—like those from the Philippines. The slightly warmer seawater here promotes rapid deposition of slightly less-lustrous nacre.[74] The name *ivory pearls* is sometimes used for cream-colored Indonesian pearls with this softer luster.[75] Collection of wild pearl oysters ceased in the mid-1990s, and Indonesian pearl oysters now come entirely from hatcheries.[76]

South Sea pearls from Myanmar (Burma) also come in these warmer colors and Myanmar's traditional specialty—silvery pink. Kichiro Takashima established the first South Sea periculture venture in Myanmar in 1954, in the Myeik (Mergui) Archipelago, a site once famous for natural pearls.[77] The Myanmar cultured pearl industry declined soon afterward, but has recently revived. Australian methods have been adopted, based on the collection of wild adult shells. The Burmese approach differs, however, in using "autograph" nucleation whereby the graft tissue inserted with the bead nucleus is cut from the pearl oyster being nucleated.[78] Also, cleaning takes place at the farm rather than at sea, and visual inspection rather than X-ray determines whether nuclei have been retained. The exceptionally heavy monsoon rainfall in the area poses a special problem, causing a drop in salinity and forcing farmers to move nucleated pearl oysters to deeper waters. As of the year 2000, other kinds of pollution were not a factor. Nacre deposition is relatively fast; the cultivation period lasts approximately two years and yields finished pearls up to 18 millimeters. The industry has been developing a hatchery system since 1987, as wild pearl oysters are becoming scarce, with renovation of hatcheries built in the 1950s.[79]

Cultured South Sea pearls from *Pinctada maxima* are also being produced in Thailand, Vietnam, Cambodia, Japan, China, and Malaysia.[80] From the 1920s until World War II, Mikimoto was producing these pearls in Palau in Micronesia, using pearl oysters imported from the Arafura Sea between New Guinea and Australia.[81] In Thailand, "mother oysters" are acquired by spat collection or hatchery production, although environmental conditions have been problematic in the 1990s.[82]

"Black Pearls" of French Polynesia

The Black-lipped Pearl Oyster, *Pinctada margaritifera*, with its dusky-rainbow nacre, has long been harvested for its beautiful mother-of-pearl. Although natural pearls were undoubtedly found during this harvest, Polynesians do not have a long history of specifically seeking pearls. However, attempts at cultured "black" pearl production go back farther than generally recognized, with the experiments of G. Bouchon-Brandely in 1884 and those of Robert Hervé between the two world wars.[83] The modern Tahitian industry took hold in 1965, with French-born and Japanese-trained Jean Domard, at the time director of the Tahitian Fisheries Service, and has progressed rapidly since then. In the year 2000, periculture was the chief export industry of French Polynesia, which ranks among today's top-producers of quality pearls.[84]

The Black-lipped Pearl Oyster is large and thick-shelled like the Silver-lipped Pearl Oyster, but it inhabits lagoons, attaching itself to rocks and reefs, like the Japanese Akoya. The lagoons of the Tuamotus and other South Pacific atolls provide excellent environments for these pearl oysters. Water quality is not a problem far from the population and industry of Papeete, and the distance between atolls keeps pearl oyster diseases from spreading.

Periculture in French Polynesia begins by deploying spat collectors—tangles of tree branches or polyethylene—to gather the free-swimming larvae over the course of six months. The spat come from rigorously protected natural populations of "breeder" pearl oysters. By the time the spat collectors are retrieved, the metamorphosed juvenile pearl oysters have grown to 1–4 millimeters in length and are ready for transfer to "grow out" areas in the lagoons where they remain until ready for nucleation, two and one-half to three years later. The use of wild-bred spat produces healthy pearl oysters. However, in Polynesia as in Japan at an earlier date, it is beginning to seem risky to depend on natural sources of spat. The Tahitian Service des Ressources Marines is developing techniques to culture the Black-lipped Pearl Oyster from egg to adult, to ensure the future of the industry.

Nucleation of the Black-lipped Pearl Oyster follows Japanese procedures. The bead nuclei, rather than the tissue grafts, can be coated with colored antibiotics. Beads in the 8-millimeter size range are used for the first nucleation. In contrast to nuclei used for lighter-nacred Akoyas and South Sea pearls, nuclei for Tahitian pearls can be less than perfectly white, as they will be coated by darker and more opaque nacre. Like Australian pearl oysters, those of French Polynesia are robust enough to withstand a second nucleation. Since 1985, this has been performed during harvesting. Third and fourth nucleations are possible but are rarely done.

Pearl production depends less on temperature in French Polynesia than in Japan; however, the water in closed lagoons can become so warm as to impede nacre production. The best pearls are produced in atolls with a natural or man-made outlet to the ocean, providing ample water circulation and temperature regulation. Grafting and harvesting both occur year-round, with the major harvest in July and August.[85]

In addition to *Pinctada margaritifera*, the Pipi Pearl Oyster, *P. maculata*, is frequently encountered in the pearl farms of French Polynesia. A small species (*pipi* meaning small in Tahitian) with bright yellow nacre, it yields small yellow, orange, or gold natural pearls, 3–4 millimeters in diameter. Although commercial jewelry is produced using the pearls, Black-lipped Pearl Oyster farmers generally consider the Pipi Pearl Oyster a nuisance species. Spat collectors intended for *P. margaritifera* often capture 80 percent Pipis, and culturing baskets for the larger species are virtually coated with them.[86]

Other Black Pearl Ventures

The geographical range of *Pinctada margaritifera* is extensive, from the Red Sea to the Indian Ocean and throughout the Pacific Islands, and efforts to cultivate its pearls have been made in many localities beyond French Polynesia, including New Zealand, New Caledonia, India, Iran, Sudan, Hawai'i, the Marshall Islands, and Christmas Island.[87] Mikimoto first produced *P. margaritifera* pearls in the Ryukyu Islands in 1912 and in Palau in 1920.[88] In the Cook Islands, commercial perliculture of Black-lipped Pearl Oysters was established around 1973, and supported

by a reportedly large wild population in Penrhyn Lagoon.[89] Spat collection has shown favorable results in the Solomon Islands.[90]

New World Black Pearls of Mexico

The two pearl oysters of the Pacific coast of Mexico and Central America, the Panama or La Paz Pearl Oyster ("*Madré Perla*" or *Pinctada mazatlanica*), and the Pacific Wing Oyster ("*Concha Nacar*" or *Pteria sterna*), produce relatively large pearls in light gray to black, with hues of iridescent purple, silvery blue and pink, and opalescent white and bronze. The western Mexican coast was famous for its natural pearls in earlier centuries, but both species were fished out by the end of the nineteenth century. Shortly afterward, Gastón Vivès attempted to cultivate *Pinctada mazatlanica* in Baja California, but his efforts came to an end with the Mexican revolution of 1914. Pearl fishing was formally prohibited in 1940, and both species were classed as endangered in 1994.

In the early 1990s, a group of scientists assisted by university research institutions began to reintroduce Mexican pearl farming at La Paz and at Guaymas on the Gulf of California. Initially, only mabé pearls were produced, but during the late 1990s, one farm has succeeded in producing cultured free pearls of 6–12 millimeters

(ABOVE): *Nucleated pearl oysters in Mexico in the 1910s were returned to the sea encased in wire mesh or handmade spiked "suits of armor." The cork rudder (top right) provided orientation for the oysters as they were deposited on the sea bottom at the culturing sites.*

(OPPOSITE): *A necklace and earrings of Tahitian cultured pearls interspersed with diamonds, emeralds, and sapphires, designed by Christopher Walling, demonstrates today's high-end use of the once less-desirable circle pearls.*

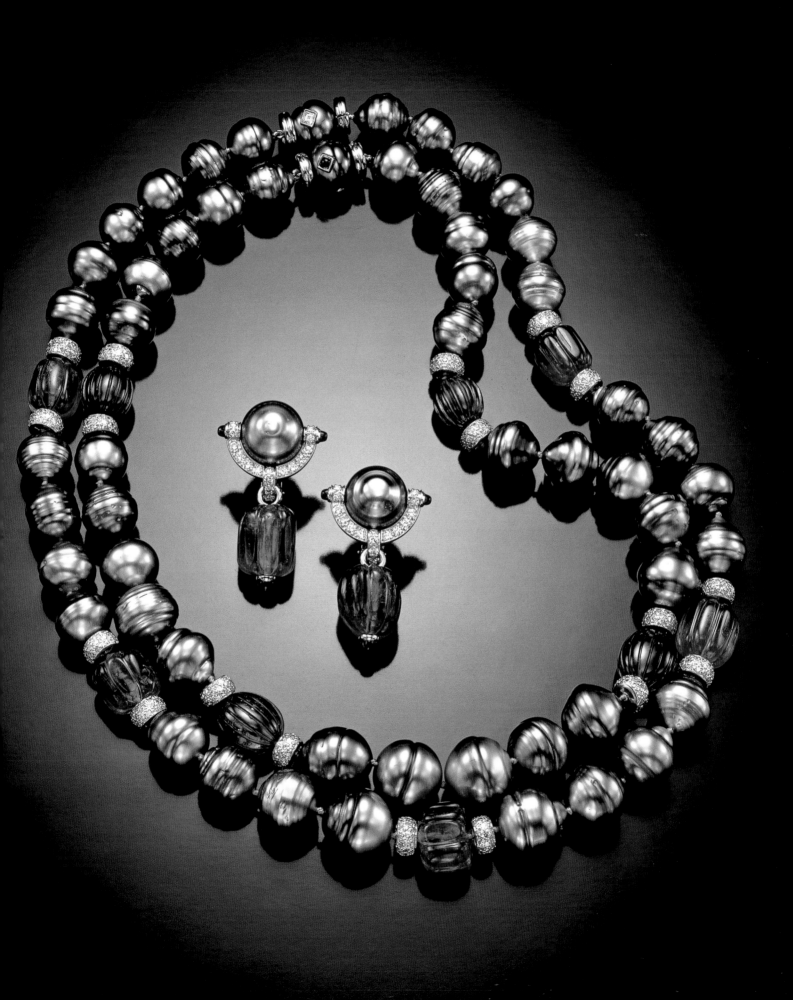

from *Pinctada mazatlanica*. The animals are either wild-collected, using spat collectors, or hatchery-raised. "Grow out" on the bottom of the bay, as a tactic against predators, lasts about a year. *Pteria sterna* is nucleated at ten to fourteen months (at 80 millimeters diameter) and *Pinctada mazatlanica* at two years of age (85–100 millimeters). Time from nucleation to harvest is approximately fifteen months. An estimated 1,500 pearls were produced in 1999, and statements in 1999 predicted a rapid increase in annual yields.[91]

Abalone Pearls

Abalone are the only gastropods to be successfully used for perliculture. Like their shell nacre, their pearls show a range of splendid colors, from azure to blue green, purple, lavender, fuchsia, orange gold, and silver. Kokichi Mikimoto is said to have tried culturing abalone pearls in Japan

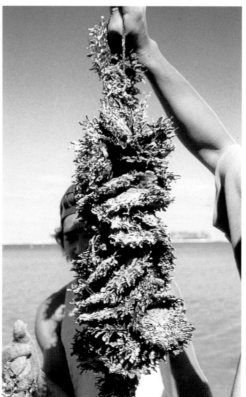

(ABOVE) *Polynesian atolls are at once a picturesque setting and well-protected lagoons for culturing Black-lipped Pearl Oysters.*

(LEFT) *A Polynesian spat collector, made of tangled ropes and nets, attracts baby pearl oysters ready to settle.*

(OPPOSITE) *Lines with attached Black-lipped Pearl Oysters, after being dipped into anti-fouling solution, are ready for transport back to the culture site in a Tahitian atoll.*

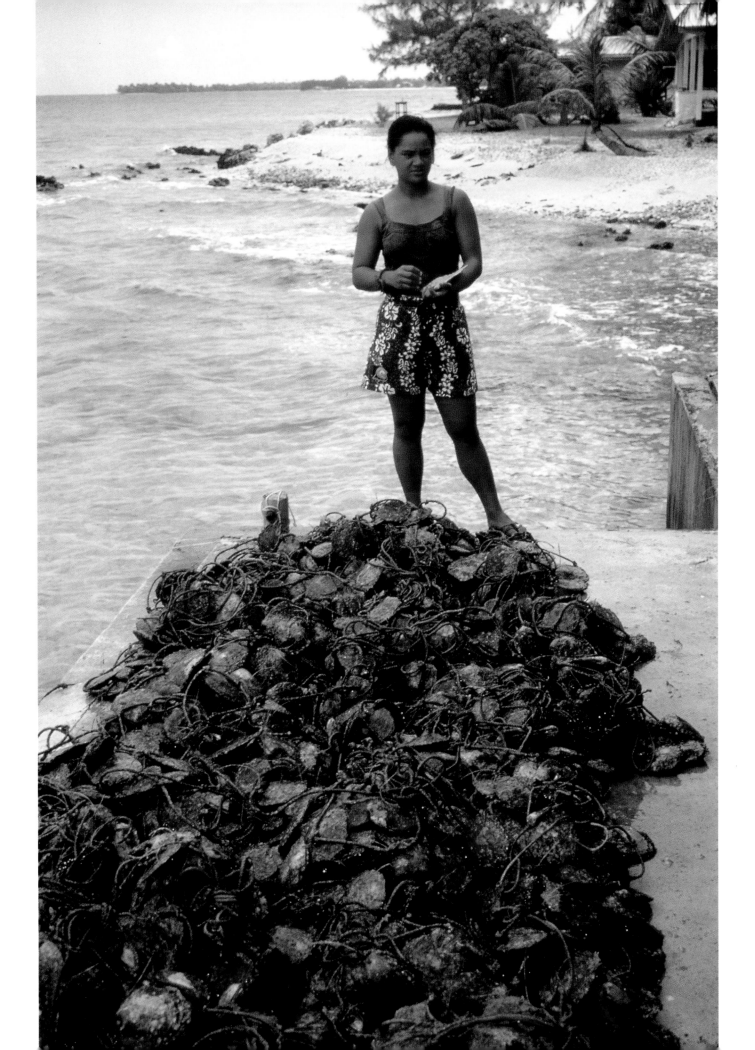

before turning to pearl oysters.[92] However, it was the French zoologist Louis Boutan who produced the first cultured abalone pearls, in the south of France in 1897. His first attempts with the European Abalone (*Haliotis tuberculata* Linné, 1758) used 6–7 millimeter natural pearls attached to horsehairs as nuclei. During the first quarter of the twentieth century, Boutan perfected the process of producing abalone blister pearls. In the mid-1950s, Kan Uno of Tokyo University improved Boutan's mabé technique using other species of abalone (*H. discus* Reeve, 1846, and *H. gigantea* Gmelin, 1791[93]).

The most common method of abalone periculture involves drilling a hole in the shell, putting a rounded half-spherical nucleus of plastic, soapstone, or mother-of-pearl into the hole against the abalone's mantle, and then securing the nucleus in place.[94] The induction of free pearls in abalone is more difficult, and involves implanting a nucleus within the large adductor muscle, and fixing it in place with fast-setting resin. Nevertheless, movements of the abalone's muscular foot often dislodge free nuclei. Infection resulting from abrasion of the nuclei against the foot can cause the snail's death.[95] In general, the costs of abalone aquaculture are high, requiring secure enclosures and an adequate daily diet of kelp. Most abalone pearl farms market the high-priced meat, reducing the monetary risk of the periculture venture.

Although the New Zealand industry relies on wild-collected adults, limited by strict fishing quotas and collection restricted to free diving, a growing number of hatcheries around the world produce farm-raised abalone for periculture.[96] Pearl harvest generally occurs one and one-half to two years after nucleation, yielding finished mabés of 9–20 millimeters in diameter.[97] Successful abalone farms in the western United States, Mexico, Canada, and New Zealand produce quality cultured abalone pearls. Research or interest in abalone pearl culturing is also ongoing in Japan, Korea, South Africa, Australia, China, Hawai'i, and Greece.[98] Many species are used for abalone periculture, including *Haliotis iris* Gmelin, 1791, or *paua*, in New Zealand, and *H. rufescens* Swainson, 1822 (red abalone), and *H. fulgens* Philippi, 1845 (green abalone), in western North America.[99]

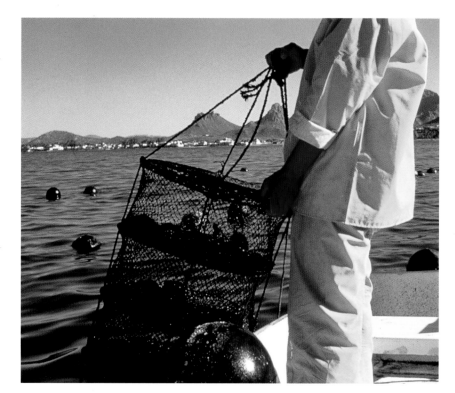

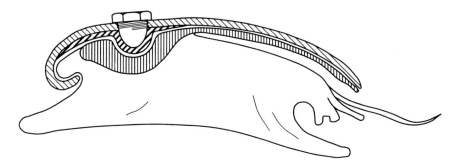

MODERN PERLICULTURE IN FRESHWATER

The early history of pearl farming in freshwater was sketched at the beginning of this chapter. Freshwater periculture has grown explosively since the 1950s, first in Japan and now in China. Although the underlying process by which free pearls are produced in freshwater pearl mussels is the same as for saltwater pearl oysters, there are several vital differences between the ways those processes are implemented.

First, hatchery methods for freshwater pearl mussels are more complex. Survival of the pearl mussel's glochidia larvae depends on their being able to attach to a fish for a time before they can settle and metamorphose. In the case of some

(TOP) *A pearl farmer checks a lantern net used to raise young La Paz Pearl Oysters to nucleation size in Guaymas, Mexico.*

(ABOVE) *In a patented procedure, a mabé nucleus, once screwed into place, has little chance of being dislodged by a living abalone.*

(OPPOSITE) *Newly cut Californian abalone mabé pearls display a variety of shapes.*

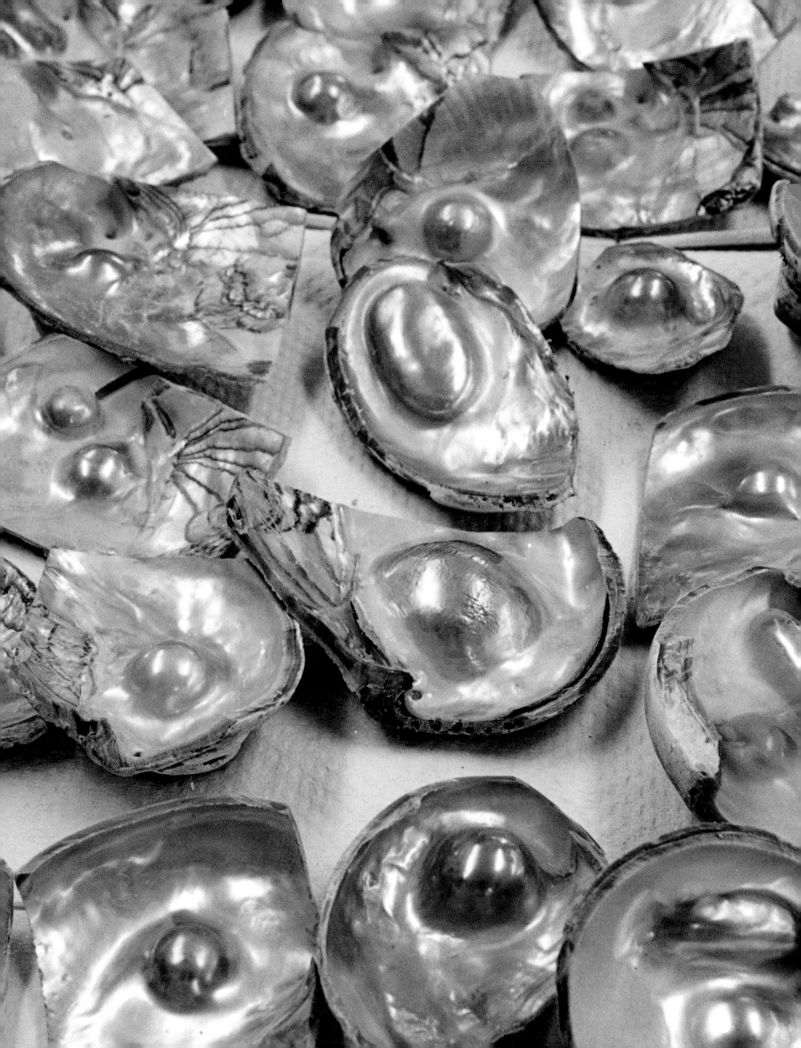

Mabé Pearls

Mabé pearls, also called assembled, domé, chicot, or button pearls, are cultured blister pearls that require assembly after production. The basic technique involves inserting a flat-bottomed plastic dome, most popularly a half-sphere, heart-shape, oval, or teardrop shape, between the mantle and shell of an anesthetized pearl oyster. Several domes can be inserted on one or both valves of the shell, placed carefully to assure that the clam will be able to close its shell unimpeded. As with natural blister pearls, nacre is secreted over the dome by the overlying mantle tissue. Following a culture period of a year or less, the mollusk is opened, the mabé pearls are cut out of the shell, and the plastic molds are removed. The hollow interior of each pearl is filled with paste or wax for support; sometimes this material is colored to produce a differently colored pearl as the tint shows through the nacre. To complete the mabé, a disk of mother-of-pearl or other material is glued to the bottom.

Mabé pearls are produced in Japan, Indonesia, French Polynesia, Thailand, Mexico, Tonga, and Australia. The principal mabé-producing mollusks are the classic Mabé Pearl Oyster, *Pteria penguin*, as well as *Pteria sterna*, *Pinctada mazatlanica*, *Pinctada maxima*, and *Pinctada margaritifera*. In abalone, mabé pearls are made by inserting the domes through a hole bored in the shell.

(ABOVE) *A necklace and earrings made with mabé pearls from the Black-Winged Pearl Oyster.*

(BELOW) *Silver-lipped Pearl Oysters are shown with cultured mabé pearls.*

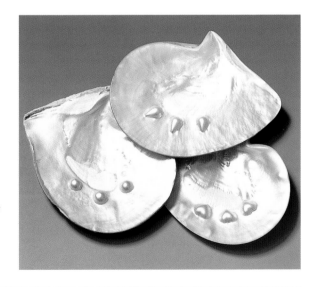

pearl mussels, possible fish hosts are restricted to a single species, while other pearl mussels utilize a variety of fish. Hence, the freshwater pearl farmer must be competent in culturing fish—with their own requirements for feeding and maintenance—in addition to adult, juvenile, and larval pearl mussels.

A second difference between saltwater and freshwater perliculture is the site of nucleation. While Akoya and other marine pearl oysters receive the nucleus implant in the soft central gonad, freshwater pearl mussels are nucleated within the mantle tissue lining each inner surface of the shell.[100] Early experiments of bead-nucleating the gonad, modeled after the Mikimoto method, usually resulted in death owing to damage to the more extensively coiled intestine of a freshwater clam.[101] Perliculturists therefore redirected their activities to the original site of cultured pearl production—the mantle.

This leads to the third important difference between saltwater and freshwater perliculture. In freshwater pearl mussels, bead nuclei are usually not implanted at all. The pearl mussel mantle proved to be unsuitable for beads; because it is a relatively thin organ, beads were often rejected or tore the mantle tissue, causing the bead to fall out or attach to the shell to form a less-desirable blister pearl. Thus, except for "fancy shape" freshwater pearls such as flattened disks that require pre-formed beads, the grafter came to implant only a relatively large piece of mantle tissue, or more normally, twenty to forty pieces, into each pearl mussel.[102] Each tissue graft proliferates to form a pearl sack in the mantle, secreting nacre onto whatever tiny speck of foreign matter might be present, perhaps a remnant of the graft itself. Such tissue-nucleated pearls are 100 percent nacre—like cultured saltwater keshi—and are difficult to distinguish from natural pearls.[103] With a reasonable success rate of quality pearls from each pearl mussel, the yield from a crop of such multiple-nucleated clams can be very high.

Freshwater pearl mussels are apparently less species-specific than Akoya Pearl Oysters about the source of the graft. Pearl farmers in Lake Nishinoko, near Lake Biwa, claim to use grafts from an unnamed native pearl mussel to produce pink to purplish-rose pearls. In Vietnam, farmers use different grafts in *Hyriopsis cumingii* to change the final pearl color: cream or gold from *H. cumingii* itself, silver or blue from a species of *Cristaria*, and pink or cream from an *Anodonta*.[104]

A fourth difference is the effort needed for maintenance. While saltwater pearl farms everywhere expend tremendous energy in cleaning their pearl oysters both before and after nucleation, this practice is virtually non-existent in freshwater ventures, other than occasional flushing of flocculent detritus from the clams and their baskets. Freshwaters quite simply lack the diverse fouling communities so common to marine systems. And, so far at least, species such as the zebra mussel, *Dreissena polymorpha* (Pallas, 1771), that have caused such problems in fouling native freshwater pearl mussels in North America, have not become an issue in commercial pearl farms.

A last difference involves production costs. Saltwater perliculture systems are far more expensive than freshwater systems. In Australia, saltwater perliculturists must use professional divers and imported grafters, a fleet of ships, boats, and seaplanes, and a variety of complex equipment. By contrast in China, a freshwater farmer needs a few hundred square meters of shallow pond, a simple rowboat, a few weeks of grafting by trained local youths, a quantity of pearl mussel food, and equipment made of bamboo, plastic, and styrofoam. His total outlay for a kilogram of pearls is a tiny fraction of what his Australian counterparts spend for the same quantity of, admittedly higher quality, pearls.

Most freshwater pearl ventures use their by-products in a variety of ways. The "meat" of the pearl mussels is used to feed fish, farm animals, or dogs, and the shells are sold for mother-of-pearl inlay, fertilizer, or roadbed material.[105] One of the best-known uses for freshwater pearls of poor quality—especially in China—is pearl powder, which is turned into various medicinal or cosmetic products.

Harvesting is not the final step for the pearls. All types of pearls are of course washed and sorted before sale. Chapter 3 referred to other treatments such as polishing, drilling, bleaching, dying, irradiating, faceting, and coating—processes that are applied to saltwater and freshwater pearls alike. Bleaching and dying are most often used with cultured saltwater Akoya pearls and lower-quality

white freshwater pearls, to even the color within a lot or to add fancy colors.

Biwa Pearls of Japan

Masayo Fujita, an early associate and friend of Nishikawa, is credited with initiating perliculture in Japan's largest and most ancient lake, Lake Biwa just north of Kyoto, around 1914.[106] It is unclear what species of freshwater pearl mussel was originally used. Several species, such as *Cristaria plicata clessini* (Kobelt, 1879) and *Anodonta* spp., were apparently early but unsuccessful experimental candidates. It appears that the Biwa Pearl Mussel (*Hyriopsis schlegelii*) was extensively used beginning in the early 1920s. The transition from bead nucleation to tissue nucleation also happened early, certainly by 1930. The modern multiple-nucleation method appeared in the 1950s. The success of the Biwa pearl farms—producing six tons by 1971[107]—is reflected in the trade name "Biwa pearls," a phrase that came to be nearly synonymous with freshwater pearls. The term is still in common use, albeit technically misapplied, in the jewelry industry.[108]

The Biwa Pearl Mussel is one of many endemic species native to the Lake Biwa/Yodo River system—meaning that it is found naturally nowhere else in the world.[109] Unfortunately, various environmental problems have rendered Lake Biwa proper unusable for culturing, and *Hyriopsis schlegelii* is now nearly extinct. Pearl cultivation continues in small lakes surrounding Lake Biwa, revitalized through use of a new pearl mussel. Crossing some of the remaining Biwa Pearl Mussels in aquaculture with their continental relative, *Hyriopsis cumingii*, has provided a new hybrid strain that has raised hopes that the freshwater pearl industry of the Lake Biwa area can survive.[110] The new pearl mussels are also being cultivated in Lake Kasumigara, near Tokyo, and their products have been sold since 1997 under the name Kasumiga Cultured Pearls.[111] Japan still produces nearly 1,000 kilograms of freshwater pearls per year,[112] but most pearl specialists think this total will continue to decline.[113]

The host fish used for Lake Biwa's hybrid pearl mussel is a small goby (*Rhinogobius* sp.), 4–6 centimeters in length, called the "reed climber." In Lake Nishinoko near Lake Biwa, ponds or tanks of these fish, with glochidia larvae attached to their fins, are maintained at or near the pearl

farms. The main sites of pearl mussel maintenance are in the lake and are marked by rows of emergent poles from which lines with racks of pearl mussels are suspended. Culture typically requires three years, but can be extended to as much as five years if water conditions are poor.

Freshwater Pearls of China

The culturing of pearls originated in China, where attached blister pearls in the shape of Buddhas goes back as far as the fifth century C.E. However, the culturing of unattached free pearls in China is only about thirty years old. The basic techniques, like those for culturing Akoyas, were introduced from Japan.[114] China produced its first cultured

(TOP) *At a shell dump near Zhuji, in southeastern China, used freshwater pearl mussel shells are processed into roadbed material.*

(ABOVE) *At a pearl factory in Zhuji, China, pearls by the basketful are washed in preparation for sorting and grading.*

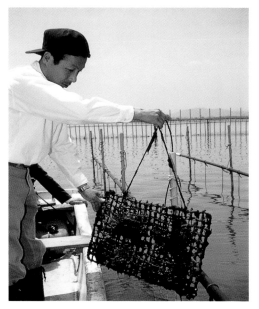

(TOP) *Poles in a lake near Lake Biwa, Japan, mark the location of a pearl farm.*

(ABOVE) *A Japanese pearl farmer pulls a rack of nucleated freshwater pearl mussels from the culturing site.*

free pearls in the 1960s from wild-harvested *Cristaria plicata*, a thin-shelled pearl mussel. The industry was initially state-controlled, with all exports passing through government agencies. Because quality was low, pearl experts outside of China called the small, white, irregularly shaped Chinese pearls by such derogatory names as "rice pearls" or "rice crispies," referencing the popular breakfast cereal.[115] By the mid-1980s, however, Chinese periliculturists were producing better-quality small baroques, ovals, and potato-shaped pearls. Spherical Chinese pearls appeared by the early 1990s, in local markets freed from state control, and by the year 2000, remarkably high-quality "rounds" up to 17 millimeters in diameter could

be found in the vaults of Hong Kong gem dealers, attracting the attention of competitive producers of Akoya, South Sea, and Tahitian pearls.[116]

In the year 2000, 30–40 percent of China's harvest was made up of round pearls, and as many as 40 percent of these, or 10–15 percent of the total, were of gem quality.[117] This evolution in pearl quality has involved a number of major changes in the perliculture process. By 1983, most pearl farms had replaced the traditional pearl mussel *Cristaria plicata* (known as Cockscomb), with the thicker-shelled, disease-resistant pearl mussel *Hyriopsis cumingii* (known as Triangleshell). Although *Hyriopsis* is more difficult to maintain in culture, its pearls are widely acknowledged as superior and thus worth the effort. *Cristaria* is still used in some areas, as is the smaller, very white-nacred, stream-dwelling pearl mussel *Lamprotula*.[118]

Nucleation is performed on younger individuals during their natural period of active growth, which also promotes pearl growth. Grafters have reportedly become more skillful, benefiting from experience, and their grafting methods have also improved, with some farmers moving from the use of "small tissue" nuclei (2-millimeter squares) to the "large tissue" technique involving fewer but larger soybean-sized, rolled-tissue nuclei implanted into larger 10- to 12-centimeter pearl mussels.[119] Almost all farmers began to suspend the pearl mussel-containing baskets from floating lines rather than stationary poles, allowing the pearl mussels to remain at a constant depth even during periods of low water.[120] Farmers also paid more attention to the

nutrition of the growing pearl mussels, which became possible because each pearl pond formed a closed system, rather than an open lake or bay. In what is known in China as "Increase of Cultivation," pearl mussels are kept longer before harvesting—up to five to seven years.[121] Pearl mussels are now often bought and sold during the growing period, which means moving them from pond to pond, something which could stimulate nacre production.[122] Amid accusations of oversupply, Chinese production reached 600–1,000 metric tons per year in the year 2000. All such figures are only estimates, as almost no statistics have been kept since the freshwater pearl industry was deregulated.[123]

There are centers of freshwater periculture in six eastern Chinese provinces: Zhejiang, Jiangsu, Anhui, Hunan, Jiangxi, and Fujian. Zhuji in Zhejiang Province is the largest in terms of area, volume of pearls produced, percentage of round pearls, and most other measures of production including pearl-based medicines and cosmetics. In Zhuji's Shanxiahu subdistrict, about 55 percent of the population—more than 15,000 people– is involved in some function of pearl production. Few pearl farms keep detailed records, although a few larger periculture ventures in Deqing county reportedly track the success of individual technicians.[124]

In Zhuji and surrounding areas, pearl farms, or pearl paddies, are scattered among other agricultural enterprises along the highways and in urban backyards, pools of brown muddy water, 1–1.5 meters deep, marked by float lines festooned with green plastic soda bottles or irregular chunks of styrofoam. Larger farms have all their necessary buildings perched along the paddy dikes, including the farmer's homes, thatch-roofed nucleation sheds, and hatcheries.

Chinese pearl mussels are hatchery-raised. Parent pearl mussels, three to five years in age, are chosen for the quality of their shells and their healthy appearance. Spawning occurs naturally, with sperm being released into the water column and collected by the siphoning female pearl mussels. Fertilized eggs develop in the female's gills until ready for release as glochidia larvae. At this time, the pearl farmer stimulates release of the larvae by moving the gravid females to a small pool containing appropriate host fish. Glochidia remain attached to the fins or gills of the fish for

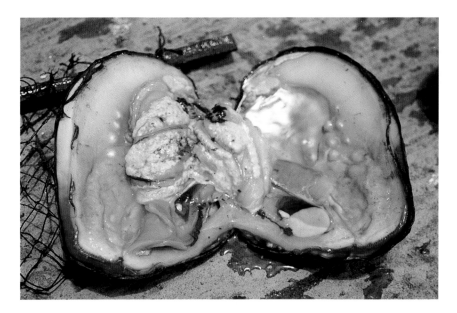

six to twelve days, when they fall off as juvenile clams about ¼ millimeter in length. Juveniles are transferred to grow-out ponds, thinned regularly to maintain ample space for growth, for about twenty days in the hatchery, followed by about eight months in shallow paddies. Throughout this process, the nurturing ponds are provided with flowing water enriched with "lime milk" or "bean-paste milk," and underlain by a base of "nutritious earth"—a mixture of pine tree soil and chicken or pig manure.[125]

An eight-month-old Chinese pearl mussel, of only 5–7 centimeters in length, is ready for nucleation. The grafters are all Chinese, mostly young women. Tissue squares are coated with yellow antibiotic, and are inserted on the inside surface of the mantle with tools resembling dental picks. After nucleation in the spring, the pearl mussels are cultured for two to three years for pearls under 7 mil-

(ABOVE) *The Chinese Triangleshell,* Hyriopsis cumingii, *opened to show the result of tissue nucleations. Note the numerous rounded pearls in the mantle tissue of each valve.*

(LEFT) *Workers sort the latest harvest of freshwater pearls for quality in Zhuji, China.*

(OPPOSITE) *A Chinese "soda bottle farm" in Zhejiang, indicating intensive freshwater pearl-mussel culture. Each row of green plastic bottles supports a line carrying nets of nucleated pearl mussels.*

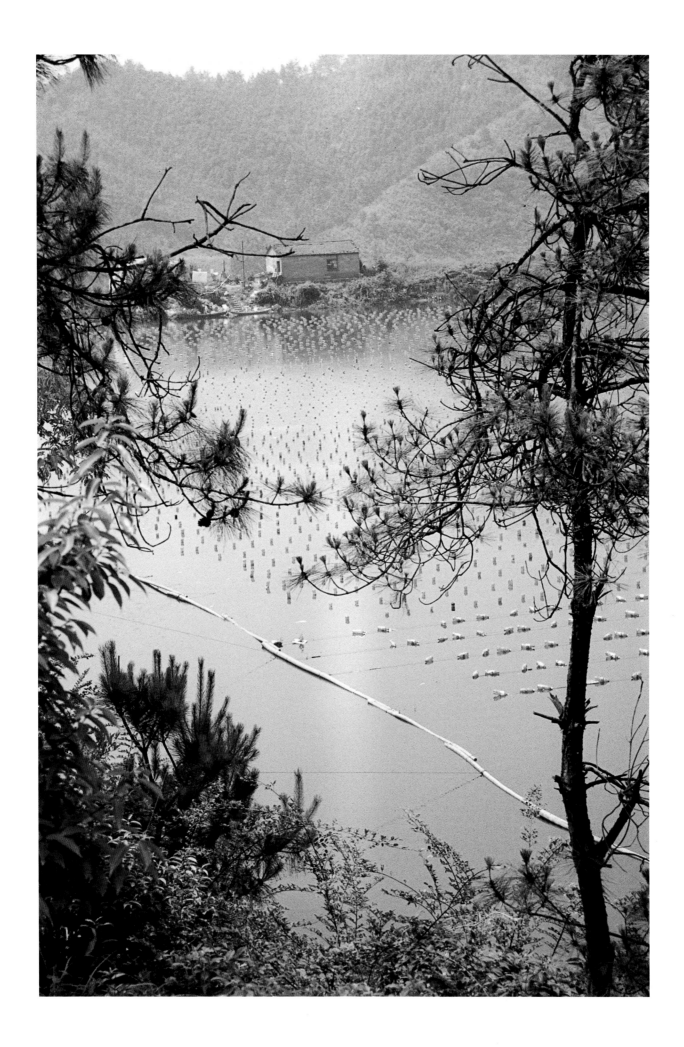

limeters, or twice as long for pearls over 7 millimeters. Grow-out first occurs in crowded shallow bamboo baskets, and later in net bags of a few large clams, each suspended from the float lines. Duck dung, liquefied bean curd, and lime are added to the water as "super-nutrition" for the growing pearl mussels. Each pearl mussel is nucleated only once, and they are opened and killed at harvest. Entire crops can be sold and moved to another pearl farm between nucleation and harvest.

In the late 1990s, the increasing proportion of round Chinese freshwater pearls led to rumors that poor-quality pearls were being implanted as nuclei.[126] This fueled a controversy among pearl gemologists because in analytical tests designed to characterize pearls, such cultured pearls can pass as tissue-nucleated or natural pearls. Although one case of pearl nucleation had been documented in 1995, the vast majority—99 percent by one estimate—of Chinese freshwater pearls is most assuredly tissue-nucleated.[127] Although some sectioned pearls show rings suggestive of a pearl nucleus, a recent study showed that this is probably caused by environmental changes when the pearl mussels are sold and moved; sectioned natural American freshwater pearls show the same kind of irregular growth rings. Examination of approximately 41,000 Chinese freshwater pearls confirmed that only tissue nuclei were present.[128] Reports from Hong Kong and Zhuji indicated that the Chinese pearl farmers use bead nucleation only for fancy baroque shapes. When beads are used, they are either of American or Chinese origin, and are generally of poorer quality than those used for saltwater pearl oysters elsewhere. The use of round bead nuclei is considered only marginally successful in Chinese freshwater pearl mussels. An adult *Hyriopsis cumingii* can accommodate only about eight bead nuclei of 4–6 millimeters diameter, while a young individual of the same species can handle up to forty tissue grafts.[129] Thus, there appears to be little incentive to invest in the bead technique. One source indicated that bead nuclei were only used when the price of pearls was high, to achieve rapid production. Other sources quite openly view bead-nucleated pearls as "fakes" or at least inferior, maintaining that only beadless cultured pearls, made entirely of nacre, could be used in pearl medicines and cosmetics.

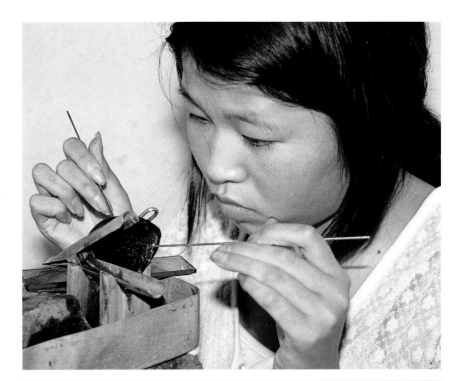

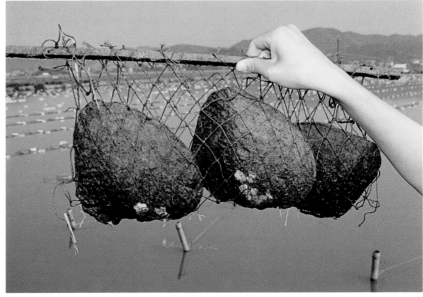

Other Freshwater Pearl Ventures

Although China and Japan are the only commercial freshwater pearl sources, other ventures were under development in the year 2000 in the United States, Thailand, India, Bangladesh, the Philippines, and Vietnam.[130] Thailand and India are examples of a scientific approach to perliculture development, where biological researchers are experimenting on locally occurring species of *Hyriopsis*, *Chamberlainia*, and *Lamellidens*.[131]

(TOP) *A worker implants multiple tissue grafts into a young Triangleshell (*Hyriopsis cumingii)*, near Zhuji, China.*

(ABOVE) *Nets and styrofoam floats support Triangleshells in a grow-out "pearl paddy" near Zhuji, China.*

Since the 1960s, the Latendresse family of Tennessee had unsuccessfully experimented with producing cultured freshwater pearls using a variety of native American pearl mussels, including the large-shelled Washboard (*Megalonaias nervosa*) and the Ebonyshell (*Fusconaia ebena*). In 1978, while Japanese periculturists faced deteriorating conditions in Lake Biwa, they agreed to a partnership, and the first marketable United States crop was produced in 1983. In this system, pearl mussels are wild-collected by divers and spend two to three years after nucleation in floating nets at the center of an artificial lake. In such a closed situation, water chemistry factors can be modified and nutrient levels increased by addition of fertilizers as are required for growth of the pearl mussels.[132]

In summary, after a century of culturing pearls, the job of a pearl farmer anywhere in the world remains both labor-intensive and, to a degree, unpredictable. The process requires many specialized tasks—rearing, feeding, cleaning, grafting, and monitoring—any of which, done carelessly, can lead to failure. The investment in a typical commercial pearl farm is enormous, with thousands of pearl oysters or mussels lying vulnerable to the whims of the environment, and to such external pressures as industrial or agricultural pollution, diseases, introduced species that compete for resources, or prey on the clams. The future of the world's pearling industries depends on a number of yet-unpredictable factors. The one thing that can be counted upon—as in many aspects of life—is change.

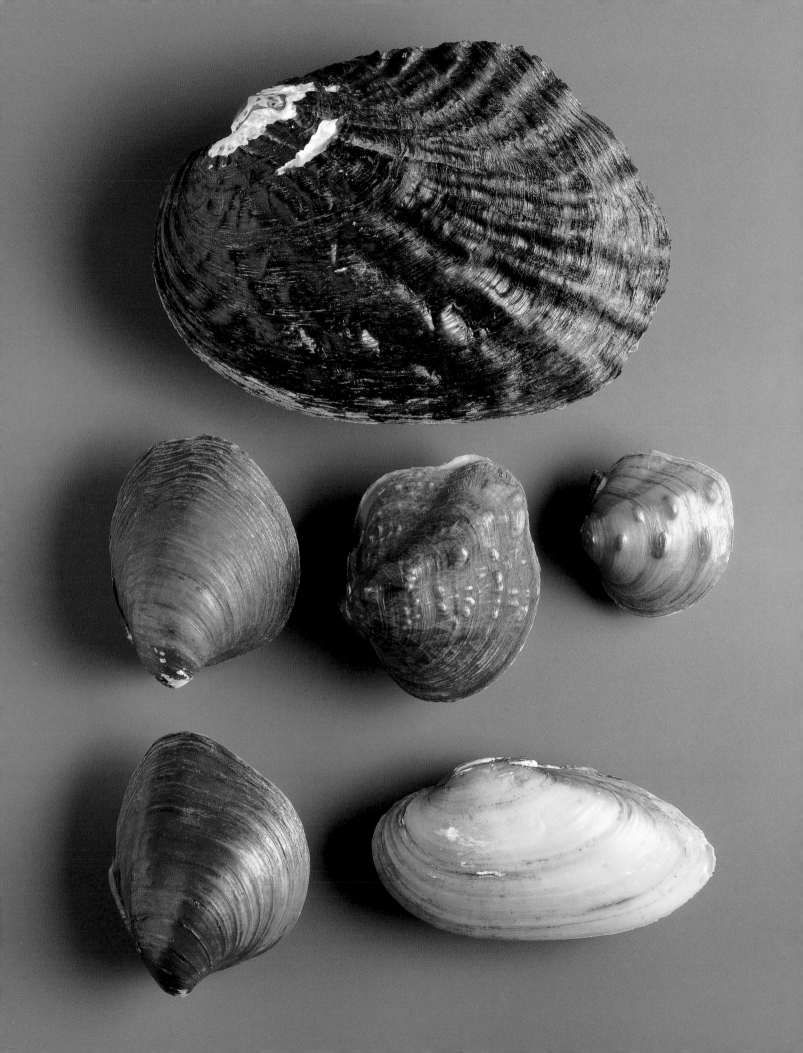

Saving Pearls

THE ECOLOGY OF
PEARL-PRODUCING MOLLUSKS

The best pearls come from contented oysters.

—"THE CREATION OF A PEARL," 1997 [1]

Things have never looked better for the world pearl industry—or worse.

—C. RICHARD FASSLER, 1996 [2]

A selection of American freshwater pearl mussels used for pearl button and bead nucleus production: top, Washboard [Megalonaias nervosa *(Rafinesque, 1920)*]; *second row, Ebonyshell* [Fusconaia ebena *(Lea, 1831)*], *Monkeyface* [Quadrula metanevra *(Rafinesque, 1820)*], *and Wartyback* [Quadrula nodulata *(Rafinesque, 1820)*]; *third row, Pigtoe* [Pleurobema cordatum *(Rafinesque, 1820)*], *and Yellow Sandshell* [Lampsilis teres *(Rafinesque, 1820)*].

In the long history of humans and pearls, the pursuit of pearl-producing mollusks and their products has led to predictable problems, adjustments, and rapid changes. As with any other material good, the market for pearls is based on supply and demand, but as a natural product, pearls depend most of all on the sustained availability of pearl oysters and mussels. Humans have managed to find and later induce the formation of pearls over thousands of years, in many places, using many techniques. Some pearl-harvesting ventures rapidly stripped all available pearl mollusks from the wild with little or no regard for the long-term. Other pearling industries, for a variety of reasons explored here, remained functional for centuries.

Pearls and coral both qualify as gems with renewable biological supplies, yet in each case, this supply is not inexhaustible. Pearl-producing mollusks, like all organisms, require a healthy environment, an adequate and consistent food supply, and breeding partners to sustain viable populations. The threats to pearl oyster and mussel populations have shifted throughout history along with the move from pearl harvesting to pearl culturing, but the new threats are no less menacing than the old to survival of the molluscan species.

Because pearl oysters and mussels are commercial species, we know more about their living requirements than we do about most other mollusks. However, learning how far these requirements can be stretched in the quest to produce bigger and better and more pearls has brought hard lessons about the ecological limits of pearl-producing mollusks.

Like any living animal, each species of pearl-producing mollusk has a set of environmental conditions under which it thrives—temperature, water current, substratum, population density, oxygen level, and availability of food. Each parameter has its own limits, narrow or broad, under which the animal can survive. When conditions pass beyond the acceptable range, the animal will die. Perliculturists must understand these limits, and determine the optimal local conditions that will allow their mollusks not only to survive, but also to produce the best possible pearls.

Many different mollusks have been or are involved in the pearl industry. The differences are not only in the size, shape, and anatomical features of the various marine and freshwater species, but also in their life cycles, habitat requirements, and environmental tolerances. The species are not interchangeable and rarely transplantable. The following brief ecological descriptions will provide glimpses into the requirements of the main pearl-producing mollusks.

Dakin provided a description of the natural history of the Ceylon Pearl Oyster, *Pinctada radiata*, in 1913 in the Gulf of Manaar.[3] The clams live in banks on a hard bottom plateau, 10–20 meters deep. The plateau is mainly sand with scattered rock outcrops to which the pearl oysters attach in clusters of several to many individuals, using tough elastic fibers of their own making, called *byssal threads*. Like all pearl oysters, they feed passively during respiration, filtering microscopic organic particles through their gills from the surrounding waters. They spawn communally, releasing eggs or sperm into the water where the gametes unite to form free-swimming larvae called *veligers*. Over the course of years, an assemblage forms on the plateau. This assemblage—made of dead pearl oyster shells, worm tubes, calcareous algal clumps, and dead coral—is necessary for the veligers to settle, metamorphose into juvenile pearl oysters, produce byssal threads to attach, and begin to grow. Storms and predators are the main natural perils in this environment. Shifting sands and heavy wave action during storms can bury the banks or throw enough silt into the water to choke the living pearl oysters. Natural enemies are skates, rays, filefish, and starfish, as well as boring mollusks and sponges that weaken the shell—virtually the same list of problems faced by pearl oysters in culture. The maximum life span of wild Ceylon Pearl Oysters in their natural environment is about eight years.[4]

The Japanese, through their long history of pearl culturing, have become expert in rearing and maintaining the Akoya Pearl Oyster, *Pinctada fucata*.[5] This species can tolerate a rather wide range of salinity (27–34 parts per thousand), and thus can survive in estuaries as well as the open ocean. However, it lives optimally in sheltered coastal areas, with relatively quiet waters, attaching to rocks and other hard surfaces over a wide depth range (5–60 meters). Natural enemies are starfish, octopus, and eels. In commercial cultivation, its life span is six years—as always, the relationship of this figure to that in the wild is an assumption.

The large Silver- or Gold-lipped Pearl Oyster, *Pinctada maxima*, inhabits deeper waters than the Ceylon or Akoya Pearl Oysters, ranging from inner- to mid-continental shelf depths (20–50 meters). It requires waters of high productivity, with large amounts of suspended particulate matter.[6] Adults are found on a wide range of substrata, including algal beds, deep ledges, mud, sand, or gravel.[7] However, settlement and growth of the juveniles requires a very specific habitat—the shells of adult *Pinctada maxima*—meaning that adult shells must be present to maintain the population. Each *Pinctada maxima* pearl oyster harbors a tiny pea-crab (*Pinnotheres villosulus* Guérin-Méneville, 1831) that lives commensally with it, protected in the mantle cavity, sharing scraps from its filtered food supply. The crab's presence seems indicative of the health of the pearl oyster, and perliculturists are careful not to harm or dislodge it.[8] *Pinctada maxima* attains the legal collecting size in Australia of 120 millimeters in about three years; pearl farmers consider its "productive" period to be about eight years.[9] In the wild, it reaches dinner-plate size and lives as long as twenty years.

The similarly large Black-lipped Pearl Oyster, *Pinctada margaritifera*, thrives in the calm, clear, shallower waters of coral reefs and atoll lagoons, mainly from 1–40 meters deep.[10] It is one of the most widely distributed pearl oysters, but as with *Pinctada*

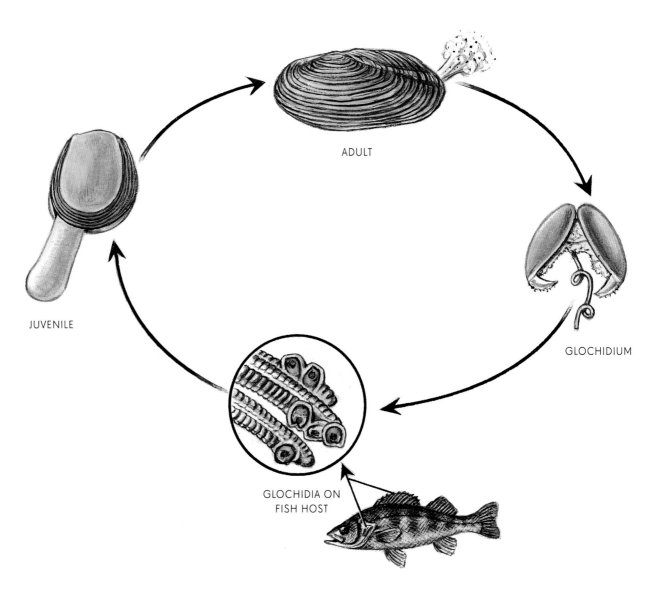

ADULT

GLOCHIDIUM

GLOCHIDIA ON
FISH HOST

JUVENILE

The life cycle of a freshwater pearl mussel includes a glochidium *(here shown enlarged), a specialized larval stage that must attach to the fin or gills of a fish before metamorphosing into a juvenile clam.*

maxima, water temperature also affects pearl quality. L. G. Seurat described the natural history of this species in 1906, reporting on other organisms that settle on its shell (cementing bivalves, chitons, corals, algae) or bore into its shell (sponges, boring bivalves), as well as its own commensal shrimp, parasitic worms, and predators (rays, crab, and octopuses). Wild individuals of *Pinctada margaritifera* can live more than thirty years.[11]

The life histories of freshwater pearl mussels are more complicated than those of pearl oysters and most other bivalves. Their reproductive cycles include specialized larvae called *glochidia.* Glochidia are released into the water by the mother clam, like the more typical veligers of other clams, but are unique in needing to attach to a fish before metamorphosis. This is an obligate stage, that is,

the larvae cannot survive without it, but it is not parasitic in that the larvae do not harm the fish. Some glochidia are equipped with tiny hooks with which they attach to the fish's fins or gills until they have grown sufficiently to drop off and take up residence in the lake or streambed. Meanwhile, the fish has carried the larvae to a fresh habitat, and has produced edible food particles for them from its own feeding and swimming activities. The fish hosts of each pearl mussel are generally predetermined and can include many fish or be restricted to a single species. The more narrowly dependent a pearl mussel is on a particular fish, the more vulnerable it will be to ecological change; the environment must be healthy enough to sustain both the pearl mussel and the fish. Accordingly, the presence of freshwater pearl mussels has often been used as an indica-

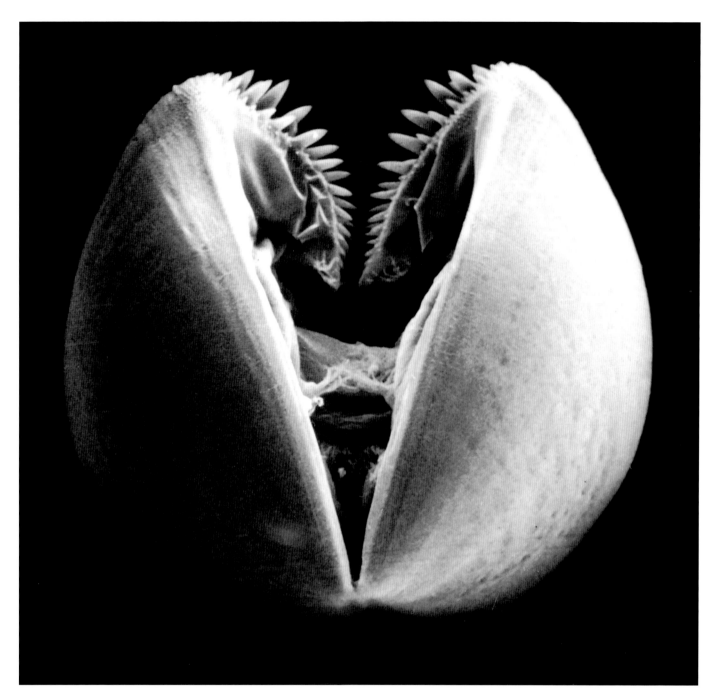

tor of healthy environmental conditions in North American rivers and lakes.

The life requirements of the European Pearl Mussel, *Margaritifera margaritifera*, which also ranges through northern Eurasia and North America, are well studied. This pearl mussel requires cool, fast-flowing streams lined with cobble and gravel. Water chemistry appears to be the most important factor limiting its distribution. It requires water low in calcium—surprising, because production of shell as well as pearls requires a supply of dissolved calcium. This might be a life requirement not of the clam, but of the fish hosts—trout and salmon—required for *Margaritifera*'s glochidia.[12] This pearl mussel is extremely long-lived, often reaching an age of eighty to one hundred years.

In China, in the culturing of the Triangleshell Pearl Mussel, *Hyriopsis cumingii*, water chemistry is also critical, but with high calcium content required; this is maintained in pearl paddies by

A scanning electron micrograph of the glochidium of an endangered pearl mussel [Dwarf Wedgemussel, Alasmidonta heterodon *(Lea, 1830)] reveals "jaws" with which it will attach to its fish host.*

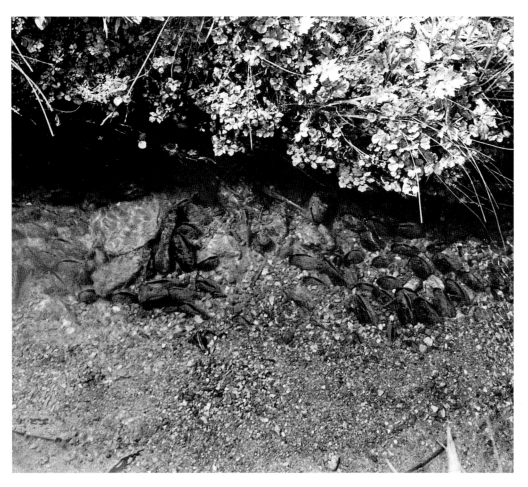

This colony of Margaritifera margaritifera *lived in a brook of Saxony's Vogtland, White Elster drainage system, in the early 1960s in Germany.*

the addition of lime and/or fertilizer to the water. Gentle water flow, as in rivers and lakes, is preferable to stagnant water, to maintain proper levels of dissolved oxygen and nutrients.[13]

Unsustainable versus Sustainable Use

In search of natural pearls and mother-of-pearl, humankind has repeatedly over-collected wild pearl oysters and mussels. Despite their efficient feeding, pearl oysters are among the slowest growing of all marine bivalves, requiring several years to attain sexual maturity.[14] Living populations with such long generation times cannot withstand heavy or repeated harvesting. In the case of immobile pearl-producing bivalves, so desirable that considerable efforts are expended in their collection, they can be rapidly exterminated. Controlling the harvest to maintain sustainable pearl fisheries or culturing efforts is thus a serious challenge, and has often not been achieved. Many of the world's natural pearl beds have been fully

depleted, but we can learn from the past by examining both these pearling ventures and those that have remained active for centuries.

After one hundred and fifty years of exploitation, diving for Black-lipped Pearl Oysters (*Pinctada margaritifera*) to find natural pearls was made illegal in Tahiti following collapse of the mother-of-pearl industry in the 1960s. The pearl populations there only recovered after the advent of perliculture and the move to spat (adult shells) collecting.[15] But elsewhere protection has not always meant salvation. Perhaps the best (or worst) case is that of the Hawai'ian variety of the Black-lipped Pearl Oyster, *Pinctada margaritifera* var. *galtsoffi* Bartsch, 1931, which has been fished to near-extinction at its most famous locality—Pearl and Hermes Reef about 1,100 miles northwest of Honolulu.[16] A commercial fisherman, William Anderson, discovered a population of Black-lipped Pearl Oysters there in 1927, and he and his crew harvested over a hundred tons of pearl oysters from the reef for the mother-of-pearl button industry in 1927–28. Smaller shells, too thin

for buttons, were probably also opened for natural pearls. In 1930, the oyster expert Paul Galtsoff conducted a survey of Pearl and Hermes Reef. Few pearl oysters were found living on the reef, and he pronounced the population "decimated." In an attempt to revitalize the pearl oyster population in another area, Galtsoff transplanted 320 of the remaining Pearl and Hermes pearl oysters to Kaneohe Bay, an area 1,800 kilometers away where "dredging and dynamiting the reefs [for military purposes] completely destroyed the initial population of oysters."[17] As a result of Galtsoff's studies, pearl oysters were placed under the protection of the Hawaiian government and harvesting without a permit became illegal in Hawaii in 1930. Unfortunately, the Kaneohe Bay population was found nearly extirpated by 1943; Galtsoff's transplantation experiment had not been successful. In 1993, the government returned to Pearl and Hermes Reef and found the pearl oyster population there even further decreased from the already alarming 1930 numbers. Thus in Hawaiian waters, although Galtsoff predicted recovery of the pearl oyster stocks after a few years of fishing moratorium, improvement was not noticeable after sixty-three years. The adult population density was simply too low; there were too few sperm released by males to fertilize the eggs released by females, and the preferred settling substratum for the spat was too sparse.[18]

As discussed earlier, the most notable region where a long-term pearl fishery has been maintained is that of the Persian Gulf. Success through the centuries has been due to the harvests being continuously restricted as to *where* and *how much* could be collected.[19] This practice maximizes the yield per unit of effort, and doubtlessly has also preserved the population. Because this region no longer supplies the world's pearls, it is often misinterpreted as "pearled out," but this is not true. It was the discovery of oil that led to the end of pearling in the Persian Gulf region by the directing of economic interests toward the more lucrative petroleum industry. According to Japanese sources, there are still large populations of *Pinctada radiata* in the Persian Gulf, and a recently rejuvenated natural pearl industry in Kuwait demonstrates this point.

In some cases, periodic over-fishing followed by a period of non harvest has resulted in recovery of the populations. In the Gulf of Mannar, surviving documents show that the marine pearl fisheries were operational for only a few decades in each century between 1663 and 1961.[20] Periodic disappearances of pearl oysters are recorded for this area back to at least the eleventh century, when Biruni noted that the pearl fishery of the Gulf of Serendib (Sri Lanka) had become exhausted.[21] In seventeenth-century China, the periodic nature of the Leizhou marine pearl fisheries was also widely recognized. As Song Yingxing wrote in 1637:

> *Pearls in nature are limited in number, and become exhausted if they are gathered too frequently. If left undisturbed for a few decades, the shellfish will have a chance to exist in peace and increase their progeny, and thus will be able to create the precious gems in great quantities.*[22]

Freshwater pearl mussels, some with life cycles of many decades, have if anything been more affected by over-collection than saltwater pearl oysters. Words of warning have been raised over the centuries, with mixed results. In the 1700s, Carl von Linné described the *Margaritifera margaritifera* pearl fisheries in Lapland, noting

> *... when it was first discovered that this neighbourhood produced pearls, the river at Purkijaur was the place where the principal pearl fishery was established. But now it is nearly exhausted.... There is no external sign about the shell, by which it is possible to know whether it contains a pearl or not. Consequently many thousands are destroyed to no purpose....*[23]

In 1899, only a few years into the boom of the freshwater-pearl-mussel-based button industry in the United States, H. M. Smith wrote:

> *If therefore, the button industry of the Mississippi is to be maintained, it seems essential that the States invested should promptly take joint action to prevent the gathering of small mussels, to give some protection to the principal mussels immedi-*

ately prior and during the spawning season, and to prohibit the running of factory and other refuse on the mussel beds.[24]

Government regulations have been decisive in sustaining the freshwater European Pearl Mussel, *Margaritifera margaritifera*, over the centuries. In the relatively cold waters that this species inhabits, pearl growth requires an exceptionally long period, sometimes twenty years or more.[25] In addition, this is an especially long-lived species, with individuals exceeding one hundred years. Extensive harvest of such a slow-growing species necessitated a tightly regulated fisheries management. In Saxony's Vogtland, particularly the River White Elster and its tributaries, pearl fisheries have been recorded since the 1500s.[26] Pearling became a royal privilege in the 1560s under Duke August of Saxony. His successor, Christian I, appointed Sebastian Schmirler the first "Kurfürstlicher Perlenfischer" in 1590.[27] The region was divided into hundreds of sectors of which only a few dozen could be checked annually for pearls, using non lethal examination tools, while other sectors had the opportunity to recover.[28] Great stability prevailed in this industry over decades and centuries, and pearling offices were passed down through generations. Until the end of natural

pearling operations in the 1920s, the masters of Saxony's pearl fisheries, with a single exception in the seventeenth century, were direct descendants of the original court-appointed pearling master.[29]

Since the beginning of the industry there, pearl theft in Germany was a serious offense. In seventeenth-century Bavaria, Johann Philipp, the Bishop and Sovereign of Passau, threatened would-be offenders with pearl gallows that he erected near the pearl mussel sites. In northern Germany threatening "beware" signs featured a severed hand, a hanged man, or torture instruments.[30] In the sixteenth-century Czechoslovak region, capital punishment could be the sentence of a convicted poacher.[31] To encourage the surrender of pearls "accidentally" collected while fishing, a small finders' fee was occasionally promised.[32]

This strictly controlled monitoring and harvesting regime guaranteed a sustainable production in Germany. Available pearl-harvest figures for the Vogtland in Saxony range between one thousand and nearly nineteen hundred highest-quality "clear" pearls in each twenty-year interval between 1719 and 1879.[33] Only with industrialization and its associated environmental impacts did this number decrease—just 471 clear pearls were found between 1880 and 1899. Pearl qual-

"Hüte Dich fur [vor] Schaden" (Don't Get Harmed),
a warning sign from 1736, forbids pearl fishing in the North German river Schwienau in undeniable terms.

ity also declined sharply until harvesting effectively ceased in the 1920s, when comparably inexpensive and rapidly produced Japanese cultured pearls reached the market.[34]

Less efficiently regulated European pearl fisheries involving *Margaritifera margaritifera* faltered earlier. In the 1880s, the once-flourishing pearl mussels of Scotland were "still collected, but only as bait for the Aberdeen codfishery."[35] In the 1990s, experimental and small-scale pearl operations were maintained or reestablished in various regions, particularly Norway, Sweden, and Great Britain, but in many areas the European Pearl Mussel is still at the brink of local extinction.[36] Efforts have been made to reinstate the pearl mussel in depleted rivers and to govern pearl harvesting using classic non invasive German methods in both the Czechoslovak region and on the Kola Peninsula, in northwestern Russia.[37]

The advent of perliculture has not immediately saved natural pearl beds from over-collection. Initially, all pearl industries began by gathering wild adult pearl oysters or mussels for implantation. One such case is still occurring—off northwestern Australia for South Sea pearl production using the Silver-lipped Pearl Oyster (*Pinctada maxima*). So far, the combination of strict governmental quotas and careful perliculture practices seems to be preventing over-collection of this resource. In other cases, however, when local pearl beds have become depleted, clams have sometimes been collected elsewhere and transported over great distances. The import of Chinese Akoya Pearl Oysters to Japan for culturing, primarily by small pearl cultivators in the 1990s, has been blamed for introducing a virus that is decimating the Japanese pearl oyster crop (see below).

The rise of perliculture has, in actuality, increased rather than decreased the risks of over-collecting for freshwater pearl mussels, through the need for bead nuclei. The world's cultured pearl industry is highly dependent on a reliable supply of high-quality freshwater pearl mussels from United States waters. So far, these pearl mussels are wild-collected and not farm-raised. Exports of pearl mussel shells for bead production peaked in 1993 and were already declining by the late 1990s.[38] At present, no substitute nucleus material is accepted by the world's pearl culture industry although there

are efforts underway.[39] In the words of Richard Neves, an authority on freshwater pearl mussel conservation in the United States, "Many mussel species, once common in rivers, will become candidates for federal protection. The future of commercial musseling in the U.S. is in jeopardy."[40] As a consequence, until a new inexhaustible source of nuclei is found, the cultured pearl industry is also in jeopardy.

One encouraging fact surrounds some of the more heavily harvested pearl mussels. Populations of certain species—such as the Washboard (*Megalonaias nervosa*), Threeridge (*Amblema plicata*), and Wartyback (*Quadrula nodulata*)—are considered "stable" today. These species can utilize a wide variety of fish hosts, often from many different genera. Others with only two or three fish hosts—for example, the Pigtoe (*Pleurobema cordatum*) and Butterfly (*Ellipsaria lineolata*)—are now reduced in numbers and protected as "species of special concern."[41] One very popular species in both the button and nucleus industries, the Ebonyshell (*Fusconaia ebena*), has five fish hosts and was stable in the year 2000; however, "excessive harvesting by commercial shellers has had a detrimental effect on some local populations."[42] Despite protection, poaching of this and other protected species or collecting in protected localities does occur.[43]

The Impact of Over-culturing

Responding to the limited availability of wild-collected specimens, collection of pearl-producing mollusks has been replaced in most of today's markets by aquaculture—the spawning and rearing of individual mollusks needed for nucleation and pearl cultivation. Although this requires specialized techniques and years of effort to maintain the growing clams, it has been successful and, in fact, necessary in perpetuating the pearl industry in Japan. However, it is not without its own problems. Typical shellfish aquaculture practices around the world emphasize the production of edible meat over all other bioproduction, to the exclusion of reproduction and shell deposition. Because reduced shell production will also mean reduced pearl production, pearl aquaculturists have needed to develop their own methods.

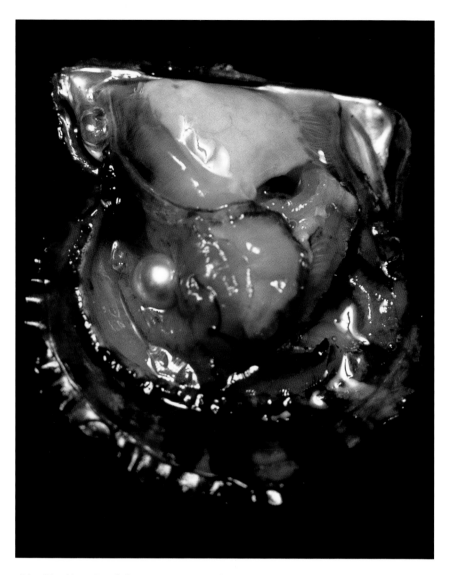

A healthy Akoya Pearl Oyster, opened to reveal its flesh and a cultured pearl. In an Akoya infected with the pearl virus, the flesh turns reddish brown.

are genetic and can be overcome only by an infusion from wild stocks, although the carefully selected physical characteristics of the strain could be compromised as a result.

Genetic weakness could be partially to blame for the now-infamous Japanese pearl virus. Four hundred million Japanese Akoyas died in 1996 and 1997, the first two years in which the virus was suspected, and the problem remains acute.[46] Japanese scientists have finally identified it as a marine birnavirus (abbreviated MABV)[47]—one that acts much like human HIV (the cause of AIDS) in that it requires other stress factors such as temperature change to express the disease. The adductor muscle of an infected pearl oyster turns reddish brown, and its gills deteriorate, so that the clam is unable to feed adequately and ultimately starves to death. Muscles of the mantle, foot, and heart are also affected.[48] The mortality has resulted in a 70 percent reduction in annual pearl production—from more than 67,000 to fewer than 19,000 kilograms in 1999.[49] Thus far, only the Akoya Pearl Oyster is known to be affected.[50] Although not definitely linked with the Japanese virus, unexplained mass mortalities in the Black-lipped and Silver-lipped Pearl Oysters have been recorded in the Red Sea, Myanmar, Tuamotus, Australia, and China since the 1970s. These have been blamed on parasites, protozoans, viruses, or tumors in the intestinal tracts or muscles of the pearl oysters, but have not recurred.[51] In the repeating case of the Akoya Pearl Oyster, scientific study has suggested that environmental degradation and genetic inbreeding are the real problem, weakening the cultured population in general—in turn allowing the birnavirus to take its toll.[52] Efforts are underway in Japan to counteract the virus by breeding and nucleating only healthy pearl oysters, by eliminating infected pearl oysters whenever they are identified, and by avoiding excessive stress to pearl oysters in culture. These efforts appear to have been successful because production is up for the first time in many years.[53] Crossbreeding the Japanese Akoya Pearl Oysters with Chinese Akoyas has also been considered, but not pursued extensively.[54] Chinese periculturists are now reportedly also using artificial spawning and aquaculture to halt the spread of the virus.[55]

Even if the genetic strain of a cultured pearl oyster is strong, aquaculture practices can inter-

As early as 1970, the noted Japanese pearl author Shohei Shirai recorded deterioration in the shells of farm-raised Akoya Pearl Oysters (*Pinctada fucata*) being cultivated for pearl production, including signs of deformed, weak, and porous shells. By the 1990s, pearl oysters had been genetically engineered, striving for larger and whiter shells to produce larger and whiter pearls. In so doing, periculturists inadvertently created pearl oysters that might be more prone to parasites and disease, a risk whenever a large population is genetically descended from a small number of individuals.[44] Thus, despite slightly larger shells, only a few of the captivity-reared Akoyas can accept beads larger than 8 millimeters while healthier wild Akoyas can accept 10-millimeter nuclei.[45] Defects owing to inbreeding

vene. The maintenance of pearl oysters in suspended racks can lead to overcrowding if they are too tightly packed. The cage itself restricts water circulation around the clams. Too many pearl oysters in too little space results in a high load of waste products in the water, too little oxygen, and too little food to adequately support all of the individuals. In Japan's Ago Bay, normal culturing techniques include hanging baskets of nucleated pearl oysters in the bay; one account told of over three thousand pearl oysters in sixty cages, which calculates to about fifty per basket.[56]

In French Polynesia, pearl farmers are experimenting with aquaculture methods, but the main source of pearl oysters for perliculture still comes from wild populations. This is accomplished not through collecting wild adult clams, but rather by collecting swimming larvae on spat collectors, to be raised to adulthood. This produces genetically stronger individuals, while still controlling shell growth. The same strategy is being suggested for the development of a pearl-culturing industry in Baja California, Mexico, involving two protected species, *Pinctada mazatlanica* and *Pteria sterna*, to minimize impact to already-depleted wild populations.[57]

Freshwater pearl mussel aquaculture has not been immune to culturing problems. Following the success of experiments in 1980 to artificially raise the Chinese Triangleshell, a mass mortality event occurred in 1982 when "disease spread and *Hyriopsis cumingii* mussels died in large numbers."[58] Although details are not known, it is likely that this event was in part due to suboptimal culturing methods.

THE IMPACT OF DEGRADED HABITAT

Although the threat of over-collecting is largely one of the past, today's wild pearl oyster and mussel populations are subject to other threats, most importantly against the fragile ecosystems that support them: water pollution, natural diseases, competition by introduced species, and loss of habitat. One of the first strong impacts of this kind was felt in the freshwater pearl mussel beds of Europe. Saxony's pearl fisheries, for instance, were already threatened in the early eighteenth century by logging and rafting that destroyed pearl mussel banks and killed pearl mus-

sel populations by siltation; other damage was introduced through siltation and wastewater from stamp mills, bleach- and dyeworks.[59] Riverbed diversion channeling causing the loss of suitable pearl mussel habitat was recognized early as a major factor in the decline of *Margaritifera* in parts of Europe.[60]

Cultured pearl farms are equally vulnerable to environmental degradation when they use lakes or coastal bays as holding grounds. Most bivalves, including all pearl oysters and mussels, are filter feeders, removing oxygen and food particles from the water by circulating it though their gills. Water quality is thus of prime importance to filter-feeding organisms. Toxic pollutants in the water, anoxia (reduced dissolved oxygen in the water), or suspended silt that can clog the mollusk's sensitive food-gathering gills can quickly decimate a population. Although they are not filter feeders, pearl-producing snails (conch, abalone) depend on healthy plants as food—plants that in turn require clean water to admit the sun's penetrating rays for photosynthesis. Water pollution of various kinds severely impacts the ability of mollusk populations to survive, especially in the face of the added stress of commercial exploitation.

Water chemistry can also affect nacre production and thus the quality of cultured pearls. Acid or alkaline water, measured by pH, has been shown to be important to freshwater pearl mussels in China (*Hyriopsis cumingii*) where highest nacre production was observed in waters of neutral pH.[61] Consistent depth and regular flow rate in freshwater also regulate temperatures and pH by preventing wild fluctuations and stagnant conditions.[62]

Habitat degradation is the most frequently cited cause for the destruction of freshwater pearl populations in mainland Europe and North America, above and beyond over-collecting. Despite centuries of pearl harvesting in Europe, biologists in both Ireland and Norway have placed the blame for decline or disappearance of *Margaritifera margaritifera* squarely on other human disturbances (pollution, encroachment, acid rain).[63] Importantly, the populations of European fish on which this species depends as its larval host have declined dramatically, and have taken the pearl mussel with it.[64] Of the 297 species of native freshwater pearl mussels (families *Margaritiferidae* and *Unionidae*) recorded

from North America, thirty-five are presumed extinct, with another sixty-nine formally listed as endangered or threatened.[65] According to The Nature Conservancy, 67 percent of freshwater pearl mussel species are at risk of extinction.[66]

Human-introduced pollution, in the form of runoff from agriculture, industry, and recreation, has a tremendous impact on inland waters. The American Pigtoe (*Pleurobema cordatum*), the freshwater pearl mussel originally developed as the source of cultured pearl nuclei and once required for it by Japanese law, has not been used in quantity in years because, in the words of musseler John Latendresse, "the agricultural pesticides got to 'em." Many species in the eastern United States were originally restricted to one river system, and because of development, are now restricted only to the most pristine part of that river system. A single untoward event, such as an accidental toxic spill, can have devastating and long-lasting consequences for such a species.[67]

What we mean by "water pollution" is also relative. While most pearl-producing mollusks, both marine and freshwater, need relatively clean, clear water to survive, Chinese freshwater pearl mussels (*Hyropsis cumingii*) achieve large adult sizes and produce large lustrous pearls in culture in what most people would consider heavily polluted water. Although this thick brown sludge is certainly super-charged by nutrients and inorganics added to improve the clams' growth, it is not contaminated by industrial chemicals. Nevertheless, the European Pearl Mussel (*Margaritifera margaritifera*) and the fragile endemic species from Lake Biwa (*H. schlegelii*) would not survive very long in this type of water. In this sense, the Chinese pearl mussel is more domesticated than its freshwater relatives, happily thriving in an agricultural setting.

A change in habitat—often not seen as destruction or disturbance—also affects freshwater pearl mussels. Any modification of a natural waterway (artificially straightening a river, concrete banks, dredging) has an impact. Damming of rivers causes changes in depth, water flow, and substratum that can tip the delicate balance of ecological parameters. Damming, in particular, although not always directly impacting the adult pearl mussels, can reduce the required host-fish populations by pre-venting their migration to areas inhabited by the pearl mussels.

The impact of introduced species to an ecosystem is often unpredictable and devastating. In Europe, the North American rainbow trout [*Oncorhynchus mykiss* (Walbaum, 1792)] has been introduced for recreational fishing. It has out-competed the native brown trout (*Salmo trutta* Linné, 1758) in many areas, but this new fish is not an acceptable host for the glochidia larvae of the freshwater pearl mussel *Margaritifera margaritifera*. This has compounded the pressures of pollution and past over-harvesting on the European clams.[68]

Introduced freshwater clams compete directly with pearl mussels for living space and food. During the 1930s, the Asian Clam, *Corbicula fluminea* (Müller, 1774), was introduced into western North America and quickly spread throughout the United States and Canada, becoming a nuisance species in the 1950s.[69] It is an amazingly successful opportunist, reproducing rapidly and thriving under a wide range of salinity and water conditions. It can even expand its range by floating through the water column on draglines of its own mucus.[70] It is remarkably well adapted to changing, or adverse, environmental conditions. It is not, like native freshwater pearl mussels, dependent upon freshwater fish to complete its life cycle. In addition to inflicting severe economic impact by plugging water pipes in power plants, irrigation systems, and the like, *Corbicula* has expanded its range and numbers so extensively that it has left native freshwater clams no space to settle.

Since the 1980s, the zebra mussel, *Dreissena polymorpha* (Pallas, 1771), and the closely related quagga mussel, *D. bugensis* Andrusov, 1897, are the new threat to American freshwater pearl mussels. These species are native to areas of Russia near the Caspian Sea, and spread through Europe in the 1800s thanks to increased boat traffic on newly built canals. First discovered in North America in Lake St. Clair in 1988, zebra mussels had successfully colonized all of the Great Lakes and waterways in eighteen states and two Canadian provinces by the early 1990s.[71] These mussels attach to hard substratum, very often to pearl mussels themselves, filtering off their oxygen and food supplies, suffocating and starving them to death.

Suggested methods to eliminate them—mollusci-cides, biological control, physical removal—must take care not to eliminate native species as well, and the best alternative appears to seek ways to exist with them.

Lake Biwa, the ancient Japanese lake and famous center of freshwater pearl cultivation, is a prime example of multiple environmental problems contributing to the decline of a pearl industry. Surrounded by rice and wheat fields, golf courses, and orchards of grapes, pears, and persimmons, the lake no longer supports a viable population of its famous inhabitant, the endemic Biwa Pearl Mussel (*Hyriopsis schlegelii*). Extensively used for pearl production since the 1960s, the slow-growing pearl mussel showed rapid decline in numbers through the 1970s and 1980s, and virtually none have been found since 1991.[72] Over-collecting and pollution from domestic waste, pesticides, and fertilizers, associated with a 33 percent increase in the resident human population, are most often blamed for this, leading to eutrophication of the deeper areas and inducing periodic freshwater red-tide outbreaks.[73]

An additional problem in Lake Biwa is the introduction of three North American fishes—the bluegill sunfish (*Lepomis macrochirus* Rafinesque, 1819; since 1968), the black or largemouth bass [*Micropterus salmoides* (Lacépède, 1802); since 1974], and the smallmouth bass [*Micropterus dolomieui* (Lacépède, 1802) since 1995, although not yet confirmed as a permanent resident]—all wildly popular for recreational fishing.[74] Their populations in the lake have been described as "explosive," doubly so owing to the common recreational practice of "catch and release," which the prefectural government is now campaigning to change. These fish are mainly carnivorous, and it is tempting to postulate that they have eradicated the small native gobies that host the larval pearl mussels, thus removing a critical link from the clam's life cycle. However, Lake Biwa scientists note that this goby (*Rhinogobius*) is the most abundant fish in the littoral zone of the lake. Furthermore, *Hyriopsis schlegelii* is capable of using a wide variety of fish as glochidial hosts.[75] Thus, decline of the pearl mussel requires additional explanation. Scientists have determined a multitude of other causes, including land reclamation of satellite lakes, reducing the area of shallow "reed habitat"; a shift from sandy bottom to muddy bottom as a result of dredging for construction and overflow of paddy fields; selective removal of pearl mussels because of their commercial value; and a change in the composition of phytoplankton, the main food of pearl mussels.[76] In response, Lake Biwa-area pearl farmers are importing Chinese pearl mussels (*Hyriopsis cumingii*) to hybridize with their remaining aquaculture stock of Biwa Pearl Mussels with the hope that the resulting stock could revitalize the industry.

Coastal oceanic waters, despite their connection to the seemingly indestructible ocean, are susceptible to environmental problems because of their ready availability to humans. However, not all problems are human-induced. In 1984, the pearl harvest in Japan was lower than normal because of suboptimal water temperatures and the lack of rain.[77] These adverse conditions affected the supply of nutritious plankton needed to sustain the filter-feeding pearl oysters. Many pearl oysters died, and others had reduced nacre production.

In Japan's saltwater Akoya pearl farms, partially landlocked in bays and estuaries, two elements of water quality are contributing factors to the recurring pearl oyster die-offs that are otherwise blamed entirely on the pearl virus—human-produced water pollution and red tides. Japan's heavily populated Ago Bay, historical center of pearl production, suffers from industrial and automobile pollutants, pesticides, herbicides, household detergents, other chemicals, and untreated sewage.[78] As filter feeders, bivalves often concentrate heavy metals and other pollutants in their tissues, adversely affecting their overall health and amplifying the effect of the pollutants.[79] Mere freshwater runoff, often increased through human development (especially land clearing), can affect survival of saltwater species in an estuary, especially sensitive larvae and juveniles. An unforeseen problem is *formalin* (formaldehyde gas in water) that runs off from nearby blowfish culturing farms where it is used to treat parasites and skin diseases in the highly-prized edible fish.[80]

Coastal pollution in Japan has affected other Japanese pearl production as well. Between the years 1988 and 1993, two Japanese abalone pearl farms closed as a result of poor-quality pearls. Pollution generated by adjacent aquaculture facilities was blamed for this.[81]

Red tide is one of the great threats to a commercial pearl farm. Behind the 3-meter (10-foot) boat, this orange-yellow surface stain contains the remains of millions of dinoflagellates that died when ecological resources could no longer sustain the huge bloom. The resulting toxins in the water are deadly to pearl oysters and other forms of marine life.

The second serious water quality problem in Japan is *red tide*, blooms of *dinoflagellates*, planktonic single-celled plants whose presence can be triggered by unusually warm temperatures, pollutants, or excess nutrients in the water. In high concentrations, dinoflagellates produce dissolved toxins that color the water red-brown and can become concentrated in filter-feeding organisms, leading to shellfish poisoning that is dangerous to seafood-eating humans but not to most clams. Several species of dinoflagellates are now associated with red tides in Japan, including one named for Mikimoto, *Gymnodinium mikimotoi* Miyake & Kominami ex Oda, 1935. One newly identified species, *Heterocapsa circularisquama* Horiguchi, 1995, is particularly noxious and does affect the clams–it can kill an Akoya Pearl Oyster within min-

utes.[82] Red tides have been a constant feature of the Japanese coastline, impacting periculture ventures since the early 1900s, but the first serious red tide occurred in Japan in 1992; they now occur once or twice each summer.[83] The Mikimoto Pearl Research Laboratory at Ago Bay monitors water conditions, including concentrations of lethal dinoflagellates at several water depths on a daily basis, and advises other pearl farmers on conditions and the need to evacuate their crops from the bay. When levels become critical, culturing racks of nucleated and unnucleated Akoya Pearl Oysters are literally trucked cross-country, to "evacuation lagoons."

Some of the newer periculture operations have adopted approaches and techniques that effectively avoid repeating the mistakes of earlier-founded industries. Tahitian experts recognize a

"biotic capacity" for their industry of eight tons a year, given the present technology and the number of usable lagoons, and aspire more toward quality than quantity.[84] Following a die-off in 1985 that occurred largely in the high-production lagoons, Tahitian pearl farmers suspected overcrowding, and decreased the density of clams in culture.[85] The pearl oyster populations responded and pearl production increased. Tahitian government scientists at the Ministère de la Mer et de l'Artisanat Service des Ressources Marines launched an eight-year comprehensive study of the Tahitian Black-lipped Pearl Oyster (*Pinctada margaritifera*). Although the cause of the die-off was never positively identified, a great deal was learned about the life requirements and physiological limits of the living animals.[86] An eco-physiological model for *Pinctada margaritifera* in Takapoto lagoon has been created to help predict ideal levels of spat collection, density in culture, choice of farming sites, and carrying capacity of the lagoon.[87] Various methods, such as measuring the relative amounts of spat in the lagoon, have been devised to monitor lagoon health. To prevent the spread of their most serious biological threat, a sea anemone that fouls the adult shells and restricts shell growth, transport of adult clams from one atoll to another is forbidden, although it does occur; transport of spat is tolerated as "safe" because anemones are not present on very small individuals.

Human-induced pollution is not a factor in the deep-water pearl farms off northern Australia. Nor is it to those of French Polynesia with its single large city, Papeete, far removed from the coral atolls and pearl farms. Australia and French Polynesia do not have histories of red tides.

In Australia and Tahiti, typhoons are among the most dreaded threats, when "high winds and waves can kill unprotected oysters and tear apart entire farms."[88] In fact, all western Pacific perliculture ventures are especially vulnerable to natural events like earthquakes and tidal waves. El Niño and La Niña phenomena, which scientists suspect could be linked with anthropogenic global warming, are also serious events that can change sea temperature, rainfall, and primary productivity sufficiently to affect nacre production.[89] A typical El Niño event can cause a three-degree rise in seawater temperature; in 1990 in Marutea, French Polynesia, a one-degree rise reduced the pearl crop by 40 percent through death of the pearl oysters or rejection of the beads. Another constant threat is the petroleum industry; a single wrecked tanker off of any pearl-producing country could create an oil spill to wipe out pearl production for years.[90] A hint of this kind of disaster was felt in 1970, when an oil spill from the vessel *Oceanic Grandeur* caused massive mortality among wild and cultivated Silver-Lipped Pearl Oysters in Queensland. Although a few Queensland pearl farms were still operating in the year 2000, the Australian pearl industry was by then centered along the northwestern coast instead.[91]

Places like relatively unspoiled French Polynesia are not, however, immune to economic pressures and individual enterprise that can result in environmental degradation. To combat temperature changes and thus increase pearl production in their lagoons, Tahitian pearl farmers have considered pumping ocean water from 100-foot depths through pipes into shallow lagoons, with the justification that this water is richer in oxygen and plankton.[92] Whether this is true or not, it is naïve to believe that it can be done without affecting the ecology of the lagoon as a whole. On another front, two large marine snails—the Pink Snail (*Trochus niloticus* Linné, 1767) and the Green Snail (*Turbo marmoratus* Linné, 1758)—were introduced to French Polynesia from other locations in the Indo-Pacific, and are now being raised in several lagoons for export to Korea and Japan as mother-of-pearl. Although local officials maintain that these have "no impact" on the native ecology, their large sizes and roles as reef grazers leave little doubt that they are changing the community structure on the atolls that they inhabit. Their impact on pearl oyster communities of the Tuamotus has yet to be determined.

PROTECTING THE RESOURCE

Although the preceding sections outlined some of the difficulties affecting molluscan populations, the future is not all dark. In the face of these threats and the renewed interest in biodiversity and habitat protection, legislated regulations now protect many of the pearl-producing mussels and oysters.

Many popular texts assert that the fascination with and beauty of pearls is responsible for saving

pearl-producing mollusks from extinction; this is, however, a clear case of rationalization. It was, after all, centuries of exploitation and over-harvesting in the quest for pearls that has placed these mollusks in danger in the first place. Nevertheless, worldwide legislation and self-regulation within the pearl industry now seek a level of sustainable use that allows the molluscan species to survive despite their commercial utilization. National and international laws increasingly protect European and North American freshwater pearl mussels. The European Community, for instance, placed *Margaritifera margaritifera* on its list of "Protected Fauna Species" in 1979.[93] Attitudes of those involved in pearl culture also make a big difference. Both Australian and Philippine marine periculturists have taken a strong stance on environmental awareness and protection, advocating the importance of a healthy marine ecosystem for their business success.[94]

Among saltwater species, both *Pinctada mazatlanica* and *Pteria sterna,* over-exploited beginning with Cortés in the early 1500s, have been legally protected as endangered species in Mexico since 1940.[95] Despite this, both are being developed in experimental pearl-culturing ventures. Those involved in such ventures recognize the need to achieve economic success without impacting wild populations that are still considered fragile and scarce.[96] Restocking is usually promoted as the method to stimulate recovery of sparse populations. This is being investigated in both Mexico and, for *Pinctada margaritifera,* Hawaii.[97] Unfortunately, the aquaculture version of restocking often includes importing specimens from another region and this has obvious risks—the introduction of diseases or parasites associated with a species from another part of its range, or unforeseen competition of an introduced species with native populations.[98]

Along with conservation efforts, biotechnology could be the answer to safeguarding the world's supply of pearl-producing mollusks. It falls to the pearl farmers and those regulating their operations to safeguard the world's captive populations of pearl-producing mollusks through sustainable aquaculture methods.

Artificial spawning and aquaculture now maintain the Japanese Akoya Pearl Oyster (*Pinctada fucata*) almost exclusively. In an effort to improve the strain, Japanese periculturists are experimenting with a co-culture system, growing pearl oysters and red algae together. In this system the algae removed the nitrogenous wastes produced by the pearl oysters, with the result that both had higher growth rates than either did in monoculture.[99]

Aquaculture methods are also being developed for the Tahitian Black-lipped Pearl Oyster (*Pinctada margaritifera*) in the event that harvesting of wild spat declines in the future. In Australia, where wild collecting of adults still supplies much of the periculture industry, hatchery-rearing of the Silver-lipped Pearl Oyster (*Pinctada maxima*) now supplements the collected quota. In other areas of the Indo-Pacific, Silver- or Gold-lipped Pearl Oysters are all hatchery-raised, and worldwide, hatcheries now produce more than 80 percent of the mother oysters for South Sea pearls, even though nearly all were wild-collected only fifteen years ago. Abalone, which have long been over-harvested for their mother-of-pearl shells as well as their meat, are heavily regulated in the wild, but are now being cultured in Australia, New Zealand, China, South Africa, Mexico, Chile, Ireland, and the western United States.[100]

Technology of a different sort plays a significant role in one of the most challenging periculture arenas—that of the Silver-lipped Pearl Oyster off northwestern Australia. Periculturists here go to extremes—in effort and expense—to assure survival of each collected pearl oyster. The reasoning behind this is of course highly economic. The expensive diving operation necessary to collect the clam, nucleation by highly paid grafters, and the ocean-going vessels that underlie this business, plus three years of constant care before harvest, can be profitably offset by gem-quality South Sea pearls. Nevertheless, the Australian periculturists express an understanding of their pearl oyster, the conditions under which it will thrive, and the risks of collecting from the wild. They keep meticulous records and modify their actions based on the results. Compared to 50 percent post-nucleation mortality in Japanese Akoyas, and 44 percent in Tahitian Black-Lipped Pearl Oysters, at least one Australian producer claims that only 5 percent of nucleated pearl oysters will die before harvest.[101]

PEARLS BEYOND THE YEAR 2000

Modern periculturists work diligently to avoid the hazards associated with pearl fishing in the past, and as a result of their success in producing large quantities, have made pearls available to the largest number of people in recorded history. However, the exploitation of our natural resources in the pursuit of human interests poses many challenges: dwindling natural populations of pearl-producing mollusks, environmental degradation, the challenges of hatchery-rearing, balancing overuse against sustained use, and maintaining the delicate balance necessary to sustain living mollusks in greater-than-normal densities. Fortunately,

today's shrinking world of modern communications and rapid travel allows for unprecedented levels of technology transfer and education, a phenomenon we witnessed first-hand during our research for this book and its associated exhibit.

Worldwide cultured pearl production is a phenomenally fast-changing scene and predictions of the future, while hard to resist, are often ultimately off the mark. Few in 1940 could have predicted, for example, that pearls of over 20 millimeters in diameter would be generally available by 2000. Chinese freshwater pearls in a few short years have rapidly evolved from inferior rice crispies pearls, to lustrous potato-pearls and ovals, to astoundingly perfect spheres that have set the entire pearl world to specu-

A Chinese pearl farmer in Zhejiang Province tends his crop.

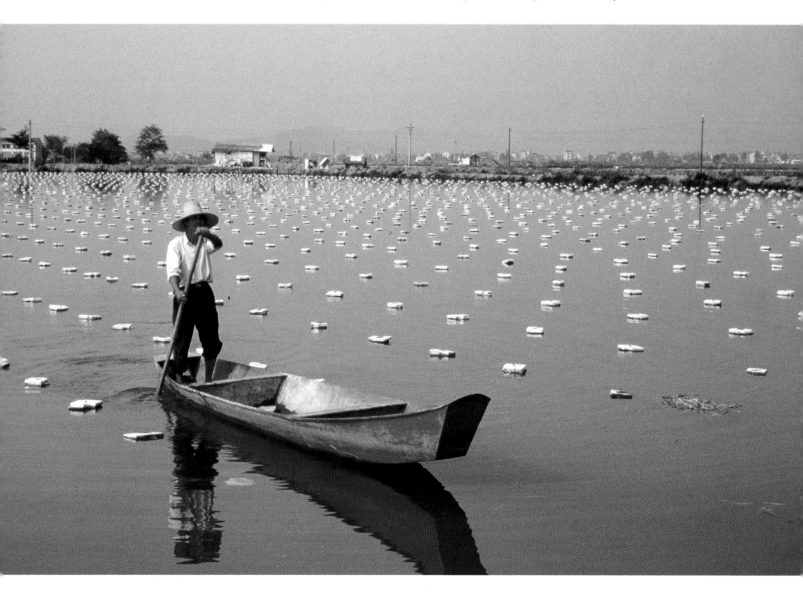

lating. As recently as the 1970s, the variety of pearls on the commercial market—dominated by Japanese Akoya and Biwa pearls, with Chinese pearls only in the "rice crispie" phase, and the other varieties barely available—was substantially different from the situation discussed here for the year 2000.

Although various countries and companies continually vie for attention and buying power, each claiming pre-eminence as producer of the "best" pearl, the research for this book has left the authors with one overriding conclusion: each of the world's pearls has a place in the market today and a unique quality to offer. Akoyas are enduring classics, offered in graduated elegance with incredibly high luster. Tahitian "black" pearls bring larger sizes in unique dusky gray greens, gray blues, and gray rainbows. South Sea pearls present astounding sizes in silky tones of silver, white, and gold. Chinese freshwater pearls create the pinks, peaches, and violets, in a multitude of shapes and quantities that allow adornment for even the slimmest budget. Other cultured products are on the rise, especially the gray blues from Baja California, and the golds from Myanmar and the Philippines. In this newest Great Age of Pearls, there is a role for them all. Pearls will remain available to us for as long as we succeed in protecting and coexisting with the mollusks that produce them.

Notes

Introduction

1. Quoted by Donkin, 1998: 8, from *Journals and Other Documents on the Life and Voyages of Christopher Columbus*, translated and edited by Samuel Eliot Morison, 1963, Heritage Press, New York. These were most likely not pearl oysters, but rather true oysters (*Crassostrea*) or mangrove oysters (*Isognomon*).

2. Quoted by Donkin, 14, from *The Observations of Sir Richard Hawkins in His Voyage into the South Sea in the Year 1523 (edition of 1622)*, edited by C. R. Drinkwater Bethune, 1847, Hakluyt Society, London.

3. Quoted by Donkin, 15, from Anselmus Boetius de Boodt, 1609, *Gemmarum et Lapidum Historia (1600)*. Such early theories were also reviewed by Cahn (1949: 9) and Joyce & Addison (1993: 55–57).

4. C.E. (Current Era) and B.C.E. (Before the Current Era), used with dates, are the secular equivalents of A.D. (Anno Domini) and B.C. (Before Christ), respectively.

5. Kunz and Stevenson, 1908: 80; $4 million from the Persian Gulf, and $1.3 million from the Gulf of Mannar, or 65 percent of the world's pearl supply, expressed in currency values of 1908.

1: Columbus's Pearls

1. Quoted by Donkin, 1998: 279, 288.

2. Quoted by Donkin, 313, from *Journals and Other Documents on the Life and Voyages of Christopher Columbus*, translated and edited by Samuel Eliot Morison, 1963, Heritage Press, New York.

3. Donkin, 313. Pearl oysters are not remarkable for their palatability–Columbus's crew may have been gathering mangrove oysters (*Isognomon* spp.) or edible oysters (*Crassostrea* spp.).

4. Quoted by Donkin, 313, from Morison.

5. Quoted by Donkin, 314, from Morison.

6. Quoted by Donkin, 314, from Morison.

7. Equivalent to 21.8 kilograms in present usage (Peter Martyr, Decade I, Bk. 8, as recorded by Carl O. Sauer, 1966, *The Early Spanish Main*, University of California Press, Berkeley, 109).

8. Donkin, 314.

9. Cited by Sauer, 112.

10. From Sauer, 191.

11. The letter was described by Sauer, 101. William F. Keegan (reprint of "The Native Peoples of the Turks and Caicos," *Times of the Islands: The International Magazine of the Turks and Caicos*, Summer 1996 [http://www.flmnh.ufl.edu/anthro/Caribarch/nativesofTCI.htm, accessed 11/3/00] noted that in 1513 Juan Ponce de Leon sailed through the Lucayan Islands on his way to Florida. He encountered only one old native man in the Turks and Caicos Islands. Other expeditions followed, including two in 1520, which failed to encounter any native peoples in the Turks and Caicos or the Bahamas themselves. A contemporary observer, Herrera, stated that Lucayans were such expert divers that enslaved individuals sold for more than 150 ducats each (Kunz and Stevenson, 1908, 229).

12. Donkin, 321.

13. The oysters mentioned here were undoubtedly the Atlantic Pearl Oyster, *Pinctada imbricata*. The source of West Panamanian pearls discovered by Balboa was most likely a mixture of two eastern Pacific pearl oysters, *Pinctada mazatlanica* and *Pteria sterna*.

14. Quoted by Donkin, 322, from Gonzalo Fernández Oviedo y Valdés, *Natural History of the West Indies*, edited and translated by S. A. Stoudemire, 1959, University of North Carolina Studies in Romance Languages and Literatures, Chapel Hill; also Oviedo y Valdés, *Historia General y Natural de las Indias (1535–1557)*, 5 vols., edited by Juan Pérez de Tudela Bueso, 1959, Biblioteca de Autores Españoles, Madrid.

15. Donkin, 320.

16. Quoted by Donkin, 321, from *The New Laws of the Indies*, 1543, translated by H. Stevens and F. W. Lucas, 1893, London.

17. Donkin, 319–20.

18. Donkin, 325.

19. This calculation is that used by Kunz and Stevenson, 232. For comparison, Jean Baptiste Tavernier reports that in 1633, the king of Persia paid 32,000 tomans (£110,000 or about 550,000 silver dollars) for a single pearl from the Gulf fisheries at El Katif; V. Ball, translator and editor, 1889, *Travels in India, by Jean Baptiste Tavernier, baron of Aubonne, translated from the original French edition of 1676, with a biographical sketch of the author, notes, appendices, etc.*, 2 vols., Macmillan & Company, London and New York, II, 130.

20. Quoted by Donkin, 329, from *Further English Voyages to Spanish America, 1583–1594*, edited by I. A. Wright, 1951, Hakluyt Society, London.

21. Donkin, 328.

22. Quoted by Donkin, 279, 288, from Garcilaso de la Vega, 1609, *Royal Commentaries of the Lucas*, edited and translated by H. V. Livermore, 1966, University of Texas Press, Austin and London.

23. In the 1670s, the French gem merchant Tavernier sold a 55-carat (220-grain) American pearl, "the largest which has ever been taken from Europe to Asia" to Shaista Khan, uncle of the Mughal emperor and governor of Bengal (Tavernier, *Travels in India*, 395).

24. Quoted by Kunz and Stevenson, 230, from Oviedo y Valdés, *Historia General y Natural de las Indias*.

25. N. M. Penzer, ed., 1927, *New Voyage Round the World, by William Dampier, with an Introduction by Sir Albert Gray*, Argonaut Press, London, pp. 39, 133–34. Dampier visited Rancho-Reys near Rio de la Hacha and Gorgonia in the Gulf of Panama.

26. Quoted by Streeter, 1886: 227, from Anonymous, *The History of Jewels and of the Principal Riches of the East and West*, Hobart Kemp, London.

27. Donkin, 323, 325.

28. Quoted by Donkin, 325, from A. Vázquez de Espinosa, c. 1628, *Compendio y descripcion de las Indias Occidentales*, edited and translated by C. U. Clark, 1942, Smithsonian Institution, Miscellaneous Collections 102, Washington, D.C.

29. Almatar et al., 1993, 35.

30. Kunz and Stevenson, 234.

La Peregrina Box: Although often repeated in the gem literature, the most common interpretations of the name La Peregrina—"The Incomparable" or "The Unconquerable"—are incorrect. Peregrina has various meanings in Spanish; the primary one is pilgrim or wanderer, but it also can mean strange, special, rare, or extraordinary. In this description, the Duc de Saint Simon was quoted by Dickinson (1968, 79). The history of ownership of this pearl was summarized by Schlüter and Rätsch (1999, 36).

2 : Natural Beginnings

1. H. Martyn Hart, 1869, *The World of the Sea*, translated and enlarged from *Le Monde de la Mer*, by Alfred Moquin-Tandon, Cassell, Petter, & Galpin, London, 224.

2. Quoted by Haas, 1957: 121.

3. N. Watabe, V. R. Meenakshi, P. L. Blackwelder, E. M. Kurtz, and D. G. Dunkelberger, 1976, Calcareous spherules in the gastropod, *Pomacea paludosa*, 283–308 in *The Mechanisms of Mineralization in the Invertebrates and Plants*, edited by N. Watabe and K. M. Wilbur, University of South Carolina Press, Columbia.

4. The evolutionary tree was constructed from those presented by authors in *Origin and Evolutionary Radiation of the Mollusca* (1996, edited by J. D. Taylor, Oxford University Press, Oxford): for Mollusca in general (L. v. Salvini-Plawen and G. Steiner, Synapomorphies and plesiomorphies in higher classification of Mollusca, 29–51), for Gastropoda (W. F. Ponder and D. R. Lindberg, Gastropod phylogeny–challenges for the '90s, 135–54), and for Bivalvia (B. Morton, The evolutionary history of the Bivalvia, 337–59); also R. C. Brusca and G. J. Brusca, 1990, *The Invertebrates*, Sinauer Associates, Sunderland, Massachusetts, fig. 56; and G. Haszprunar, 2000, Is the Aplacophora monophyletic? A cladistic point of view, *American Malacological Bulletin*, 15 (2): 115–30.

5. It is well known that molluscan nacre is not all the same; the arrangement of the crystals in bivalves is pavement-like, whereas in gastropods and cephalopods it is stacked like coins (see, e.g., H. Mutvei, 1980, The nacreous layer in molluscan shells, pp. 49–56 in *The Mechanics of Biomineralization in Animals and Plants*, edited by M. Omori and N. Watabe, Tokai University Press, Tokyo). C. Hedegaard (1997, Nacre is homoplastic–then

what? *Program & Abstracts, Combined Annual Meeting, American Malacological Union & Western Society of Malacologists, Santa Barbara, California, 21–27 June 1997*, 35) has reexamined this issue from a mineralogical and modern phylogenetic standpoint.

6. R. Seed, 1991, An unusually heavy infestation of pearls in the mussel *Mytilus edulis* L., *Journal of Molluscan Studies*, 57(2): 296–97.

7. R. A. Lutz, K. Chalermwat, A. J. Figueras, R. G. Gustafson, and C. Newell, 1991, Mussel aquaculture in marine and estuarine environments throughout the world, pp. 57–97 in *Estuarine and Marine Bivalve Mollusk Culture*, edited by W. Menzel, CRC Press, Boca Raton, Florida; S. M. Bower, 1992, Diseases and parasites of mussels, pp. 543–63 in *The Mussel Mytilus: Ecology, Physiology, Genetics, and Culture*, edited by E. Gosling, Elsevier, Amsterdam; J. Cáceres-Martinez and R. Vásquez-Yeomans, 1999, Metazoan parasites and pearls in coexisting mussel species: *Mytilus californianus, Mytilus galloprovincialis*, and *Septifer bifurcatus*, from an exposed rocky shore in Baja California, northwestern Mexico, *The Veliger*, 42(1): 10–16.

8. S. Shirai, 1970, *The Story of Pearls*, Japan Publications, Tokyo, 39.

9. H. L. Jameson, 1912, A pearl from *Nautilus, Nature*, 90: 191.

10. Richard Walter, editor, 1747, *A Voyage Round the World in the Years MDCCXL, I, II, III, IV, by George Anson, Esq.*, 5th edition, J. & P. Knapton, London, 219.

11. In Hong Kong, *Pinctada maxima* "pearl meat" sells for A\$75 per kilogram frozen or A\$430 per kilogram dried, wherein it is considered an aphrodisiac (N. Paspaley, pers. comm., 2000).

12. There is one report from Bangkok, Thailand, of attempts to culture melo pearls; K. Scarratt, pers. comm., 2000.

13. J. L. Harris and M. E. Gordon, 1990, *Arkansas Mussels*, Arkansas Game and Fish Commission, Little Rock, 3.

14. A vast body of knowledge exists about this freshwater pearl mussel, whose association with humans dates back for centuries. For an extensive bibliography, see J. H. Jungbluth, H. E. Coomans, and H. Grohs, 1985, Bibliographie der Flussperlmuschel *Margaritifera margaritifera* (Linnaeus, 1758) [Mollusca: Pelecypoda], *Verslagen en Technische Gegevens, Instituut voor Taxonomische Zoologie (Zoologisch Museum), Universiteit van Amsterdam*, no. 41.

Fossil Pearls Box: The earliest *Megalodon* pearls were cited by N. Cox, 1969, General features of Bivalvia, pp. N2–N129 in *Treatise on Invertebrate Paleontology, Part N (1 of 3), Mollusca 6, Bivalvia*, edited by R. C. Moore, Geological Society of America and University of Kansas, Lawrence, p. N78. Inoceramid pearls were discussed by E. G. Kauffman, 1990, Giant fossil inoceramid bivalve pearls, pp. 66–68 in *Evolutionary Paleobiology of Behavior and Coevolution*, edited by A. J. Boucot, Elsevier, New York.

Pearls That Aren't Pearls Box: Information about cave pearls is from: Garry K. Smith, *Glossary of Caving Terms*, http://wasg.iinet.net.au/glossary.html, and http://www.britannica.com/bcom/eb/article/6/0,5716,22246+1,00.html, both accessed 9/30/00. A 10-centimeter cave pearl found in Vietnam is illustrated on the website of the caving club of the Belgian University of Leuven (http://users.pandora.be/spekul/grotparel.htm, accessed 9/30/00). The myth that coconut pearls are produced by the coconut palm was recounted at http://daphne.palomar.edu/wayne/ww0901.htm#coconut, in *Wayne's Word* (web page) 9(1), Spring 2000, on Botanical Jewelry, accessed 10/23/00; modified from W. P. Armstrong, 1998, *Terra* 30 (3): 26–33. Reyne's research on "coconut pearls" was also discussed by Haas, 1957: 117.

Abalone Pearls Box: The frequency of gem-quality natural abalone pearls is from S. Koethe and K. C. Bell, 1999, Natural abalone pearls: rare organic gems, *Gems & Gemology*, 35(3): 171–72. Fankboner (1995: 3) discussed the use of abalone pearls by early native peoples of California. The last known owner of the world's largest abalone pearl was Wesley Rankin, a diver in Petaluma, California, and it was valued in 1991 at \$4,700,000 (Fankboner, 4).

Conch Pearl Box: The biochemical reasons for fading in conch pearls were described by Fritsch and Misiorowski (1987: 217) and K. S. Orr and C. J. Berg, Jr., 1987, *The Queen Conch*, Windward Publishing, Miami, Florida, 19. The earliest mention of conch pearls in 1839 was given by Kunz and Stevenson: 464; also Fritsch and Misiorowski, 209. H. E. Coomans, 1973, Pearl formation in gastropod shells, *Acta Musei Nationalis Pragae*, 29B(1–2): 55–64 (citing G. F. Kunz, 1898, The fresh-water pearls and pearl fisheries of the United States, *United States Fish Commission Bulletin for 1897*, art. 9: 373–426, pls. 1–22), mentioned a case in British Honduras (Belize) in which a nucleus was introduced through a hole bored in a conch's shell, resulting in a pink pearl. The story of Bostwick hypnotizing the conchs into producing pearls was described in a 1936 letter to

the writer Catherine Meursinge, quoted by Fritsch and Misiorowski, 214. Serious efforts to culture conch pearls were described by R. L. Creswell and M. Davis-Hodgkins, 1994, Queen conch pearls—a uniquely Caribbean gem, Abstracts, *Pearls '94*, Honolulu, Hawaii, 14–19 May 1994, *Journal of Shellfish Research*, 13(1): 332–33.

3: The Mechanism of Luster

1. Tavernier, 1678: 378.

2. Perles de Tahiti, http://www.tahiti-blackpearls.com/buyers/how2buy/imitations.html, accessed 10/25/00; and *GIA Insider*, 28 March 2000.

3. Pliny, *Historia Naturalis*, 9: 58.

4. The myth that a grain of sand is the nucleus of every pearl appears to have originated in 1671 in *Experiments on Diverse Natural Things, Particularly Those Brought to Us from the Indies*, by the Italian Francesco Redi; cited by Cahn, 1949: 9; see also http://galileo.imss.firenze.it/multi/redi/eopere.html, accessed 10/26/00.

5. See *Gems and Gemology*, Summer 1998: 130–31, for a description of the beads used in cultured pearls. Scarratt et al. (2000: 104–5) illustrated X-radiographs of tissue-nucleated cultured pearls.

6. For estimates of the rates of nacre formation in cultured pearls, see U. Livstrand, 1986, Black pearls of Manihi, *Lapidary*, April 1986; Lintilhac, 1985: 55; and M. Goebel and D. M. Dirlam, 1989 (Polynesian black pearls, *Gems & Gemology*, 25 [Fall 1989]: 130–48): 137.

7. See Scarratt et al., 106, 108, for a description of the microstructural changes resulting from a change in environment.

8. The contrast between summer and winter growth is a widely cited phenomenon; see Taburiaux, 1985: 112.

9. From "The Australian pearling industry and its pearls," by Grahame Brown, http://www.gem.org.au/gallery/pearltext.html, accessed 9/21/00.

10. For a recent review of this process, see A. M. Belcher, X. H. Wu, R. J. Christensen, P. K. Hansma, G. D. Stucky, and D. E. Morse, 1996, Control of crystal phase switching and orientation by soluble mollusc-shell proteins, *Nature*, 381(2): 56–58.

11. A. L. Matlins, 1996, *The Pearl Book: The Definitive Buying Guide*, GemStone Press, Vermont, 64.

12. Kunz and Stevenson, 52–53.

13. Many consumer guides explain the assessment of luster; see, for example, R. Newman, 1999, *Pearl Buying Guide*, International Jewelry Publications, Los Angeles, California, 31.

14. Cited by M. S. Giridhar and S. K. Srivatsa, 1999, Pearls and shells, *Current Science*, 76(10): 1324–25.

15. Akoya pearls are generally acknowledged as having the highest luster of all cultured pearls, although the thickness of their nacre is relatively thin compared, for example, to thicker-nacred but satiny South Sea pearls.

16. See Taburiaux, 112; J.-P. Cuif, 1992, Données actuelles concernant la structure et la composition de la nacre et des perles, pp. 77–87, in *Nacres et Perles*, Musée Océanographique, Monaco: 81; and Joyce and Addison, 1993: 63–64, for a more extensive discussion of orient.

17. Matlins, 65.

18. See Kunz and Stevenson, 53, for a description of the wax impression. A similar phenomenon occurs in many animals. The skin of the Eastern Indigo Snake, *Drymarchon carais couperi* (Holbrook, 1842), is covered with scales, each of which bears rows of tiny projections. Light is diffracted by this grate-like pattern to produce an iridescent effect (K. Nassau, 1983, *The Physics and Chemistry of Color*, John Wiley & Sons, New York, 277).

19. This story was recounted by Renée Newman, 1999, *Pearl Buying Guide*, 3rd ed., International Jewelry Publications, Los Angeles, 125, and according to her, first appeared in A. E. Farn, 1986, *Pearls: Natural, Cultured and Imitation*, Butterworth, London. Another story, related by Hugh Edwards (1994: 23), described strength tests performed on pearls published in the *Proceedings of the British Royal Society* in 1888:

On one occasion being desirous to crush into powder a pea-sized pearl, we folded it between two plies of notepaper, turned up the carpet and placing it on the hard, bare floor, stood on it with all our weight. Yet notwithstanding that we weigh over 12 stones (75 kilos) we failed to make any impression whatever upon the pearl, and even stamping on it with the heel of our boot did not so much as fracture it. It was accordingly given to the servant to break with a hammer and on his return he informed us that in attempting to break it with the hammer against the pantry table all he succeeded in doing was to make the pearl pierce through the paper and sink into the wooden table just as if it had been the top part of an iron nail.

According to Edwards, the pearl was finally broken using a hammer against a piece of solid steel.

20. For more on the strength of nacre and pearls, see L. Addadi and S. Weiner, 1997, A pavement of pearl, *Nature*, 389: 912–13; Taburiaux, 116.

21. Cited by Newman, 41–49.

22. Pliny, *Historia Naturalis*, 9: 54.

23. For further discussion about the color in conchiolin, see K. Wada, 1996 (Genetical and physiological control of calcification in pearl cultivation, *Bulletin de l'Institut Océanographique, Monaco*, no. special 14, 4: 183–93): 189, and R. Jabbour-Zahab, D. Chagot, F. Blanc, and H. Grizel, 1992 (Mantle histology, histochemistry and ultrastructure of the pearl oyster *Pinctada margaritifera* (L.), *Aquatic Living Resources*, 5: 287–98); and D. L. Fox, 1979, *Biochromy*, University of California Press, Berkeley, 156.

24. Taburiaux, 114; Fox, 1979.

25. Donkin, 261.

26. For more tests to detect dyed or irradiated pearls, see Newman, 96–98; and Lintilhac, 83–84.

27. The terms density and specific gravity are sometimes used interchangeably but the term density requires the citation of units such as grams per cubic centimeter. One source listed specific gravities for a variety of pearls: Persian Gulf 2.715, Australia 2.74, Venezuela 2.65–2.75, Japan 2.66–2.74, Tahiti 2.61–2.69, and pink conch pearl 2.85 (http://www.geo.utexas.edu/courses/347k/redesign/Gem_Notes/Pearl/pearl_main.htm, accessed 11/3/00).

28. Webster, 1978: 445; Fritsch and Misiorowski, 217–18.

29. J. Rosewater, 1965, The family Tridacnidae in the Indo-Pacific, *Indo-Pacific Mollusca* 1(6): 347–96; G. Sisla, pers. comm., 2000. Also spelled Lao-Tse. The "Pearl of Allah," collected at Palawan Island, Philippines, 1934, is so called because its surface bears the image of a turbaned face. The giant clam that formed this pearl was blamed for the death of a young conch diver. The story was recounted in 1939 by its owner, W. D. Cobb (1939, The Pearl of Allah, *Natural History*, 44(4): 197–202). In 1980, the pearl was purchased by Peter Hofman, a jeweler from Beverly Hills, California, for $200,000. The *Guinness Book of World Records* valued it at $40–42 million. Although replicas exist in several museum collections (including the Museum für Naturkunde, Berlin,

Germany), the location of the real Pearl of Allah is unknown.

30. Conversions from grains to millimeters rely on a table presented by Kunz and Stevenson, 328.

31. Webster, 447. Sets of sieves used for sorting pearls indicate that those larger than 3 millimeters were encountered historically in the Persian Gulf.

32. Kunz and Stevenson, 124, 232.

33. Almatar et al., 35.

34. Newman, 73.

35. The relationship between the shape of a pearl and its position within the soft tissues is widely quoted (see, e.g., Joyce and Addison, 67).

36. N. Sitwell, 1985, The 'queen of gems'—always stunning, and now more cultured than ever, *Smithsonian*, 15(10): 40–51.

37. Kunz and Stevenson, 466.

38. Schlüter and Rätsch, 62.

Caring for Pearls Box: Pearls in a necklace that have developed flattened surfaces are called "barrel pearls." This is very common in older strands. The originally spherical pearls become barrel-shaped because of their constant rubbing against each other, the skin, and mildly acidic perspiration.

Imitation Pearls Box: Imitation pearls are also called faux, fashion, simulated, organic, man-made, majorica, "I," or shell pearls. The term "I pearl" is used in Japan, with the "I" as an abbreviation for imitation or for Izumi City, the primary center of production. Phillips (1996: 92) reported on Queen Elizabeth's use of imitation pearls. The fifteenth-century recipe for imitation pearls was described by Donkin, 263. Leonardo da Vinci's recipe was quoted by Donkin, 263, from E. A. C. McCurdy, ed. and trans., 1938, *Notebooks* [of Leonardo da Vinci, 1480–1482], London, 2: 582–83. Pearl essence is now produced as a by-product of herring fisheries, and is also used in lipstick, nail polish, paint, and ceramics (National Marine Fisheries Service, "Fish FAQ" page, http://www.wh.whoi.edu/faq/faq.html, accessed 9/27/00). See also Schlüter and Rätsch, 78–79; Riedl, 1928: 352; L. Boutan, 1925, *La Perle, Etude Generale de la Perle*, Octave Doin, Paris, pp. 91ff. Properties of imitation pearls are also described at http://www.tahiti-blackpearls.com/buyers/how2buy/imitations.html, accessed 7/26/00. The X-ray properties of imitation pearls were cited by Newman, 104.

4: Pearls in Human History: The European Tradition

1. Kunz and Stevenson, 1908: 10.

2. For more details on early British pearl fisheries, see E. Forbes and S. Hanley, 1853, *A History of British Mollusca, and Their Shells, Vol. II*, John van Voorst, London, 149ff.

3. Pliny, *Historia Naturalis*, 6: 37.

4. Kunz and Stevenson, 9.

5. Pliny, 6: 37.

6. Kunz and Stevenson, 10.

7. Female doctors of the time called *auriculae ornatrices* specialized in ear tumors and infections, perhaps associated with the common practice of wearing heavy pearl earrings.

8. Donkin, 1998: 91.

9. Donkin, 251.

10. Phillips, 1996: 41.

11. Quoted by Manuel Komroff, editor, 1926, *The Travels of Marco Polo (the Venetian)*, Boni & Liveright, New York, 287.

12. Dall, 1883: 581; Schlüter and Rätsch, 1999: 13–14.

13. Ziuganov et al., 1994: 86, quoting from A. A. Gaevsky, 1926, Northern pearls, pp. 5–8 in *Karelo-Murmanskij kraj*, no. 21 (in Russian). Novgorodian pearls are probably freshwater pearls from the ancient city of Novgorod between Moscow and St. Petersburg on the Volhov River and Lake Ilmen; Novgorod was the largest city in Russia in the year 1200. "Sable" in this context refers to the prized fur of a species of marten [*Martes zibellina* (Linné, 1758)] found in the region and made into a cloak or robe.

14. Dall, 582.

15. Quoted by Joyce and Addison, 1993: 93.

16. In 1599, the law in Venice read: ". . . any woman, whether of noble birth or a simple citizen, or of any other condition, who shall reside in this our city for one year (except her Serenity, the Dogaressa and her daughters and her daughters-in-law who live in the palace), after the expiration of fifteen years from the day of her first marriage, shall lay aside the string of pearls around her neck and shall not wear or use . . . this string or any other kind of pearls or anything which imitates pearls . . . under the irremissible penalty of two hundred ducats"; quoted by Kunz and Stevenson, 26.

17. From Marcus Nathan Adler's 1907 translation of *The Itinerary of Benjamin of Tudela*, Phillip Feldheim, New York; reproduced at http://www.uscolo.edu/history/seminar/benjamin/benjamin1.htm, accessed 10/31/00.

18. Recorded by Diana Scarisbrick, 1995, *Tudor and Jacobean Jewellery*, Tate Publishing, London, 30.

19. Dall, 582.

20. Quoted by Scarisbrick, 81, from F. Moryson, 1617, *Itinerary*, complete edition in 4 volumes, Glasgow (1907–8).

21. A full-size wax effigy of Elizabeth was made upon her death; it featured a coronet of large round pearls, necklaces of pearls, pearl earrings, a pearl stomacher, and pearl medallions on her shoes (Kunz and Stevenson, 454). In the recent Hollywood films *Shakespeare in Love* (Universal/Miramax, 1998) and *Elizabeth* (Polygram Entertainment, 1998), the pearl-encrusted costumes and pear-shaped pearl earrings of the sixteenth century were meticulously reproduced.

22. Quoted by P. Bargellini, 1993, *Donne di casa Medici*, R. Vita, Florence, Italy, 23.

23. Quoted by Daniela Mascetti and Amanda Trioss, 1990, *Earrings: From Antiquity to the Present*, Thames & Hudson, London, 23.

24. Recorded by Rudau, 1961: 6.

25. Baer, 1995: 97.

26. Girandole earrings tended to be heavy; those with precious stones weighed as much as 39 grams. The maximum weight of earrings considered comfortable today is 22 grams; Mascetti and Trioss, 45.

27. D. Syndram and U. Weinhold, 2000, ". . . und ein Leib von Perl"–Die Sammlung der barocken Perlfiguren im Grünen Gewölbe, Staatliche Kunstsammlungen Dresden, Edition Minerva.

28. V. S. Goncharenko and V. I. Narozhnaya (translated by Kathleen Cook-Horujy), 1995, *The Armoury: A Guide*, Red Square Publishers, Moscow, 231, 235–36.

29. At the time of the Revolution, the French Crown jewels were confiscated and Marie Antoinette sent most of her personal collection to Brussels and London for sale. Among the items she retained was a set of pearls; Bernard Morel, 1988, *The French Crown Jewels*, Fonds Mercator, Antwerp, 211.

30. Hans Schoeffel, 1996, *Pearls: From the Myths to Modern Pearl Culture*, Schoeffel Pearl Culture, Stuttgart, Germany, 23.

31. Dall, 582.

32. Quoted by Martha Gandy Fales, 1995, *Jewelry in America, 1600–1900*, Antique Collectors' Club, Woodbridge, Suffolk, England, pp. 210 and 212, respectively.

33. Kunz and Stevenson, 438.

34. Ki Hackney and Diana Edkins, 2000, *People and Pearls*, HarperCollins Publishers, New York, 68.

35. Reproduced by Kunz and Stevenson, frontispiece.

36. Hackney and Edkins, 26.

37. Fales, 303.

38. Reproduced by Kunz and Stevenson, 419.

39. Reproduced by Kunz and Stevenson, 473.

40. D. Pulliam, 1997, The pearly kings and queens of London, *Piecework*, 5(4): 26–28.

41. Hackney and Edkins, 98.

42. Quoted by Hackney and Edkins, 118.

Pearls in Medicine and Cosmetics Box: Hildegard von Bingen was described by Schlüter and Rätsch, 127–130. Albertus Magnus was quoted by D. Wyckoff, translator, 1967, *Book of Minerals (De Mineralibus)*, c. 1261–1263, by Albertus Magnus, Oxford, p. 106. Alfonso X of Castile was quoted by Dickinson, 1968: 41, and Donkin, 260. Shaik 'Ali Hazin was discussed by S. Khan Khatak and O. Spies, ed. and trans., 1954, *The Treatise on the Nature of Pearls of Shaikh 'Ali Hazin*, Verlag für Orientkunde, Walldorf-Hessen, Germany, 17–18. German rural medicine was discussed by Schüter and Rätsch, 126. The use of freshwater Bavarian pearls was given by Malachias Geiger, 1637, *Margaritologiae*, Munich; Latin text reproduced at http://www.reger.rmc.de/perle/latein.htm, accessed 11/14/00. Anselmus de Boodt was quoted by Kunz and Stevenson, 311. Cahn (1949: 58) claimed that pearl culturing gave the Japanese control of the pearl medicine market. The mixture Long-zhu Ye was described by Si Zhang, 1997, Studies on the pharmacodynamics of Longzhu Ye (in Chinese), *Marine Science Bulletin/Haiyang Tongbao*, 16(5): 66–70, reproduced by *Cambridge Scientific Abstracts*, no. 4412993. Ancient and modern use in China was described by Schlüter and Rätsch, 132–39. The advantage of cultured Chinese freshwater pearls for medical and cos-metic use was given by http://www.jajagroup.com/HBADivision/pearlhist.htm, accessed 11/13/00. Mexican "Concha Nacar" was described by http://www.pimsa.com/nassh/mopp.html, accessed 11/13/00. Medical opinion on the amount of assimilable calcium from pearls was given by Cahn, 58.

5: Pearls in Human History: The Non-European Traditions

1. Translated by the authors from Tavernier, 1678: 380.

2. In this chapter, we have made extensive use of the admirable summaries by Kunz and Stevenson (1908) and Donkin (1998). We have expanded and updated their information wherever possible and have drawn our own conclusions. However, we would be remiss if we did not acknowledge our profound debt to those writers.

3. David Reese, 1990, Marine and worked shells, 410–16 in *Town and Country in Southeastern Anatolia II: The Stratigraphic Sequence at Kurban Höyük*, edited by G. Algaze, Oriental Institute of the University of Chicago, Chicago, 416.

4. David Reese, 1995, Marine invertebrates and other shells from Jerusalem (sites A, C, and L), 265–78 in *Excavations by K. M. Kenyon in Jerusalem 1961–1967*, Vol. 4, edited by I. Eshel and K. Prag, Oxford University Press, Oxford, 271.

5. David Reese, 1991, The trade of Indo-Pacific shells into the Mediterranean Basin and Europe, *Oxford Journal of Archaeology*, 10(2): 159–96: 186.

6. Donkin, 45–46; also Ernst Heinrich, 1936, *Kleinfunde aus den archaischen Tempelschichten in Uruk*, Ausgrabungen der Deutschen Forschungsgemeinschaft in Uruk-Warka, vol. 1, O. Harrassowitz, Leipzig: 36.

7. Donkin, 45–48; see also Bibby, Geoffrey, 1970, *Looking for Dilmun*, Collins, London, p. 165.

8. Donkin, 48.

9. Donkin, 48–50.

10. 400–500 drilled pearls were found at Susa (Donkin, 46) and another 244 at Pasargadae (David Stronach, 1978, *Pasargadae*, Clarendon Press, Oxford, p. 172, pls. 156, 159). 180 of the Pasargadae pearls were about 2 millimeters in diameter with another 64 between 3 and 9 millimeters.

11. From Androsthenes of Thasos and Alexander's redoubtable admiral, Nearchus, both of whom visited the eastern part of the Gulf about 325 B.C.E.; described by Donkin, 51.

12. Donkin, 51–55.

13. Quoted by Donkin, 87, from Athenaeus of Naucratis, *The Deipnosophists*, translated and edited by C. B. Gulick, 7 vols., 1959–1969, W. Heinemann, London.

14. Donkin, 87–88.

15. James F. Strange, 1994, *Excavations at Sepphoris, Israel: Report of the Excavations: 14 June–15 July, 1994*, University of South Florida, Tampa, square 90; also http://www.colby.edu/rel/Sep94.html, accessed 10/30/00.

16. D. Michaelides, 1995, Cyprus and the Persian Gulf in the Hellenistic and Roman Periods, 211–16 in *Proceedings of the International Symposium, Cyprus and the Sea, Nicosia, 25–26 September 1993*, Nicosia.

17. Reese, 1995: 271.

18. Eusebius of Caesarea, [*Origen's*] *Commentaries on the Gospel of St. Matthew*, 10: 8; also at Christian Classics Ethereal Library, http://www.ccel.org/fathers2/ANF-10/anf10-46.htm# P7275_1473138, accessed 10/31/00.

19. St. Ephraim of Syria, *The Pearl*, translated by J. B. Morris, 1990?, Christian Classics Ethereal Library, Calvin College, Ohio. Parenthetically, St. Ephraim seems to have subscribed to a lightning bolt theory of the origin of pearls. In a later commentary, he was quoted as saying "In the Red Sea there are shellfish which swim from the bottom to the surface of the water, which, when there is thunder and lightning, are struck and entered by the lightning-bolt. Then they close themselves up, conceive, and produce a pearl. Thus did Mary conceive the Word of God." (Jane Stevenson, 1998, Ephraim the Syrian in Anglo-Saxon England, Hugoye, *Journal of Syriac Studies*, 1(2), from http://syrcom.cua.edu/Hugoye/Vol1No2/HV1N2Stevenson.html, accessed 11/10/00).

20. Reese, 1995, Marine shell and coral, in G. Hermann and K. Kurbansakhatov et al., The Third International Merv Project, Preliminary Report on the Third Season (1994), *Iran* 33: 53.

21. Donkin, 94, citing Robert J. Braidwood, 1933, Some Parthian Jewelry, in *Preliminary Report on the Excavations at Tell Umar, Iraq*, vol. 2, edited by L. Waterman, University of Michigan Press, Ann Arbor; David Whitehouse, 1972 (Excavations at Siraf: fifth interim report, *Iran*, 10: 63–87): 70.

22. A. Djavakhichvili and G. Abramichvili, 1986, *Orfèvrerie et toreutique des musées de la république de Géorgie*, Éditions d'Art Aurora, Leningrad, pls. 51, 55-56, 67.

23. Prudence Harper, 1978, *The Royal Hunter, Art of the Sasanian Empire*, Asia Society, New York, 52-63.

24. Donkin, 94; Kunz and Stevenson, 411, quoting Tabari, *Chronique*, translated by Zotenberg, 1869, Paris.

25. Kunz and Stevenson, 411.

26. Quoted by Charles J. Lyall, 1912, The pictorial aspects of ancient Arabian poetry, *Journal of the Royal Asiatic Society*, 1: 133-52: 147.

27. Professor Janet Johnson, Oriental Institute, University of Chicago, pers. comm., 2000.

28. Donkin, 88, 91.

29. C. Kallenberg, 1884, Der Handel mit Perlen und Perlmutterschalen im Rothen Meere, *Oesterreichische Monatsschrift für den Orient*, March 1884: 80-96: 86.

30. Cheryl Ward, 1998, Sadana Island shipwreck: final season, *Institute of Nautical Archaeology Quarterly* 25(3): 3-5.

31. Kunz and Stevenson, 142-44.

32. Donkin, 121-22.

33. "Pearl-encrusted headdresses" were featured in the exhibit "Morocco: Jews and Art in a Muslim Land" at The Jewish Museum, New York, 20 September 2000-11 February 2001 (see http://www.thejewishmuseum.org/Pages/Exhibitions/Special_Exhibits/morocco/morocco.html, accessed 11/13/00), and in the exhibit "Maroc Magie des Lieux: l'art de la ville et de la maison" at Institut du Monde Arabe, Paris, 19 October 1999-30 January 2000 (from the exhibit catalog, *Maroc Magie des Lieux: l'art de la ville et de la maison*, 1999, Institut du Monde Arabe, Paris, 133).

34. Donkin, 57-65, 129-31, and 152-91, provided the most authoritative review of the history of South Asian pearls, and the reader is referred there for additional details.

35. J. Carswell, 1992, The port of Mantai, Sri Lanka, 197-203 in *Rome and India: the Ancient Sea Trade*, edited by V. Begley and R. DePuma, University of Wisconsin Press, Madison, 200.

36. Donkin, 59-65.

37. Quoted by (and perhaps translated by) Richard and Kanitha Brown, http://www.agtgems.com/AGTbook/AGTav/pearl.html, accessed 10/30/00.

38. Donkin, 65.

39. Donkin, 65.

40. Donkin, 174-75.

41. Ramesh Gupte and B. D. Mahajan, 1962, *Ajanta, Ellora and Aurangabad Caves*, Taraporevala, Bombay, India; J. Griffiths, 1896-1897, *The Paintings in the Buddhist Cave Temples of Ajanta*, 2 vols., Sundeep, Delhi, India (1983 reprint).

42. J. Boisselier, 1979, *Ceylon*, Archaeologia Mundi Series, Nagel Publishers, Geneva, pls. 8-10. See also UNESCO Photobank Online, Sri Lanka Image No: 10011540, http://www2.unesco.org/photobank, accessed 10/30/00.

43. George Michell and Vasundhara Filliozat, eds., 1981, *Splendors of the Vijayanagara Empire—Hampi*, Marg Publications, Bombay, 114-20.

44. Kunz and Stevenson, 334, from a translation by Louis Finot, *Les Lapidaires Indiens*, Paris, 1896.

45. See, for instance, the illustrations by Bamber Gascoigne, 1971, *The Great Moghuls*, Harper & Row, New York: 129-30, 178, 186, 202, 214.

46. Kunz and Stevenson, plates opposite 101, 108, 450.

47. The weight calculation is from Kunz and Stevenson, 328; the size measurement is from the life-sized engraving by Tavernier: 395.

48. Kunz and Stevenson, 457; the conversion of weight to size was done using the tables on p. 328.

49. Zhao Rugua, writing in the thirteenth century, mentioned the Persian Gulf, Sri Lanka, South India, Sumatra, and the Philippines as suppliers of pearls to China (Hirth and Rockhill, 1911: 229-30); writing in the early sixteenth century, Tome Pires said that seed pearls were shipped from Southeast Asia to India (H. B. Sarkar, 1985, *Cultural Relations between India and Southeast Asian Countries*, Indian Council for Cultural Relations and Motilal Banarsidass, India, 259).

50. See, e. g., Ball, 108; Miles, 1919: 416.

51. Quoted by S. Arasaratnam, translator and editor, 1978, *François Valentijn's Description of Ceylon*, The Hakluyt Society, London, 139.

52. E. Eden, 1983, *Up the Country: Letters Written to Her Sister from the Upper Provinces of India*, Virago Press, London, 232-33.

53. Donkin, 153-56, 176-80.

54. Donkin, 179.

55. Berthold Laufer, 1915 (The diamond, a study in Chinese and Hellenistic folk-lore, *Fieldiana, Anthropological Series*, 15[1]: 56-63), opined that in China after the mid-first millennium, these night-shining gems were not pearls but diamonds.

56. See Jan Fontein, 1990, *The Sculpture of Indonesia*, National Gallery of Art, Washington, D.C. and Harry N. Abrams, New York: object nos. 13-14, 70-71.

57. See, for example, Helen I. Jessup, 1990, *Court Arts of Indonesia*, Asia Society Galleries, New York.

58. See, for example, Susan Rodgers, 1985, *Power and Gold: Jewelry from Indonesia, Malaysia and the Philippines*, Barbier-Müller Museum, Geneva.

59. See, for example, T. Bowie, M. C. Subhadradis Diskul, and A. B. Griswold, 1972, *The Sculpture of Thailand*, The Asia Society, New York; and Bernard P. Groslier, 1966, *Indochina*, Archaeologia Mundi series, World Publishing Company, Cleveland and New York.

60. See, for example, J. Auboyer, 1971, *Angkor*, Ediciones Polígrafa, Barcelona, Spain, pls. 45, 49, 55.

61. Kunz and Stevenson, 149.

62. For instance, several hundred items of pearl-less gold jewelry were excavated at Oc Eo in southern Vietnam; Louis Malleret, 1962, *L'Archéologie du Delta du Mékong, vol. 3, La Culture du Fou-nan, planches*, École Français d'Extrême-Orient, Paris, pls. 3-60.

63. According to the *History of Later Han*; see Wang Gungwu, 1958, The Nanhai trade, *Journal of the Malayan Branch, Royal Asiatic Society*, 31(2): 1-135: 25.

64. Hirth and Rockhill, 1911: 230.

65. This is a retranslation of the original passage in Wang Dayuan's *Daoyizhiliu* by Dr. Ho Chuimei, The Field Museum. The translation by Rockhill (1917: 270-71), which Donkin, 207, quoted, is incorrect in several places.

66. E. H. Blair and J. A. Robertson, eds., 1903, 1, in 1903-1909, *The Philippine Islands, 1493-1898*, 55 vols., Arthur H. Clark Company, Cleveland, Ohio: 330-31.

67. J. Hejzlar, 1973, *The Art of Vietnam*, Hamlyn, London, 51.

68. For the fourth through third centuries B.C.E., see Donkin, 67–68; for the sixth through fourth centuries B.C.E., see Niu, 1994: 20; for Hepu in Guangxi in the third through second centuries B.C.E., see Wang, 21.

69. Laufer, 190.

70. Anonymous, 1166, *Mengxi Bitan*, Zhonghua Shujo, Hong Kong (1987 reprint), chapter 24.

71. Donkin, 212.

72. Donkin, 214.

73. National Museum of Chinese History, 1998, *Exhibition of Chinese History*, Morning Glory Publishers, Beijing, China, 111.

74. National Museum of Chinese History, 1998: 139.

75. Rolf Stein, 1940, Leao-Tche, *T'oung Pao*, 35: 1–154: 97–98.

76. Donkin, 224–27.

77. Palace Museum, 1992, *Qingdai Houfei Shouxi . . . |Jewelry and Accessories of the (Empress and) Royal Consorts of the Qing Dynasty]* (in Chinese), Forbidden City Press, Beijing, China; Yang Xin & Zhu Chengru, 2000, *Secret World of the Forbidden City*, The Bowers Museum of Cultural Art, Santa Ana, California, 52–53, 70, 76–77, 80.

78. C. A. S. Williams, 1931, *Outlines of Chinese Symbolism*, Customs College Press, Peiping, China, 280.

79. W. Eberhard, 1986, *A Dictionary of Chinese Symbols*, Routledge & Kegan Paul, London and New York, 230.

80. Ma Touan-lin, 1876–1883, *Ethnographie des Peuples Etrangers—la Chine*, 2 vols., translated and with commentary by Le Marquis d'Hervey de Saint-Senys, H. Georg, Geneva, 305–6.

81. Kunz and Stevenson, 14; that Japan was still an important pearl exporter in the early nineteenth century was confirmed by Milburn, 1813, 2: 357.

82. Edward F. Strange, 1926, *Chinese Lacquer*, Ernest Benn Ltd., London, p. 8; James C. Y. Watt and B. F. Ford, 1991, *East Asian Lacquer*, Metropolitan Museum of Art, New York, 24, 154, 304–10.

83. J. C. Beaglchole, ed., 1968, *The Journals of Captain Cook, 1: The Voyage of the Endeavour 1768–1771*, The Hakluyt Society, Cambridge, England, 388.

84. K. P. Emory, W. J. Bonk, and Y. H. Sinoto, 1968, *Fishhooks*, Bishop Museum Special Publication 47, Bishop Museum Press, Honolulu, 21.

85. J. C. Beaglehole, ed., 1963, *The Endeavour Journal of Joseph Banks 1768–1771*, 2 vols., Agnus & Robertson, Sydney, Australia, 1: 326.

86. Quoted by Kunz and Stevenson, 254.

87. Mester, Ann Marie, 1990, *The Pearl Divers of Los Frailes: Archaeological and Ethnohistorical Explorations of Sumptuary Good Trade and Cosmology in the North and South Andes*, Ph.D. Dissertation, University of Illinois at Urbana-Champaign, 202.

88. Mester, 21.

89. Mester, 188.

90. Mester, 302.

91. G. M. Feinman and L. M. Nicholas, 1993, Shell-ornament production in Ejutla, *Ancient Mesoamerica*, 4: 103–19: 112; G. M. Feinman and L. M. Nicholas, 2000, High-intensity household-scale production in ancient Mesoamerica, 119–42 in *Cultural Evolution: Contemporary Viewpoints*, edited by G. M. Feinman and L. M. Nicholas, Kluwer Academic/Plenum, New York, 127.

92. Peter Schmidt, Mercedes de la Garza, and Enrique Nalda, 1998, *Maya*, Bompiani-CNCA INAH, Mexico City, Mexico, 556.

93. John R. Swanton, 1946, *The Indians of the Southeastern United States*, 2 vols., Bureau of American Ethnology Bulletin 137, United States Government Printing Office, Washington, D.C., 488, 510.

94. Kunz and Stevenson, 258–59, quoting Daniel Coxe, 1722, *A Description of the English Province of Carolana, by the Spaniards call'd Florida, and by the French La Louisiane, as also of the Great and Famous River Meschacebe or Missisipi* [sic], London.

95. Thomas M. N. Lewis and M. Kneberg, 1970 (1996 reprinting), *Hiwassee Island: An Archaeological Account of Four Tennessee Indian Peoples*, University of Tennessee Press, Knoxville, 130; but see Charles C. Jones, 1873, *Antiquities of the Southern Indians*, D. Appleton, New York, 490–91.

96. E. G. Squier and E. H. Davis, 1848, *Ancient Monuments of the Mississippi Valley*, Smithsonian Contributions to Knowledge 1, Smithsonian Institution, Washington, D.C., 232–33.

97. Warren K. Moorehead, 1922, The Hopewell Mound group of Ohio, *Fieldiana, Anthropological Series* 6(5), 145–61.

98. F. W. Fischer, 1974, *Early and Middle Woodland Settlement, Subsistence and Population in the Central Ohio Valley*, Ph.D. Dissertation, Washington University, St. Louis, Missouri, 50–51.

99. Kunz and Stevenson, 485.

100. Nicholas J. Saunders, 1999, Biographies of brilliance: pearls, transformations of matter and being, c. A.D. 1492, *World Archaeology*, 31(2): 243–57: 247.

6: Getting Pearls

1. Kunz and Stevenson, 1908: 200–01.

2. "The Australian pearling industry and its pearls," by Grahame Brown, http://www.gem.org.au/gallery/pearltext.html, accessed 9/21/00.

3. The evidence is indirect, based on pearls and pearl shells found at early Mesopotamian and Gulf area sites and on an episode in the Gilgamesh Epic, c. 2000 B.C.E., in which the hero descends to the bottom of the sea using a stone weight, just like traditional pearl divers in that region.

4. Doumenge, 1992: 16, followed Kunz and Stevenson, 80, in estimating that more than half of the world's pearls in 1905 originated in the Persian Gulf. The rest came from saltwater fisheries in the Red Sea, Sri Lanka-India, the Malay Archipelago, Australia, Polynesia, Mexico, Panama, and Venezuela, and from freshwater fisheries in Britain, continental Europe, the United States, and China-Siberia.

5. The Gulf fishery continued with few changes through the early twentieth century. Good first-hand sources, written in the nineteenth and twentieth centuries, include J. R. Wellsted, 1840, *Travels to the City of the Caliphs*, 2 vols., Henry Colburn, London; Miles, 1919: 417; and Alan Villiers, 1969, *Sons of Sinbad*, Charles Scribner's Sons, New York, 349–75. Both Kunz and Stevenson, 85–99, and Streeter, 1886: 212–21, offered comprehensive summaries.

6. Tennant, 1860, 2: 559–66.

7. Kunz and Stevenson, 86.

8. Measured by value: Kunz and Stevenson, 80.

9. Almatar et al., 1993: 36.

10. Ulrico Orilia, 1908, *La Madreperla e il Suo Uso nell'Industria e nelle Arte*, Libraio della Real Casa, Milan, 8.

11. Kunz and Stevenson, 141–42; Henri de Monfreid, 1930, *Pearls, Arms and Hashish*, Coward-McCann, New York, 36.

12. Monfreid, 34.

13. D. Sharabati, 1981, *Saudi Arabian Seashells: Selected Red Sea and Arabian Gulf Molluscs*, VNU Books International, London, 53.

14. Zhou's *Lingwai Taida* was first published after his death in 1178 but was written in the 1050s or 1060s. His account of the Si-nan fisheries was included by Zhao Rugua in his *Zhufanji* of 1225 (Hirth and Rockhill, 1911: 229); this is the version quoted here.

15. James Hornell, 1950, *Fishing in Many Waters*, Cambridge University Press, Cambridge, England, 183–84.

16. Milburn, 1813, 2: 358.

17. Kunz and Stevenson, 115–16. Streeter, 189, reported twenty men per steersman, while Kunz and Stevenson, 112–13, said that crews ranged from twelve to sixty-five (with an average of thirty-five). Tavernier, writing in 1678: 385, said that there were only one or two divers per boat. In 1904, Max Bauer (*Precious Stones*, 2 vols., Dover Publications, New York [1968 edition], vol. 2, 595) noted as many as 300 boats, each carrying ten divers. Milburn, 358, who had access to the secret files of the British East India Company and thus was exceptionally well informed, regarded a twenty-three-person crew as normal.

18. Tavernier, 385–86.

19. Hornell, 188.

20. For example, the Persian Gulf (Miles, 416) and China (Niu, 1994: 54); Tavernier, 382.

21. For such an instance, see Streeter, 199–206.

22. Villiers, 349–74, described a voyage in an Arab *dhow* from the Persian Gulf to Tanzania in the 1930s, in which a number of crewmembers were part-time pearl divers. We may presume that Gulf trading ships of earlier periods also had captains and crews familiar with pearling, which was the chief summer occupation of most ships and sailors in Bahrain, and on the coasts of Arabia, Kuwait, and the Gulf Emirates.

23. Kunz and Stevenson, 154–56.

24. Quoted by Donkin, 1998: 122.

25. Doumenge, 3–5.

26. Translated by the authors from Tavernier, 380.

27. Kunz and Stevenson, 134–39.

28. Kunz and Stevenson, 138–39; David E. Sopher, 1977, *The Sea Nomads*, National Museum Publications, Singapore, 60.

29. Rockhill, 1917: 270–71.

30. A. Dalrymple, 1770, *An Historical Collection of the Several Voyages and Discoveries in the South Pacific Ocean*, vol. 1, J. Nourse, T. Payne, and P. Elmsley, London, 10–14; also Christophe Loviny, 1996, The pearl people, 125–59 in *The Pearl Road: Tales of Treasure Ships in the Philippines*, edited by Christophe Loviny, Asiatype, Inc. and the author, Makati City, Philippines: 126–27.

31. Streeter, 139–40.

32. Dalrymple, 14.

33. James Francis Warren, 1985, *The Sulu Zone 1768–1898*, New Day Publishers, Quezon City, 68–74.

34. Warren, 72.

35. Dalrymple, 11.

36. Loviny, 125.

37. The status of the Danjia or Tanka people was mentioned by Niu, 6, and confirmed by many other writers on Hong Kong and Canton, e. g., John Henry Gray, 1878, *China, A History of the Laws, Manners, and Customs of the People*, 2 vols., Macmillan & Co., London, 2: 280–83.

38. Niu, 6.

39. Niu, 24–25.

40. Quoted by Kunz and Stevenson, 145–46. The encyclopedia cited by these authors, the *Gezhi Jingyuan*, appeared in 1717, but the pearling entry could refer, as Kunz implied, to a situation many decades earlier.

41. Sun and Sun, 1966: 286.

42. Niu, 6.

43. Quoted by Edward H. Schafer, 1967, *The Vermilion Bird*, University of California Press, Berkeley, 161. Yuan Zhen was describing the suffering caused among pearl divers when over-exploitation had temporarily exhausted the Leizhou pearl banks. An alternative reading of the last line is "Now even he collects them. How can men not want them too?" (C. Ho, FMNH, pers. comm., 2000). But Schafer's version, with its image of the sea god collecting men's lives, as well as pearls, is striking and memorable.

44. Niu, 24.

45. Niu, 55–57.

46. Hague, 1856: 282; Kunz and Stevenson, 146.

47. Translated by the authors from Tavernier, 379.

48. Donkin, 299–313.

49. Kunz and Stevenson, 193.

50. Kunz and Stevenson, 194–96, cited a number of observations of Tuamotu divers remaining underwater at depths of 20–25 fathoms (37–46 meters) for as long as 2–3 minutes.

51. Bengt Danielson, 1952, *Raroia, Happy Island of the South Seas*, Rand McNally, Chicago, 68–70.

52. Some pearl experts of a hundred years ago claimed that the treatment of native divers was not too bad. Streeter, 156–57, noted that in his day, an Australian magistrate supervised hiring. Kunz and Stevenson, 202, reported that "there was no complaint that the men thus impressed were treated with inhumanity; on the contrary, they were well fed and cared for" Other writers were less inclined to whitewash the situation. The dangers faced by forcefully recruited aboriginal divers were described by a former pearl ship captain, Henry Taunton (1903, *Australind*, Edward Arnold, London, 239–44). The existence of "hell ships," where aboriginal divers were beaten and sometimes killed out-of-hand, was confirmed by a modern historian of Australian pearling, Hugh Edwards (1994: 45–47).

53. Streeter, 168–69, 184–85.

54. Kunz and Stevenson, 205.

55. Frank Hurley, 1924, *Pearls and Savages*, G. P. Putnam's Sons, New York and London, 37; "The History of Pearling," from Fisheries of Western Australia, *Western Fisheries* Back Issues, http://www.wa.gov.au/westfish/aqua/broc/pearl/pearlhistory.html, accessed 11/1/00.

56. Kunz and Stevenson, 210.

57. Of Britain (Kunz and Stevenson, 159–68; Streeter, 233–45; Sprott, Gavin, 1984, Pearl Fishing in Scotland, 407–22 in *The Fishing Culture of the World*, vol. 1, edited by Bela Gunda, Akadémiai Kiadó, Budapest; Countryside Council for Wales, 1997, *Misglen berlog—Margaritifera margaritifera—Freshwater Pearl Mussel*, http://www.ccw.gov.uk/biodiv/freshwat.htm, accessed 11/1/00); of Scandinavia and the Baltic Republics (Kunz and Stevenson, 179–83); of Central Europe (Bauer, 2: 598); of European Russia (Kunz and Stevenson, 184–85); of Siberia and northeastern China (Kunz and Stevenson, 146–47; Niu, 48–55; Abraham Rees, 1810–1824, *The Cyclopædia; or, Universal Dictionary of Arts, Sciences, and Literature*, 41 vols., first American edition, S. F. Bradford, Philadelphia, Pennsylvania, vol. 26, entry for "pearl").

58. Kunz and Stevenson, 162.

59. Donkin, 261.

60. Kunz and Stevenson, 163–64.

61. Woodward, 1994: 91–95.

62. Hessling, 1859; see also summary by Riedl, 1928: 262.

63. Hessling, 351, for Bavarian harvests from 1831–1832. Such numbers differ greatly by region and according to the degree of cultivation and harvesting. G. Wellmann, 1939 (Untersuchungen über die Flußperlmuschel (*Margaritana margaritifera* L.) und ihren Lebensraum in Bächen der Lüneburger Heide, *Zeitschrift für Fischerei und deren Hilfswissenschaften*, 36: 489–603): 598, reported for the north German river Lachte one pearl per twenty-five pearl mussels, and one good pearl per 100. K.-H. Reger, 1981 (*Perlen aus bayerischen Gewässern*, Heinrich Hugendubel Verlag, München, Germany): 110, cited official 1957 data from the Bavarian river Lamitz, reporting thirty-five pearls in 3,060 pearl mussels, only three of which were of first quality.

64. Dall, 1883: 584, translating from Nitsche, 1882: 57.

65. Nitsche, 59.

66. Nitsche, 60; Rudau, 1961: 11ff.

67. Schlüter and Rätsch, 1999: 20.

68. Martell, 1915: 474.

69. Ziuganov et al., 1994: 10, 80ff.

70. Niu, 54.

71. Hague, 283–84; *Encyclopædia Britannica*, 9th edition, entry for "Pearls."

72. C. Claassen, 1994, Washboards, pigtoes, and muckets: historic musseling in the Mississippi Watershed, *Historical Archaeology*, 28(2): 1–145: 10.

73. Claassen, 5–8.

74. Barada, 1969: 54.

75. Miles, 416.

76. Charles Belgrave, 1966, *The Pirate Coast*, G. Bell & Sons, London, 164.

77. Hornell, 187–88.

78. Kunz and Stevenson, 117–18.

79. Kunz and Stevenson, 119–20.

80. Belgrave, 165; Villiers, 353.

81. Streeter, 220–21.

82. Niu, 24–25.

83. For the depth, see Kunz and Stevenson, 201; for the inhumane conditions, see note 51.

84. Kunz and Stevenson, 109.

Boepple Box: The origins of Boepple's button manufacturing ideas in the United States were discussed by Claassen, 6; R. F. Coker, 1919, Fresh-water mussels and mussel industries of the United States, *Bulletin of the United States Bureau of Fisheries*, 36 (1917–1918): 11–90: 65; Madsen, 1985: 55. Boepple's quote on "the right kind of shells" is from J. Boepple, 1900, Story of Mr. Boepple [letter to the editor from Boepple], *Muscatine Journal*, 4 October, p. 4. Details of Boepple's Muscatine business were discussed by Claassen, 6–7; Smith, 1899: 86; Boepple, 1900; Fassler, 1997: 266.

Freshwater Pearl Button Box: Coker, 70 ff., discussed the criteria for good button material. Attempts to reseed U.S. rivers were discussed by H. H. Vertrees, 1913, *Pearls and Pearling*, A. R. Harding, Columbus, Ohio, p. 68ff. Fassler, 1997: 266, provided harvest statistics. "In all branches of the button industry a gross is considered as consisting of 14 dozen, in order to make allowance for the imperfect or defective buttons that are liable to be produced at every stage of the business from the cutting of the rough blanks to the sewing of the finished buttons on cards"; Smith, 11. Smith, 15, gave the use of waste. Fassler, 266, discussed alternate button materials. Reasons for decline of the pearl button industry were given by J. A. Farrel-Beck and R. H. Meints, 1983, The role of technology in the fresh-water pearl button industry of Muscatine, Iowa, 1891–1910, *The Annals of Iowa*, (3)47(1): 3–18: 17, and *Des Moines* (Iowa) *Register*, 6 July 1946.

7 : Making Pearls

1. Fassler, 1995.

2. Kunz and Stevenson (1908: 285) attributed this story to Philostratus, a Greek of the third century C.E. writing about the life of Apollonius. In modern terms, this liquid is mainly composed of mucus and molluscan "blood" (called hemolymph), so it is doubtful that this method ever actually succeeded. Apollonius's celebrated magical powers may indeed have played a role in this story.

3. Joyce and Addison, 1993: 54. This is the earliest date cited for this technique; other authors cite the tenth or thirteenth century C.E. The development of this method has been attributed differently by different authors: to Yu Shun Yang, at the end of the fourteenth century (Kunz and Stevenson, 244, from D. J. MacGowan, 1857, *Album der Natur*, 8th edition); to Hou-Tchéou-Fou, in the

thirteenth century (Dakin, 1913: 127); or to Yi-jin-yang of Hoochow (B. L. Burch, 1995, Pearly shells—part 11, Mother-of-pearl—yesterday and today, *Hawaiian Shell News*, 43[12]: 5–7). MacGowan believed that the report of a Buddha pearl shell from 400 B.C.E. was probably an unusually shaped natural blister pearl.

4. Kunz and Stevenson, 286, reviewed an account written in 1734 that described implanting pea-size beads made from pulverized "seed-pearls (*Yo tchu*), such as are commonly used in medicine, moisten[ed] . . . with juice expressed from leaves of a species of holly (*Che ta-kong lao*)." Scarratt et al., (2000: 100) figured an X ray of a pair of presumably shell-bead-nucleated free pearls, joined by a nacre-covered thread, from eighteenth-century China.

5. Kunz and Stevenson, 286.

6. Hague, 1856; see also "Pearls" in *Encyclopædia Britannica*, 9th ed.

7. Hague, 1856; Kunz and Stevenson, 289, citing MacGowan, 1857.

8. Researching perliculture methods for King Maximilian II of Bavaria, the German biologist T. von Hessling (1859): 334 ff. reported these historic cases.

9. Reviewed by Woodward, 1994: 16.

10. First mentioned by Chinese scholars as early as the second century B.C.E. French naturalist Guillaume Rondelet (1554, *Universae Aquitilium Historiae Pars Altera*, Lugduni; cited by Cahn, 1949: 9 and Kunz and Stevenson, 40) believed that pearls were gallstones of the clams.

11. Anselmus de Boot in 1600, related by Cahn, 9.

12. Joyce and Addison, 55, citing Girolamo Benzoni, 1578, *Historia del Mondo Nuovo*, Geneva; O. Herr, 1924 (Zur Geschichte der Perlenfischerei in der Oberlausitz, *Abhandlungen der naturforschenden Gesellschaft Görlitz*, 29[2]: 65–79) citing work by Dr. Müller, 1759, Anmerkungen über die Muscheln und die in selbigen enthaltenen Perlen, welche um Marglissa in der Oberlausitz in dem Queisse gefunden werden, *Arbeiten einer vereinigten Gesellschaft in der Oberlausitz zu den Geschichten und der Gelahrtheit überhaupt gehörende*.

13. The earliest reference to parasites in pearl formation appears to be Rondeletius in 1558 (cited by W. A. Herdman, 1905, Presidential address, 1905, *Proceedings of the Linnean Society of London*, 117th Session: 18–30). The parasite theory was confirmed for marine species by R. Garner (1873, On the formation of British pearls and their

possible improvement, *Journal of the Linnean Society [Zoology]*, 11: 426–28), A. Giard (1903, L'épithélium sécréteur des perles, *Comptes Rendus de la Société de Biologie*, 55: 1222–25), and W. A. Herdman and J. Hornell, 1903–1906, *Report to the Government of Ceylon on the Pearl Cyster [sic] Fisheries of the Gulf of Manaar. Pars I–V*, Colombo. Some authors, such as R. Dubois (1901, Sur le mécanisme de la formation des perles fines dans le *Mytilus edulis*, *Comptes Rendus de l'Académie des Sciences, Paris*, 133: 603–5; and H. Lyster Jameson (e.g., 1902, On the origin of pearls, *Proceedings of the Zoological Society of London for 1902*, 1: 140–66), accepted different explanations for pearl development, with and without parasite involvement.

14. From, respectively, H. A. Pagenstecher (1858, Ueber Perlenbildung, *Zeitschrift für wissenschaftliche Zoologie*, 9[4]: 496–505, pl. 20) and T. von Hessling (1858, Ueber die Ursachen der Perlbildung bei *Unio margaritifer*, *Zeitschrift für wissenschaftliche Zoologie*, 9[4]: 543–46; also Hessling, 312). Pearl formation around small, white, elastic bodies was summarized by Herr, 75, citing C. A. Schwarze, 1800–1804, Ueber die Natur und Entstehungsart der Perlen, besonders in den Muscheln des Queisses, *Neue Lausitzer Monatsschrift*, 1800 II: 323–40; 1802 I: 241–53, 273–91; 1804 II: 207–21. Similarly, according to A. Rubbel (1911, Über Perlen und Perlbildung bei *Margaritana margaritifera* nebst Beiträgen zur Kenntnis ihrer Schalenstruktur, *Zoologische Jahrbücher, Abteilung für Anatomie und Ontogenie der Tiere*, 32 [3]: 287–366, pls. 17–18), a nucleus can be formed by small yellowish-brown bodies, which are probably connected to the process of shell formation and naturally occur in the mantle and connective tissue of the bivalve.

15. E. Korschelt, 1911, Über Perlen und Perlbildung bei *Margaritana*, *Verhandlungen der Deutschen Zoologischen Gesellschaft*, 1911: 92–95, citing W. Hein, 1911, Zur Frage der Perlbildung in unseren Süsswassermuscheln, *Allgemeine Fischereizeitung*, 8.

16. Riedl (1928: 297) described Waltl's experiments on *Margaritifera* in the 1840s, in which he inserted spheres through drill holes, but only succeeded in creating dull calcareous coverings around the nucleus; Riedl claimed better success in his own subsequent experiments.

17. Giard, 1903.

18. A. Zawarzin, 1927, Über die reaktiven Veränderungen des Epithels bei Einfügung eines Fremdkörpers in den Mantel von *Anodonta*, *Zeitschrift für mikroskopisch-anatomische Forschung*, 11: 215–282; see also F. Haas, 1931,

Bau und Bildung der Perlen, Academische Verlagsgesellschaft, Leipzig: 266–67.

19. L. Boutan, 1903, L'origin réelle des perles fines, *Comptes Rendus de l'Académie des Sciences*, 137: 1073–75; Rubbel, 1911: 42.

20. Schlüter and Rätsch, 1999: 31–32.

21. F. Alverdes (1913a, Über Perlen und Perlbildung, *Zeitschrift für wissenschaftliche Zoologie*, 105[4]: 598–633, pls. 30–31; and 1913b, Versuche über die künstliche Erzeugung von Mantelperlen bei Süßwassermuscheln, *Zoologischer Anzeiger*, 42[10]: 441–58) explicitly described a method to produce cultured pearls by injecting epithelial cells into mantle tissue, then adding a parasite-egg-sized bead as a nucleus onto which the cells would organize to form the pearl sack. Riedl (295) gave Alverdes priority for culturing mantle pearls; Haas (1957: 125) claimed that Mikimoto had a Japanese translation of Alverdes's work.

22. Haas, 122, who emphasized the work of Alverdes, 1913a and b.

23. Herdman, 28. It is unknown whether these were blister or free pearls.

24. Kunz and Stevenson, 290. Isaac Lea (1792–1886), a prominent Philadelphia conchologist, wrote numerous influential scientific articles on freshwater pearl mussels during the mid- to late 1800s that have "formed the basis for much of the understanding of unionoids in North America" (Parmalee and Bogan, 1998: 17).

25. Presumably blister pearls; Kunz and Stevenson, 290–91, citing "La Pêche et la Culture des Huitres Perlières à Tahiti," Paris, 1885.

26. Dakin, 129; C. D. George, 1994, Concept of the South Sea pearl and its future from lessons of the past, Abstracts, *Pearls '94*, Honolulu, Hawaii, 14–19 May 1994, *Journal of Shellfish Research*, 13(1): 336; C. Cáceres and J. Chávez, 1997, The Beginnings of pearl oyster culture in Baja California Sur, México, *World Aquaculture*, June 1997: 33–38; D. O'Sullivan, 1999, Global importance of pearls increases, *Aquaculture Magazine*, 25(2): 28–32.

27. Mikimoto Pearl Island Company, 1998, *Pearl Museum: Human Involvement with Pearls Through the Ages*, Mikimoto Pearl Island Company, Toba, Japan: 27. The date of the first cultured pearl, July 11, is now celebrated in Japan as "Pearl Memorial Day" (http://www.portnet.ne.jp/~kobe-p-p/pearlnewse.htm, accessed 9/16/00). Mikimoto's 1896 patent (Japanese Patent no. 2,670) was nullified in 1912 according to Cahn, 12.

28. E. Wigglesworth, 1938, The Story of cultured pearls, *Bulletin of the New England Museum of Natural History*, 86: 3–7: 6, quoting R. M. Shipley of the American Gem Society. A. E. Alexander (1939, Pearls through artifice, *Scientific American*, 160[4]: 228–29) also provided a detailed description "taken from Japanese sources."

29. Cahn, 11; F. Ward, 1998, *Pearls*, Gem Book Publishers, Bethesda, Maryland: 12–13; also (in part) at http://www.pbs.org/wgbh/nova/pearl/time.html, accessed 8/21/00. Nishikawa's patent application of 1907 (Japanese Patent no. 29,630) actually post-dated Mise's by five months. Neither Mise nor Nishikawa received a 1907 patent. Mise's patent was rejected and Nishikawa's was not formally granted until 1916, a month after the award of Mikimoto's 1916 patent (Japanese Patent no. 29,409).

30. O'Sullivan, 1999. Dickinson (1968: 156–57) also discussed this connection, although she construed that "an unsung Australian oysterman [who] hit accidentally upon the method" must have had contact with Mise's stepfather, in his capacity as government oyster inspector, and/or with Nishikawa, who as a zoologist might have visited the Australian pearl oyster beds.

31. Cahn, 61. Based on a chart published by K. T. Wada (1973, Modern and traditional methods of pearl culture, *Underwater Journal*, 28: 28–37), these 10 million pearls amounted to approximately 5,000 kilograms. The Japanese government curtailed pearl farming during WWII as a non-essential industry. During the Allied occupation, all pearl sales were required to pass through the Allied Forces. Following the war, the Japanese pearl farms rebounded to a maximum of 130,000 kilograms in 1966. Since then, disease and environmental problems have seen this volume decline. The report "Pearl Culture in Japan" by A. R. Cahn in 1949 must have played a substantial role in the spread of pearl culture technology to countries outside of Japan.

32. Kunz and Stevenson, 292, citing Mitsukuri. Wada, 1991: 247, referred specifically to "suspended leaves of the Japanese cedar (*Cryptomeria*)" being used in Japan.

33. Cahn, 38.

34. Time in culture for Akoyas was estimated at six to seven years by H. Schenck (1963, Japanese pearl culture [abstract of a presented movie], *American Malacological Union, Annual Report for 1963*, 36–37), but amounts to less than four years according to the schedule observed by the authors in Ago Bay in 1999.

35. A. M. Keen, 1949, The Japanese pearl culture industry [abstract], *The American Malacological Union News Bulletin and Annual Report, 1949*: 21. Wada, 1991: 251, reported an even shorter period of less than one year.

36. In fact, one study showed that fouling was greater in cages than in natural populations (L. Mao Che, T. Le Campion-Alsumard, N. Boury-Esnault, C. Payri, S. Golubic, and C. Bézac, 1996, Biodegradation of shells of the black pearl oyster, *Pinctada margaritifera* var. *cumingii*, by microborers and sponges of French Polynesia, *Marine Biology*, 126[3]: 509–19). In another study, culture cages were shown to promote the growth of a different set of fouling organisms than those found in natural populations: M. S. Doroudi (1996, Infestation of pearl oysters by boring and fouling organisms in the northern Persian Gulf, *Indian Journal of Marine Sciences*, 25[2]: 168–69, reproduced by *Cambridge Scientific Abstracts*, no. 3960550) reported barnacles, edible oysters, and tube-dwelling polychaetes to be the most serious foulers in Iranian pearl farms, while sponges, algae, and sea-squirts were most numerous in wild beds.

37. Several early Japanese patents (nos. 23,645 and 24,917, both awarded in 1913 to K. Mikimoto) described methods to paint or coat the outer surface of pearl oysters to prevent fouling. Metal armature was used against fouling in pre-1920s perliculture ventures in the Gulf of California (M. Cariño and M. Monteforte, 1999, *El Primer Emporio Perlero Sustentable del Mundo*, Universidad Autónoma de Baja California Sur, Mexico, 140, 142). These methods were apparently not successful.

38. T. Hirose (United States Patent 5,749,319, 12 May 1998, "Pearl and method for producing same") devised an intriguing method that would eliminate the grafter, the mother oysters, and (perhaps) the shell bead nucleus from the process of perliculture. Basically, the genes for mantle cells are incorporated into the genes of a microorganism. These new "pearl generating microorganisms" are then adhered to a synthetic nucleus and begin secreting nacre. To our knowledge, this method has not been put to practical use.

39. Vane Simmonds introduced relaxing (by exposure to air and sun) and wedging a pearl mussel open to avoid stress on the mollusk's adductor muscles; this was done in Cedar Rapids, Iowa, in the late 1890s (Kunz and Stevenson, 291). Kunz and Stevenson suggested that chemical narcotants might be more successful, foreseeing the method in common use today.

40. The terms "graft" for the mantle epithelium, or "grafting" for the nucleation operation, may have originally referred to the fusion of tissues. Japanese patent no. 29,409 (awarded in 1916 to K. Mikimoto; see Cahn, 84) describes making a slit into the mantle tissue of a pearl oyster, inserting a bead nucleus, turning one side of the cut mantle edge into the cavity, then "grafting" the other cut edge over the opening onto the mantle surface.

41. Taburiaux, 1985: 151.

42. Attempts to implant mantle tissue of a different species (a *heterograft*) to produce a differently colored pearl have usually been unsuccessful. For instance, use of tissue from the yellow-nacred Pipi Pearl Oyster (*Pinctada maculata*) to graft Black-lipped Pearl Oysters in French Polynesia (presumably to produce marketable yellow-black pearls) has failed. In the more common technique, a sacrificed individual of the same species (a *homograft*) supplies the tissue. In Japan, therefore, Akoya Pearl Oyster tissue is used to graft other Akoya Pearl Oysters. Tissue from the same individual (an *autograft*) has been successfully used in the larger pearl oysters (*Pinctada maxima*, especially in Myanmar) but is too stressful for the smaller species (Tint Tun, 1994, A view on seeding, Abstracts, *Pearls '94*, Honolulu, Hawaii, 14–19 May 1994, *Journal of Shellfish Research*, 13[1]: 352–53).

43. Webster, 1978: 471. A scarlet dye was described in Japanese Patent no. 45,421 (awarded in 1923 to K. Mikimoto; Cahn, 86) as "aminoazotoluene-azo-beta-naphthol solution before grafting . . . washed in Ringer's solution as it is grafted." Experiments involving coating the mantle tissue with "pearl growth hormone" have shown significantly faster nacre deposition in Chinese Akoya pearls (Qizeng Jin, H. Li, and H. He, 1998, Effects of pearl-growth-hormone [PGH] on pearl culture of *Pinctada martensii*. [In Chinese] *Tropic Oceanology/Redai Haiyang*, 17[4]: 44–50, reproduced by *Cambridge Scientific Abstracts*, no. 4642623). Betadine (povidone iodine) has also been found to be an effective antiseptic used at the operation site or on instruments or mantle tissue (J. H. Norton, J. S. Lucas, I. Turner, R. J. Mayer, and R. Newnham, 1999, Studies to improve the percentage of gem quality pearls, *Abstracts, World Aquaculture Society meeting, 1999*; also at http://www.spc.org.nc/coastfish/News/POIB/13/POIB13-8a.htm, accessed 8/22/00).

44. J.-P. Cuif, Y. Dauphin, C. Stoppa, and S. Beeck, 1993, Forme, structure et couleurs des perles de Polynésie, *Revue de Gemmologie a.f.g.*, no. 114: 3–6, abstract in *Gems & Gemology*, Summer 1993: 143.

45. Porter, 1991.

46. Webster, 472; Wada, 1991. Previous over-crowding during the two- to three-year culture period has been blamed (along with pollution and a newly identified virus) for recent declines in Akoya pearl production. The pearl farmers of Ago Bay began reducing the densities of their pearl oysters in 1996 in an attempt to "[get] more with less" (Andy Müller in December 1996/January 1997 issue of *Pearl World*, quoted by NOVA, "The Perfect Pearl," http://www.pbs.org/wgbh/nova/pearl, accessed 10/25/00). The hopeful prognosis is that pearl production will return to "healthy" levels by the year 2002.

47. NOVA, "The Perfect Pearl," http://www.pbs.org/wgbh/nova/pearl, accessed 10/25/00.

48. As a general rule throughout these descriptions, exact details of procedure, such as the frequency of cleaning or the number of days in post-operative care, will not be given. In some cases, this is considered proprietary information by our sources; in others, these data are omitted in the interest of available space.

49. N. C. Reece, 1958, *The Cultured Pearl: Jewel of Japan*, Charles E. Tuttle, Rutland, Vermont, 83ff.; also Mikimoto Pearl Island Company, 52.

50. Japanese statistics from Mikimoto Pearl Island Company, 53; Tahitian statistics from J.-L. Saquet and J.-F. Dilhan, 1996, *Perles de Tahiti / Pearls of Tahiti*, Au Vent des Iles, Tahiti and Dilhan, 54.

51. Cahn, 13.

52. S. Akamatsu, pers. comm., 1999.

53. Yonick, 1999; plus pers. comms. from S. Akamatsu, 1999; T. Gao, 2000; Cheng Tai Po, 2000.

54. FAO/UNDP Regional Seafarming Project, 1991, *Training Manual on Pearl Oyster Farming and Pearl Culture in India*. Prepared for the Pearl Oyster Farming and Pearl Culture Training Course conducted by the Central Marine Fisheries Research Institute at Tuticorin, India, and organized by the Regional Seafarming Development and Demonstration Project, Training Manual 8.

55. FAO/UNDP Regional Seafarming Project, 1991; Fassler, 1995; Doroudi, 1996; S. Akamatsu, pers. comm., 1999.

56. G. S. Rao and M. Devaraj, 1996, Prospects of large scale onshore marine pearl culture along the Indian coasts, *Marine Fisheries Information Service Technical and Extension Series*, no. 143: 1–7, reproduced in *Cambridge Scientific Abstracts*, no. 4289193.

57. Müller, 1999; S. Akamatsu, pers. comm., 1999; also "The Australian pearling industry and its pearls," by Grahame Brown, http://www.gem. org.au/gallery/pearltext.html, accessed 9/21/00.

58. B. K. Bowen and D. A. Hancock, 1989, Effort limitation in the Australian rock lobster fisheries, 375–93 in *Marine Invertebrate Fisheries: Their Assessment and Management*, edited by J. F. Caddy, John Wiley & Sons, New York. In 1999, the total government quota was 572,000 live pearl oysters (advertisement for Devino Pearl Exporters, in *Jewellery News Asia*, May 1998; also Müller, 1999).

59. Joll, 1994.

60. Joll, 1994; also I. A. Knuckey, 1995, Settlement of *Pinctada maxima* (Jameson) and other bivalves on artificial collectors in the Timor Sea, northern Australia, *Journal of Shellfish Research*, 14(2): 411–16, reproduced by *Cambridge Scientific Abstracts*, no. 3902398.

61. N. Paspaley, pers. comm., 2000. An estimated 350,000 pearl oysters (61 percent of the wild-collected quota) were produced in hatcheries in 1999, but they produced less than 3 percent of the annual yield (Müller, 1999). Queensland-area pearl farms cannot collect sufficient wild *Pinctada maxima* off their coasts, and so depend more upon hatchery technology (C. Robertson, 1998, Increased activity in pearl farming in Queensland, *Queensland Aquaculture News*, 13: 1, reproduced in *Cambridge Scientific Abstracts*, no. 4636948).

62. http://www.paspaleypearls.com/pcreation1. html, accessed 5/5/00.

63. Paspaley Pearling Company produces 75 percent of Australia's annual harvest of South Sea pearls; http://www.paspaleypearls.com/ pcreation6.html, accessed 5/5/00.

64. Doumenge et al. (F. Doumenge, J. Branellec, and A. Toulemont, 1991, *The South Sea Pearls: The Philippine Golden Pearl*, Musée Océanographique, Monaco, 39); also "The Australian pearling industry and its pearls," by Grahame Brown, http://www.gem.org.au/gallery/ pearltext.html, accessed 9/21/00.

65. The use of X rays in perliculture was first described by J. I. Solomon (1910, A process for preserving the pearl-oyster fisheries and for increasing the value of the yield of pearls, *Proceedings of the Fourth International Fishery Congress: Organization and Sessional Business, Papers and Discussion*, Washington, D.C., 22–26 September 1908, 303–13) in Ceylon, using "*Margaritifera vulgaris*" (now called *Pinctada radiata*).

66. A. Müller, 1997, *Cultured Pearls: The First Hundred Years*, Golay Buchel Group, Lausanne, Paris, 71, and 1999; also "The Australian pearling industry and its pearls," by Grahame Brown, http://www.gem.org.au/gallery/pearltext.html, accessed 9/21/00.

67. "The Australian pearling industry and its pearls," by Grahame Brown, http://www. gem.org.au/gallery/pearltext.html, accessed 9/21/00. This report did not include figures for percent mortality during the entire culturing period, or percent producing top-grade pearls.

68. D. O'Sullivan and D. Cropp, 1994, An overview of pearl production techniques in Australia, Abstracts, *Pearls '94*, Honolulu, Hawaii, 14–19 May 1994, *Journal of Shellfish Research*, 13(1): 348; NOVA, "The Perfect Pearl," http://www.pbs.org/wgbh/nova/pearl, accessed 10/25/00.

69. Doumenge et al., 21ff.; D. F. Landra, 1994, Trends and development of the pearl oyster industry in the Philippines, Abstracts, *Pearls '94*, Honolulu, Hawaii, 14–19 May 1994, *Journal of Shellfish Research*, 13(1): 339; J. Branellec, pers. comm., 2000.

70. Doumenge et al., 26; O'Sullivan and Cropp, 1994; NOVA, "The Perfect Pearl," http://www.pbs.org/wgbh/nova/pearl, accessed 10/25/00. "Indicator pearls" or "baby South Sea pearls" are implanted with 8-millimeter bead nuclei at eighteen months, and harvested six to eight months later (*Jewellery News Asia*, May 1999).

71. Doumenge et al., 41; J. Branellec, pers. comm., 2000.

72. J. Branellec, pers. comm., 2000.

73. George, 1994; Müller, 1997: 54, and 1999; Mikimoto Pearl Island Company, 27. Cahn, 12–13, indicated that this industry was started by Masayo Fujita.

74. Müller, 1999. The notion that populations south of the equator produce silver pearls and those north of the equator produce golden pearls is oversimplified—all populations range in nacre color from silver to gold.

75. From "The Creation of a Pearl," *Western Fisheries Magazine*, 1997, http://www.wa.gov.au/ westfish/aqua/broc/pearl/pearlcreation.html, accessed 10/25/00.

76. D. Soedharma, 1998, Indonesian pearl culture project (abstract), p. 188 in *Proceedings of the Eighth Workshop of the Tropical Marine Mollusc Programme (TMMP), Thailand, 18–28 August*

1997, Part 1, edited by J. Hylleberg, Phuket Marine Biological Center Special Publication 18; Müller, 1999; P. Sutton, 1999, Mixing local and latest know-how, *Jewellery News Asia*, May 1999: 60–62, 64, 67–68, 70.

77. Müller, 1999.

78. Myanmar grafting techniques were developed by university biologists; Tint Tun, "Myanmar pearling: past, present and future," Secretariat of the Pacific Community, Coastal Fisheries Programme Report, http://www.spc.org.nc/ coastfish/News/POIB/12/1aMyanmar.htm, accessed 11/1/00.

79. Sutton, 1999; http://kelleyjewelers.itlnet.net/ pearls.htm, accessed 8/21/00; also from "Part I: New pearls of the Orient, Part II: Gold, gods, and glory, Part III: Down on the farm, Part IV: Tasaki to launch Burmese pearl line," by T. Themelis, http://www.gemkey.com/newscenter/news/ default.asp?NTYPEID=38&NNEWSID=1749, -1752, -1759, -1763, accessed 8/19/00; also from "Treasures of Mergui, Parts I–II. Part III: The golden isle," by T. Themelis, http://www.gemkey. com/newscenter/news/default.asp?NTYPEID=41 &NNEWSID=2086, -2088, -2094, accessed 8/19/00.

80. Müller, 1999; Wu and Pan, 1999; S. Akamatsu, pers. comm., 1999; from *GemKey News Center*, "Tasaki Shinju cultures gold pearls," http://www.gemkey.com/ newscenter/news/default.asp?NARCHID= 1024&NTYPEID=I&NNEWSID=1229, last updated 8/30/99, accessed 1/27/01.

81. Cahn, 13.

82. Somchai Bussarawit, 1995, Marine pearl farms of Phuket Island, pp. 41–42 in *Proceedings of the Fifth Workshop of the Tropical Marine Mollusc Progamme (TMMP) conducted in Indonesia at Sam Ratulangi University, Manado and Hasanuddinn University, Ujung Pandang, 12–23 September 1994*, edited by J. Hylleberg and K. Ayyakkannu, Phuket Marine Biological Center Special Publication no. 15; Tipaporn Traithong, T. Poomtong, and C. Sookchuay, 1997, Growth of hatchery-produced juvenile pearl oyster, *Pinctada maxima* (Jameson) in the Gulf of Thailand, pp. 251–54 in *Proceedings of the Seventh Workshop of the Tropical Marine Mollusc Programme (TMMP) on Central and West Java, Indonesia, 11–22 November 1996, Part 1*, edited by J. Hylleberg, Phuket Marine Biological Center Special Publication 17.

83. Saquet, 1992: 24. So-called "black" pearls are rarely black, but range in color from cream to shades of blue, green, rose, and gray. The French Polynesian cooperative now markets its pearls as

Tahitian Cultured Pearls in recognition of this misnomer.

84. Exports of Tahitian cultured pearls began in 1972, with about 1.5 kilograms. Export passed the 1,000-kilogram or 1-ton mark in 1992, and was estimated at 6 tons in 1998 (R. Wan, 1999, The Tahitian cultured pearl: Past, present, and future, *Gems & Gemology*, 35[3]: 76). In 1999, contacts suggested the maximum output to be 8 tons annually—this was expected by 2004 according to Robert Wan, but was surpassed in 1999 (http://www.tahiti-blackpearls.com/market/index.html, accessed 9/16/00). It is not known how much of this dramatic increase is due to an increase in the number of nucleations or to an overall increase in the quality of the product.

85. GIE Tahiti Pearl Producers, pers. comm., 1999.

86. Lintilhac, 1985: 41.

87. W. Reed, 1965, *Final Technical Report to Sudan Government on Marine Fisheries Development and Mother-of-Pearl Oyster Culture 1958–1964 and Recommendations for Future Development*, Game and Fisheries Department, Ministry of Animal Resources, Karthoum; Sims and Sarver, 1994; Fassler, 1995; Doroudi, 1996; Walther, 1997: 35–36; S. Akamatsu, pers. comm., 1999.

88. Cahn, 12–13.

89. E. Buscher, 1999, Natural pearls from the northern Cook Islands, *Gems & Gemology*, 35: 147–48.

90. K. J. Friedman, J. D. Bell, and G. Tiroba, 1998, Availability of wild spat of the blacklip pearl oyster, *Pinctada margaritifera*, from "open" reef systems in Solomon Islands, *Aquaculture*, 167(3–4): 283–99, reproduced by *Aquatic Sciences & Fisheries Abstracts (ASFA)*, (1)29(2): 381.

91. L. G. Hertlein, 1950, Pearl oysters of the Gulf of California (abstract), *American Malacological Union, News Bulletin and Annual Report for 1950*: 23–24; S. Farrell, D. McLaurin, and E. Arizmendi, 1994, Perspectives and opportunities of pearl oyster culture development on the coast of Sonora, Gulf of California, Mexico, Abstracts, *Pearls '94*, Honolulu, Hawaii, 14–19 May 1994, *Journal of Shellfish Research*, 13(1): 334–35; Monteforte, 1994; Monteforte and Aldana, 1994; Monteforte and Bervera, 1994; M. Monteforte, H. Bervera, S. Morales, V. Pérez, P. Saucedo, and H. Wright, 1994, Results on the production of cultured pearls in *Pinctada mazatlanica* and *Pteria sterna* from Bahia de La Paz, south Baja California, Mexico, Abstracts, *Pearls '94*,

Honolulu, Hawaii, 14–19 May 1994, *Journal of Shellfish Research*, 13(1): 344–45; Saucedo et al., 1994; Cáceres and Chávez, 1997; C. R. Fassler, 1999, Recent developments in the farming and marketing of Mexican pearls, *Abstracts, World Aquaculture Society meeting, 1999* (also http://www.spc.org.nc/coastfish/News/POIB/13/POIB13-8a.htm, accessed 8/22/00); O'Sullivan, 1999; C. Rangel-Davalos, H. Acosta-Salmon, E. Martinez-Fernandez, O. Hirales-Cosio, S. Valdez-Murillo, and L. Hernandez-Moreno, 1999, First massive hatchery production of the pearl oyster *Pteria sterna* (concha nacar) in Mexico, *Abstracts, World Aquaculture Society meeting, 1999* (also http://www.spc.org.nc/coastfish/News/POIB/13/POIB13-8a.htm, accessed 8/22/00); *Jewellery News Asia*, May 1999.

92. http://www.sfc.ca/~fankbone/r/pcfcprl.html, accessed 9/27/00.

93. Also *Haliotis sieboldii* Reeve, 1846, which D. L. Geiger, 1998, has determined to be a synonym of *H. gigantea*, Recent genera and species of the family Haliotidae Rafinesque, 1815 (Gastropoda: Vetigastropoda), *The Nautilus*, 111(3): 85–116: 106.

94. P. V. Fankboner, 1994, *Process for Producing Pearls in Abalone and Other Shell-Bearing Molluska* [sic] *and Nucleus Used Therewith*, United States Patent 5,347,951.

95. From *Australian Gemmologist* (1997) 19: 375–79; reproduced at http://www.aquatech-aust.com.au/pages/gem-article.html, accessed 9/27/00.

96. P. V. Fankboner, 1994, Abalone pearls: past, present and future, Abstracts, *Pearls '94*, Honolulu, Hawaii, 14–19 May 1994, *Journal of Shellfish Research*, 13(1): 333–34.

97. L. McKenzie, 1999, Cultured abalone mabé pearls from New Zealand, *Gems & Gemology*, 35(3): 172; http://www.sfc.ca/~fankbone/r/pcfcprl.html, accessed 9/27/00.

98. Fankboner, 1995; Fassler, 1995; http://www.pickapearl.com/types.htm, accessed 9/27/00.

99. http://www.aquatech-aust.com.au/pages/gem-article.html, accessed 9/27/00.

100. Chronologically, successful nucleation of free pearls in Akoya Pearl Oysters was first accomplished in the mantle tissue. Cahn, 17, related that following a red tide in 1905, Mikimoto discovered free pearls near the adductor muscles of five dead pearl oysters, which suggested the now-favored site of pearl nucleation away from the mantle. However, Cahn's list of Japanese pearl patents

("Summary of patents relating to pearl and pearl oyster culture"; Cahn, 83–88, Appendix H) makes fascinating reading on the sequence of inventions relevant to the site of nucleation. The first mention of insertion of bead-plus-tissue anywhere other than in the mantle appears in 1922 (Japanese Patent no. 43,352) when K. Otsuki placed a nucleus "in the flesh tissue near the foot." This was made more explicit a few years later (Japanese Patent no. 77,325, awarded 1928) by the same inventor inserting "between the foot and liver." Several additional patents to Otsuki or Nishikawa followed in 1930, describing partial removal of pedal retractor muscles that would interfere with pearl formation in this part of the pearl oyster. Finally, S. Ida received a patent in 1934 (Japanese Patent no. 106,825) for inserting the nucleus specifically into the gonad.

101. Cahn, 66; also Coleman Douglas Pearls web site, http://www.pearls.co.uk/passion4pearls.htm, accessed 8/21/00.

102. Although non-beaded nucleation is the rule, production of spherical (i.e., not fancy shaped) bead-nucleated freshwater pearls has been reported from Japan, as "Kasumiga pearls" (from "Japan's freshwater pearl industry reborn," by B. Scheung, http://www.belpearl.com/news.htm, accessed 8/21/00; also "Freshwater cultured 'Kasuminga pearls,' with Akoya cultured pearl nuclei," *Gems & Gemology*, Summer 2000).

103. Such pearls are often called "non-nucleated." This is a misnomer, because deposition of nacre technically requires some sort of object to coat. What makes so-called non-nucleated pearls different is the absence of the bead.

104. Ha Duc Thang, 1994, Pearl farming in Vietnam, Abstracts, *Pearls '94*, Honolulu, Hawaii, 14–19 May 1994, *Journal of Shellfish Research*, 13(1): 350–51.

105. "Used" shells of *Pinctada maxima* in Australia and of *Pinctada margaritifera* are also used for inlay.

106. Mikimoto Pearl Island Company, 27. Lake Biwa is 63.5 km long, covers 674 square kilometers, and has an average depth of 41 meters, with a maximum depth of 104 meters. It was formed about five million years ago during the Tertiary Period (http://www.ilec.or.jp/database/asi/asi-01.html, accessed 8/21/00). Cahn, 62, claimed that freshwater pearl culture in Lake Biwa dates from 1928, beginning in the lowermost section, the Hirako Reservoir.

107. SESEJHSSP, 1996: 28; E. A. Jobbins and K. Scarratt (1990, Some aspects of pearl production with particular reference to cultivation in

Yangxin, China, *Journal of Gemmology*, 22(1): 3–15) indicated that perliculture did not begin in Lake Biwa until the 1950s.

108. "Biwa pearl" is restricted by the U.S. Federal Trade Commission to "cultured pearls grown in fresh water mollusks in the lakes and rivers of Japan" (http://www.ftc.gov/bcp/guides/jewel-gd.htm, accessed 8/21/00). A simple WWW-search for the phrase "Biwa pearl" located the websites of numerous commercial jewelers. Many of the pearls so labeled appear to be large, flat, irregular or "fancy shaped" pearls (approx. 2 x 1 centimeters) presumably produced using large tissue nuclei. It is unlikely any of them are from Lake Biwa, and equally unclear whether they are from anywhere else in Japan.

109. *Hyriopsis schlegelii* is also occasionally listed as native to Lake Kasumigaura, however according to SESEJHSSP, 28, it was imported there from Lake Biwa in 1936. A recent news article ("Freshwater cultured 'Kasuminga pearls,' with Akoya cultured pearl nuclei," *Gems & Gemology*, Summer 2000) acknowledged that Lake Kasumigaura Pearl Mussels are now hybrids (discussed in this section, following).

110. Nakai, 1999. A recent article in *Gems & Gemology* ("Freshwater cultured 'Kasuminga pearls,' with Akoya cultured pearl nuclei," Summer 2000) reported on Japanese freshwater pearls from Lake Kasumigaura, north of Tokyo, supposedly the product of a hybrid between the Biwa Pearl Mussel (*Hyriopsis schlegelii*) and "*Anadonta plicata*" (= *Cristaria plicata*, origin not indicated). However, hybridization would not be likely between *Cristaria* and *Hyriopsis* (A. E. Bogan and K. Nakai, pers. comms., 2000) and it is more likely that the hybrid is the product of a cross between Japanese *H. schlegelii* and Chinese *H. cumingii*. Sakai et al. (H. Sakai, M. Ujiie, E. Mizutani, and I. Ikeda, 1997, Allozyme comparison between Japanese and Chinese limnetic pearl mussels, *Journal of the National Fisheries University [Japan]*, 46(2): 101–4, reproduced in *Cambridge Scientific Abstracts*, no. 4474857) have shown that the genetic distance between *H. schlegelii* and *H. cumingii* is "quite low . . . in spite of the great difference in shell morphology."

111. http://www.jckgroup.com/archives/1997/04/jc04-106.html, accessed 9/28/00.

112. S. Akamatsu, pers. comm., 1999.

113. As one Hong Kong pearl merchant expressed it to us, "Lake Biwa does not exist"; F. Yip, pers. comm., 2000.

114. F. Yip, a Hong Kong pearl dealer (pers. comm., 2000), said that pearl farming in China is only twenty years old. Ms. Gao Tao of the National Gemstone Testing Center (Beijing, pers. comm., 2000) stated that pearl farming started in the 1960s, becoming profitable in the 1970s (agreed by Scarratt et al., 99). Y. Feng (1997, Present situation and prospects of China freshwater pearl breeding, *China Gems*, 6(4): 35–37, reproduced in Gemological Abstracts, *Gems & Gemology*, Summer 1998: 151) claimed that Chinese freshwater pearl culturing began in 1972.

115. B. Scheung, 1999, Chinese freshwater begins new era, *Jewellery News Asia*, May 1999: 92, 94, 96, 99; Scarratt et al., 99.

116. "Cultured pearls, round and near-round freshwater tissue-nucleated," Gem Trade Lab Notes, *Gems & Gemology*, Summer 1994: 118.

117. F. Yip, pers. comm., 2000. A second source (Cheng Tai Po, pers. comm., 2000) insisted that only about 1 percent of the annual harvest is perfectly round. Only a little over one year earlier, other sources claimed that 3 percent of the Chinese crop was considered round (P. E. Holewa, 2000, Made in China, *GemKey*, 2(2): 50–57; also at http://pearl.sxagri.com/dynamic.htm, accessed 10/25/00, and http://www.gemkey.com/newscenter/news/default.asp?NTYPED=7&NNEWSID=1634, accessed 1/27/01; "White and pastel Chinese freshwater cultured pearls," *Gems & Gemology*, Spring 1999).

118. *Cristaria* was still in use into the 1990s (Ge, 1996; Jobbins and Scarratt, 1990; Scarratt et al., 100–1). Two *Lamprotula* species have been given by various sources: *Lamprotula leai* (Gray, 1834), also called Humpy-back Clam, was used in a display on cultured pearls at the Beijing Natural History Museum (pers. observ.), and *L. rochechouarti* (Heude, 1875) was mentioned by Holewa (2000). Ge, 12, wrote that *Lamprotula* (and three other pearl mussel species) were used only for "studying pearl culturing methods and for producing man-made nuclei."

119. Scheung, 1999; Scarratt et al., 100.

120. K. Scarratt, pers. comm., 2000.

121. According to A. Yip, Evergreen Pearl Company, Hong Kong, in litt., 1999.

122. Scarratt et al., 101.

123. Jobbins and Scarratt, 1990; Feng, 1997; Scarratt et al., 2000. Our Chinese sources indicated a range as low as 500 metric tons, and as high as 1,200 tons. Production in 1998 was reported as 800 tons, expected to double by 2003 (Yonick, 1999). Another author predicted output of 1,500 tons by 2005 (J. L. Peach, Sr., 1999,

Freshwater pearls: new millennium—new pearl order, *Gems & Gemology*, 35(3): 75). China's production capacity has been estimated at 1,200 tons (Scheung, 1999).

124. Gao Tao, pers. comm., 2000.

125. Ge, 30.

126. A. Matlins, 2000, Chinese freshwaters: the whole story, *Professional Jeweler*, 3(2): 28. A recent article in *Gems & Gemology* ("Freshwater cultured 'Kasuminga pearls,' with Akoya cultured pearl nuclei," Summer 2000) showed convincing evidence (by X ray and sectioning) that Japanese freshwater pearls from Lake Kasumigaura, north of Tokyo, had been nucleated with low-quality, drilled Akoya pearls.

127. Using *Hyriopsis cumingii* in Guangdong Province ("China producing nucleated rounds," *Jewellery News Asia*, May 1995: 56, 58); also Scarratt et al., 2000.

128. Scarratt et al., 2000.

129. Saelim, 2000.

130. Thang, 1994; Fassler, 1995.

131. S. Panha and P. Kosavititkul, 1997, Mantle transplantations in freshwater pearl mussels in Thailand, *Aquaculture International*, 5(3): 267–76; K. Janaki Ram, 1997, Freshwater pearl culture in India, *Naga*, 20(3–4): 12–17 (reproduced in *Cambridge Scientific Abstracts*, no. 4334679); A. Panigrahi, 1997 (1998) Occurrence of pearl-bearing mussels *Lamellidens marginalis* (Bivalvia: Unionidae) at Standeshkhali, West Bengal, India, *Research Bulletin of the Panjab University, Science* 47(1–4): 107–9.

132. J. L. Sweaney and J. R. Latendresse, 1982, *Freshwater Pearl Culturing in America: A Progress Report*, American Pearl Company, Nashville, Tennessee; American Pearl Company, http://mjsa.polygon.net/~10835, accessed 9/12/00; also "American freshwater pearls," by M. Mycko, http://www.beadshows.com/ibs/articles/freshwaterpearl.html, accessed 1/27/01.

Linné's Pearls Box: The quote by Linné is from Wilfrid Blunt, 1971, *The Compleat Naturalist: A Life of Linnaeus*, Collins St. James Place, London, p. 60. Linné's interest in pearl mussels and their products had been piqued during his Lapland voyage of 1732, and he began experimenting with the River Mussel *Unio pictorum* in a creek in Uppsala as early as 1740 (L. Koerner, 1999, *Linnaeus: Nature and Nation*, Harvard University Press, Cambridge, Massachusetts and London, 140–42). The first full account of Linné's culturing method was published by Herdman, 1905; later

accounts were provided by Woodward, 16; Webster, 462; Scarratt et al., 100 (taken by Fred Woodward in 1994), figured an X ray of Linné's pearls (two pearls still attached to a piece of shell). Hessling, 335, and subsequent authors have maintained that Linné received his title years before his pearl experiments. However, according to Herdman, 26, he received it in 1761, the year he offered his secret technique to the Swedish government. Koerner, 144–46, described the circumstances in greater detail. According to her, Linné was given 6,000 silver thalers, the right to appoint his academic successor at Uppsala University, and his noble title in 1762.

Struggle for Acceptance Box: Accounts of the lawsuit between Mikimoto and the European syndicate are from a 1965 brochure for Mikimoto & Company; also B. Zucker, 1984, *Gems and Jewels: A Connoisseur's Guide,* Thames & Hudson, New York; Woodward, 18–19; M. Cariño, 1996, The cultured pearl polemic, *World Aquaculture,* 27(1): 42–44, reproduced in *Cambridge Scientific Abstracts,* no. 3901076. Regulations that now require accurate labeling of cultured pearls include the United States Federal Trade Commission (Jewelry Guides, dated 30 May 1996, Part 23—Guides for the Jewelry, Precious Metals, and Pewter Industries, http://ftc.gov/bcp/guides/jewel-gd.htm, accessed 8/21/00), the Canadian Competition Bureau (Industry Canada, Competition Bureau, Pearls Guidelines, dated 1 September 1995, http://strategis.ic.gc.ca/SSG/cp01018e.html, accessed 10/25/00), and the Confédération Internationale de la Bijouterie, Joaillerie, Orfèvrerie (CIBJO; discussed by G. Grospiron, 1992, Les règles et nomenclatures françaises et internationals en matière de perles, *Bulletin de l'Institut Océanographique, Monaco,* special no. 8: 117–25).

Bead Nuclei Box: Early bead nuclei were described by Cahn, 48. American pearl mussels were chosen by Mikimoto for bead nuclei according to F. H. Pough, 1963, Cultured pearls—the inside facts, *The Lapidary Journal,* 17(1): 6, 10–11, 14; Fassler, 1997. Shells that show "Tullberg's lamellae," strengthened conchiolin layers that appear as "oily" or metallic stains on the shell surface (see Baer, 80) and are linked with fluctuations in the water chemistry, cannot be used because: (1) the color layers show through light-colored nacre, (2) nacre does not adhere evenly to the layers, and (3) the layering may cause the pearl to chip or crack when it is drilled (Barada, 1969: 55; Madsen, 1985). The shell beads are sometimes mistakenly called mother-of-pearl. The pearl mussel species used for bead nuclei production were given by Ward, 1985,

citing J. Latendresse, pers. comm. Locations of bead nuclei production were from Fassler, 1995, and pers. observ. Techniques of bead nuclei production were described by Cahn, 49; Neves, 1999. Minimum size regulations are 3¾ inches for Washboards and 2¾ inches for other species; Koch, Leroy, 1989, Pearls at what price? *Missouri Conservationist,* 50(4): 24–28. Statistics of bead nuclei production were given by Neves, 1999; Fassler, 1996: 60. By one estimate, only about 4 percent of this weight would be converted into usable nuclei (Pough, 1963). Predictions of decline of nuclei material were described by Koch, 1989; Cahn, 49; Pough, 1963; Fassler, 1996: 60; American musseler John Latendresse was quoted by *Jewellery News Asia,* November 1994; see also Fassler, 1997. Less-than-perfectly white nuclei are in fact acceptable to producers of dark-nacred pearls, e.g., in Tahiti. Substitute nuclei materials were summarized by Fassler, 1997. A report in *Jewellery News Asia* (November 1994) indicated that Myanmar, Vietnam, and China were attempting to utilize their freshwater pearl mussels for nuclei. However, the size was small (less than 6 millimeters) and the quality was poor. One American shell company was investigating introducing American freshwater pearl mussel species to China to supplement dwindling supplies of pearl mussels in U.S. rivers; this plan does not seem to have materialized. O'Sullivan (1999) reported that a 22-millimeter nucleus has been produced in India from the shell of a large marine gastropod (*Turbo* sp.); however, this resource seems as limited (if not more so) than pearl mussel shell sources. This same source indicated that the South Sea pearl industry (*Pinctada maxima*) is using "mother-of-pearl shell" for nuclei—its own shell by-product from previous grafting. However, Pough (1963) discounted this material (at least for thin-nacred pearls) because the bead's mother-of-pearl layers would visually conflict with the cultured pearl's iridescence. Bironite was described by G. Ventouras, 1999, Nuclei alternatives—the future for pearl cultivation, *Abstracts, World Aquaculture Society meeting, 1999;* also at http://www.spc.org.nc/coastfish/News/POIB/13/POIB13-8a.htm, accessed 8/22/00; acceptability of this and other substitute materials was discussed by Fassler, 1995. The use of reconstituted nuclei was mentioned by Fassler, 1996: 65. Neves (1999) described recent efforts to raise pearl mussels in aquaculture; seven to nine years of growth are required before adequate shell thickness is achieved (J. Latendresse, quoted by *Jewellery News Asia,* November 1994).

Mabé Pearls Box: For further information on mabé pearls, see B. L. Burch, 1995, Pearly shells—part 7, a pearling family in North

America—foragers, farmers, wholesale jewelers, *Hawaiian Shell News,* 43(8): 6–7; Monteforte et al., 1994; T. Yamamoto and H. Tanaka, 1997, Potential of commercial development of mabé pearl farming in Vava'u Islands, Kingdom of Tonga, *FAO Field Document,* no. 5, GCP/RAS/116/JPN, reproduced in *Cambridge Scientific Abstracts,* no. 4607295; also http://www.pearlinfo.com/consumer/variety.html, accessed 9/28/00, and http://www.paspaleypearls.com/pcreation6.html, accessed 5/5/00. Cahn, 83, referred to Mikimoto's Japanese Patent no. 5,542.

8: Saving Pearls

1. Quote from "The Creation of a Pearl," *Western Fisheries Magazine,* 1997, http://www.wa.gov.au/westfish/aqua/broc/pearl/pearlcreation.html, accessed 10/30/00.

2. Fassler, 1996: 59.

3. Dakin, 1913: 46ff.

4. G. Ranson, 1961, Les Espèces d'huitres perlières du genre *Pinctada* (biologie de quelques-unes d'entre elles), *Institut Royal des Sciences Naturelles de Belgique, Mémoires,* 2e série, fasc. 67, p. 11ff.

5. Summarized by Wada, 1991.

6. H. Yukihira, D. W. Klumpp, and J. S. Lucas, 1998, Comparative effects of microalgal species and food concentration on suspension feeding and energy budgets of the pearl oysters *Pinctada margaritifera* and *P. maxima* (Bivalvia: Pteriidae), *Marine Ecology Progress Series,* 171: 71–84.

7. Ranson, 86; Yukihira et al, 1998.

8. Smith in A. E. Verrill, 1869 (On the parasitic habits of Crustacea, *The American Naturalist,* 3(5): 239–50), reported a similar relationship between the eastern Pacific *Pinctada mazatlanica* and two crustaceans, a pea-crab *Pinnotheres margarita,* and a caridean shrimp, *Pontonia margarita* (Smith, 1869).

9. Joll, 1994; NOVA, "The Perfect Pearl," http://www.pbs.org/wgbh/nova/pearl, accessed 10/25/00.

10. Yukihira et al., 1998; S. K. Rodgers, N. A. Sims, D. J. Sarver, and E. F. Cox, 2000, Distribution, recruitment, and growth of the black-lip pearl oyster, *Pinctada margaritifera,* in Kane'ohe Bay, O'ahu, Hawai'i, *Pacific Science,* 54(1): 31–38.

11. Rodgers et al., 36, citing W. Reed, 1973, *Pearl Oysters of Polynesia,* Société des Océanistes, Dossier 15.

12. Woodward, 1994: 38; P. Bouchet, G. Falkner, and M. B. Seddon, 1999, Lists of protected land and freshwater molluscs in the Bern Convention and European Habitats Directive: are they relevant to conservation? *Biological Conservation*, 90: 21–31.

13. Ge, 1996: 59.

14. A. J. S. Hawkins, R. F. M. Smith, S. H. Tan, and Z. B. Yasin, 1998, Suspension-feeding behaviour in tropical bivalve mollusks: *Perna viridis, Crassostrea belcheri, Crassostrea iradelei, Saccostrea cucculata* and *Pinctada margaritifera, Marine Ecology Progress Series*, 166: 173–85, reproduced in *Cambridge Scientific Abstracts*, no. 4515829.

15. Saquet, 1992: 24; W. Reed, 1973, *Pearl Oysters of Polynesia*, Société des Océanistes, Dossier 15, Paris.

16. Named for two English whalers, the *Pearl* and the *Hermes*, which were wrecked on the atoll in 1922; Walther, 1997: 19.

17. Walther, 35, quoting Galtsoff in an article in the *Honolulu Star-Bulletin*.

18. R. B. Moffitt, 1994, Pearl oysters in Hawaii, *Hawaiian Shell News*, 42(4): 3–4; Rodgers et al., 2000.

19. Kunz and Stevenson, 1908: 294.

20. Doumenge, 1992: 7; Tennant, 1860, 2: 560–61.

21. Kunz and Stevenson, 106, citing Joseph-Toussaint Reinaud, 1845, *Fragments arabes et persans inédits relatifs à l'Inde antérieurement au XIe siècle de l'ère chrétienne*, Paris; these authors went on to note that between 1648 and 1907, a total of 249 years, the pearl grounds of Ceylon were operational only sixty-nine of these years.

22. Quoted by Sun and Sun, 1966: 298.

23. Quoted by Woodward, 48.

24. Smith, 1899: 15.

25. Based on a rate of formation of at best 1/5 of a millimeter per year and a 4-millimeter finished pearl; Schlüter and Rätsch, 1999: 14.

26. Rudau, 1961: 5, citing E. Stella, 1517, *De rebus ac populis priscis orae inter Albim et Salam, Germaniae flumina.*

27. Rudau, 7.

28. Nitsche, 1882: 58–59; Baer, 1995: 98.

29. Nitsche, 58, citing J. G. Jahn, 1854, *Die Perlfischerei im Voigtlande in topographischer,* *natur- und zeitgeschichtlicher Hinsicht, nach den besten Quellen verfasst und dargestellt, mit den einschlagenden Urkunden und Beweisstellen versehen . . .* , Privately published, Oelsnitz; Baer, 97.

30. Schlüter and Rätsch, 17; see also Baer, 99.

31. J. Nemec, 1993, *Margaritifera margaritifera* (Linné, 1758) in Czechoslovakia, *Of Sea & Shore*, 15(4): 211–12.

32. So stated, for instance, in a 1666 edict by Georg Wilhelm, Duke of Brunswick and Luneburg; Hanover State Archives, quoted in detail by Schlüter and Rätsch, 18–20.

33. Nitsche, 60.

34. Baer, 80.

35. Dall, 1883: 582.

36. Baer, 7 ff.

37. L. Nezlin and V. Zyuganov, 1991, Want to help resuscitate "Russian pearls"? *Business Contact*, 1: 39–41; Nemec, 1993.

38. Neves, 1999.

39. Fassler, 1996: 61ff.

40. R. J. Neves, 1994, Prognosis for the future: crisis management of an imperiled mussel fauna, Abstracts, *Pearls '94*, Honolulu, Hawaii, 14–19 May 1994, *Journal of Shellfish Research*, 13(1): 345

41. J. D. Williams, M. L. Warren, Jr., K. S. Cummings, J. L. Harris, and R. J. Neves, 1993, Conservation status of the freshwater mussels of the United States and Canada, *Fisheries*, 18(9): 6–22.

42. Parmalee and Bogan, 1998: 118.

43. The Japanese-owned Tennessee Shell Company pled guilty in 1998 in a U.S. federal court to purchasing and exporting thousands of pounds of freshwater pearl mussels taken from closed rivers in Michigan, Ohio, Kentucky, and West Virginia. The company paid a fine of $1 million; from http://southeast.fws.gov/news/1998/r98-063.html, accessed 10/24/00.

44. Oohara et al. (I. Oohara, T. Kobayashi, I. Nakayama, and J. C. Stephens, 1999, On the genetic diversity of wild and cultured populations of the Japanese pearl oyster *Pinctada fucata, Bulletin of the National Research Institute of Aquaculture*, supplement 1: 27–31) showed that genetic diversity of hatchery-raised "white" *Pinctada fucata* was significantly lower than that of a wild population.

45. Ward, 1985: 201.

46. "Mysterious virus at source drives up the price of pearls," *New York Times*, 5/24/98; T. Miyazaki, K. Goto, T. Kobayashi, T. Kageyama, and M. Miyata, 1999, Mass mortalities associated with a virus disease in Japanese pearl oysters *Pinctada fucata martensii, Diseases of Aquatic Organisms*, 37(1): 1–12, reproduced in *Cambridge Scientific Abstracts*, no. 4586622.

47. S. Suzuki, I. Utsunomiya, and R. Kusuda, 1998a, Experimental infection of marine birnavirus strain JPO-96 to Japanese pearl oyster *Pinctada fucata, Bulletin of Marine Sciences and Fisheries, Kochi University*, no. 18: 39–41; S. Suzuki, M. Kamakura, and R. Kusuda, 1998b, Isolation of birnavirus from Japanese pearl oyster *Pinctada fucata, Fisheries Science, Tokyo*, 64(2): 342–43, reproduced in *Cambridge Scientific Abstracts*, no. 4519560.

48. Miyazaki et al., 1999.

49. Yonick, 1999. The pre-viral production figure was already severely depressed from the 1966 peak of about 118,000 kilograms; Fassler, 1995.

50. NOVA, "The Perfect Pearl"; http://www.pbs.org/wgbh/nova/pearl, accessed 10/25/00.

51. Summarized by A. Colorni, 1998, Pathobiology of marine organisms cultured in the tropics, 209–55 in *Tropical Mariculture*, edited by S. S. De Silva, Academic Press, San Diego; see also M. Comps, A. Fougerouse, and D. Buestel, 1998, A prokaryote infecting the black-lipped pearl oyster *Pinctada margaritifera, Journal of Invertebrate Pathology*, 72(1): 87–89; M. Comps, C. Herbaut, and A. Fougerouse, 1999, Virus-like particles in pearl oyster *Pinctada margaritifera, Bulletin of the European Association of Fish Pathologists*, 19(2): 85–88, reproduced in *Cambridge Scientific Abstracts*, no. 4642246; P. M. Hine and T. Thorne, 1998, *Haplosporidium* sp. (Haplosporidia) in hatchery-reared pearl oysters, *Pinctada maxima* (Jameson, 1901), in north Western Australia, *Journal of Invertebrate Pathology*, 71(1): 48–52; Wu and Pan, 1999; Tint Tun, Myanmar pearling: past, present and future, Secretariat of the Pacific Community, Coastal Fisheries Programme Report, http://www.spc.org.nc/coastfish/News/POIB/12/1aMyanmar.htm, accessed 11/1/00.

52. Suzuki et al., 1998a: 40.

53. Russell, Shor, 2000, Akoyas on the road to recovery, *GemKey*, http://www.gemkey.com/newscenter/news/default.asp?NTYPEID=6&NNEWSID=1618, accessed 8/19/00.

54. S. Akamatsu, 1999, The present and future of Akoya cultured pearls, *Gems & Gemology*, 35(3):

73–74; Yonick, 1999; S. Akamatsu, pers. comm., 1999.

55. S. Akamatsu, pers. comm., 1999.

56. Webster, 1978: 472.

57. Monteforte and Aldana, 1994; Monteforte and Bervera, 1994.

58. From "Road of Development for Shaoxing Pearl Farm," by Paul Holewa, http://pearl.sxagri.com/dynamic.htm, accessed 10/30/00.

59. Martell, 1914: 473.

60. Boettger, 1954 (Flußperlmuschel und Perlenfischerei in der Lüneburger Heide, *Abhandlungen der Braunschweigischen Wissenschaftlichen Gesellschaft*, 6: 1–40): 32, also citing F. Borcherding, 1885, Zweiter Nachtrag zur Mollusken-Fauna der nordwestdeutschen Tiefebene, *Abhandlungen herausgegeben vom Naturwissenschaftlichen Verein zu Bremen*, 9: 141–66.

61 A.-D. Qiu and A.-J. Shi, 1999, Effects of pH on nacre secretion of freshwater pearl mussel *Hyriopsis cumingii*, *Acta Zoologica Sinica*, 45(4); also at http://www.chinainfo.gov.cn/periodical/dwxb/dwxb99/dwxb9904/990401.htm, accessed 10/31/00.

62. Saelim, 2000.

63. See, respectively, C. R. Beasley and D. Roberts, 1999, Towards a strategy for the conservation of the freshwater pearl mussel *Margaritifera margaritifera* in County Donegal, Ireland, *Biological Conservation*, 89: 275–84; D. Dolmen and E. Kleiven, 1997, *Elvemuslingen* Margaritifera margaritifera *I Norge [The freshwater pearl mussel (*Margaritifera margaritifera*) in Norway]* (in Norwegian), *Vitenskapsmuseet Rapport Zoologisk Serie* no. 6, reproduced in *Cambridge Scientific Abstracts*, no. 4206764.

64. Bouchet et al., 1999.

65. Neves, 1999.

66. Fassler, 1997.

67. "Toxic spill on the Clench [*sic*] River, VA," posted on Conch-L listserver, 11 September 1998, by Andrew K. Rindsberg, archived at http://listserv.uga.edu/cgi-bin/wa?A2=ind9809B&L=conch-l&P=R2565, accessed 10/31/00, reprinted in *AMU Newsletter*, Fall/Winter 1998, 29(1): 10.

68. Bouchet et al., 1999. See also Volker Buddensiek, The culture of juvenile freshwater pearl mussels *Margaritifera margaritifera* L. in cages: a contribution to conservation programms [*sic*] and the knowledge of habitat requirements, http://home.t-online.de/home/v.buddensiek/culture.htm, accessed 10/30/00.

69. J. C. Britton and B. Morton, 1979, *Corbicula* in North America: the evidence reviewed and evaluated, pp. 250–87 in *Proceedings of the First International* Corbicula *Symposium*, edited by J. C. Britton, Texas Christian University Research Foundation, Ft. Worth, Texas; B. G. Isom, 1986, Historical review of Asiatic clam (*Corbicula*) invasion and biofouling of waters and industries in the Americas, *American Malacological Bulletin*, special edition 2: 1–5.

70. R. S. Prezant and K. Chalermwat, 1984, Flotation of the bivalve *Corbicula fluminea* as a means of dispersal, *Science*, 225(4669): 1491–93.

71. F. L. Snyder, M. B. Hilgendorf, and D. W. Garton, 1990 (revised 1994), Zebra mussels in North America: the invasion and its implications, *Ohio Sea Grant College Program, Ohio State University*, OHSU-FS-045, p. 1.

72. Nakai, 1999. Following a 6-ton production in 1971, one source (SESEJHSSP, 1996) indicated that pearl mussels were declining in Lake Biwa by 1977. *Hyriopsis schlegelii* requires from six to seven years to reach "operable size" of 130 millimeters in length (Cahn, 1949: 64). It is now among the most threatened species listed by the current version of the Japanese Red Data Book [rank CR(itically endangered) + EN(dangered); http://www.osaka-kyoiku.ac.jp/~kondo/redlist.htm, accessed 8/21/00, maintained by Dr. Takaki Kondo, Osaka Kyoiku University, a member of the committee for evaluation of the Red Data Book] and the Shiga Prefecture Red Data Book (K. Nakai, pers. comm., 2000). The Red Data Book or "Red List" is compiled periodically by the World Conservation Union (IUCN) or similar regional organizations to officially categorize the endangered, threatened, and otherwise protected animals and plants of the world or of selected regions. Included species are often referred to as "listed species" and are usually afforded special governmental protection.

73. T. Nakajima and K. Nakai, 1994, Lake Biwa, in *Speciation in Ancient Lakes*, edited by K. Martens, B. Goddeeris, and G. Coulter, *Archiv für Hydrobiologie, Beiheft, Ergebnisse der Limnologie*, 44: 43–54. Population figures for Shiga Prefecture (approx. 850,000 in 1965, to 1.13 million in 1985) from World Lakes Database (http://www.ilec.or.jp/database/asi/asi-01.html, accessed 8/21/00). Lake Biwa was "declared biologically dead in 1985," http://www.pearls.co.uk/passion-4pearls.htm; accessed 8/21/00. In 1949, Cahn, 64, wrote "artificial propagation of the species is still unnecessary" but warned that it probably would become important as the native stock became reduced. The peak harvest of 1943 (21,186 pounds, reflecting the catch of two species, *Hyriopsis schlegelii* plus the edible *Cristaria spatiosa*) had already reduced to 1,816 pounds in 1947 (Cahn, 66).

74. M. Ibuki, pers. comm., 1999. Bluegill were originally brought to Shiga Prefecture in the early 1960s, to be served as food for people and as host to the glochidial larvae of the Biwa Pearl Mussel; they were released in many surrounding satellite lakes supporting pearl fisheries, and migrated to Lake Biwa proper by 1968 (Nakai, 1999).

75. According to K. Nakai (pers. comm., 2000), *Rhinogobius* spp. is the best but not the only glochidial host for *Hyriopsis schlegelii*. The native Biwa Pearl Mussel can also use the Japanese medaka, *Oryzias latipes* (Temminck & Schlegel, 1846), several cyprinids, *Squalidus chankaensis biwae* (Jordan & Snyder, 1900) and *Biwia zezera* (Ishikawa, 1895), the Lake Biwa loach, *Cobitis biwae* (Jordan & Snyder, 1901), the bagrid catfish, *Pseudobagrus* (or *Pelteobagrus*) *nudiceps* (Sauvage, 1883), and interestingly, the introduced bluegill (*Lepomis macrochirus*).

76. K. Nakai, pers. comm, 2000. As early as 1949, phytoplankton was estimated to comprise only about 40 percent of the normal plankton in Lake Biwa (with zooplankton comprising the other 60 percent; Cahn, 64).

77. Anonymous, 1985, Gem News: Pearls, *Gems & Gemology*, 21(Fall 1985): 187.

78. NOVA, "The Perfect Pearl," http://www.pbs.org/wgbh/nova/pearl, accessed 10/25/00.

79. This phenomenon can also be used beneficially, wherein the bivalve can act as a bioindicator of the level of contaminants in the water. The Ceylon Pearl Oyster, *Pinctada radiata*, is being investigated to serve as a measure of pollution in the Arabian Gulf; see H. Al-Madfa, M.A.R. Abdel-Moati, and F. H. Al-Gimaly, 1998, *Pinctada radiata* (pearl oyster): a bioindicator for metal pollution monitoring in the Qatari waters (Arabian Gulf), *Bulletin of Environmental Contamination and Toxicology*, 60(2): 245–51, reproduced by *Aquatic Sciences & Fisheries Abstracts [ASFA]*, (1)29(2): 367–68.

80. S. Akamatsu, pers. comm., 1999. Although a correlation between formalin and pearl deaths has not been proven, Takayanagi et al. showed that pearl oysters can detect formaldehyde in the water and reduce their respiration rate in response. Akamatsu (1999) reported that fish farmers are now using a formalin substitute (K. Takayanagi,

T. Sakami, M. Shiraishi, and H. Yokoyama, 2000, Acute toxicity of formaldehyde to the pearl oyster *Pinctada fucata martensii, Water Research,* 34|1|: 93–98).

81. P. V. Fankboner, 1993, Pearls and abalones, *Aquaculture Magazine,* 19(6): 28–38.

82. Y. Matsuyama, K. Nagai, T. Mizuguchi, M. Fujiwara, M. Ishimura, M. Yamaguchi, T. Uchida, and T. Honjo, 1995, Ecological features and mass mortality of pearl oysters during the red tide of *Heterocapsa* sp. in Ago Bay in 1992 (in Japanese), *Nippon Suisan Gakkaishi,* 61(1): 35–41. See also *Heterocapsa* bibliography at http://www.nnf.affrc.go.jp/hcaphp/biblio_e.htm, accessed 10/30/00.

83. Cahn, 52–53.

84. M. Coeroli, pers. comm., 1999

85. A. Intès, 1992, La periculture engendre- t-elle sa propre mort? 63–75 in *Nacres et Perles,* edited by F. Doumenge and A. Toulement, *Bulletin de l'Institut océanographique, Monaco,* numéro spécial 8; A. Intès, 1994, Growth and mortality of *Pinctada margaritifera* in French Polynesia, Abstracts, *Pearls '94,* Honolulu, Hawaii, 14–19 May 1994, *Journal of Shellfish Research,* 13(1): 337–38.

86. D. Buestel, S. Pouvreau, J. Tiaparri, S. Bougrier, J. M. Chariband, P. Geairon, and A. Fougerouse, 1995, *Ecophysiologie de l'Huitre Perlière, Approche des Relations Entre la Croissance de l'Huitre* Pinctada margaritifera *et le Milieu dans le Lagon de Takapoto,* IFREMER Taravao Tahiti (Polynésie Française), Rapport Interne DRV 95-18 RA/TAHITI, reproduced in *Cambridge Scientific Abstracts,* no. 4078161.

87. S. Pouvreau, 1999, *Study and Modeling of Mechanisms Implied in Growth of the Black-lipped Pearl Oyster,* Pinctada margaritifera *in the Shellish |sic| Ecosystem of Takapoto Lagoon (French Polynesia),* Ph.D. Dissertation, École Nationale Supérieure d'Agronomie, Rennes, France, reproduced in *Cambridge Scientific Abstracts,* no. 4628818.

88. NOVA, "The Perfect Pearl," http://www.pbs.org/wgbh/nova/pearl, accessed 10/25/00.

89. Müller, 1999.

90. NOVA, "The Perfect Pearl," http://www.pbs.org/wgbh/nova/pearl, accessed 10/25/00.

91. From "The Australian pearling industry and its pearls," by Grahame Brown, http://www.gem.org.au/gallery/pearltext.html, accessed 9/21/00.

92. Porter, 1991.

93. Council of Europe, European Treaty, ETS no. 104, *Convention on the Conservation of European Wildlife and Natural Habitats,* Appendix III, http://conventions.coe.int/treaty/EN/cadreprincipal.htm, accessed 1/27/01.

94. L. Sanchez, 1999, Philippine South Sea pearl industry moves towards the big league, *Jewellery News Asia,* May 1999: 72–73, 77.

95. Saucedo et al., 1994.96. Monteforte, 1994.

97. Saucedo et al., 1994; N. A. Sims and D. J. Sarver, 1994, Hatchery culture of the black-lip pearl oyster in Hawaii—stock re-establishment and expansion of commercial pearl culture throughout the region, Abstracts, *Pearls '94,* Honolulu, Hawaii, 14–19 May 1994, *Journal of Shellfish Research,* 13(1): 350.

98. Fassler noted in 1995 that Hawaiian periculturists were importing *Pinctada margaritifera* from Micronesia for hatchery operations for restocking both Micronesian and Hawaiian reefs.

99. P.-Y. Qian, C. Y. Wu, M. Wu, and Y. K. Xie, 1996, Integrated cultivation of the red alga *Kappaphycus alvarezii* and the pearl oyster *Pinctada martensii, Aquaculture,* 147(1–2): 21–35, reproduced in *Cambridge Scientific Abstracts,* no. 3996373.

100. Fankboner, 1995.

101. N. Paspaley, pers. comm., 2000.

Bibliography*

Almatar, S. M., K. E. Carpenter, R. Jackson, S. H. Alhazeem, A. H. Al-Saffar, A. R. Abdul-Ghaffar, and C. Carpenter. 1993. Observations on the pearl oyster fishery of Kuwait. *Journal of Shellfish Research*, 12(1): 35–40.

Baer, O. 1995. *Die Flussperlmuschel*, Margaritifera margaritifera *(L.)*. Neue Brehm-Bücherei Band 619. Westarp Wissenschaften, Magdeburg, Germany.

Barada, B. 1969. Freshwater pearls: a treasure bonanza for the inland diver. *Skin Diver Magazine*, January 1969: 52–55.

Cahn, A. R. 1949. *Pearl Culture in Japan*. General Headquarters, Supreme Commander for the Allied Powers, Natural Resources Section, Report no. 122.

Dakin, W. J. 1913. *Pearls*. Cambridge University Press, Cambridge, England.

Dall, W. H. 1883. Pearls and pearl fisheries, part I. *The American Naturalist*, 17(6): 579–87.

Dickinson, Joan Younger. 1968. *The Book of Pearls: Their History and Romance from Antiquity to Modern Times*. Crown Publishers, New York.

Donkin, R. A. 1998. *Beyond Price: Pearls and Pearl Fishing: Origins to the Age of Discoveries*. American Philosophical Society, Philadelphia.

Doumenge, F. 1992. Nacres et perles, traditions et changements. pp. 1–52 in *Nacres et Perles*, edited by F. Doumenge and Anne Toulement. Musée Océanographique, Monaco.

Edwards, Hugh. 1994. *Pearls of Broome and Northern Australia*. Published by the author, Swanbourne, Western Australia.

Fankboner, P. V. 1995. Abalone pearls: natural and cultured. *Canadian Gemmologist*, 16(1): 3–8.

Fassler, C. R. 1995. Farming jewels: new developments in pearl farming. *World Aquaculture*, 26(3): 4–10.

Fassler, C. R. 1996. The American mussel crisis: effects on the world pearl industry, part II. *Aquaculture Magazine*, 22(5): 59–70.

Fassler, C. R. 1997. The American mussel crisis: effects on the world pearl industry. pp. 265–77 in *Conservation and Management of Freshwater Mussels II: Initiatives for the Future*, edited by K. S. Cummings, A. C. Buchanan, C. A. Mayer, and T. J. Naimo. Proceedings of a UMRCC Symposium, 16–18 October, 1995, St. Louis, Missouri. Upper Mississippi River Conservation Committee, Rock Island, Illinois.

Fritsch, E., and E. B. Misiorowski. 1987. The history and gemology of queen conch "pearls." *Gems & Gemology*, 23: 208–21.

Ge, Xian Piang. 1996. *Freshwater Mussel Pearl Culturing and Pearl-Processing Techniques in Question and Answer Format*. Farmer's Practical Techniques series, General Science Publishers, Beijing, China. In Chinese; English translation provided by M. and C. Chan.

Haas, F. 1957 (1955). Natural history of pearls. *Comunicaciones del Instituto Tropical de Investigaciones Científicas de la Universidad de El Salvador*, 4(3/4): 113–26.

Hague, F. 1856. On the natural and artificial production of pearles [sic] in China. *Journal of the Royal Asiatic Society of Great Britain and Ireland*, 16(2) (art. 15): 280–84.

Hessling, T. von. 1859. *Die Perlmuscheln und ihre Perlen; naturwissenschaftlich und geschichtlich mit Berücksichtigung der Perlengewässer Bayerns beschrieben*. Wilhelm Engelmann, Leipzig.

Hirth, Friedrich and W. W. Rockhill. 1911. *Chau Ju-Kua: His Work on the Chinese and Arab Trade in the Twelfth and Thirteenth Centuries, entitled Chu-fan-chi*. Imperial Academy of Sciences, St. Petersburg.

Joll, L. M. 1994. Research for wild stock management of *Pinctada maxima*. Abstracts, *Pearls '94*, Honolulu, Hawaii, 14–19 May 1994, *Journal of Shellfish Research*, 13(1): 338.

Joyce, K. and S. Addison. 1993. *Pearls: Ornament and Obsession*. Simon & Schuster, New York.

Kunz, G. F. and C. H. Stevenson. 1908. *The Book of the Pearl: The History, Art, Science and Industry of the Queen of Gems*. Dover Publishers, Mineola, New York (1993 reprint).

Lintilhac, J.-P. (with English translation by J. L. Sherman). 1985. *Black Pearls of Tahiti*. Royal Tahitian Pearl Book, Papeete, French Polynesia.

Madsen, J. 1985. Mississippi shell game. *Audubon*, 87(2): 47–69.

Martell, P. 1915. Zur Geschichte der Perlenfischerei in Sachsen. *Mitteilungen des Landesvereins Sächsischer Heimatschutz*, 4 (1914–15): 471–75.

Milburn, William. 1813. *Oriental Commerce*, 2 vols. Black, Parry & Company, London.

Miles, S. B. 1919. *The Countries and Tribes of the Persian Gulf*, 2 vols. Harrison & Sons, London.

Monteforte, M. 1994. Perspectives for the installation of a pearl culture enterprise in Bahia de La Paz, south Baja California. Abstracts, *Pearls '94*, Honolulu, Hawaii, 14–19 May 1994, *Journal of Shellfish Research*, 13(1): 339–40.

Monteforte, M. and C. Aldana. 1994. Spat collection, growth and survival of pearl oyster *Pteria sterna* under extensive culture conditions in Bahia de La Paz, south Baja California, Mexico. Abstracts, *Pearls '94*, Honolulu, Hawaii, 14–19 May 1994, *Journal of Shellfish Research*, 13(1): 340–41.

Monteforte, M. and H. Bervera. 1994. Spat collection trials for pearl oyster *Pinctada mazatlanica* at Bahia de La Paz, south Baja California, Mexico. Abstracts, *Pearls '94*, Honolulu, Hawaii, 14–19 May 1994, *Journal of Shellfish Research*, 13(1): 341–42.

Müller, A. 1999. Cultured South Sea pearls. *Gems & Gemology*, 35(3): 77–79.

Nakai, K. 1999. Recent faunal changes in Lake Biwa, with particular reference to the bass fishing boom in Japan. pp. 227–41, in *Ancient Lakes: Their Cultural and Biological Diversity*, edited by H. Kawanabe, G. W. Coulter, and A. C. Roosevelt. Kenobi Productions, Ghent, Belgium.

Neves, R. J. 1999. Conservation and commerce: management of freshwater mussel (Bivalvia:

*Additional references are provided in the Notes.

Unionoidea) resources in the United States. *Malacologia*, 41(2): 461-74.

Nitsche, H. 1882. Die Süßwasserperlen auf der internationalen Fischerei-Austellung in Berlin, 1880. *Nachrichtsblatt der deutschen malakozoologischen Gesellschaft*, 14(4/5): 49-64.

Niu Bingyue. 1994. *History of Pearls [Zhenju Shihua]* (in Chinese). Zijincheng Publishers, Beijing. Translated by the authors.

Parmalee, P. W. and A. E. Bogan. 1998. *The Freshwater Mussels of Tennessee*. University of Tennessee Press, Knoxville.

Phillips, Clare. 1996. *Jewelry: From Antiquity to the Present*. Thames and Hudson, London.

Porter, B. 1991. The black-pearl connection. *Connoisseur*, April 1991: 120-26, 157.

Riedl, G. 1928. Die Flußperlmuscheln und ihre Perlen. Zur Förderung der Zucht der Flußperlmuschel in Österreich. *Jahrbuch des Oberösterreichischen Musealvereins, Linz*, 82: 257-358, pls. 1-24.

Rockhill, W. W. 1917. Notes on the relations and trade of China with the eastern archipelago and the coast of the Indian Ocean during the fourteenth century. *T'oung Pao*, 16: 61-159, 236-71, 374-92, 435-67, 604-26.

Rudau, Bruno. 1961. Die Flusspperlmuschel im Vogtland in Vergangenheit und Gegenwart. *Museumsreihe, Abteilungen Kultur des Rates der Stadt Plauen und des Landkreises Plauen und vom Vogtländischen Kreismuseum*, Heft 23: 1-59.

Saelim, L. 2000. Secrets of the trade. In "Made in China," by P. E. Holewa. *GemKey*, 2(2): 55.

Saquet, J.-L. 1992. *Pearls of Tahiti/ Perles de Tahiti*. Collection Survol, Tahiti.

Saucedo, P., M. Monteforte, H. Bervera, V. Pérez, and H. Wright. 1994. Repopulation of natural beds of pearl oysters *Pinctada mazatlanica* and *Pteria sterna* in Bahia de La Paz, south Baja California, Mexico. Abstracts, *Pearls '94*, Honolulu, Hawaii, 14-19 May 1994, *Journal of Shellfish Research*, 13(1): 349-50.

Scarratt, K., T. M. Moses, and S. Akamatsu. 2000. Characteristics of nuclei in Chinese freshwater cultured pearls. *Gems & Gemology*, 36(2): 98-109.

Schlüter, J., and C. Rätsch. 1999. *Perlen und Perlmutt*. Edition Ellert & Richter, Hamburg.

Science Education Society of Elementary and Junior High Schools of Shiga Prefecture [SESE-JHSSP], ed. 1996. *Freshwater Animals of Shiga Prefecture*. Shingaku-sha Company, Kyoto, Japan.

Sims, N. A., and D. J. Sarver. 1994. Bringing back Hawaii's black pearls. *Hawaiian Shell News*, 42(1): 5-6.

Smith, H. M. 1899. The pearl-button industry of the Mississippi River. *The Scientific American*, 81(6): 81, 86-87.

Streeter, Edwin W. 1886. *Pearls and Pearling Life*. George Bell & Sons, London.

Sun, E-Tu Zen, and S.-C. Sun, trans. 1966. *T'ien-Kung K'ai-Wu, Chinese Technology in the Seventeenth Century, by Sung Ying-Hsing*, Pennsylvania State University Press, University Park.

Taburiaux, J. (translated by D. Ceriog-Hughes). 1985. *Pearls: Their Origin, Treatment and Identification*. Chilton Book Company, Radnor, Pennsylvania.

Tavernier, Jean Baptiste. 1678. *Les six voyages de Jean Baptiste Tavernier . . . qu'il a fait en Turquie, en Perse, et aux Indes*, 2 vols. Paris.

Tennant, James Emerson. 1860. *Ceylon*, 2 vols. Longman, Green, Longman and Roberts, London.

Wada, K. T. 1991. The pearl oyster, *Pinctada fucata* (Gould) (family Pteriidae). pp. 245-60 in *Estuarine and Marine Bivalve Mollusk Culture*, edited by W. Menzel, CRC Press, Boca Raton, Florida.

Walther, M. (edited by C. Fassler). 1997. *Pearls of Pearl Harbor and the Islands of Hawaii—the History, Mythology and Cultivation of Hawaiian Pearls*. Natural Images of Hawaii, Honolulu.

Ward, F. 1985. The pearl. *National Geographic*, 168(2): 192-222.

Webster, R. 1978. *Gems: Their Sources, Descriptions and Identification*, 3rd ed. Archon Books, Handon, Connecticut.

Woodward, F. 1994. *The Scottish Pearl in its World Context*. Diehard, Edinburgh.

Wu, X., and J. Pan. 1999. Studies on rickettsia-like organism disease of the tropical marine pearl oyster I: the fine structure and morphogenesis of *Pinctada maxima* pathogen rickettsia-like organism. *Journal of Invertebrate Pathology*, 73: 162-72.

Yonick, D. 1999. A new pearl culture. *Basel Magazine*, no. 3: 31-34; reviewed in *Gems & Gemology*, Summer 2000: 177-78.

Ziuganov, V., A. Zotin, L. Nezlin, and V. Tretiakov. 1994. *The Freshwater Pearl Mussels and Their Relationships with Salmonid Fish*. VNIRO Publishing House, Moscow.

Acknowledgments

Assembling information for this book and its associated exhibit required access to an incredibly broad range of subject matter in printed, verbal, and visual formats, and we have received the generous assistance of a great many people. We especially thank Kathleen Moore (AMNH) for her research efforts and help with the book and exhibit; Devin Macnow (Cultured Pearl Information Center, New York) for his introductions to many pearl entrepreneurs and jewelers; and Chuimei Ho (The Field Museum, Department of Anthropology) for her invaluable facilitation of our research travel in China.

For assistance during our research trips, we thank the following. In Europe: Anita Eschner, Karl Edlinger, and Herbert Summesberger (Naturhistorisches Museum, Vienna), Elfrede Henhapl (E. Swietly-Peony Perlen, Vienna), Manfred Leithe-Jasper (Kunsthistorisches Museum, Vienna), Peter Kristiansen (Rosenborg Castle, Copenhagen), Gina Douglas and Kathie Way (Linnean Society of London), Andrew Clark, John Cooper, Alan Hunt, and Joan Pickering (The Natural History Museum, London), John Cherry and Dyfri Williams (The British Museum, England), Edwina Ehrman and Hazel R. Forsyth (Museum of London), Sandra Martin and Sarah Skinner (Manchester City Art Gallery, England), Julia Poole, Duncan Robinson, and Liz Woods (Fitzwilliam Museum, England), Irene Aghion and Catherine Goeres (Bibliothèque Nationale de France, Paris), Brahim Alaoui and Marie-Hélène Bayle (Institut du Monde Arabe, Paris), Daniel Alcouffe and Jean-Pierre Cuzin (Musée du Louvre, France), Elizabeth Antoine (Musée National du Moyen Age, Thermes de Cluny, France), Pierre Arizzoli-Clementel, Jean-Pierre Babelon, Thierry Bajou, and Claire Constans (Musée National du Château de Versailles et de Trianon, France), Dominique Doumenc, Michel Guiraud, Bernard Metivier, and Henri-Jean Schubnel (Musée National d'Histoire Naturelle, France), Jean-Paul Leclercq (Musée de la Mode et du Textile, France), Evelyne Possémé (Musée des Arts Décoratifs, France), Luc F. Thevenon (Musée d'Art et d'Histoire–Palais Masséna, France), Marika Genty (Chanel, Inc., Paris), Nicholas Kugel (J. Kugel Antiquaires, Paris), Paul Levy (Paris), Jean Vendôme (Paris), Hubert Rosenthal (Paris), Wulf Köpke (Hamburgisches Museum für Völkerkunde, Germany), Dirk Syndram, Ulrike

Arnold, and Jutta Bäumel (Staatliche Kunstsammlungen Dresden, Germany), Katrin Schniebs (Staatliches Museum für Naturkunde, Dresden, Germany), Eleni Vassilika (Roemer- und Pelizaeus-Museum, Germany), Karl-heinz Reger (Munich), Andrea Lorenzo and Annalisa Zanni (Museo Poldi Pezzoli, Italy), Marilena Mosco (Museo Degli Argenti, Florence), Ettore Vio (Basilica de San Marco, Venice), Deanna Farneti Cera (Milan), Marco Chiarini (Galleria Palatina, Florence), Irene Favaretto (University of Padova, Italy), François Simard, Maurizio Würtz, and François Doumenge (Musée Océanographique de Monaco), and Gerter Van Berge (Rijksmuseum, Amsterdam).

In Australia: Nicholas Paspaley, Russel Hanigan, Dennis Hart, John Kelly, and Marilynne Paspaley (Paspaley Pearling Company), Richard C. Willan (Northern Territory Museum of Arts and Sciences), and Peter J. F. Davie (Queensland Museum).

In Japan: Shigeru Akamatsu (K. Mikimoto & Company and Japan Pearl Promotion Society), Shunsaku Tasaki and Toshiaki Tasaki (Tasaki Shinju Company), Mikio Ibuki (Japan Pearl Exporters' Association), Izumi Yamamoto and Torino Yamamoto (Yamakatsu Pearl Company), Kiyoo Matsuzuki (Pearl Museum, Toba City), Tosiaki Ibuki (Jinbo Pearl), Kiyoo Matsuzuki (Mikimoto Pearl Museum), Katsunori Kawabata (Kawabata Shinju Company), T. Nakamura (World Pearl Organization, Kobe), and Yukiko Kada, Nobuo Nishioka, and Katsuki Nakai (Lake Biwa Museum).

In French Polynesia: Martin Temehameharii Coeroli, Ted Guefen, Charles Amaru, and Gerald Adams (GIE Perles de Tahiti), Robert Wan (Tahiti Perles), Guy Wan (Robert Wan Pearl Museum), Gérard Clairefend (Wan Pearl Farm), Terii Seaman and Terii Vallaux (Service des Ressources Marines, Ministère de la Mer et de l'Artisanat, Papeete), Franck Tehaamatai, Marcel Pons, and Loïc Wiart (GIE Tahiti Pearl Producers), Philippe Siu (GIE Poe Rava Nui), and Henri Teiva Le Duc (Centre des Métiers de la Nacre et de la Perliculture et de l'Écloserie de Rangiroa, Polynésie Française Service des Ressources Marines).

In the People's Republic of China: Frances and Allan Yip (Evergreen Pearls Company, Hong Kong), Cathine Lor and Tai Po Cheng (Man Sang

Group, Hong Kong), Brigitte Scheung (Jewellery News Asia, Miller Freeman Asia Ltd., Hong Kong), Li Gang, Bao Fuxing, and Mr. Zhou (Zhejiang Provincial Museum, Hangzhou), Mr. Mao and Wu Tie (Zhuji County Museum), Le Jieping (Shanxiahu Zhen governmental office), He Xiao Fa (Shanxiahu Pearl Business Firm, Zhejiang), Mr. Su (Zhuji hatchery), Tang Tieming (Xidoumen Village, Shanxiahu Zhen, Zhuji), Chen Zhanmi (Jiaotong Shuini Factory, Shanxiahu Zhen, Zhuji), Liaong Qixiao (Guanqiao Cun Village, Shanxiahu Zhen, Zhuji), Gao (Tina) Tao (National Gemstone Testing Center), He Nan Yang (People's Government of Shanxiahu, Zhuji), Ruan Tiejun (Fuyuan Pearl Jewelry Company, Zhuji), Mr. He (Zhuji pearl farmer), Zhu Fenghan, Li Ji, Zhang Wei, and Wang Yong Hong (National Museum of Chinese History), Wang Liying (Gugong), Yang Xin, Liang Jin Sheng, Shan Guoqiang, and Li Shaoyu (The Palace Museum, Beijing), and Wu Xiaoping (Nanchang University).

In the United States: Hicham Aboutaam (Phoenix SoHo Gallery, New York), Louisa Bann, Stephanie Carson, Douglas Parker, Diana Renehan, and Annamarie Sandecki (Tiffany & Company, New York), Stefano Carboni, Joyce Denney, Clare LeCorbeiller, Claire Vincent, Daniel Walker, and James Watt (Metropolitan Museum of Art, New York), Beth Dincuff and Gretchen Fenston (Calvin Klein Library, New York), Claudia Florian (Sotheby's, Chicago), Ella Gafter and Talila Gafter (EllaGem, New York), Julia Haiblen, Todd Olson, Deborah Shinn, and Cynthia Trope (Cooper-Hewitt National Design Museum, New York), Gabrielle Heimann, Margaret Trombly, and Robyn Tromeur (Forbes Collection, New York), Vivian Mann, Laura Mass, and Claudia Nahson (The Jewish Museum, New York), Frank Mastoloni and Raymond L. Mastoloni (Frank Mastoloni & Sons, New York), Patricia Mears (The Brooklyn Museum of Art, New York), Krystyna Mielczarek (New York), Dorothy Moore (New York), Lea Koonce Ogundiran (Christie's, New York), Peter L. Schaffer (À La Vieille Russie, New York), Rosa Strygler (New York), Koichi Takahashi (Mikimoto & Company, New York), Suzi Zetkus (The Domestic and Foreign Missionary Society, New York), Lillian Rojtman Berkman (New York), Dona Dirlam and Tom Moses (Gemological Institute of America, New York and Carlsbad, California), Philippe Diotallivi

(Wildenstein & Company, New York), Ulysses Dietz and Valrae Reynolds (Newark Museum, New Jersey), Bill Larson (Pala International, Falbrook, California), George Chang, William Johnston, and Joaneath Spicer (Walters Art Museum, Baltimore, Maryland), Max W. Churchill (Pearl Button Museum, Muscatine, Iowa), Kelly Engelken (Muscatine Convention and Visitors Bureau, Iowa), Marsha E. Tate (Musser Public Library, Muscatine, Iowa), Gina Latendresse, Renée Latendresse, Chessy Latendresse, and the late John R. Latendresse (American Pearl Company, Camden, Tennessee), Ron Brister (Pink Palace Museum, Memphis, Tennessee), and Raye Germon, Craig Orr, and David H. Shayt (Smithsonian Institution, Washington, D.C.).

Valuable information and access to pearl literature and materials were also provided by Vladimir M. Grusman and Alexander A. Mirin (Russian Museum of Ethnography, St. Petersburg, Russia), Irina A. Rodimtzeva, Olga Mironova, Inna Vishnevskaya, and Ludmila Barbinova (Moscow Kremlin State Cultural and Historical Site, Russia), Galina Khatina (International Department, Russia), Alexander M. Shedrinsky (New York), His Grace The Duke of Norfolk (Arundel Castle, Scotland), Ronald Janssen (Forschungsinstitut Senckenberg, Germany), Matthias Glaubrecht and Lothar Maitas (Museum für Naturkunde, Berlin), Gerhard Haszprunar and Enrico Schwabe (Zoologische Staatssammlung München, Germany), Kenneth Scarratt (American Gem Trade Association, New York), Susan Hendrickson (Seattle, Washington), Neil Goldberg (Sunlion Jewelry, Key West, Florida), Peter V.

Fankboner (Simon Fraser University, British Columbia, Canada), Dan Delmonico (Miami), Christianne Douglas (Coleman Douglas Pearls, London), Christopher Walling (New York), Benjamin Zucker (New York), Jacques Branellec and Ana Marie F. Echevarria (Jewelmer International, Philippines), Rebecca Eddins (George Washington's Mount Vernon Estate and Gardens), R. Lee Hadden (United States Geological Survey), Arthur E. Bogan (North Carolina State Museum of Natural Science), Daniel L. Geiger (University of Southern California, Los Angeles), Sue Hobbs and Phil Dietz (Cape May, New Jersey), Lorraine Suermann (*Professional Jeweler* magazine), Lonnie Garner (Alabama), Richard Neves (Virginia Tech, Blacksburg), Enrique Arizmendi and Douglas McLaurin Moreno (Perlas del Mar de Cortés, Guaymas, Mexico), Megan Davis-Hodgkins (Harbor Branch Oceanographic Institution, Ft. Pierce, Florida), Susan Bean, Karina Corrigan, Daniel Finamore, Paula Richter, William Sargeant, and Janie Winchell (Peabody Essex Museum, Salem, Massachusetts), K. C. Bell (San Francisco, California), George Bosshart (Gübelin Gemmological Laboratory, Lucern, Switzerland), Shaik Nasser al-Sabah and Shaikha Hussah al-Sabah (Dar al-Arhar Al-Islamiyyah, Kuwait City), Somsak Panha (Chulalongkorn University, Bangkok), Gayle Pollock (Bryce Canyon Natural History Association, Utah), George Ruiz (Geneva), Nick Sunday (New York), Jabir (Bahrein), and John Hatleberg (New York).

Invaluable technical and administrative assistance was provided at the AMNH by Geralyn Abinader, François Avenas, Jackie Beckett,

Christopher Boyko, Craig Chesek, Denis Finnin, Marjorie Gilbert, Ellen Giusti, Terri Guest, Lauri Halderman, David Harvey, Susan Klofak, Annie Langlois, Daryl Lowenthal, Nancy Lynn, Karen Manchester, Andrea Mercado, Laura Morse, Craig Morris, Lori Pendelton, Melissa Posen, Kathleen Sarg, Gerhard Schlansky, Joel Sweimler, Nick Terry, Stephen Thurston, Maron L. Waxman, Angela Klaus, Yumiko Iwasaki, Barbara Worcester, Maria Yakimov, and Stephanie Crooms; and at FMNH by Elisa Aguilar, Margaret Baker, Sheryl Breedlove, Michael Burns, Jean Cattell, David Foster, Pam Gaible, Jochen Gerber, Meghan Ghani, Robin Groesbeck, Anne Haskel, Jaap Hoogstraten, David Layman, Ray Leo, Holly Lundberg, Dorren Martin-Ross, Francie Muraski-Stotz, Stephen Nash, Clarita Nunez, Ariel Orlov, Marty Pryzdia, Sophia Shaw, Stefanie Stevens, Christine Taylor, John Weinstein, Martin Widhalm, and Felisia Wesson. NHL thanks Kirk Cochran and his family for support and encouragement. Systematic bivalve research at both institutions is supported by NSF PEET award DEB-9978119 to RB and PMM.

Contributions to the World Wide Web from a wide variety of academic, commercial, and private sources have provided substantial additional assistance in compiling information for this volume. In recognition of the sometimes transient or changing nature of such sources, hard-copy printouts of the pages cited in the Notes are deposited in the mollusk divisional libraries at the American Museum of Natural History and The Field Museum.

Illustration Credits

Illustrations and maps by Howard S. Friedman

Lyrics, page 98 "Guys and Dolls" from *Guys and Dolls* by Frank Loesser © 1950 (renewed) Frank Music Corp. All Rights Reserved

Cover and title page: AMNH 99382, 200651, 232663; FMNH 278467; Susan Hendrickson Collection; Mastoloni Collection; Gayle Pollock Collection. Photograph by Denis Finnin

Introduction

page 8: *Shah Jahan*. Courtesy of the V&A Picture Library, Victoria and Albert Museum
Columbus's Pearls
page 12: Engraving. AMNH 232654. Photograph by Jackie Beckett
page 17: *The Pelican Portrait*. Courtesy of the Board of Trustees of the National Museums and Galleries on Merseyside (Walker Art Gallery), Liverpool, inv. WAG 2994
page 18: *The Pearl Borer*. Bettmann/CORBIS
page 19: *Isabel de Valois*. Kunsthistorisches Museum, Vienna
page 20: La Peregina. Bettmann/CORBIS

Natural Beginnings

page 22: Paua Abalone, *Haliotis iris*. AMNH 232654. Photograph by Craig Chesek
page 24: Top, *Mytilus edulis*. Courtesy of Raymond Seed, University of Wales, Bangor, UK, and the Malacological Society of London. Bottom, types of mollusks. Photograph by Paula M. Mikkelsen
page 26: Fossil *Pinna*. By kind permission of The Natural History Museum (London), collection L.5117. Photograph by H. Taylor
page 29: Top, living abalone. Courtesy of Daniel L. Geiger, Los Angeles. Center, abalone gonad pearl (80.30 x 47.40 x 23.35 mm). Courtesy of Latendresse Family, Nashville. Bottom, sectioned blister pearl. AMNH. Photograph by Jackie Beckett
page 30: Top, Grace Kelly. Underwood and Underwood/CORBIS. Center, cave pearls. Courtesy of Spekul, the Leuven University Caving Club, Belgium. Photograph by Steve Smeyers. Bottom, *coques de perle* necklace. Courtesy of the Massachusetts Historical Society
page 31: Living pearl oyster (shell diameter 25-28 cm). Mark S. Mohlmann

page 32, table: Top, Silver-lipped Pearl Oyster. AMNH 294074. Photograph by Jackie Beckett. South Sea pearl. Mastoloni Collection. Photograph by Denis Finnin. Second row, Black-lipped Pearl Oyster. FMNH 278466, gift of Robert Wan Pearl Farm. Photograph by Jackie Beckett. Tahitian or "Black" pearl. Mastoloni Collection. Photograph by Denis Finnin. Third row, La Paz Pearl Oyster. AMNH 27824, gift of Perlas del Mar de Cortéz. Photograph by Denis Finnin. New World Black pearl. Susan Hendrickson Collection. Photograph by Denis Finnin. Fourth row, Akoya Pearl Oyster. AMNH, gift of Mikimoto Pearl Company. Photograph by Denis Finnin. Akoya pearl. Mastoloni Collection. Photograph by Denis Finnin. Bottom, Atlantic Pearl Oyster. AMNH 261358. Photograph by Denis Finnin. Venezuelan pearl. Susan Hendrickson Collection. Photograph by Denis Finnin
page 33, table: Top, Ceylon Pearl Oyster. AMNH 84522. Photograph by Denis Finnin. Oriental pearl. Courtesy of Mr. Mohammed Idris Jabir. Photograph by Denis Finnin. Second row, Pipi Pearl Oyster. FMNH 278467, gift of Robert Wan Pearl Farm. Photograph by Denis Finnin. Pipi pearl. FMNH 278467. Photograph by Denis Finnin. Third row, Black-winged Pearl Oyster. AMNH 232664, gift of Tasaki Pearls. Photograph by Jackie Beckett. Mabé pearl. Tasaki Pearls Collection. Photograph by Denis Finnin. Bottom, Western Winged Pearl Oyster. AMNH 232658, gift of Perlas del Mar de Cortéz. Photograph by Denis Finnin. New World black pearl. AMNH 232657, gift of Perlas del Mar de Cortéz. Photograph by Denis Finnin
page 34: Freshwater pearl mussel habitat. Courtesy of Arthur E. Bogan, North Carolina State Museum of Natural Sciences, Raleigh
page 35: Top, living Queen Conch. Courtesy of Stephen Frink/Waterhouse, no. FB-C-347. Photograph by Stephen Frink
page 35: Bottom, conch pearl necklace. The Walters Art Museum, Baltimore
page 36, table: Top left, Queen Conch with pearls. Shell, AMNH 177245; pearls, Susan Hendrickson Collection. Photograph by Craig Chesek. Top right, Noble Pen Shell with pearls. Shell, AMNH 168791; pearls, Musée Océanographique, Monaco, 98000. Photograph by Denis Finnin. Center left, Hard-Shell Clam with pearls. Shell, AMNH 91166; pearls: AMNH 200651 and 232653. Photograph

by Denis Finnin, Center right, Edible Oyster with blister pearl. AMNH 268828. Photograph by Denis Finnin. Bottom left, Blue Mussel with pearls. Shell, AMNH 243417; pearls, AMNH 99382. Photograph by Denis Finnin. Bottom right, Giant Clam with blister pearl. AMNH 110357. Photograph by Jackie Beckett
page 37, table: Top left, Baler Shell and melo pearl. Shell, AMNH 289214. Photograph by Jackie Beckett. Pearl. Photograph by Ken Scarratt. Top right, Green Abalone with blister pearls. AMNH 254131. Photograph by Jackie Beckett. Center left, Paua Abalone with pearls. Shell, AMNH 232654. Photograph by Craig Chesek. Pearls, © 1998 Gemological Institute of America. Photograph by Maha DeMaggio. Center right, Atlantic Deer Cowrie with pearl. Shell, AMNH 216373. Photograph by Jackie Beckett. Pearl, J. H. Pete Carmichael, Sarasota, Florida. Bottom left, Horse Conch with pearls. Shell, AMNH 209356. Pearls, Susan Hendrickson Collection. Photograph by Jackie Beckett. Bottom right, Knobbed Whelk with pearl. Sue Hobbs collection. Photograph by Denis Finnin
page 39, table: Top, Biwa Pearl Mussel with cultured blister pearls. FMNH 297381, gift of Kawabata Shinju Company. Photograph by Jackie Beckett. Second row, Triangleshell Pearl Mussel with pearls. Shell, AMNH 232665; pearls, AMNH 232663. Photograph by Denis Finnin. Third row, Hybrid Pearl Mussel with pearl. Shell, AMNH 232666, gift of Kawabata Shinju Company; pearl, Gerhard Schlanzky collection. Photograph by Denis Finnin. Fourth row, Cockscomb Pearl Mussel with "rice crispie" pearls. Shell, AMNH 30255; pearls, AMNH 232662. Photograph by Denis Finnin. Fifth row, European Pearl Mussel with pearls. Shell, AMNH 30440; pearls, Susan Hendrickson Collection. Photograph by Denis Finnin. Bottom, Washboard Pearl Mussel with cultured pearls. Shell, gift of American Pearl Company. AMNH 30282. Photograph by Jackie Beckett. Pearls, American Pearl Company, Nashville, Tennessee

The Mechanism of Luster

page 40: Carved Nautilus shell. Musée Océanographique, Monaco
page 42: Graph. Samples supplied by the American Pearl Company, Nashville; Kawabata Shinju Company, Lake Biwa, Japan; Yamakatsu Com-

pany, Japan; Paspaley Pearls, Australia; and Susan Hendrickson, Seattle. Measurements courtesy of Daniel Schrag, Harvard University

page 44: Top, blister pearl. Musée National d'Histoire Naturelle, Paris. Photograph by Jackie Beckett. Bottom, scanning electron micrographs of natural Pipi pearl and cultured Akoya pearl (gift of Yamakatsu Pearl Company). AMNH Interdepartmental Laboratory. Photograph by Kathleen Sarg and Angela Klaus

page 45: Top, cross-section of a *Pinna* pearl (Musée Océanographique, Monaco). Photograph by Denis Finnin. Bottom, scanning electron micrographs of nacreous layers. AMNH Interdepartmental Laboratory. Photograph by Neil H. Landman

page 46: Top, light photomicrograph. Photograph by Neil H. Landman and Paula M. Mikkelsen. Bottom, scanning electron micrograph. AMNH Interdepartmental Laboratory. Photograph by N. Landman and Angela Klaus

page 47: Top, Shooting Star necklace. Designed by Robert F. Clark, 1963, for Miriam Haskell. Deanna Farneti Cera Collection, Milan. Photograph by Stefano Porro, Milan. Bottom, engraving. Photograph by Jackie Beckett

page 48: Bottom, polishing machine. Photograph by Rüdiger Bieler

page 49: Toi et Moi ring. Designed by Jean Vendôme, 1990, for Jean Vendôme, Paris. Photograph by Raphaël Vendome

page 50: Fossil ammonite. AMNH 46866. Photograph by Denis Finnin

page 51: Conch pearl. Susan Hendrickson Collection. Photograph by Denis Finnin

page 52: Top, pearl drilling machine. Photograph by Bennet Bronson. Bottom, irradiated pearls. Photograph by Denis Finnin

page 53: Cultured pearls. Private collection. Photograph by Denis Finnin

page 54: Matched pearls. Mastoloni Collection. Photograph by Denis Finnin

page 55: Tarantula brooch. Designed by Stefan Hemmerle for Stefan Hemmerle Juweliere, Munich

page 57: Pearl of Allah. AMNH

page 58: Top, natural pearls. Mastoloni Collection. Photograph by Denis Finnin. Bottom, rolling pearls. Photograph by Rüdiger Bieler

page 59: Seed pearl parure. Cooper-Hewitt, National Design, Museum Smithsonian Institution/Art Resource. Photograph by Matt Flynn

page 60: Octopus and Butterfly brooch. Schmuckmuseum Pforzheim. Photograph by Guenter Meyer, Pforzheim

Pearls in Human History

page 62: *Ermine Portrait* of Queen Elizabeth I. Courtesy of the Marquess of Salisbury

page 64: Cypriot pin (length 17.8 cm). Courtesy of the Trustees of the British Museum.

page 65: Head of Venus. The J. Paul Getty Museum, Malibu, California

page 66: Left, mummy portrait. The J. Paul Getty Museum, Malibu, California. Right, Roman earring. Courtesy of the Trustees of the British Museum

page 68: Emperor Justinian, Empress Theodora. Scala/Art Resources, New York

page 69: bracelet (diameter 3.25 in.). The Metropolitan Museum of Art, gift of J. Pierpont Morgan, 1917 (17.190.1670). Photograph © 1998 The Metropolitan Museum of Art

page 71: Chinese pearl medicine. Photograph by Craig Chesek

page 72: German Imperial Crown. Kunsthistorisches Museum, Vienna

page 73: Visigothic crown. Museo Arqueologico Nacional, Madrid

page 74: Chalice of Abbé Suger. Photograph © Board of Trustees, National Gallery of Art, Washington. Photograph by Philip A. Charles

page 75: Archangel Michael. Scala/Art Resource, NY

page 76: Coronal of Princess Blanche. Bayerische Verwaltung der staatlichen Schlösser, Gärten und Seen

page 78: Top, Robert Dudley. By permission of the Trustees of the Wallace Collection, London. Bottom, Maria de Medici. Scala/Art Resource, NY

page 79: Charles IX after François Clouet. Château de Versailles et de Trianon. © Photo RMN - Gérard Blot

page 80: Pendant (8.9 x 5.7 cm). Studio Fotografico Antonio Quattrone

page 81: Pendant. Poldi Pezzoli Museum

page 83: *Madonna with Chancellor Rolin* by Jan Van Eyck. Musée du Louvre. © Photo RMN – C. Jean

page 84: *Marie Antoinette, à la Rose* by Louise Elisabeth Vigée Le Brun. Musée du Louvre. Château de Versailles et de Trianon. © Photo RMN

page 85: *Mistress and Her Maid*. © The Frick Collection, New York

page 86: Top left, cradle. Studio Fotografico Antonio Quattrone. Top right, figurine. Grünes Gewölbe, Dresden

page 87: Top and bottom, amatory lockets. Courtesy of the Trustees of the Victoria and Albert Museum, London, V&A Picture Library. Photograph by D. P. P. Naish

page 88: Icon. Residenz Museum, Munich/Art Resource, NY

page 89: Russian boot. State Museum of the Kremlin, Moscow

page 90: Stickpin. Cooper-Hewitt, National Design Museum, Smithsonian Institution/Art Resource, NY. Photograph by Matt Flynn

page 91: Empress Eugénie. Réunion des Musées Nationaux/Art Resource, NY. Photo by RMN - Franck Raux

page 92: Top, Mary Todd Lincoln (73292). © Collection of The New York Historical Society. Bottom, Martha Washington. Courtesy of the Mount Vernon Ladies' Association

page 94: Consuelo Vanderbilt. Kunz and Stevenson 1908

page 95: Pearlie King and Queen costume. Museum of London

page 96: Art nouveau brooch. Christie's Images, New York

page 97: Chrysanthemum brooch. Wartski, London

page 98: Van Cleef advertisement. Van Cleef and Arpels

page 99: Coco Chanel. © 2001 Man Ray Trust/Artists Rights Society (ARS), NY/ADAGP, Paris

page 100: Audrey Hepburn. Courtesy of Photofest.

page 101: Top, Josephine Baker. Yale Collection of American Literature, Beinecke Rare Book and Manuscript Library. Bottom, Princess Diana. Corbis/Sygma. Photograph by Tim Graham

Pearls in Human History

page 102: Fath Ali Shah. Collection Prince Sadruddin Aga Khan

page 105: Top, necklace. Musée National de Bahreïn. Bottom, Sumerian deity. FMNH 156787. Photograph by Bennet Bronson

page 106: Head of Sassanian king. The Metropolitan Museum of Art, Fletcher Fund, 1965 (65.126). Photograph © 1982 The Metropolitan Museum of Art

page 107: Earrings. FMNH 299956. Photograph by John Weinstein

page 108: Ajanta fresco. From J. Griffiths 1896-1897, *The Paintings in the Buddhist Cave Temples of Ajanta*

page 109: Pendant. Courtesy of the Trustees of the Victoria and Albert Museum, London, V&A Picture Library

page 110: *Shah Jahan*. Courtesy of the V&A Picture Library, Victoria and Albert Museum

page 111: Top, Rana of Dholpur. Kunz and Stevenson 1908. Right, Tippoo Sultan. Courtesy of the Trustees of the Victoria and Albert Museum, London, V&A Picture Library

page 112: Hair ornament. FMNH 82242. Photograph by Mark Widhalm

page 113: Necklace. The Metropolitan Museum of Art, John Stewart Kennedy Fund, 1915 (15.95.73). Photograph © 1983 Metropolitan Museum of Art

page 114: Baroda carpet. Photograph by Christian Poite

page 115: Measuring tools. Pearl Museum, Mikimoto Pearl Island, Japan

page 116: Robe (detail). The Metropolitan Museum of Art, gift of Robert E. Tod, 1929 (29.36).
Photograph © 1980 Metropolitan Museum of Art

page 117: Siamese prince. Kunz and Stevenson 1908.

page 119: Headdress. National Museum of Chinese History, Beijing. Photograph by Mrs. Shao Yulan

page 121: Left, earrings. FMNH 254274; Photograph by Mark Widhalm. Right, headdress. National Museum of Chinese History, Beijing. Photograph by Mrs. Shao Yulan

page 122: Armor. National Museum of Chinese History, Beijing

page 123: Helmet. National Museum of Chinese History, Beijing

page 124: Tray. AMNH. Photograph by Jackie Beckett

page 125: Tray. The Florence and Herbert Irving Collection.

page 126: Shell. Musée Océanographique, Monaco.

page 127: "Chief lady of Pomeicoc." AMNH 329174. Theodore deBry 1594. Photograph by Jackie Beckett

page 128: Mask. AMNH 7847 (16/594). Photograph by Lynton Gardiner

page 129: Top, Hopewell man. FMNH 56614. Right, Hopewell raven. FMNH 56536. Photographs by R. Testa

Getting Pearls

page 130: Advertisement for Boepple Button Company. Muscatine Art Center, Muscatine, Iowa

page 133: Top, pearl earrings. Courtesy of Mr. Mohammed Idris Jabir. Bottom, engraving Malachias Geiger 1637. *Margaritologia.* Compliments of the U.S. Geological Survey Library

page 134: Pearl diving in Ceylon. Gottlieb Tobias Wilhelm 1813. *Unterhaltungen aus der Naturgeschichte der Würmer.* AMNH. Photograph by Jackie Beckett

page 135: Pearl diving in Persian Gulf. *Catalan Atlas.* Bibliothèque nationale de France

page 136: Top, Australian pearling lugger. Bottom, divers. Paspaley Pearls, Darwin, Australia.

page 138: Pearl dredge. Edwin W. Streeter 1886. *Pearls and Pearling Life*

page 139: Woodcut. Song Yingxing 1637. *Tiangong Kaiwu* (Sun and Sun, 1966)

page 141: Mexican pearling fleet, Micheline Cariño, *Gems & Gemology,* Summer 1995

page 142: German mussel tools. Courtesy of Karl-Heinz Reger, Munich

page 143: Necklace. Reproduced by kind permission of His Grace The Duke of Norfolk

page 144: Left, necklace. Grünes Gewölbe, Dresden. Right, German pearler. Courtesy of Karl-Heinz Reger

page 145: Queen Marie. Schloss Nymphenburg Collection. Courtesy of Karl-Heinz Reger

page 146: John boat (postcard, c. 1910-20). Max W. Churchill. Collection for Muscatine Pearl Button Museum. Photograph by Denis Finnin

page 147: Top, shells with button holes. Courtesy of Paul W. Parmalee and Arthur E. Bogan, 1998, *Freshwater Mussels of Tennessee.* Bottom, John Boepple at drill. Muscatine Art Center, Muscatine, Iowa

page 149: Montana brooch (6 x 6 cm). Copyright Tiffany & Co. Archives 2001.

Making Pearls

page 152: Mabé pearls in pearl mussel. AMNH 232663. Photograph by Denis Finnin

page 155: Left, Buddha shell. AMNH. Right, Mao shell. FMNH. Photographs by Jackie Beckett

page 156: Linné's pearls. By kind permission of the Linnean Society of London. Photograph by H. Taylor, The Natural History Museum, London

page 158: Top, statue. Photograph by Rüdiger Bieler. Left, Yaguruma Sash Clip. Pearl Museum, Mikimoto Pearl Island, Japan

page 159: *The Abalone Shell (Awabi Kai,)* Edo period (c. 1769). Clarence Buckingham Collection 1925.2129. Photograph by Greg Williams. © The Art Institute of Chicago. All rights reserved

page 160: Top, pearl oysters in basket. 2nd row, pearl grafter. Photographs by Rüdiger Bieler. Center, pearl oysters. Photograph by Bennet Bronson. 4th row, pearl shells. Mikimoto Pearl Company. Bottom, black pearl. Photograph by David Doubilet © Doubilet Photography Inc.

page 161: Top, grafting tools. A. R. Cahn 1949, *Pearl Culture in Japan.* Bottom, Masanori Kubo, grafter. Photograph by Rüdiger Bieler, reproduced with permission of Mikimoto Pearl Farm

page 162: Bead nuclei cubes. AMNH. Photograph by Jackie Beckett

page 163: Preparing graft. Photograph by Rüdiger Bieler

page 165: Top, opened pearl oyster. Photograph by Rüdiger Bieler. Bottom, shells. Photograph by Bennet Bronson

page 166: Top, pearl floats. Photograph by Paula M. Mikkelsen. Bottom, cleaning machine. Photograph by Bennet Bronson

page 167: Top, boat. Photograph by Rüdiger Bieler. Bottom, divers. Photograph by Bennet Bronson

page 168: Pearls. Photograph by Rüdiger Bieler

page 170: Pearl oyster armor. Micheline Cariño, *Gems & Gemology,* Summer 1995

page 171: Pearl necklace and earrings. Designed by Christopher Walling for Christopher Walling, New York. Photograph by Michael Oldford

page 172: Top, atoll. Bottom, spat collector. Tahiti Perles, A Robert Wan Company

page 173: Lines of shells. Photograph by Rüdiger Bieler

page 174: Top, pearl farmer. Courtesy of Douglas McLaurin, Perlas del Mar de Cortéz. Bottom, abalone with screwed-in nucleus. Peter V. Fankboner

page 175: Abalone mabé pearls. Peter V. Fankboner

page 176: Top, mabé earrings and necklace. Tasaki Pearls. Bottom, pearl oysters with mabé pearls. Photograph by Andy Muller, Golay Group

page 178: Top, shell dump. Photograph by Bennet Bronson. Bottom, washing pearls. Photograph by Paula M. Mikkelsen

page 179: Top, lake. Bottom, farmer. Photographs by Rüdiger Bieler.

page 180: Top, opened pearl mussel. Bottom, sorting pearls. Photographs by Rüdiger Bieler

page 181: Pearl paddy. Photograph by Rüdiger Bieler

page 182: Top, grafter. Bottom, pearl mussels. Photographs by Rüdiger Bieler

Saving Pearls

page 184: Pearl mussels. AMNH 130282, 31183, 127989, 139382, 34217, 139085. Photograph by Craig Chesek

page 188: Glochidium (250 microns or one one-hundredth of an inch). Barry J. Wicklow, Saint Anselm College, Manchester, New Hampshire

page 189: Living pearl mussels. Museum für Tierkunde, Staatliche Naturhistorische Sammlungen, Dresden. Photograph by Georg Hoffmann

page 191: Warning poster. Kloster Ebstorf, Germany. Photograph by Karl-Christian Lyncker

page 193: Akoya oyster. Pearl Museum, Mikimoto Pearl Island, Japan

page 197: Red tide. Photograph by Peter J. S. Franks, Scripps Institution of Oceanography, La Jolla, California

page 200: Pearl farmer. Photograph by Paula M. Mikkelsen

Index